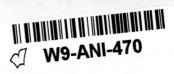

Censorship of Political Caricature
in Nineteenth-Century France

Censorship of Political Caricature in Nineteenth-Century France

Robert Justin Goldstein

THE KENT STATE UNIVERSITY PRESS
Kent, Ohio, and London, England

©1989 by The Kent State University Press, Kent, Ohio 44242
All rights reserved
Library of Congress Catalog Card Number 89-32670
ISBN 0-87338-392-3
ISBN 0-87338-396-6 (pbk.)
Manufactured in the United States of America

Library of Congress Cataloging-in-Publication Data

Goldstein, Robert Justin.
 Censorship of political caricature in nineteenth-century France /
Robert Justin Goldstein.
 p. cm.
 Bibliography: p.
 (alk. paper)
 Includes index.
 ISBN 0-87338-392-3 (alk. paper) ∞
 ISBN 0-87338-396-6 (pbk.: alk. paper) ∞
 1. France—Politics and government—19th century—Caricatures and
cartoons. 2. Censorship—France—History—19th century. 3. French
wit and humor, Pictorial—History—19th century. 4. Freedom of the
press—France—History—19th century. 5. Political satire, French—
Censorship—History—19th century. I. Title.
DC252.G57 1989
320.944′0270—dc20 89-32670
 CIP

British Library Cataloging-in-Publication data are available.

Cover illustration: French caricature journals endlessly pictured censorship wreaking havoc with their publications. On June 9, 1879, *La Jeune Garde,* a caricature journal which supported restoration of the Bonapartist dynasty overthrown in 1870, protested the censorship of caricature during the early Third Republic by depicting it as a huge pair of scissors with legs ruthlessly cutting apart the journal's drawings. *La Jeune Garde* stopped publishing in 1880 because, as it declared on June 6 of that year, the lack of "liberty of the crayon" (i.e., freedom from censorship) made its work impossible. It began publishing again in 1885, following the abolition of caricature censorship in 1881.

Contents

Preface and Acknowledgments

On June 15, 1880, *Le Grelot,* a French caricature journal which frequently had its illustrations banned by the authorities, complained bitterly, "When future generations learn that the preliminary censorship, abolished for the printed word in 1830, still existed for drawings in 1880 . . . they will not fail to consider us a remarkable race of hydrocephalics [i.e., people with brain-damage]." Another caricature journal, *L'Eclipse,* observed on September 20, 1874, that "one could, one day, write an exact history of the liberty which we enjoy during this era by writing a history of our caricatures."

These comments suggest several of the most salient aspects of censorship of caricature in nineteenth-century France: pictures were feared by the authorities far more than words, with the result that for fifty of the sixty years between 1820 and 1881 the French government censored drawings in advance of publication while forgoing prior censorship of the printed word; and the enormous sensitivity of the authorities to the power of political drawings and to the symbolic significance of the issue of freedom of caricature was demonstrated by incessant changes in the regulation of the so-called liberty of the crayon. These changes invariably reflected major developments in France's internal politics and largely determined the nature of French caricature during the period. Thus, prior censorship of caricatures was eliminated in 1814, restored in 1820, abandoned again in 1830, reestablished in 1835, ended once more in 1848, reimposed in 1852, abolished again in 1870, decreed once more in 1871, and finally ended permanently in 1881 (at least in peacetime, as it was temporarily restored again during World Wars I and II). By contrast, although until 1881 the French authorities regu-

larly subjected the printed word to a great deal of administrative regulatory harassment and postpublication prosecution, the written press was not—save for a few very brief and exceptional circumstances—ever subjected to prior censorship after 1822.

The caricature censorship, and the varying manner in which it was enforced at different times, was a critical factor in shaping the nature of French caricature throughout the 1820–81 period—and even when prior censorship was not in effect, as between 1830 and 1835 and after 1881, the possibility of postpublication prosecution for such "crimes" as offense to the king, the president, or the military still conditioned the form of French caricature. Thus, throughout the nineteenth century, which has often been termed an "age of gold" for French caricature (well over 350 caricature journals were established between 1830 and 1914 in what one expert has termed the "richest and most varied production of any time and any country"), the degree to which the artist's "gold" could shine or was tarnished before it could appear in public was strongly determined by governmental officials.[1] Yet, curiously, caricature censorship has attracted relatively little attention or interest from French historians and virtually none from English and American historians. For example, L. Gabriel-Robinet's 1965 book, *La Censure* presents a wealth of information about French censorship of books, newspapers, plays, and cinema, yet never mentions censorship of caricature (although it is clear from the sources he cites that he is aware that it existed).[2] As mentioned in my bibliographic essay, only one ten-page article and no previous books have been devoted to a survey of censorship of French caricature in the nineteenth century. Since this is a subject most readers are not likely to have thought much about, this will probably not sound like a surprising statement, but by the time the reader completes this book, perhaps it will seem quite surprising indeed.

Repression (if not prior censorship) of caricature in nineteenth-century France *has* attracted considerable attention for the brief period of 1830–35, primarily because it was during this time that the most famous caricaturist in French (and probably world) history, Honoré Daumier, was jailed for six months for a drawing which attacked King Louis-Philippe. This is a surprisingly well-known fact, as I discovered in talking to people while writing and researching this volume. Yet virtually no one knew that caricature drew severe regulation and repressive attention from French authorities *throughout* the nineteenth century and that Daumier's experience was by no means exceptional. Well over a score of artists, editors, and printers involved in publishing caricatures were jailed for their efforts between 1815 and 1914 in France, and about twenty caricature journals were suppressed. The French

authorities were by no means alone in their fear of the image. Governments throughout Europe during the nineteenth century viewed caricatures as especially dangerous, and subjected them to censorship or strict regulation, because they were accessible to the large percentage of the population which was illiterate and also because they were seen as simply having more impact than the written word and being more effective in transmitting a message. Napoleon once declared, "The shortest sketch says more than a long report," the equivalent of the English cliché that "a picture is worth a thousand words."[3]

The fear of images has by no means disappeared in France (or elsewhere) since 1914, the limit for this study. In France, two caricature journals were prosecuted in 1959 for drawings alleged to defame the army and to offend President de Gaulle, and in 1963 the journal *Sine-Massacre* was prosecuted nine times for its drawings. In July 1987 a well-known Palestinian caricaturist was shot and killed in London, while in May 1988 a group of Chicago city councilmen were so offended by a portrait of the late Mayor Harold Washington dressed in lingerie that they seized and removed it from the Art Institute of Chicago (which subsequently publicly apologized for displaying it). During the week in August 1988 when I was completing the text of this book, three separate incidents surrounding controversial images attracted widespread attention: the film *The Last Temptation of Christ,* an unconventional depiction of its subject, was attacked by some as blasphemous; a mural by Ecuador's most famous artist, displayed in the chamber of the Ecuadorean legislature, was publicly denounced by American Secretary of State George Schultz for its visual linking of the CIA and Nazi Germany; and the University of Michigan withdrew from circulation an already-published magazine whose cover reproduced a 1907 caricature concerning freshman hazing, because the depiction of a large, white upperclassman throttling a small, green (i.e., inexperienced) freshman could be mistaken for, as a University spokesman said, "a small black person in the clutches of some white upperclassman." A defamation suit resulting from a caricature ridiculing conservative preacher Jerry Falwell was decided in the U.S. Supreme Court in February 1988, with the court dismissing the complaint partly on the grounds that throughout American history "graphic depictions and satirical cartoons have played a prominent part in public and political debate" and "it is clear that our political discourse would have been considerably poorer without them."[4]

Most authors writing on the subject of caricature have concluded that this term defies precise explanation, although it has often been suggested that all caricatures must feature exaggeration and/or political criticism. I have used

"political caricature" in a broad sense to mean politically oriented drawings with an intended mass circulation; such drawings sometimes, but not always, use exaggeration and usually, but not always, are critical (although those that were censored or prosecuted always were at least critical of the authorities by implication, of course). Since my focus is on political caricature, I have paid at most glancing attention to censorship and prosecution of eroticism, a subject which occupied the attention of many caricaturists in nineteenth-century France, thereby often attracting the unfavorable attention of the authorities.

Because political caricature always occurs in a specific context, I have provided for the reader with little knowledge of nineteenth-century French history some basic background information about political developments, as well as some basic information about legislation concerning the press in general and overall trends in caricature. However, since this is a book about censorship of caricature, it cannot, without doubling or tripling in length, also provide comprehensive information about nineteenth-century French history, the entire French press or non-censorship-related matters concerning political caricature. For the reader wishing more information about nineteenth-century French history, there are plenty of excellent English-language treatments, of which Gordon Wright's *France in Modern Times* (Chicago: Rand McNally, 1974) can be recommended as a reliable and readable treatment for beginners. The book by Irene Collins cited in the bibliographic essay is an excellent English-language study of government regulation of the nineteenth-century French press (although it provides minimal information about caricature). There is no good English-language study of French nineteenth-century caricature, so this volume is designed to provide background information on this subject for all but specialists. (By "nineteenth century" I am using the historians' convention of 1815–1914—Waterloo to World War I.)

The plan of the book is as follows: Chapter 1 discusses why the French authorities feared caricature so much and explains how the censorship worked, as well as discussing the penalties incurred by those who violated the laws regulating caricature. Chapter 2 discusses why caricaturists and their supporters had a very different view of the role played by their craft than did the authorities and summarizes their manifold criticisms of censorship of caricature. Chapters 3 through 6 give a chronological survey of censorship and repression of caricature from its sixteenth-century beginnings until 1914, with the main stress on the periods between 1820 and 1881 when censorship was enforced. The argument is reinforced by extensive illustrations, which are referenced in the text. I have included the publication dates

of caricature journals within the text where that seemed particularly relevant; this information is included in the index for all journals mentioned in the book. Birth and death dates of caricaturists mentioned in the book are also included in the index. In order to keep the footnotes down to hundreds rather than thousands, I have tried whenever possible to incorporate dates for cited newspapers within the text itself, and I have often gathered all footnotes pertinent to a paragraph in one footnote at the end of the paragraph rather than independently citing each quotation or fact. Monetary units are cited throughout the book in nineteenth-century French francs, which were equivalent to twenty cents in American currency of the time. To compute a modern day equivalent, nineteenth-century European currency must be multiplied by a factor of twelve or more due to inflation, which is to say that one nineteenth-century French franc was worth about the present equivalent of $2.40 or more.[5]

I have run up many debts in the course of researching and writing this book. I am indebted first to the many libraries which allowed me access to examine and photograph often-rare original copies of nineteenth-century caricature journals: these include the libraries of the University of Michigan (Ann Arbor), the University of Connecticut (Storrs), the University of Wisconsin (Madison), Wayne State University (Detroit), Michigan State University (East Lansing), Northwestern University (Evanston, Illinois), and Yale University (New Haven, Connecticut), as well as the New York Public Library, the Library of Congress (Washington, D.C.), the British Newspaper Library (Colindale, London), the Musée Historique de la Ville de Paris, and the Bibliothèque Nationale (Paris). I am especially indebted to Russell Maylone and Richard Schimmelpfeng, the curators at, respectively, Northwestern and Connecticut, whose help went far beyond what could reasonably have been expected.

I benefited greatly from generous advice and assistance from many American friends and colleagues who share my fascination with nineteenth-century French caricature and whose help was even more remarkable since in most cases we have never met but only corresponded: among these generous colleagues are Steven Heller, Art Director of the *New York Times Book Review;* Donald Crafton, Director of the Wisconsin Center for Film and Theater Research, Madison; Professor Tom Osborne of the University of North Alabama; Professor Michael Driskel of Brown University; Professor Mary Lee Townsend of the University of Tulsa; James Cuno, Director of the Grunwald Center for the Graphic Arts at UCLA; Professor Elizabeth Childs of SUNY-Purchase; Professor Jeff Rosen of Columbia College, Chicago; and Professor Gary Stark of the University of Texas at Arlington.

During my research in France, I received inestimable assistance and encouragement from Odile Krakovitch of the Archives Nationales, whose book *Hugo Censuré,* a study of censorship of the theater in nineteenth-century France, is a model of clarity and scholarship; from Pierre Courtet-Cohl, the grandson of Emile Cohl, a caricaturist and early cinema pioneer who was a disciple of the great French caricaturist André Gill, whose work is discussed at length in these pages; from Marcelle Courtet-Cohl, Pierre's mother and Cohl's daughter-in-law; and from Jean Frapat, a journalist who shares my fascination with Gill.

Scattered portions of this volume first appeared in preliminary form in three journals which graciously permitted me to reprint them here. These articles are: "Approval First, Caricature Second: French Caricaturists, 1852–81," in *The Print Collector's Newsletter,* May–June, 1988; "The Debate over Censorship of Caricature in Nineteenth-Century France," in *Art Journal,* Spring 1989; and "Censorship of Caricature in France, 1815–1914," *French History,* March, 1989. Generous grants from the National Endowment for the Humanities and the Swann Foundation for Caricature and Cartoon helped considerably with the research costs for this project. I am responsible for the translations from French materials; although I did all of the photography, I am greatly indebted to the University of Michigan Photo Services Department and to Foto 1 of Ann Arbor for developing and printing the photographs. Finally, I am most thankful to Kent State University Press for undertaking this somewhat unorthodox project, to copyeditor Hilah Selleck, and especially to my editors, Jeanne West and Julia Morton, who welcomed this book from the very beginning with enthusiasm and provided along the way the kind of constant support and encouragement that every author needs and greatly appreciates.

This book is dedicated to the memory of the great French caricaturist André Gill (1840–85).

1

The Fear of Caricature and the Censorship Mechanics

THE DEFENSE OF CENSORSHIP AND THE FEAR OF CARICATURE

Caricatures were often denounced by governmental spokesmen and their supporters in nineteenth-century France in extraordinarily emotional and extreme language, which makes it clear that caricatures were genuinely viewed as posing a threat to the social order. Thus, in support of a proposal made by King Louis XVIII to continue prior censorship of caricature in 1822, while at the same time abolishing censorship of the printed word, legislative deputy Louis Bonnet declared that "there is nothing in the world more dangerous and whose danger is propagated more quickly than the sale and exhibition of drawings which offend mores or laws or which manifest factious intentions." Similarly, in 1835, when the government of King Louis-Philippe proposed reimposing censorship of caricature, which had been abolished in 1830, his minister of commerce, Charles Duchatel, told the legislature that "there is nothing more dangerous, gentlemen, than these infamous caricatures, these seditious designs," which "produce the most deadly effect." Ministerial directives concerning the implementation of caricature censorship laws were usually framed in language indicating similarly extreme concern. Thus, on May 20, 1822, the minister of the interior told prefects throughout France that he could not "recommend to you too much severity" in the enforcement of the caricature censorship; on September 8, 1829 the minister urged his prefects to implement the censorship "with the most exact severity"; and on May 4, 1874 another such message stated that the minister attached "the greatest importance to the strict execution" of the censorship laws.[1]

The authorities were especially sensitive to pictures due to the general belief that drawings had a much greater impact and were far more widely accessible than the printed word. Caricatures were viewed as even more dangerous than the print press partly because they were perceived as simply being a more powerful means of communication. Thus, in 1789 an observer congratulated the revolutionary authorities for reinstating prior censorship of illustrations while abolishing press censorship because "paintings and engravings are the most powerful means of influencing the heart of man, because of the lasting impressions they leave." Drawings were viewed as having such a strong impact because they were perceived as speaking directly to people's senses and emotions. Therefore, it was argued, illustrations had an immediate impact which amounted to an incitement to action, whereas the printed word was seen as speaking more to the intellect, with its effect dampened and delayed by the thoughtful consideration and time needed to process its message. Thus, when the government requested the reimposition of prior censorship of drawings (and of the theater) in 1835, Minister of Justice Jean-Charles Persil argued that this request was constitutional despite article seven of the 1830 charter, which guaranteed the "right to publish" and declared that "censorship can never be reestablished," on the grounds that:

> This ban on the reestablishment of the censorship only applies to the right to *publish* and have *printed one's opinions;* it is the [written] press which is placed under the guarantee of the Constitution, it is the free manifestation of *opinions* which cannot be repressed by preventive measures. But there the solicitude of the charter ends. It would clearly go beyond that goal if the charter were interpreted to accord the same protection to opinions converted into actions. Let an author be content to print his play, he will be subjected to no preventive measure; let the illustrator write his thought, let him publish it in that form, and as in that manner he addresses only the *mind,* he will encounter no obstacle. It is in that sense that it was said that censorship could never be reestablished. But when opinions are converted into *acts* by the presentation of a play or the exhibit of a drawing, one addresses people gathered together, one speaks to their eyes. That is more than the expression of an opinion, that is a *deed,* an *action,* a *behavior,* with which article seven of the charter is not concerned.

The chairman of the legislative committee which considered the government's proposal in the Chamber of Deputies, Paul Sauzet, completely supported Persil's argument, proclaiming that the charter guaranteed only freedom to express opinions and that it would "force the meaning of words to consider drawings the same as opinions" or to "establish a parallel be-

tween writings which address themselves to the mind and the illustration which speaks to the senses. The vivacity and popularity of the impressions they leave must create for drawings a special danger which well-intended legislation must prevent at all costs."[2]

Since the impact of caricatures was perceived as immediate, it was argued that only prior censorship could be effective in controlling its harmful effects, unlike the case of the printed word, whose appeal to the intelligence delayed its effect and afforded the authorities time to take countermeasures, including postpublication seizures and prosecutions, if necessary. Thus, the minister of the interior told French prefects on September 8, 1829 that, "Engravings or lithographed images act immediately upon the imagination of the people, like a book which is read with the speed of light; if it wounds modesty or public decency the damage is rapid and irremediable. It is then extremely important to forbid all which breathes a guilty intention in this regard." The threat posed by caricatures, it was argued, was further aggravated by their customary public display in the windows of print sellers and in street kiosks, which often attracted large crowds susceptible to incitement to mob action, whereas the printed word was typically read by individuals or small groups inside private homes and buildings. Thus, when the question of censorship of caricature was discussed in 1822, deputy Claude Jacquinot-Pampelune told the legislature:

> Caricatures, drawings, offer a means of disturbance which it is very easy to abuse and against which repressive [postpublication] measures can only be of very little help. Printed matter does not even have as many readers as there are examples printed and it requires a considerable time for that writing to produce its effect. Thus, the vigilance of the magistrates can prevent the continuation of a commotion by seizing it. But it isn't the same with engravings and illustrations. As soon as they are exhibited in public, they are instantly viewed by thousands of spectators and the disturbance has taken place before the magistrate has had time to repress it.[3]

The concern caused by the authorities' perception that caricatures had greater impact than the printed word was greatly aggravated by the fact that drawings were also far more accessible to the most feared elements of the population—the lower classes. During most of the nineteenth century a large percentage of the population was illiterate, but members of this group were not blind, and therefore although relatively immune from subversive printed words, they were considered highly vulnerable to dangerous pictures. Fifty percent of all army recruits in the 1830s were illiterate. While fewer than 10 percent of recruits were illiterate by 1900, only 2 percent had

3

completed secondary school, so as historian Donald English has noted, France throughout the nineteenth century "remained a nation of semiliterate people" for whom the image remained "a more easily understandable and accessible medium" than print. Illiteracy was especially common among the poverty-stricken masses who were particularly feared as threats to the power and privilege of the middle- and upper-class elites, who dominated France throughout the nineteenth century. The particular fears concerning the impact of subversive caricatures upon the illiterate poor were expressed by the Paris Police Prefect in 1823, who urged a crackdown on itinerant print sellers, since such traders frequently spread dangerous ideas among the "lowest classes of society." A September 8, 1829 directive from the minister of the interior concerning the circulation of portraits of Napoleon informed the prefects that, "In general, that which can be permitted without difficulty when it is a question of expensive engravings, or lithographs intended only to illustrate an important [i.e., expensive] work, would be dangerous and must be forbidden when these same subjects are reproduced in engravings and lithographs at a cheap price."[4]

The intense fears of the authorities about the impact of caricatures in general and their effect upon the "unwashed masses" in particular were summarized in a dispatch by the minister of police to his subordinates on March 30, 1852:

> Among the means employed to shake and destroy the sentiments of reserve and morality which are so essential to conserve in the bosom of a well-ordered society, drawings are one of the most dangerous. This is so because the worst page of a bad book requires some time to read and a certain degree of intelligence to understand, while the drawing offers a sort of personification of the thought, it puts it in relief, it communicates it with movement and life, so as to thus present spontaneously, in a translation which everyone can understand, the most dangerous of all seductions, that of example.

Another good summary of the fears provoked by caricatures was offered to the Chamber of Deputies by a conservative legislator, Emile Villiers, in 1880:

> I believe that, if the liberty of the press, practiced without restraint or regulation, poses problems and dangers, the unlimited freedom of drawings presents many more still. An article in a journal only affects the reader of the newspaper, he who takes the trouble to read it; a drawing strikes the sight of passersby, addresses itself to all ages and both sexes, startles not only the mind but the eyes. It is a

means of speaking even to the illiterate, of stirring up passions, without reasoning, without discourse.[5]

That caricatures were viewed as more powerful and accessible than the printed word would not automatically have aroused alarm among governmental officials had not their content often been perceived as highly threatening and politically objectionable. In fact, however, except when harsh censorship totally stifled opposition caricatures, as during the rule of Emperor Napoleon III (1852–70), political caricature was usually dominated by political dissidents, whose work was perceived, as the 1852 police minister put it, as threatening to "shake and destroy" the popular support needed for a "well-ordered society." Perhaps the single most common theme expressed in the attacks made on caricatures was that they denigrated government officials, created disrespect for the established order, and demoralized society. Often in such criticisms, political caricatures were lumped together with obscene or pornographic drawings, in references, such as that made in 1871 by the Bonapartist newspaper *Le Gaulois,* to caricatures which have become "a scandalous display of filthy coarseness and an instrument of public demoralization, deserving to be swept away with a broom just like the filth of the gutter and the streets." During the legislative debate on censorship of caricature in 1822, Count Joseph Portalis, speaking on behalf of a committee of the House of Peers, told his colleagues that the provision was designed to eliminate the "disgusting spectacle of so many disturbing or licentious exhibitions," while during the 1835 debate the duc de Broglie, who served King Louis-Philippe as prime minister and foreign minister, referred to "that display of disgusting obscenities, of infamous baseness, of dirty productions" that forced pedestrians to "lower our eyes blushing from shame."[6]

Despite the frequent references to "disgusting obscenities" made in attacks upon caricatures, supporters of censorship did not conceal their great concern about the political content of drawings, especially those that attacked the government of the day. Thus, in successfully introducing the first measure establishing censorship of caricature in the post-1815 period, the duc de Fitz-James referred in 1820 to "those ignoble caricatures which have sought for five years to ridicule and besmirch the long-time servants of the king" and "have delivered to the scorn of the populace" the "most august personages" including "the king himself and his family." In urging the adoption of censorship of caricature in 1835, Minister of Justice Persil referred to "obscene engravings, which shame our morals" and offend "public decency," but he also stressed the "insolent lithographs which bring derision, ridicule and scorn on the person and the authority of the king and his

family." Deputy Sauzet, speaking for a committee of the Chamber of Deputies in 1835, insisted on the need to impose censorship on drawings because "no measure is more needed by the situation and desired by public opinion" than "putting an end to these outrages which corrupt the spirit of the population in degrading with impunity the royal majesty."[7]

In a country in which a popular saying declared that "ridicule kills," the authorities feared that "subversive" satires could significantly undermine support for the established order and might even lead to revolutionary outbreaks or assassination attempts. Thus, the minister of the interior told his prefects on May 20, 1822 that, "If the license of the press has always been a powerful auxiliary of the factious, the license of engraving is even more dangerous, because it acts directly upon people, and could lead them to revolt, or at least to scorn for the most respectable things." Similarly, during a trial of the caricature journal *Le Charivari* in April 1835, the government prosecutor declared that "before overthrowing a regime, one undermines it by sarcasm, one casts scorn upon it." While discussing his proposal to introduce censorship of caricature in 1820, in the immediate aftermath of the assassination of the King's nephew by a man named Louvel, the duc de Fitz-James, referring to a caricature which attacked the duchess of Angoulême, daughter of Louis XVI, suggested that "tomorrow some miserable person as could still exist, some new Louvel, saturated like him in the spleen of his hatred, inflamed at the sight of that infamous engraving," might assassinate her. He suggested that if such an event were to occur "would not those who were able to prevent the display of such a horror and did not do so [i.e., his fellow legislators] be complicit in the assassination?" During legislative debate in 1835, which followed a spectacular attempt on the life of King Louis-Philippe, Minister of Commerce Duchatel declared that "there is no more direct provocation to crimes which we all deplore" than that provided by subversive caricatures. Similarly, deputy Eugène Janvier declared that drawings "don't address opinions, they address passions and generally bad passions" and that they "deprave those who observe them, degrade intelligence, address themselves only to the low chords of the heart, play with crime and frolic with assassination! I choose these last words very carefully." The Paris police chief during the 1830s, Gisquet, similarly strongly implied in his memoirs that the "outrages" committed by widely circulated drawings attacking King Louis-Philippe amounted to suggestions that "regicide" was a "meritorious deed."[8]

The French authorities were by no means unique in nineteenth-century Europe in their harsh treatment of political drawings. Every major European country except England enforced a harsh censorship on caricatures until after 1848, and in the case of Russia such controls lasted throughout the

entire nineteenth century. Conservatives throughout Europe were moti-
vated by the same fears which disturbed French elites. Thus, one English-
man writing in the late eighteenth century condemned caricatures as teach-
ing lessons "not of morality and philanthropy, but of envy, malignity and
horrible disorder," and concluded that it would be "better, better far," if
there were "no art, than thus to pervert and employ it to purposes so base,
and so subversive of everything interesting to society." In 1831, the English
journal the *Athenaeum* characterized the work of caricaturists as that of
someone who "insults inferiority of mind and exposes defects of body—and
who aggravates what is already hideous, and blackens what was sufficiently
dark." The German democratic, antimilitarist caricature journal *Simplicis-
simus,* founded in 1896, was, as historian Robin Lenman notes, endlessly
denounced by the German authoritarian establishment as "subversive, por-
nographic 'brothel literature' which was a danger to morality, youth and
national strength." Thus, in 1898, a conservative German newspaper
claimed *Simplicissimus* was characterized by a "flood of artistic and moral
poison," while a few years later minister of war von Heeringen condemned
it as the "bacillus which destroys all our ideals" and required all German
officers to pledge not read it. Bavarian officals banned the sale of *Simplicis-
simus* from state railway stations in 1909 after the Munich police urged such
action on the grounds that "a publication which systematically and in the
most shameless manner ridicules and seeks to bring into contempt the
foundations of the existing social order is not suitable for sale in public
places belonging to the state."[9]

As in France, the impact of opposition caricatures upon the illiterate
lower classes was especially feared by the authorities elsewhere in Europe.
Thus, the Prussian minister of the interior in 1843 successfully urged King
Frederick William IV to reimpose the recently abolished censorship of
drawings by arguing that caricatures "prepare for the destructive influence
of negative philosophies and democratic spokesmen and authors," espe-
cially since the "uneducated classes do not pay much notice to the printed
word" but they do "pay attention to caricatures and understand them," and
"to refute [a caricature] is impossible; its impression is lasting and some-
times ineradicable." The fear which many conservative elites held with re-
gard to drawings was expressed by one of the characters in Oliver Gold-
smith's 1773 play *She Stoops to Conquer;* when his folly is revealed, Marlow
exclaims in dread, "I shall be stuck up in caricaura [caricature] in all the print
shops!" The fear of hostile lampooning by caricaturists even crossed the
Atlantic: the notoriously corrupt New York City politician William "Boss"
Tweed, who felt the sting of hostile caricatures by the brilliant cartoonist
Thomas Nast in the post–Civil War period, declared, "Those damned pic-

tures; I don't care so much what the papers write about me—my constituents can't read, but damn it they can see pictures!"[10]

Certainly it was the case in France that caricatures were widely distributed and aroused enormous interest among all classes of the population, as is clear from the numerous drawings which depict large crowds gathered in front of print shops. Especially during periods of high political tension and when censorship of caricature either had broken down or was being widely evaded or defied—such as during the early days of the French Revolution, Napoleon's One Hundred Days of rule after his escape from Elba in 1815, the early 1830s, and the 1867–79 period—displays of caricatures in print shops and street kiosks often attracted large crowds and the appearance of new caricatures was eagerly awaited. Thus, during the One Hundred Days, when censorship of caricature had been abolished, one journal reported that the mobs which gathered to examine caricatures being displayed at street stalls were so great that the "quays and boulevards are obstructed" and that sometimes fistfights broke out among those of different political persuasions. Art historian Henri Beraldi has written that during the period of widespread censorship evasion and defiance between 1867 and 1879, when the brilliant young caricaturist André Gill was the leading practitioner of the genre, Gill's drawings "remained for a dozen years one of the indispensable dishes needed for the existance of a Parisian; the Parisian waited for his Gill of the week." Journalist Gustave Geffroy recalled of this same period that for a dozen years a "burst of laughter would sometimes erupt from the suburbs to the boulevards [of Paris] when the caricature signed André Gill appeared in the surging streets, lighting up the kiosks, opening up the front of the bookstores."[11]

Before about 1860, the relatively high price of individual prints and of newspaper subscriptions kept down the numbers of caricatures that were sold and the subscription levels of caricature journals. Thus, the most important caricature journal of the pre-1860 period, the weekly *La Caricature* (1830–35), had a subscription price of fifty-two francs a year (about ten dollars in the equivalent American currency of the time, or well over one hundred dollars in 1980s currency), the equivalent to almost a month's wages for an average manual worker in the French provinces. *La Caricature* never had more than about one thousand subscribers, while its sister publication, the daily *Le Charivari*, which charged sixty francs a year in the 1830s, had only two to three thousand subscribers. After 1860, the combination of drastically lower prices, increased wages and higher literacy rates boosted the circulation levels of caricature journals considerably, with sales of individual issues and sometimes subscription levels reaching into the tens of thousands. Thus, the weekly *La Lune* (1865–68) and, after its suppression,

its successor *L'Eclipse* (1869–76), sold for five francs per year, the equivalent of about three days' pay for a provincial manual worker, and published thirty to forty thousand copies during the late 1860s. *L'Assiette au Beurre* (1901–12), which cost a considerably higher fifty centimes per weekly issue (equal on an annual basis to over a week's pay for the same worker), sold over 250,000 copies of one of its most successful issues.[12]

Although it is impossible to measure precisely what impact caricatures had upon the French population, it seems clear that at least during some periods, such as 1830–35 and 1867–79, caricature journals had a profound effect in bolstering and increasing antigovernment feelings among key segments of the urban population. Thus, one Frenchman wrote of the opposition caricatures published in the 1830s that they allowed "us in each of those journals to retrieve our thoughts of the previous day, translated into vivid images, sculpted in relief." Another observer, the historian Jules Lermina, referring to the opposition caricatures of André Gill published in the 1860s during the waning years of Napoleon III's reign, declared that Gill had cleverly targeted the "weak point in our political adversaries" and thus had served as "one of the most useful artisans of the fall of the Empire." Similarly, Gill's friend and fellow caricaturist Etienne Carjat declared in 1895 that "all Republican Paris remembers that unforgettable period during which his incisive and biting crayon" struck "terrible blows" against the regime of President MacMahon (1873–79). As has already been suggested, governmental officials clearly shared the view that caricatures had enormous impact, especially among the lower classes. Thus, in 1869, a bureaucrat stationed at Rouen informed his superiors in Paris that:

> The great Parisian newspapers play a role in the movement of public opinion, but that which dominates it especially and entertains it is the small, acrimonious press, denigrating, ironic, which freely spreads each day scorn and calumny on all that concerns the government. . . . The weekly newspapers, the illustrated journals of opposition [i.e., caricature journals] sell many more examples and are read much more than the serious organs of the same opinion. It is by ridicule, by perfidious jesting and defamations, that they are now making war on our institutions and the men who personify them. It is sad to avow that this war without dignity and without good faith is succeeding among all classes.[13]

At least in the case of the so-called "war of disrespect" waged by *La Caricature* and *Le Charivari* against King Louis-Philippe during the 1830–35 period, caricatures have even significantly shaped our present interpretation of French history. Thus, a French government catalog concerning an exhibit on King Louis-Philippe which was published in 1975 notes that "it is under

9

the form of a pear [the caricaturists' depiction of the king] that the image of Louis-Philippe would be fixed in the popular conscience," and a recent scholarly account by Richard Terdiman notes that "the representation of the Orleanist regime [of Louis-Philippe] which the satirical papers institutionalized has quietly but decisively become our own common wisdom," and as a result "we have learned to conceive his politics and the entire atmosphere of his regime under the sign of ridiculous vulgarity and burlesque exaggeration."[14]

The interest in caricatures in France and suggestive evidence about their impact both upon contemporary and subsequent popular views of the nineteenth century were paralleled in other European countries. Thus, an observer in England described the scene at a leading British printshop in 1802: "If men be fighting over there [across the channel] for their possessions and their bodies against the Corsican robber [Napoleon], they are fighting here to be first in Ackermann's shop and see Gillray's latest caricatures. The enthusiasm is indescribable when the next drawing appears; it is a veritable madness. You have to make your way through the crowd with your fists." In Russia, where strict censorship confined most drawings to religious subjects, the clamor for prints was also great; at fairs and markets, peddlers wandered through the crowds, calling out, "Who wants The Seven Deadly Sins? Who wants the future in the other world?" Concerning the impact and importance of caricatures, German playwright Gerhart Hauptmann termed *Simplicissimus* the "sharpest and most ruthless satirical force in Germany," while Russian author Leo Tolstoy declared, "For the historian of the 22nd and 23rd centuries who describes the 19th century, *Simplicissimus* will be the most valuable source, enabling him to become familiar not only with the state of our present-day society, but also to test the credibility of all other sources."[15]

The Mechanics of Censorship

The language of the September Laws of 1835 was invoked whenever censorship of illustrations was enforced in France between 1835 and 1881 (i.e., continually save for 1848–52 and a few months in 1870–71). The relevant language provided that:

> No drawing, no engravings, lithographs, medals and prints, no emblem of whatever nature and kind may be published, exposed, or put on sale without preliminary authorization of the Ministry of the Interior at Paris and of the prefects in the departments. In case of violation, the drawings, engravings, lithographs,

medals, prints or emblems will be confiscated, and their publisher will be sentenced by the courts of correction [i.e., a magistrate sitting without a jury] to a prison sentence of one month to one year and to a fine of 100 to 1,000 francs, without precluding prosecution resulting from the [contents of the] publication, exhibition or sale of the aforesaid objects.[16]

For caricatures published in Paris (which constituted the overwhelming percentage of all caricatures) the minister of the interior retained ultimate authority whenever censorship was enforced between 1820 and 1881. However, in practice censorship was almost always delegated to a bureau within one of the ministry's major divisions, which was frequently renamed and shifted around within the ministry. Thus, in 1824, censorship was handled by the Bureau of Printing and Bookstores within the Police Division of the ministry, in 1840 the task was handled by a bureau with the same name which was located within the Fine Arts Division, by 1858 the same bureau had been shifted to the Public Safety Division, by 1863 the office was renamed the Bureau of Literary Propriety and placed within the Division of Printing and Bookstores, and in 1876, censorship was once again entrusted to the Bureau of Printing and Bookstores, now placed under the Division of General Security.[17]

The censorship administration was all-powerful since no explanation was required for its decisions, and since its rulings were considered to be administrative in nature, entailing no criminal penalties, no appeal could be made to the courts. Although censorship criteria were never made public, documents in the French archives suggest that at least some vague guidance was provided to the censors. For example, a dispatch from the minister of the interior to the prefects on May 20, 1822 urged them to "examine with a particular care" all illustrations "which could present some character of immorality, irreligion or of outrage against the king and his government," while a document dated January 4, 1879, apparently intended for the guidance of censors in Paris, directed them to "refuse absolutely when a drawing is directed against the head of state" and to authorize "only with the greatest circumspection concerning the [legislative] chambers, the magistrates, the army, religion or the clergy." The most detailed explanation of the censorship criteria appeared in a message from the minister of the interior to the prefects on September 8, 1829. It included the following guidelines:

Religion, good mores, the public or private life of citizens, legitimate authority must be protected by you from all direct or indirect offense, including all fiction or allusion which could wound them in that which constitutes national honor and the country.
1. Religion. The respect owed to the religion of the state and to the belief of

Christians cannot permit that one subjects the mysteries and holy truths to allusions which suggest incredulity and ridicule, or to representations unworthy of their majesty. . . .

2. Good mores. . . . It will be easy to distinguish that which belongs to the realm of taste and art from that which only tends to excite or flatter passions.

3. Public or private life. All personal caricature, all allusion, even indirect, to the public or private life of any individual whomever must be refused by the administration. . . .

4. Legitimate authority. It does not suffice that that which belongs to the royal majesty and to the august dynasty of the Bourbons be spared from guilty attacks or allusions of whatever kind. We are held to be as severe on this point with regard to foreign monarchs as toward our king himself, because the sovereigns are reciprocally supportive of one another with regard to all which could attack their sacred character.[18]

Presumably using these or similar criteria, censors rejected thousands of caricatures during the 1820–81 period, including over two hundred in each of several years, including 1864, 1875, 1877, and 1880. In 1875, during a period of monarchist-oriented conservative republican rule, the liberal republican journal *Le Grelot* suffered sixty-seven censorship rejections, while in 1880, under a moderate republican regime, forty-two caricatures submitted by the monarchist *Le Triboulet* were refused. Caricatures which were not banned outright were sometimes allowed only with major mutilations. Thus, on August 3, 1873, *L'Eclipse* published a caricature by André Gill, which sought to complain that the contributions of President Adolphe Thiers, a moderate republican who had been forced to resign by monarchist legislators, were being too quickly forgotten (fig. 1). However, the censors demanded that Thiers be removed from the drawing, with the result that its intended meaning was completely obscured in the published version, both for contemporary readers and generations to come. Thus, in a book published in 1975 by Paul Ducatel, a leading historian of French caricature, the message of the caricature is interpreted as, "Attempts are made to make people forget their problems," whereas its intended message was, "Attempts are made to make people forget President Thiers." In some cases the censors allowed illustrations to pass unchanged but only with the proposed captions entirely deleted or modified. Thus, of the sixty-four drawings forbidden by the censors in 1840, nine were subsequently allowed after the captions were changed.[19] In one bizarre case, *Le Grelot* of September 21, 1873, was allowed to publish its caricature as submitted but only in black and white instead of the proposed colors (which may have reflected what *L'Eclipse* reported on September 20, 1874, was a total ban on the use of the color red, as "red, in the eyes of the censors, is purely seditious").

12

Figure 1. Censors could approve proposed drawings without change, reject them outright, or approve them only with changes. Right: On August 3, 1873, L'Eclipse appeared with this drawing by André Gill of a man carrying a barrel on his back labeled "forgetfulness." Left: In the original drawing, Adolph Thiers, the recently deposed president of France, is depicted being carried in the barrel. With this crucial element effaced from the published caricature by the censor, Gill's message that Thiers's service to France was being forgotten was completely destroyed.

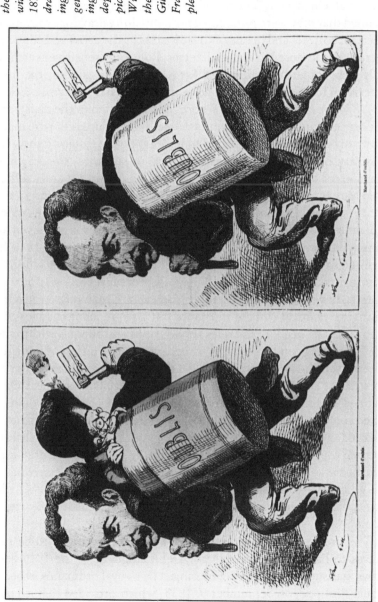

Detailed information about the daily workings of caricature censorship are difficult to obtain, because the censors never produced written justifications for their decisions and at least at times they refused to even sign official statements of approval or rejection, instead relying entirely on oral messages. By refusing to provide written statements, the censors preserved the ability to always claim that a published caricature had not received their approval. On at least four occasions in the 1870s, caricature journals complained that they were prosecuted for publishing drawings they insisted had been authorized, and in one of these instances the artist and editor involved were both sentenced to short jail terms. Politically sensitive sketches reportedly were sometimes submitted for a personal decision by the minister of interior. Thus, according to an account published in *L'Eclipse* of September 20, 1874, proposed caricatures were first submitted to the assistant chief of the censorship bureau, who transmitted it to his superior, who made a decision only if the design appeared to have no political significance. If "on the contrary, one suspected the least political importance" the sketch would be transferred to the chief of the police division, which supervised the censorship bureau, and eventually it would be transmitted to the interior minister for his advice. The time required to get a censorship decision could be considerably affected by how controversial the drawing was perceived to be; two to four days was the norm reported for an average decision in 1840, but more than eight days was reported as often being required for a decision on a controversial drawing in 1874. The exact procedures followed by the censors seem to have changed considerably from year to year, reflecting not only the changing political climate in France but also frequent changes of interior ministers and heads of the relevant divisions and bureaus within the ministry. Thus, between 1865 and 1869 there were three different ministers of the interior, and between 1878 and 1880 there were at least four different directors of the censorship bureau. Monarchist legislator Emile Villiers complained in 1880 that each new republican head of the censorship bureau acted completely differently. Villiers declared that one censorship head had allowed "a certain liberty of representing the Republic under whatever form pleased the illustrator of a journal, but pitilessly forbade all drawings which could offend his political friends in their appearance or stateliness," while his successor "complacently authorized portraits of high personalities but one could not touch the Republic" and yet a third censor "tolerates nothing at all."[20]

The precise form in which a proposed caricature had to be submitted seems to have varied considerably. The language of the 1835 September Laws was supplemented on this subject by a royal ordinance issued by King Louis-Philippe, on September 9, 1835, which provided that, to obtain the

necessary authorization, an applicant would have to submit "a summary description of the drawing, engraving, lithograph, print or emblem that he wishes to publish, and the title which he intends to give it" and that upon receiving approval of any illustration to be produced in mass quantity he would have to "deposit, with the Ministry of the Interior or the office of the Prefecture, a proof for purposes of comparison" and to "guarantee the conformity of this proof with those that he intends to publish." This procedure, which essentially required the submission of a completely finished composition before any illustration could be mass-produced, was followed between 1835 and about 1863. Thus, on November 6, 1835, shortly after the promulgation of the September Laws, *Le Charivari* complained bitterly that because the proofs of each submitted drawing had to be certified as conforming to the final publication, when a caricature was refused it meant "not only the loss of a simple sketch, a kind of sample," but "that of a lithographic stone, as finished as possible." Sometime after 1863 (when a contemporary book confirms this procedure was still in effect), the censors apparently ceased demanding a finished proof before authorizing drawings: *La Fronde* reported on June 21, 1874 that it was being prosecuted because a published caricature was not exactly the same as a rough sketch that had been submitted and approved, "as if it were possible for an illustrator . . . to make from memory a drawing absolutely similar to a sketched scenario." A few years later, the procedure had apparently changed again. A book published in 1878 reported that the censors first examined a "sketch or outline," then required submission of the finished drawing and "if the drawing be colored, it must be afresh inspected after the dangerous paints have been smirched on." This account is confirmed in a report published by *Le Grelot* on January 16, 1881, which complained that under the authoritarian regime of Napoleon III rough sketches had been acceptable to the censors but that a supposedly liberal republican regime was requiring the submission of "definitive drawings, often costing the caricaturist several days of work and which they are free to pitilessly cross out."[21]

Despite the lack of any statutory justification for exercising censorship over any textual matter, the censors routinely considered caricature captions as part of the drawings. Thus *Le Titi* of June 7, 1879, complained that, although the legends could not be considered drawings, "we are no less forced, as in the past, to submit the captions to censorship at the same time as the design" and "if we refuse this they would refuse all authorizations!" Attempts to challenge the right of the censors to scrutinize captions got nowhere in the French courts. In a key test case in 1880, *Le Monde Parisien* printed an "authorized" caricature along with a caption that had been substituted for the submitted and approved caption. When the government prose-

cuted for publication of an unauthorized "caricature," on the grounds that the drawing was not the same as the one which had been approved since the caption had been changed, the journal claimed that this meant that the government was trying to illegally censor text rather than illustrations. However, three different court decisions on this case upheld the government on the grounds that the illustration and caption of a caricature were inseparable and that if an unapproved caption were substituted for an approved one it changed the character of the drawing. *Le Monde Parisien* had to pay a fine of fifty francs for its trouble. The courts also upheld challenges to several other "interpretations" which the government used in its enforcement of censorship. Thus, although censorship laws and decrees of 1822, 1835, and 1852 nowhere indicated that caricatures which had been published when censorship was not in effect would have to be submitted to the authorities if they were to be still (or again) circulated after the new provisions took effect, ministerial circulars interpreted the requirements in this manner, and an 1836 court decision upheld this interpretation. Also, in an 1875 case, the courts held that even censorship authorization of an illustration would not excuse the publishers from subsequent prosecution if the drawing was later determined to be in violation of the press laws. In an 1880 case the court upheld the fining of two journals which had republished drawings, previously authorized for other journals, without submitting an application to the censors, on the grounds that each publication of an illustration required new authorization.[22]

Yet another interpretation of censorship rules was usually, although not always, imposed between 1852 and 1881, with a profound impact upon French caricature: the requirement that before a caricature could be published, any living person depicted in the drawing would have to give written consent. Although this requirement apparently was not enforced between about 1869 and about 1874 and again for a short period around early 1878, when it was implemented it created what amounted to a dual censorship of drawings: any caricature which depicted living people would now have to be approved both by government authorities and by the subject or subjects of the caricature. While supposedly the "personal authorization rule" was intended to prevent invasion of privacy, it also was clearly intended to make the lives and work of caricaturists more difficult, since obtaining written approval from the subjects of caricatures in the pretelephonic age often required much time and energy, with considerable correspondence and/or multiple personal visits sometimes required. The regulation also provided a supplemental safeguard against the introduction of subversive allusions into illustrations by making sure that any member of the establishment who was

16

caricatured would have a chance to impose a veto on a drawing before it was published if he believed it would subject him to ridicule or otherwise denigrate the ruling elements.[23]

The personal authorization rule unquestionably had a major effect on French caricature between 1852 and 1881. Virtually no caricatures of Emperor Napoleon III or of President MacMahon appeared during their reigns. One of the few attempts to caricature Napoleon III led to the suppression of *La Lune,* a journal which featured the drawings of André Gill. On November 17, 1867, *La Lune* published a truly brilliant caricature by Gill of the Emperor in the guise of a supposed drawing of Rocambole, the half-dandy, half-convict hero of a series of popular novels (fig. 2). Although the drawing apparently fooled the censors, all of Paris immediately recognized that the facial features were clearly those of Napoleon III, whose personality similarities to Rocambole were thus highlighted at a time when the Emperor's popularity was on the decline. As historian Jules Lermina has noted, Gill's drawing was greeted with "universal joy," and as Gill's biographer Charles Fontane has concluded, although *La Lune* was suppressed in the aftermath of "Rocambole," "it was the Empire that was truly condemned." President MacMahon was so horrified at seeing himself criticized in drawings that in one instance the Swiss government, apparently responding to French diplomatic pressure, seized an issue of a Swiss caricature journal which had mocked him: in another case, the French government banned the English journal *Punch* from distribution in France in 1877, after it published a caricature showing MacMahon "stuck in the mud" of reaction while the French people wanted democracy (fig. 3). "Punch" responded to this ban by declaring in "his" issue of November 17, 1877, that "while France is as France is now, he would rather any day be stopped there than stop there."[24]

Although many prominent individuals aside from Napoleon III and MacMahon refused their authorization, (including a number of leading republican politicians who had often stressed their support for freedom of the press, such as Leon Gambetta, Jules Ferry, and Adolphe Thiers), probably the most notorious case in which a well-known personality refused to be portrayed was that of Alphonse de Lamartine, the French author and politician. Lamartine made himself an object of widespread ridicule when his refusal was published:

> I cannot authorize the derision of my human form, which, even if it would not offend man, would offend nature and place humanity in mockery. . . . It would only be a false magnanimity on my part that would authorize an offense to the dignity of a creature of God. I do not wish to be an accomplice to this. . . . My

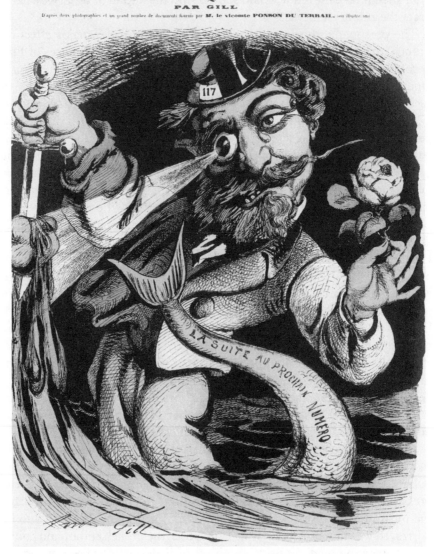

Figure 2. André Gill's brilliant portrait of "Rocambole," the half-bandit, half-dandy hero of popular novels, was a severe blow to the regime of Emperor Napoleon III (who is in fact depicted, although somehow this caricature slipped by the censor). Gill's caricature showed clearly the Emperor's two-faced nature. If the picture is divided by a line passing vertically through the Emperor's face, on the right he is a sophisticated, soft-hearted dandy, while on the left he is a blood-thirsty thug. Shortly after this caricature was printed in La Lune *on November 17, 1867, the regime suppressed the journal, supposedly because it had published another caricature without authorization from the censors.*

Figure 3. On at least two occasions, the British journal Punch was banned from France for its caricatures. Left: In 1843, Punch was "turned out of France" for its hostility to King Louis-Philippe. Right: In 1877, a caricature depicting President MacMahon as "stuck in the mud" of the politics of monarchy and reaction despite the rising tide of republican sentiment in France led to another ban.

personage belongs to all the world, to the sun as to the streams, but just as it is. I do not wish to voluntarily profane it, because it represents a man and is a gift of God.

Although the authorization rule clearly restricted the freedom of French caricaturists considerably between 1852 and 1881, many personalities were quite happy to have their faces displayed before all of France and personal portraits became a major fad among caricature journals during the late 1860s. As Charles Gilbert-Martin, the editor and caricaturist of *Le Don Quichotte* noted in his column published on May 21, 1887, if some refused to be caricatured at all and others demanded to see the drawing before giving approval, others responded favorably to a request without posing conditions. Some, he continued, even "gave their authorization without being asked for it" as in the case of one person who wrote, "In case you take a fancy to portraying me in your journal, you can do with my head what you want, I deliver it to you." Commenting on the avid desire of many to gain the free publicity which resulted from being caricatured, one poet wryly commented in 1870:

> A great artist wrote without scruple to a great man,
> I wish the happiness of making you look ridiculous,
> The latter responded, "My dear man, well! . . .
> It is too great an honor which you do me,
> For the success of your journals.
> I am enchanted with my celebrity."[25]

As it became customary in the late 1860s for caricaturists to publish the written authorizations of their subjects along with the drawings, those portrayed often spent a great deal of effort and energy on composing an appropriate statement. Thus, writer Gustave Aimard (the pen name of Olivier Gloux) told *Le Hanneton* to "take my head, but don't scalp it!" The famous, elderly actor Frédérick Lemaître told *La Lune* on June 16, 1867, it should really "make caricatures of the young! Time makes caricatures of the old." Composer Richard Strauss told *La Lune* of January 6, 1867, to make his portrait "en trois temps" [a musical allusion suggesting something like "at a fast pace"]. Journalist Henri Rochefort authorized *Le Masque* of May 23, 1867, "to make of me what it wishes, but I defy it to make me into a handsome man." Painter Gustave Courbet authorized *Le Hanneton* of June 15, 1867, to make his portrait "however you wish," adding both the comment that he found it "extremely ridiculous that I must authorize the publication of my portrait" since "my face belongs to all" and the joking "condition" that "you not forget to surround my portrait with a beautiful halo." A similar

joking authorization was made by French justice minister Theodore Cazot in *Le Don Quichotte* of May 28, 1880 (fig. 4). Cazot authorized the journal to make his portrait "on condition that it make me very handsome, very eloquent, very distinguished, . . . etc., etc., etc." Caricaturist Gilbert-Martin responded by drawing Cazot as he really was, a rather elderly and portly man, holding in one hand the authorization and in the other a portrait of himself as he wanted to look: young, debonair, and handsome.[26]

In one incident which became widely known, the regime of Napoleon III found an authorizing comment so threatening that it was censored. On May 18, 1867, Gill published in *La Lune* a beautiful caricature of Victor Hugo, the exiled author who was the spiritual leader of the opposition to the Emperor's authoritarian rule. Gill depicted Hugo as emerging from the sea against the background of a rising sun, accompanied by Hugo's sparse but elegant comment, "I want all liberty as I want all enlightenment." The caricature powerfully suggested that liberty would soon come again to France. The regime allowed Gill's portrait of Hugo to appear, but censored Hugo's statement, so that only his signature appeared in the published version. Even without the original caption, according to historian Arsène Alexandre, the portrait of Hugo dealt to Napoleon III "one of the most terrible blows, because it was a moderate, dignified, solemn protest, with which there could be no argument."[27]

ENFORCEMENT OF CENSORSHIP

When the authorities felt that the press laws concerning caricatures had been broken, police agents usually seized copies of the allegedly offending prints or caricature journals at the printer, in editorial offices, in the mail, and at stores and kiosks where they were being sold. *La Trique* offered, on October 15, 1880, the following graphic description of the seizure of one of its issues:

> All the police stations were placed on the alert by special dispatches from the police prefect and thus extended a network like that of an immense spider's web, which enveloped us so that not a single issue is remaining. . . . They tracked our vendors in all corners of the city, pursuing them like a pleasant game, tearing from them their newspapers, ransacking them, turning them upside down, seizing our papers from the mail like they were malefactors and bandits. . . . During the night, kiosks were searched in the absence of their owners with a key, which it appears, opens all these small establishments. . . . We would like to know the reason for so much rigor and what great crime we have committed which would

21

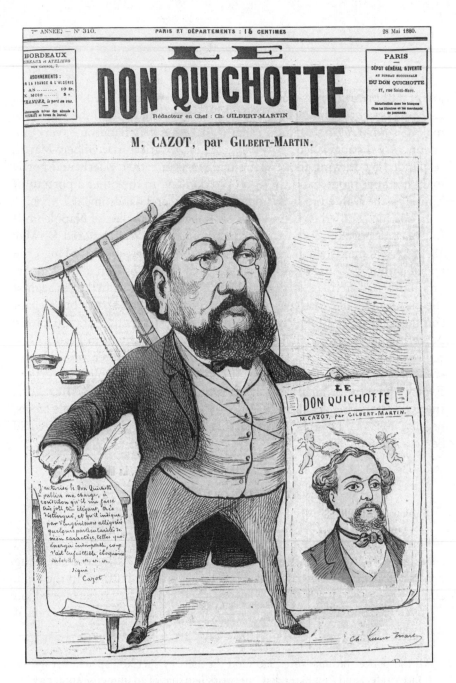

*Figure 4. Caricaturist Charles Gilbert-Martin playfully lampooned the requirement
that all living caricature subjects give their written permission before their por-
traits could be published. In a caricature of Minister of Justice Theodore Cazot pub-
lished on May 28, 1880, in* Le Don Quichotte, *Cazot is shown as he truly appeared
and also as he jokingly asked Gilbert-Martin to portray him in the authorization
letter shown in Cazot's right hand. Cazot requested that he be depicted as "very
handsome" with an "irresistible eloquence, etc., etc., etc."*

evidently place in peril the tranquility of Paris? . . . Well! We were in the process of publishing an unauthorized drawing.

Seizures were often, if not always, followed by prosecutions, and prosecutions usually, if not always, led to court-ordered destruction of the confiscated material, often accompanied by fines and/or jail sentences, and sometimes also by the suppression of the caricature journal involved. Altogether, about twenty caricature journals were directly suppressed or indirectly forced to close as a result of government repression during the 1815–1914 period, and well over a score of caricaturists and their editors, directors, and printers were jailed for their role in publishing drawings. When seizures were not followed by prosecutions or when prosecutions led to acquittals, the seized issues or prints were usually returned to their publishers, but often their economic value had been destroyed in the meantime. In 1881, when censorship of caricature was permanently ended as part of a sweeping liberal reform of the French press laws, the practice of preventive seizure of newspapers (i.e., after publication but prior to a court judgment of guilt) was generally abolished since, as a government memorandum interpreting the law put it, such a practice created an "irreparable prejudice." However, even in this liberal law, the especial fear of caricatures was expressed; one of the few exceptions to the general ban on preventive seizure involved drawings alleged to outrage good morals.[28]

During periods when censorship of drawings was not enforced, such as 1830–35, 1848–52, and after 1881, postpublication prosecutions of caricatures were still allowed for certain crimes such as offense to the king or president and attacks upon the army, and those alleged to violate press laws were tried by juries. However, during the fifty years between 1820 and 1881 when censorship of caricature was in effect, those alleged to violate censorship regulations by failing to submit drawings for prior approval before publishing them were not entitled to jury trials. They were judged only by magistrates who presided over so-called correctional tribunals and whose appointments and promotions were controlled by the same government which initiated prosecutions. Trials by these government-appointed magistrates resulted in guilty findings in press cases far more often than did trials by juries. Thus, juries acquitted in about 60 percent of press prosecutions between 1831 and 1833 and between 1871 and 1874, yet during the period between 1852 and 1866 when all press cases were tried by magistrates, guilty verdicts were returned 80 percent of the time.[29]

Even government spokesmen admitted at times that trials by government-appointed judges often created considerable skepticism about the impartiality and independence of the courts. Thus, in 1819 Minister of Justice

Pierre de Serre, in proposing a law which would replace judges by juries in press cases, stressed the advantage to be gained by submitting politically charged offenses to a body with an "impartiality and an independence which everyone would ask for himself," since it was important that public confidence in such procedures "must not be subjected to the slightest doubt." A bad jury verdict, he pointed out, has no further repercussions, while a magistrature viewed as politically biased would be discredited "for always and in all cases." In 1871, the duc de Broglie, speaking for the government, made the same argument in seeking to end the practice of the fallen Second Empire in which all press offenses were tried only by judges. He pointed out that press prosecutions "almost always" had a political character or appearance, and to "submit such offenses to the judgment of the magistrature is then to inevitably descend into the arena of politics." Opposition spokesmen made this argument even more forcefully. Thus, Lucien Prevost-Paradol, the brilliant satirical writer who was jailed by the magistrates of the Second Empire for one of his works, declared in 1868 that "the law has much less importance in press matters than the jurisdiction, since the law cannot avoid being vague and leave a large place to the whim of the judge. . . . That is so true that, in order to know if the press is free among such and such people, we do not think of asking what law is applied but we ask immediately and instinctively: who decides?" Although juries were empowered to try almost all press cases after 1881, once again an exception was made for drawings alleged to outrage good morals.[30]

During the Second Empire, when all press offenses, not just those concerning caricatures allegedly not submitted to the censors, were tried by the correctional tribunals, particular outrage was directed by journalists and caricaturists against the Sixth Chamber of the Police Correctional Tribunal of Paris. This court handled most cases involving press offenses and became notorious both for the harshness of its sentences and for the repeated promotion of its judges to high places in the government as apparent rewards for what press historian Roger Bellet has termed "their servility and their zeal." Especially hated was a magistrate named Delesvaux, who sat on the court in 1868 and sent a number of caricaturists to jail, including Charles Gilbert-Martin, whose journal *Le Philosophe* had published two caricatures which had not been approved by the censors.[31] In his memoirs, published in *Le Don Quichotte* on June 4, 1887, Gilbert-Martin vented his spleen at Delesvaux (who killed himself after the Second Empire was overthrown in September 1870). Gilbert-Martin described Delesvaux as a "scoundrel, capable of anything" who, after Louis Napoleon's coup of December 1851 overthrowing the Second Republic, had denounced and arranged the depor-

tation of "one of his own relatives whose wife he desired" and who was often seen in the company of prostitutes. "A man so devoid of scruples could not fail to be utilized," Gilbert-Martin wrote, "in an epoch in which there was so much base work to accomplish"; therefore Delesvaux was made president of the Sixth Chamber and assigned to the "execution of journalists," which deed he accomplished with "the monotonous regularity of a condemning machine; the sentence fell heavily and harshly, and then he went on to the next case."

This hatred of Delesvaux apparently played a major role in one of the most notorious cases of a prosecution involving a caricature. Following a series of incidents in which the censors banned drawings by André Gill intended for publication in *L'Eclipse,* the journal published on August 9, 1868, with the censors' approval, a caricature by Gill which depicted a cantaloupe with some humanoid features apparently retreating before an artist's crayon (fig. 5). *L'Eclipse* explained in the text accompanying the design that because the censors were making it dangerous to draw almost anything, Gill had decided to avoid any possibility of a drawing with "dangerous aspects" by simply sketching a melon, which allowed him to give his "unique engraved salute" to a "high official, very in favor at the moment," in a form, "in which, certainly, no one will be tempted to recognize himself."

Although the humanoid cantaloupe, captioned "Monsieur X . . . ?" was not well enough defined to possibly resemble anyone, everyone immediately saw in it a portrait of Delesvaux. The government, apparently at a loss, decided to prosecute Gill on the absurd charge of obscenity, which Gill denounced in a letter published by *Le Temps* of August 2, 1868. "My drawings often have a malicious intent," he wrote, "but never an obscene one. . . . If *L'Eclipse* must be prosecuted, let it be for the intentions it has, not for those which have been imputed to it." On the day of his trial, Gill brought a cantaloupe to court with him to demonstrate his innocent intentions, and the case was dismissed (apparently by a judge other than Delesvaux). The end result was that the government only succeeded in making itself look ludicrous. The brilliant opposition journalist Henri Rochefort declared in his famous satirical newspaper, *La Lanterne,* that the authorities had descended to "prosecuting vegetables." The "melon of Gill" quickly became one of the leading legends in the history of caricature, even inspiring two poems about the "innocence of melons," one of which, supposedly written by a "desperate melon," was sold as a pamphlet. Gill found himself thereafter forever identified with the melon, just as *La Caricature* editor Charles Philipon was to be forever associated with the pear. In one self-portrait, Gill drew himself with a melon tied to his foot like a ball and chain.[32]

Figure 5. This is the famous melon of André Gill, published in L'Eclipse *of August 9, 1868. This caricature led to an aborted obscenity prosecution which made the regime of Napoleon III an object of intense ridicule. The authorities apparently felt that the melon, which seems to be withdrawing before a caricaturist's crayon, portrayed a judge who was notorious for jailing journalists and caricaturists. The "melon of Gill" quickly became one of the leading legends of the history of caricature.*

Although Gill escaped unscathed with his melon, often government prosecution of caricaturists and their editors had far more serious results, especially during the periods when juries were excluded from caricature prosecutions. Among those who were jailed for violating the press laws in connection with the publication of drawings were many of the most important names in caricature, including artists Honoré Daumier, Charles Vernier, Charles Gilbert-Martin, Pilotell (Georges Labadie), Louis Legrand, Henri Demare, Alfred Le Petit, Aristide Delannoy, and Jules Grandjouan and journal editors Charles Philipon of *La Caricature* and *Le Charivari,* Leopold Pannier of *Le Charivari,* François Polo of *La Lune* and Victor Meric of *Les Hommes du Jour.* Their sentences ranged from the few days punishment handed out to Demare in 1879 to the extraordinary sentences of one year each given to Delannoy and his editor Meric for a caricature published in 1908; sentences averaged about six months, as was the case with Philipon in 1831 and again in 1832. Before the ending of censorship of caricature in 1881, virtually every leading political or quasi-political caricaturist who had not been jailed had, like Gill, been prosecuted and acquitted or like Henry Monnier, Grandville (Jean-Ignace-Isidore Gérard), and Traviès (Charles-Joseph Traviès des Villers) had endured the censorship or seizure of their work by the authorities.

Curiously, of all aspects related to the political repression of caricature in nineteenth-century France, the administration of jail sentences appears to have been the most relaxed and enlightened. Throughout the nineteenth-century most French political prisoners were housed at the Paris prison of Sainte-Pelagie (until its destruction in 1899), a former convent which had become a prison in 1790 and which was located between the Jardin des Plantes and the Pantheon near the current site of the Paris Mosque. Although Sainte-Pelagie was sometimes overcrowded when political arrests were numerous, the prison regime in the jocularly named "Pavillion of Princes" section reserved for political prisoners, including journalists and writers, was notoriously lax.[33] Since some cells were especially desirable, it was common, as Gilbert-Martin, who was jailed there in 1868, noted in *Le Don Quichotte* of June 4, 1887, for journalists expecting to be prosecuted or convicted to reserve their favorite cell in advance, since "this free but obligatory lodging was so well-used."

During the administration of at least some of the prison directors, inmates were allowed to receive outside visitors with few restrictions, hold boisterous parties with outside guests, write, obtain books, order food from restaurants, and even leave a few nights a week on the honor system for such pressing duties as attending the theater. Thus, Daumier wrote from Sainte-

Pelagie to a friend on October 8, 1832, shortly after his incarceration, that he was "having fun" and aside from a certain loss of "blissful solitude" that came when he thought of his family, "I am not finding prison at all unpleasant." He added that he was "working four times as hard as a boarder than I did in my father's house," as he was "beseiged and bullied by a crowd of citizens who make me do their portraits." Charles Gilbert-Martin recalled in his memoirs published in *Le Don Quichotte* on June 18 and June 25, 1887, that close relatives, including sisters-in-law, could visit without restrictions, while others were subject to individual approval. While girlfriends were strictly banned, all the journalists somehow had "admirably devoted" sisters-in-law who visited several times a week, until the prison director noted this odd fact and struck in-laws from the approved list, Gilbert-Martin reported. "We enjoyed at St. Pelagie a considerable freedom; we were only deprived of liberty. We could use our time as we wished, have food brought in from outside, install furniture as we desired, invite to dinner our friends who were approved and our relatives who weren't sisters-in-law." When Alfred Le Petit was jailed in 1889, he refused to depart on his scheduled day of release until he had finished a sketch, leading a prison clerk to declare, "I have seen people demand to leave before the designated hour, but never after!"[34]

During the 1830s, republican journalists and political prisoners who wanted even more freedom than was available at Sainte-Pelagie often were able to arrange transfers to a so-called mental hospital, operated by a republican sympathizer named Dr. Pinel, which amounted to little more than a comfortable rest home. Thus, Daumier spent 77 of the 149 days he was incarcerated in 1832–33 at Dr. Pinel's, and Philipon also spent a considerable portion of his thirteen months in jail there. Since writers and artists were to a considerable extent able to continue their work under these lax conditions of incarceration, in a number of instances they were prosecuted anew for press offenses committed while in custody. Thus Philipon, who had been jailed in 1832 for publishing caricatures in his weekly *La Caricature,* continued to edit his journal from Sainte-Pelagie and Dr. Pinel's, and was prosecuted (but acquitted) in January 1833 for a caricature he drew while in custody. He even founded a new daily caricature journal, *Le Charivari,* in late 1832 while housed at Dr. Pinel's, after discussing the project with Daumier while they were both at Sainte-Pelagie. Although Daumier did not have lithographic stones available to him at Sainte-Pelagie or at Dr. Pinel's hospital, he was able to produce drawings and watercolors which were transmitted by messenger and transferred to lithographic stones by a friend; sixteen caricatures thus produced at Dr. Pinel's were published in *Le*

Charivari and *La Caricature*.[35] After the destruction of Sainte-Pelagie, the ability of jailed caricaturists to work freely at their profession appears to have deteriorated. Thus, when *L'Assiette au Beurre* published a special issue on May 5, 1909, to help raise money for caricaturist Aristide Delannoy, who was jailed at the Santé Prison, no drawings by Delannoy appeared in it; the journal complained that, while even under the authoritarian Second Empire artists could work freely in prison, under the supposedly liberal Third Republic they could work "for themselves, but it is forbidden to publish."

One of the traditions of incarcerated caricaturists was to produce drawings on their prison cell walls and/or to publish caricatures of themselves in jail or on trial (fig. 6). Thus, Daumier apparently reproduced on his cell wall the very caricature which had led to his prison sentence, and after his release, he published in *Le Charivari* a drawing of himself in jail. Philipon apparently drew a pear—the symbol he had created to stigmatize King Louis-Philippe—on his wall for each day in captivity, since he reported, on leaving prison, that he had told his warden not to expect to see "crayoned on your blank corridors my 386th pear." According to a journal published by prisoners at Sainte-Pelagie, by early 1833 much of the prison walls were covered with graffiti representing fruits that "are neither apples, nor cherries, nor peaches, nor apricots."[36] Following the imposition of heavy fines and jail terms for editor Leopold Pannier and caricaturist Charles Vernier of *Le Charivari* in May 1851, the journal published a cartoon on May 8, 1851, which expressed its defiance by showing the mascot-symbol of *Le Charivari* festooning a cell wall with drawings despite being burdened with a heavy fine (fig. 7).

Charles Gilbert-Martin reported with great glee in his memoirs published in *Le Don Quichotte* on July 16, 1887, that, during his 1868 incarceration at Sainte-Pelagie, he had covered his cell walls with thinly disguised violent satires directed against the regime and person of Napoleon III but that the prison director failed to detect the hidden meanings of his drawings and took great pride and joy in looking at them and showing them to visitors to the jail. Gilbert-Martin reported, "My comrades, who were in on the secret, hurried to take turns in watching this piquant spectacle of a Bonapartist functionary enraptured by drawings against the Empire crayoned in a state establishment." Unfortunately, Gilbert-Martin related, after he left prison an order was given to repaint the interior of the entire jail, and the director failed to get an exception for Gilbert-Martin's former cell. Alfred Le Petit continued the caricaturist's tradition during his 1889 stay at Sainte-Pelagie. He drew a portrait of the prison director on his door each day, and the director kept making Le Petit erase it. The artist finally persuaded his jailer

Figure 6. Caricature journals which were prosecuted by the regime often depicted themselves in jail or on trial. Left: The monarchist Le Triboulet of April 25, 1880, mocked what it considered the arbitrary nature of justice under the Third Republic. Its symbol appears before a medieval-looking court, commenting, "So, two and two don't equal four." The judges respond, "We're in charge now and two and two are whatever we say, without limit." Right: Caricaturist Aristide Delannoy, in this print from L'Assiette au Beurre of October 31, 1908, shows himself on trial for a caricature (fig. 75) for which he was sentenced to a year in jail.

Le Charivari dessinant quand même.

Surprise du geôlier qui, ayant enfermé le *Charivari* tout seul, le retrouve une heure après entouré d'une foule de personnages.

Figure 7. This pair of caricatures, by Cham, published in Le Charivari of June 8, 1851, protested the prosecution of a caricature (fig. 52), which led to the fining and jailing of two Le Charivari staff members. Left: Even though encumbered by a heavy fine and imprisoned, Cham says, Le Charivari's crayon will not be stilled. Right: These depictions on "Charivari's" prison cell walls all seem to be general mockery of the middle class and its exaggerated fears of dissent.

to remove and save the painted door (it is now in the Musée Grévin) and replace it.[37] While Delannoy was apparently unable to produce work for publication while at the Santé prison, shortly before he was jailed there *L'Assiette au Beurre* published on December 5, 1908, his drawing portraying how his editor and he might look in shackles and chains.

2

The Defense of Caricature and the Attack on Censorship

PRAISE OF CARICATURE

While government officials and their supporters greatly feared the influence of critical drawings, caricaturists and their backers considered caricatures to be one of the most powerful means of gaining support and spreading enlightenment, especially among the illiterate and the less educated. Thus, the great caricaturist Honoré Daumier noted that, "Caricatures are good for those who cannot read," and the director of a leading publisher of popular prints told one of his artists, "Don't forget, my son, that you design for those people who cannot read." Victor Hugo wrote caricaturist Alfred Le Petit that, "You create laughter, and laughter leads to thought." Radical republican journalist Jules Valles, a leader of the internal opposition to Napoleon III, declared, "I am one of those who believe that caricature is an weapon of the disarmed. Laughter makes a hole in the wood of idols." Valles added, "Nothing gives more courage to the valiant and amuses the sad like that malign or cruel caricature, which seizes in flight the ridiculous and the stupid, in order to nail to paper by wing or paw, with the tip of a pen or the point of a crayon."[1]

In 1871, drama critic Francisque Sarcey praised caricature for exactly the same reasons the authorities feared it, terming it a weapon which "hits with more force" than the printed word because

> the pamphlet addresses itself only to the mind; in order to understand and taste it, morever, requires a certain level of instruction, or at least of attention. Caricature hits the eyes and affects that which is the most susceptible in us, the imagination.

It is intelligible to everyone; it stops us in our tracks. . . . The pamphlet only leaves in the memory ideas, and others quickly come along to erase them. Caricature engraves in the memory images of form and color which last long after it has been viewed.

A more scholarly student of caricature, Robert de la Sizeranne, offered a similar analysis in a book published in 1902:

> Caricature is armed with a weapon more powerful than the writer has because it can signify more clearly the thought of the multitude. . . . It is a marvelous means of making concrete an abstract idea and thus presenting it before a group not receptive to abstractions. It specifies and incarnates sentiments already floating in the mind. . . . It makes available to the eyes images which the mind can scarcely conceive. It clears up, it objectifies, it solidifies. It is an enlightenment.[2]

Caricature journals were quick to boast of their influence and importance (although, as will be noted below, when they were prosecuted they typically ridiculed the authorities for exaggerating the influence of caricature). Thus, Charles Philipon, in a prospectus published shortly before the first issue of *La Caricature* appeared in late 1830, boasted that the role of caricature in helping to bring about the overthrow of King Charles X a few months earlier demonstrated that it had become a "power" of "great importance."[3] Following the first of his many indictments by the government of King Louis-Philippe, he boasted in *La Caricature* of April 28, 1831, that "our blows have struck hard and true, but we are called to higher destinies, we who will one day be the bogeyman of the big children who play under our eyes at quasi-government." In *La Caricature* of January 3, 1833, Philipon wrote, while imprisoned, that

> in our hands, caricature is not only a grotesque picture, a coarse picture without an idea, without taste and especially without a purpose; . . . No, caricature for us is something grander, it takes all forms and characters; it plays all roles; it laughs, is harsh, mournful, or crazy; but it always has a wise reason to act thus. We use it in turn to make a mirror for the ridiculous, a whistle for the stupid, a whip for the wicked, and for everyone a magic lantern which paints now a cemetery, now a mascarade, or which spotlights court balls or prison cells, in a useful and popular purpose. . . . Caricature, our cherished infant, grows and develops in our sight: the climate of France is that which nourishes it best, we are happy to have led its development in our country. That child, well directed, will make its way and will some day be the pride of its family. May it be useful to the holy cause which we serve, and, as a good father, we will never regret the difficulties and the jail sentence which its infancy will have cost us.

Le Trombinoscope of April 1882 referred to the "crushing superiority of the polemic crayon over the written discussion," and boasted that "in two seconds, illustrators can say more to the public than writers can in 500 lines." In its issue of May 16, 1901, *L'Assiette au Beurre* declared that its goal went beyond artistic concerns to encompass "social justice" and asked, "How could one better do that than by the drawing, which engraves an idea in the brain with an energy which the effort of the most powerful writer can never achieve?" On August 15, 1901, *L'Assiette au Beurre* returned to this theme, declaring, "It is certain, indeed, that in the near future it is the image which will constitute the best weapon of combat; it has the advantage of not fatiguing the mind, absorbed by daily preoccupations, and of refreshing, all while retaining an importance greater than the best newspaper articles, which often leave even the most serious reader indifferent."

RIDICULE OF CENSORSHIP

Given the perceived importance of caricature for the political opposition and of the artists' need for "liberty of the crayon" (as freedom from censorship became known) both to earn a living and to carry out their work effectively, it is not surprising that caricaturists and their supporters bitterly denounced restrictions on their freedom. *Le Trombinoscope* defined censorship in July 1874 as a "famous libercidal machine," which was the daughter of the Inquisition. *L'Eclipse* of October 25, 1874, termed the censor "a real blockhead," and *Le Grelot* (November 5, 1871, November 31, 1875, December 15, 1878, and September 28, 1879) labeled censorship a "wormeaten and deadly institution," "deplorable, tyrannical and arbitrary" and the "last and odious vestige of customs of another age" which was "as useless for the country as a pair of braces for an elephant." *Le Triboulet,* in its issues of April 6 and 13, 1879, termed the institution "la Sangsure" ("certain blood," also a play on "la sangsue" or "bloodsucker"), the "holy perquisition," and as "absurd as it is superfluous," adding that "French citizens do not have, in their bodies, enough acid saliva to spit on the literary and artistic inquisition—Censorship." On November 2, 1879, *Le Triboulet* described in writing and depicted with a drawing censorship's physical characteristics as that of a witch "on horseback on a broom, a pair of monstrous scissors in her sash, a hideous old woman with bloodshot eyes, with teeth yellow as wood." *Le Carillon,* referring to its illustrator, Henry Demare, complained on April 19, 1879, that "the peevish censor cuts without pity the umbilical cord of his

best drawings before their birth." A poem published in *La Lune Rousse* of May 18, 1879, described censorship as an "infamous jailor of the spirit" which "cuts, with its scissors, drawings more quivering than little birds whose wings a roguish child would cut off." On January 16, 1830, the first modern caricature journal published in France, *La Silhouette,* declared that "the artist creates, the censor destroys: to each his talent." Fifty years later, its namesake, *La Silhouette,* celebrated the final demise of censorship in similar terms: the censor, it declared, on April 4, 1881, was an "old woman with a bottom of lead, eternally armed with scissors of the same metal" who "devours drawings the same way that phylloxera [an insect, notorious for damaging grapevines] destroys the vine."

Especially during the bitter debate over censorship of caricature that was waged during the 1870s, caricature journals often launched personal attacks upon individual censors, usually directed against the head of the Bureau of Printing and Bookstores. Royalist journals were especially incensed by bureau director Anatole de la Forge (1878–79), a republican, whose reputation for liberalism was not apparent in his treatment of their caricatures. The Bonapartist journal *La Jeune Garde* declared on April 6, 1879, that de la Forge "surpasses in arbitrariness and in rigor all that tradition reports of the arbitrary rule of Louis XIV and of Richelieu" and complained that "it is simply death without beating about the bush that M. de la Forge wishes to decree to our *Jeune Garde,*" while allowing "liberty only for vermin." *La Jeune Garde*'s hatred for de la Forge was only slightly dented when he was forced to resign in mid-1879 for submitting a report calling for the abolition of censorship. On May 25, 1879, it published a sarcastic poem hailing his departure and then followed this up on June 15, 1879, with a written attack which termed him a "rascal." *La Jeune Garde* gallantly conceded that, unlike "three quarters of his political coreligionists [republicans]," de la Forge was not a forger, thief, assassin, escapee from a madhouse, procurer, whorehouse operator, swindler, or committer of incest, then concluded, "No, Anatole was and will be only a simple imbecile." Incessant prosecutions led the monarchist *Le Triboulet* to also make repeated bitter attacks upon de la Forge, whom it termed, on April 6, 1879, "the grand master of censorship" who was out to "*anéantolise*" (*anéantir,* "to annihilate") liberty. His successor, Boucher-Cadart, was however, no more pleasing to *Le Triboulet,* which complained on June 22, 1879, in an article which began sarcastically, "We finally have liberty!" that the rate of refused drawings had increased from half a dozen to a dozen a week. Boucher-Cadart had "replaced the scissors with a mowing machine," it declared, and was creating a veritable "*boucherie*" (butchery).

Republican journals also sometimes leveled attacks on individual censors.

36

Thus *Le Carillon* demanded to know, on March 22, 1879, after the censorship had mutilated one of its caricatures, "M. Anatole de la Forge, are you a member of the republic, yes or no?" Although some republican journals had hailed the appointment of one of de la Forge's predecessors, the well-known republican journalist Hector Pessard, as head of the press bureau in early 1878, *Le Grelot* was more skeptical. On February 3, 1878, it published a caricature of Pessard, depicting his body as a huge pair of scissors (fig. 8), and portrayed him telling representatives of caricature journals, "Henceforth you will have the honor of having your drawings forbidden by me." *Le Grelot* commented, "It is unworthy of a true republican" to "pick up the poisoned scissors which have fallen from the crooked paws of the reptiles" of the monarchist-dominated regime which lost the 1877 parliamentary elections, and demanded that Pessard "renounce this cowardly weapon or renounce your reputation as a honest republican and a loyal man!"

Although caricaturists and their supporters boasted of the power and educational role of caricature, they often simultaneously ridiculed government officials for grossly overestimating the threat which drawings posed. The essential theme of this argument was stated by *La Caricature* of April 18, 1833, which argued that "caricature is a game at which fools get angry, while men of spirit know how to laugh," and by *Le Grelot* of November 12, 1871, which declared, "only small men fear small drawings." This basic argument was endlessly elaborated. Thus, during the first of the many trials of *La Caricature* editor Charles Philipon, reported in that journal on May 26, 1831, his lawyer, Etienne Blanc, declared that the government, "this political giant, is afraid of a drawing, of a crayoned satire, and comes to fight man to man with a caricature. What adversaries the authorities choose in their noble struggles!!!" The regime, Blanc added, viewed Philipon's crayon as "nothing more nor less than a lever of Archimedes, overthrowing the world in leaning it on ridicule." When the authorities seized a print from Philipon's publisher, Aubert, a few months later, Philipon wrote in *La Caricature* of September 22, 1831, "Courage, gentlemen of the prosecutor's office. . . . Hit, hit the images. You must show force, you have done well to seize at Aubert my last caricature; it would have overthrown Europe and you can now sleep tranquil. Sleep then. It is grasped, this lithographic conspiracy. You have it!" Following passage of the 1835 September Laws, the republican militant François Raspail declared that while the authorities found nonpolitical drawings charming, these officials, when they became the target, turned into "ferocious beasts" who screamed, "Oh, oh, oh, that's too much; order, caricature! Order! . . . Down with caricatures! Death to caricature!"[4]

When the government of Louis Napoleon Bonaparte prosecuted *Le*

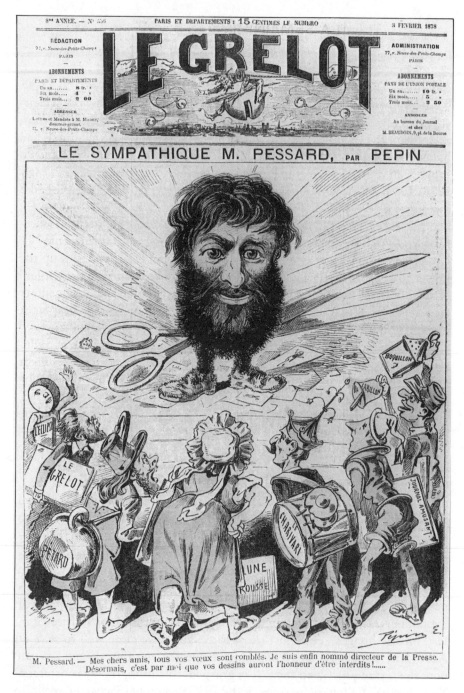

Figure 8. On February 3, 1878, Le Grelot *greeted the appointment of the well-known republican journalist Hector Pessard as head of the Press Bureau of the interior ministry, and thus as chief censor, with a caricature which suggested the journal's considerable lack of enthusiasm. Although Pessard was reputedly "sympathetic" to demands for more press liberty,* Le Grelot *complained that the censors were still effacing its drawings and it portrayed Pessard as a scissors man standing on a pile of caricatures. He informs various caricature journals that "henceforth, you will have the honor of having your drawings forbidden by me."*

Charivari in 1851, the journal reported on May 20 of that year that, "Parisians who for such a long time were under the reign of terror of the caricatures of *Le Charivari* could finally breathe at ease and some of them even dared leave their homes without having to fear the crayons" of its "hardened illustrators." After two of its staff were ordered jailed for the offending caricature, *Le Charivari* reported on May 28, 1851, that "society, the family and religion are saved forever." *Le Petard* of February 3, 1878, reported on a supposed meeting of censors at which one of them declared he had had a "fearful dream" in which the journal's caricaturist Alfred Le Petit, "armed with a formidable crayon, raising his gigantic crayon was going to crush me under a titantic blow. . . . And I, in my fright, wet my pants." When *La Jeune Garde* was prosecuted in 1878, it commented on December 22 that apparently it was "shaking the foundations of the republic. . . . As fragile as we suppose those foundations, we would never have believed them this shaky." *Le Triboulet,* which was repeatedly fined for publishing unauthorized drawings and whose editor, an American citizen, was expelled from France, suggested on August 15, 1880, that to be consistent, the government "must now beat to death, discreetly, this evening, all the editors of *Le Triboulet*" and reported that they planned to leave their office "only armed to the teeth and protected from head to foot by a coat of mail." On December 19, 1880, in a report on its thirtieth prosecution in two years, *Le Triboulet* declared, "Dear readers, it's pointless to send your children to the school benches, *Triboulet* will be able to teach them arithmetic using nothing but the fines resulting from its trials. Two thousand [francs] plus two thousand make four thousand, four thousand plus one thousand make five thousand." Reporting on its thirty-sixth trial on April 3, 1881, *Le Triboulet* suggested that its two hundred-franc fine for publishing an unauthorized drawing of a rabbit looking at a fox "be consecrated, to demonstrate well the liberty which we enjoy, to the purchase of a new pair of scissors for the government to offer to the censors."

PRINCIPLED OBJECTIONS TO CENSORSHIP

Although much of the attack launched against censorship of caricature consisted of ridicule and insults, caricature journals also made reasoned arguments for their position. For example, they sometimes claimed that attacking caricatures amounted to an "unFrench" assault on the long-standing tradition of Gallic wit and also that the overreaction of French authorities was made more obvious by the lack of restriction on caricatures in England,

39

which was often portrayed as the leading model of democracy by French liberals. Philipon's lawyer, in defending him in 1833 against a prosecution resulting from a drawing published in *La Caricature,* declared that "nothing is more innocent than singing and laughing, these two contemporary children that are indigenous to our France," while a columnist for *L'Opinion Nationale,* in attacking censorship of the journal *Le Grelot* in 1871, protested, "I do not believe it is the duty of the state to regulate laughter in France." *La Republique,* in attacking the prosecution of a *Charivari* caricature by the regime of President Louis Napoleon Bonaparte in 1851, declared, "My God! In the times we live one must not prosecute those who make us laugh; there are enough people who make us cry! . . . If satire is no longer permitted, if caricature is prosecuted, what will become of our country, the most satiric in the universe, especially since the subjects of caricature are today so common? . . . Caricature is French, don't proscribe it."[5] *L'Eclipse* lamented on September 20, 1874, that caricature, a "tactic as French as song," a "joyous weapon of battle," had had its "nails clipped like a cat which scratches" and had been "muzzled like a dog that bites."

Adverse comparisons between the English tolerance of caricature and French intolerance were made on a number of occasions during the early period of French controls during the nineteenth century. When censorship of drawings was first debated by the French legislature in 1820, Count Stanislaw de Girardin declared:

> Those who offer more or less piquant epigrams that they publish each morning in the form of caricatures could frighten some touchy people, but I can affirm that this mischief will never inspire real worries for true men of state. How many times have I seen [English politicians] William Pitt and Charles Fox, in going to the House of Commons, stop before the print merchants, in order to attentively examine the satiric caricatures which malignity has come to compose against them. How many times have I seen them join their smiles to the bursting eruptions of laughter of John Bull! These great men don't attach much importance to little things. Their occupations are too busy for the desire to suppress miserable caricatures to play a part in it; but as all men aren't hewn from the same stone it is natural that some are minutely concerned over what would be disdained by others. There are men who see things from on high and others with less broad horizons [such as] those who class among the great dangers which they claim menace France the daily publication of more or less witty caricatures.

During an 1830 trial of *La Silhouette* for a drawing alleged to mock the king, the newspaper's lawyer similarly declared that in England caricatures not only ridiculed the monarch's official acts but even his private life without

causing any harm. "In recent times," he declared, "one has even seen the doors of Windsor Castle besieged by crowds having come to express concern over the health of their king minutes after having laughed at publicly exposed caricatures [which mocked him]." Philipon declared during one of his trials that he had been condemned to jail and fined for "drawings 100 times less biting than those which are made in England without causing concern."[6]

During the period between 1822 and 1881, when caricature was almost continuously subject to prior censorship while the printed word was not, the most frequent and angry specific criticism of pictorial censorship was that the discriminatory treatment enforced against illustrations was unfair and illogical. Caricature journals repeatedly argued that drawings were a form of expression and publication just like the printed word and that it made no sense that supposedly offensive or seditious drawings could be prevented from appearing in advance of publication, while similar words could be prosecuted under various laws only after appearing in print (as will be noted below, many journals made this point by printing extensive written descriptions of caricatures which had been forbidden). Censorship of drawings, they argued, effectively denied caricaturists the right to freedom of expression enjoyed by the written press. This argument dated from the early days of the French Revolution, when such differential treatment of the word and picture was first effected. Thus an archeologist named Millin asked, "Who could deny man the exercise of his thought? Are not the engraving and burin, like the printing press, a means of manifesting it?"[7]

Almost one hundred years later, in the final years of caricature censorship, this same argument was made with increasing anger. On November 26, 1871, *L'Eclipse* declared it was an

> absurd anomaly and a revolting injustice [that] a writer can vulgarize his thought today in a newspaper without any shackle and the recourse of the law against him can only occur after publication, [while] an artist, expressing the same idea, is subject to the control of an administrative agent who has the right to suppress that expression before it appears before the public and to condemn behind closed doors, affected only by his caprices, prejudices, and personal rancors, what would under written form probably be absolved in public by judges and jury.

Yet, *L'Eclipse* concluded, "the writer and the artist use the same instrument of production: the press." The editor of *L'Eclipse* asked, in an open letter to the minister of the interior published on January 21, 1872, how the government could explain why when he published a detailed written account "which the censor of the crayon had forbidden me to publish [as a drawing]"

he had not been prosecuted "if the idea of the illustrator, explained by the editor, was really seditious or immoral?" On January 27, 1878, *Le Grelot* appealed to the government to, if necessary, "prosecute our drawings after they appear, like defamatory newspaper articles, but don't prevent them from appearing." The same journal asked on February 3, 1878, "By what right can one prevent the crayon from saying what the pen is allowed to?" It demanded equal treatment of both instruments, declaring that prior censorship "under the pretext that we might commit stupidities" was equivalent to having a citizen

> followed by two police under the claim that he could have the intention of taking off his shorts in the street. . . . To run away from discussion, to combat enlightenment with the blows of the *éteignoir* [candlesnuffer, or light extinguisher], to fight an adversary by cutting out his tongue and pulling out his four limbs, that is worthy of a Badinguet [a nickname for the recently deposed authoritarian Emperor Napoleon III], a cynical tyrant and cowardly hypocrite.

On December 1, 1878, *Le Grelot* complained that to speak of liberty of the crayon as being "tempered" by censorship was like speaking of the "liberty of the convict being moderated by the ball and chain attached to his foot." *Le Don Quichotte* demanded on June 25, 1875, "Can you explain by any plausible reason why drawing cannot enjoy the same liberty as writing?" adding that the "French press would only be a vast factory of whipped cream" if authors faced similar prior controls. On May 7, 1880, the same journal lamented, "An article can be aggressive in comfort without being subject to any [prior] repression, but the same thought translated into the form of a sketch is exposed to the most fantastic penalties."

Aside from the alleged basic unfairness of subjecting illustrations alone to prior approval, caricaturists complained of the arbitrariness of the censors, arguing that the censors' decisions often seemed to reflect only the changing winds of governmental policy, the unpredictable whims or the political views of individual censors, and/or the fears of censors for their jobs if an undetected "allusion" slipped through or if a new regime took power and they had allowed criticism of their eventual superiors. Thus, in a sly comment on the variability of the censorship rules as governments changed, a caricaturist named Machereau, whose work was often banned during the Restoration, had a courtesan in one of his drawings declare, "We have to hold chamber pots under ministers while they are in office and then pour them on their heads when they aren't."[8] *Le Grelot* lamented on March 10, 1872, that it "has become almost impossible to continue a satirical publication" because there was no way to determine what the censors would allow

since "what is forbidden today was authorized a week ago and perhaps will be allowed tomorrow." On March 17, 1872, the same journal bitterly protested that the "crayon knows only one regime, one of arbitrariness," since "one drawing is refused, another is accepted according to whether a bureaucrat has had a bad lunch; whether he lost his cane or found his lost dog or his barber cut him; whether his wife is angry at him or a creditor gave him a bill." *Le Droit du Peuple* complained on October 8, 1880 that one day the censors would suppress a completely "inoffensive image," and yet the next authorize a "drawing in which all the members of the government are ridiculed," while *Le Monde Parisian* similarly complained on September 18, 1880 that "the drawings which one fears not being accepted pass without difficulty while those which contain no bad ideas are stopped."

The variety of subjects forbidden to caricaturists often stirred bitter complaints. On January 11, 1874, *L'Eclipse* sarcastically complained that "in this time of unlimited liberty, journals are allowed to concern themselves with everything, on condition that they touch nothing," while *La Lune Rousse* of November 18, 1877, protested that the censorship's "systematic harassment" amounted to a decision "to bar us from all political drawings." *Le Grelot* similarly lamented on November 12, 1871, that it had been "formally forbidden" to forever laugh at "the ministers, the generals, the imperial family [of the deposed Napoleon III], the pretenders [monarchist claimants to the throne], the police, the rural guards, men in office, or anything which touches on anything." On December 1, 1878, *Le Grelot,* upon being informed that it could not print a caricature criticizing the Swiss government without obtaining permission from the Swiss ambassador, ridiculed the censorship by parodying a famous speech attacking press censorship which first appeared in Beaumarchais's (originally banned) eighteenth-century play, *The Marriage of Figaro:*

> As in the time of Beaumarchais, provided we do not ridicule the republicans—that would be firing on the government—nor the reactionaries—that would lack the courtesy due to its adversaries—that we criticize neither the established ministry—which shackles the execution of the best drawings—nor fallen ministers—that which denotes a perfectly bad taste, a Frenchman never striking an enemy on the ground—provided that we attack neither the government—that would cause domestic problems—nor foreign countries—that would create foreign embarrassment—provided finally that we don't talk about things which matter nor those that don't; neither those in office today nor those in the past or in the future, nor those who have not been, are not and will never be; neither honest men nor dishonest; neither believers nor atheists; neither our friends nor our enemies; neither our compatriots nor foreigners; we are free to say whatever

we want to—subject to the inspection of a half a dozen French censors and 50 to 75 foreign ambassadors.

Caricature journals complained that the list of forbidden topics was further expanded by the constant propensity of the censors to see political "allusions" to such banned subjects even in the most "innocent" designs (which in fact often did contain such allusions). On August 29, 1835, shortly before final passage of the September Laws, reimposing the censorship of caricature abandoned in 1830, *Le Charivari* predicted that the laws would make political caricature impossible because "the searchers of the public prosecutor see an attack on the king behind everything that *Le Charivari* prints, in the pear, in a bear, in a criminal pursued by divine justice, in an illustration of a penitent confessing to an enormous sin; what can I say? *Le Charivari* could design a pumpkin and they would see in that pumpkin the person of the king." Following passage of the law, which led to the voluntary closure of its sister publication *La Caricature, Le Charivari* lamented that its prediction had come true. On September 24, 1835, the journal reported that it had been forbidden to print a drawing which showed a rabbit viewed from behind on the grounds that it resembled the "pear" which had been used to symbolize King Louis-Philippe before the passage of the September Laws. Subsequently, *Le Charivari* reported, a revised version of the sketch without the "subversive rabbit" had been banned on the grounds that it contained a carafe which "resembled a rabbit which resembled a pear which resembled, etc." *Le Charivari* continued that it had decided to abandon the caricature since even without the carafe the authorities would no doubt "discover some jar which could have resembled the carafe or some clock which could have resembled the jar, then some vase which could have resembled the clock and so on."

During the reign of Emperor Napoleon III, the censors were so notoriously picky that after the emperor's demise, Leon Bienvenu, editor of the caricature journal *La Trombinoscope,* published a satirical "practical guide" to becoming "the perfect Emperor's censor." It declared, "The Imperial government must try to place itself on guard against the subtleties of writers, dramatists and artists, who, with a guilty purpose, disguise the most pernicious allusions under the apparent innocence of a perfidious phrase or a demagogic stroke of the crayon." According to the "guide," in one case a caricaturist had so cleverly slipped a subversive allusion into a drawing that sixty-five thousand people bought it and "saw nothing unusual in it." Only after it was examined under a microscope was its true intent revealed, the

"guide" continued, demonstrating that "one cannot deliver to too minute an examination" drawings destined for the public.[9]

The fall of Napoleon III did not improve matters much from the standpoint of caricature journals. During the presidency of the monarchist Marshal MacMahon, a biographer of a republican caricaturist reported, it became "impossible to design an animal without the censors seeing in it the figure of Marshal MacMahon; when it was a complete menagerie these gentlemen recognized the entire ministry."[10] The pro-Bonapartist journal *La Jeune Garde* complained of similar treatment under the republican ministries which ruled after 1877, reporting on April 6, 1879, for example, that press director de la Forge "denies to the illustrated conservative journals the right to publish all drawings, without exception, seeing as far as conceivable an allusion of some sort." Republican leaders "fall into epilepsy at the most inoffensive caricatures," *Le Triboulet,* another monarchist journal, declared on August 15, 1880.

The only constant in censorship practices, caricature journals complained, was that the censors' decisions reflected the bias of the regime in power at any particular time. *Le Charivari* was prosecuted for an April 1851 drawing which suggested that President Louis Napoleon Bonaparte (the future Napoleon III) was seeking to undermine the Second Republic (which he subsequently overthrew in a military coup in December 1851). The journal protested on April 20, 1851, that it was being punished for defending the constitution while the president's friends were allowed to repeatedly "push each day for violating the constitutional pact. . . . It is necessary that the law be equal for all." *Le Grelot* of November 5, 1871, complained that under the monarchist-dominated Third Republic censorship had become a "political instrument which serves only the enemies of the republic," while the Bonapartist *La Jeune Guarde* complained on July 8, 1880, that the consolidation of republican control after 1877 had created a censorship bureau that was a "ministerial Janus which turns toward illustrated republican journals a debonair and smiling face but only shows us one that is hostile and menacing." Similarly, the monarchist *Le Triboulet* complained on April 13, 1879, that Press Director de la Forge divided all caricatures into two categories "those which are republican and those which are not, authorizes the first and refuses the others."

In addition to the perceived arbitrariness of the content of censorship decisions, caricature journals also complained of the arbitrary nature of the censorship process, which usually offered journals no explanation of its decisions and never afforded any judicial appeal procedure. *Le Grelot* complained on September 9, 1871, that censorship decisions were made with

"no trial, no conviction, just an order of the minister of the interior," while *Le Don Quichotte* protested in its June 8, 1877, issue that censorship was a "discretionary power in all its blooming, without balance, without measure, without limit, that is to say the most flagrant abuse which one could imagine and the most flagrant contradiction which has ever slipped into our liberal institutions." The July 1874 *Le Trombinoscope* combined complaints about the censors' constant finding of nonexistent "allusions" with a protest over the lack of explanation of the decisions made by "Anastasie," the nickname given to the ugly old woman wielding a huge pair of scissors who personified censorship: "She searches out allusions in the hatchings, seditious profiles in the shapes of shadows and ten times out of seven she finds this solution: 'I see nothing, then there must be something': she refuses the illustration. . . . She persecutes for the pleasure of persecuting, but without knowing why. She would be very embarrassed if she had to justify the fits and starts of her crayon and scissors." *L'Eclipse* protested on March 22, 1874, that not only had the censors banned a beautiful caricature by Gill but "as usual" Anastasie gave no reason for the ban. It demanded: "For the love of God! . . . let Anastasie tell us in good faith what she wants—or doesn't want—if she knows it herself, . . . Anastasie! . . . my angel! . . . You lack common sense, that's known; but you sniff out in horror all that is beautiful, all that is strong, all that is elevated."

The additional burden imposed on caricaturists by the personal authorization rule, a requirement that any living person portrayed in a published drawing give his written consent, also attracted thunderous denunciations from the illustrated journals. Charles Gilbert-Martin, the editor and caricaturist of *Le Don Quichotte,* who was jailed in 1868 and again in 1878 for refusing to abide by the censorship rules, declared on May 21, 1880, that this regulation forced on caricaturists an "unsupportable role for which I personally have neither a backbone supple enough nor a soul humble enough." He complained the rule forced artists to "bow and scrape" before those whom they would prefer to "flagellate." Leon Bienvenu, who also had repeated problems with censorship as editor of *Le Trombinoscope,* declared in *L'Eclipse* of October 25, 1874, that the regulation, which was enforced episodically, was the "favorite trick" of the censorship. He complained that:

> Never could one invent anything more stupid than to subordinate a critique to the approval of the person who is the object of it. . . . Everyone knows that to ask authorization of certain people, to say, write and draw what one thinks of them, would be as naive as to ask a bankrupt to allow you to print several extracts from his account books. . . . Suppose I wrote that M. de Lorgeril [perhaps a play on

lorgner, "to ogle"] looks like a big melon [in French, also a word for *simpleton*]; and if M. de Lorgeril demands it from the courts, they will punish me with a 200-franc fine for this injury, both gross and not very clever. But the law doesn't force me to go find M. de Lorgeril and humiliate myself before him by saying, "I have the honor to humbly ask you, monsieur, your authorization to call you a large melon in one of my next articles."

La Jeune Garde complained on November 9, 1879, that republican politicians like Leon Gambetta, the president of the Chamber of Deputies, and Jules Ferry, minister of public instruction, allowed sympathetic journals to portray them, even critically, but refused all permission to monarchist caricaturists. It lamented, "Every fist becomes a caress if the left hand is used, while the lightest tickle becomes a blow if delivered with the right hand." However, the republican *Le Grelot* complained on October 11, 1878, that leading republican politicians like Gambetta "gave their authorization with two hands" if "one made an [artistic] apology to them," but "they refused with enthusiasm each time one criticized them in a fashion too vivid and just." *Le Titi* complained bitterly on May 3, 1879, that it had been unable to even get past Ferry's personal secretary in an attempt to get Ferry's permission to publish a drawing. It reported, "The secretary took a position of unbelievable arrogance and conceit, disdainfully looked at us and said, 'Do you believe I am going to bother M. Ferry for a caricature?' Oh, there was such scorn in his haughtiness that it could not be described." Subsequently the journal reported, Ferry a "so-called ultra-liberal," conveyed through a valet his "absolute refusal" to agree to the drawing. *Le Titi* reported the apparent reason was that it had portrayed Ferry once before and "neither he nor his adorable secretary have pardoned us for it." The journal concluded on June 7, 1879, that, "So long as one cannot publish a portrait of someone without having the written authorization of that person, liberty of the crayon will only by a myth."

On several occasions, the subjects of caricatures used their authorization statements to attack censorship. Thus, journalism magnate Emile de Girardin's authorization published in *La Lune* of November 11, 1866, declared, "If I refused to *La Lune* the authorization which the law requires of me, I would contradict all my past, because I would be agreeing to censorship and would recognize that which I don't, the unequal treatment of the pen and the crayon." Similarly, journalist Henri Rochefort authorized *La Charge* of April 14, 1870, to print his portrait since as a "partisan of liberty, it is not for me to ever forbid its usage." Another journalist, Edmond About, told *La Lune* of August 25, 1867, "I respect liberty of the press too much to not completely deliver myself to you."

Practical Objections to Censorship

Although most of the criticism and ridicule was directed against the basic principle of censorship, caricature journals also protested against the practical difficulties which it imposed upon them, such as the problems caused if the censors did not make their decisions quickly, the monetary losses caused when drawings were refused, and the logistical burdens imposed in having to transmit each drawing to the authorities (and sometimes to the subjects of the caricatures as well). On many occasions, caricature journals appeared without illustrations or with hastily arranged substitute drawings, or even missed entire issues because of delayed decisions or refusals from the censors. *Le Charivari* reported on November 6, 1835, that due to censorship difficulties it would no longer try to publish a caricature in each daily issue. It lamented that when a drawing was refused due to "making the error of counting a little too much on the good sense" of the censors, it often cost the loss of "the entire edition" unless the journal tried to hastily produce a substitute drawing. "A refused illustration costs us as much as an approved one," it declared, "yet our subscribers don't receive it." *Le Grelot* of March 10, 1872, reported that each refused caricature cost it a loss of three hundred francs, and required twelve hours in transit and ministerial interviews. (At that time, in the aftermath of the 1871 Paris Commune uprising, the interior ministry was located at Versailles, imposing a considerable logistical burden on caricature journals, which were almost all edited in Paris.)

Complaints about delays in obtaining censorship decisions were common. *Le Charivari* protested on July 4, 1840, that while caricature journals required the "greatest possibly urgency" of action from the censors, "nothing is as disorderly and irregular as the service of the censors." It complained that sometimes multiple trips were required to the censorship office to have a drawing even accepted for examination. Forty years later *Le Triboulet*'s editor requested on April 13, 1879, that Press Director de la Forge "please transport my meals and my bed to the ministry of the interior" since "when things go quickly, it is necessary to wait a minimum of three hours" before he would agree to give "his authorization, excuse me, his refusal." *Le Petard* of December 24, 1878, lamented that often a censorship ban was transmitted shortly before a publication deadline, with the result that at the last minute its caricaturist had to "throw together a drawing any which way."

Le Titi of March 19, 1879, complained that last minute bans increased its costs by requiring a more expensive night press run and decreased sales by delaying its arrival at kiosks and bookstores. When issues were seized for alleged censorship violations, *Le Titi* of May 10, 1879, related, the entire

publication cost was effectively lost, whether or not conviction or even prosecution followed. Such seizures, it declared angrily, were "already a coarse enough preliminary penalty which no law can justify since it precedes any kind of judgment," but the authorities "scarcely concern themselves with such paltry affairs. What difference does it make that one kills someone in advance!"

The additional practical difficulty for caricature journals posed by the personal authorization requirement simply added to their complaints. Thus, *Le Don Quichotte*'s Gilbert-Martin protested on May 21, 1880, that the need to personally obtain the approval of the subjects to be caricatured often proved highly time-consuming and made it difficult for artists to publish drawings commenting on current events, especially since their work was, to begin with, "less rapid" than that of writers. Thus, the net effect of the regulation, Gilbert-Martin complained, was to "deprive the illustrator of the topicality which alone can pay the costs of a journal" and to leave him with the possibility only of drawing dead people, like sixteenth-century King "Henry IV putting a chicken into a pot or [sixteenth-century Scottish Queen] Marie Stuart [who had been originally betrothed to the French heir] saying her goodbyes to France." Similarly, *L'Eclipse* complained on October 25, 1874, that "for the journal especially, which only lives from current events and seizes facts as they occur, which under penalty of death must deliver the next day to the public the events of the day, it is materially impossible to satisfy such ridiculous demands." The authorization rule, it complained, added two or more days to the five days already required to produce a caricature and then obtain governmental approval (conditioned, of course, on subsequent approval by the subject of the caricature).

While most of the practical rather than principled arguments against censorship and prosecution of caricature centered on the logistical burdens such restrictions imposed upon caricature journals, another set of practical arguments centered around the contention that the government would not be able to achieve the ends it sought through repression. The only effects of persecuting caricature, this argument suggested, would be to provide free publicity for and create martyrs among the victims of repression, to discredit the government for overreacting to harmless drawings, to drive forbidden art underground, and to increase the demand and the price for banned caricatures. One extraordinary piece of evidence for this argument emerged during the trial of a merchant, during the rule of Louis XVIII following Napoleon's final defeat at Waterloo, for selling busts of the fallen emperor, which were deemed "seditious images." When he appeared for trial, it was disclosed that the same merchant had earlier been arrested in June 1815, during the One Hundred Days of Napoleon's rule, for selling busts of Louis

XVIII (who ruled both before and after the One Hundred Days). The merchant explained that "the public only seeks these stupidities [the busts] when they are forbidden, only asking for busts of Louis XVIII during the Hundred Days, and today only demanding the portrait of the usurper [Napoleon]."[11]

This "forbidden fruit" argument frequently was made by opponents of censorship of drawings. Thus, during an 1822 parliamentary debate, Count Stanislaw de Girardin declared, "When the law is injust it forces the use of ruses to avoid arbitrariness. Personal interest will always be more clever than the most clever police; that which is forbidden will nonetheless remain in existance; and its rigor will have no other result than to increase the sale and the price of the unauthorized prints." In 1831, during Philipon's first trial for publishing an allegedly seditious caricature, his lawyer declared that Philipon's drawings had sold well previously, and "I dare whisper in the ears of the jury, they will sell better yet after this trial." In response to repeated prosecutions of journals for publishing unauthorized drawings during the 1878–80 period, *Le Rappel* asserted: "These trials render a service to the journals; they provide a cheap advertisement; these journals obtain for 25 francs [a typical court-imposed fine] what they would not have had for a million, a huge publicity in all the journals of the world. . . . It will place on the side of caricatures, which a government should smile at, all those who are for liberty of the crayon as for liberty of the pen."[12]

Although it is impossible to determine with any precision how accurate such assessments were, repression seems to have had such reverse effects in at least some cases. According to *La Caricature* of May 19, 1831, its first prosecution merely increased the demand for the forbidden print, while the banning of caricatures on "moral" grounds during the 1871 Paris Commune reportedly led to a ten-fold increase in the price that the outlawed drawings could obtain. After the first prosecution of *Le Triboulet* in early 1879, a Versailles newspaper reported that "everyone hastened to obtain" the banned issue and "passed it from hand to hand," while *Le Triboulet* reported on August 15, 1880, that the recent expulsion of its editor from France had so stimulated demand that the journal had increased its press run from 25,000 to 35,000 copies (fig. 17). In at least one instance, the government itself clearly recognized that its actions threatened to create a martyr. After caricaturist Aristide Delannoy was sentenced to a year in jail for a 1908 drawing which depicted a French general as a butcher dripping with blood for his role in the subjugation of Morocco (fig. 75), his fragile health quickly deteriorated during his incarceration at the Santé Prison. Delannoy was freed after less than four months in jail after the prison director wrote to his supervisor on June 19, 1909, that the artist should be released so that he could receive adequate treatment and "thus avoid complications which could

be fatal for him," especially since "it could not be doubted that if an accident were to happen, a certain press would not fail to exploit that against the administration."[13]

In at least two cases, repression of caricature clearly backfired on a major scale. As will be discussed at length in chapter 4, the incessant persecution of *La Caricature* by the regime of King Louis-Philippe between 1831 and 1835 made the pear symbol of the king so famous that it was scrawled all over the walls of Paris. Largely to silence *La Caricature,* the regime reinstituted in 1835 the censorship of caricature that had been abolished when it came to power in 1830.

Another instance where repression greatly fostered the popularity of the target came in 1877, when during a national political crisis and election campaign, the prefect of Gironde (Bordeaux), Jacques de Tracy, waged a bitter and protracted war against Charles Gilbert-Martin's newspaper *Le Don Quichotte,* one of the few outstanding caricature journals not published in Paris. Week after week Gilbert-Martin's caricatures were banned, and when he stopped publishing caricatures to protest these measures, while continuing to print bitter verbal tirades against de Tracy and censorship, de Tracy repeatedly ordered that issues of *Le Don Quichotte* be seized as soon as they were published. According to Gilbert-Martin's biographer, each week on the day a new issue was to be placed on sale, all the police of Bordeaux were detailed, "as though some revolution was about to break out" and as soon as copies appeared, squads of police spread throughout the city to seize them. In the meantime, hundreds of hopeful buyers awaiting copies lined up in front of the doors of bookstores, "which barricaded their doors with tables in order to avoid being invaded. People bought the journal by packages of 10, 20 or more. . . . Scarcely a quarter of an hour after sales began, the police began seizing the journal, dispersing buyers, pursuing them in the street, tearing it out of their hands."[14]

Caricature journals generally sought to help fulfill the prophecy that repression of caricature would backfire. Most journals which became targets of government persecution actively fought back against their tormentors and did their best to defy and evade restrictions on their activity, often breathing fire at the regime as they did so. Thus, the republican *La Caricature* promised on July 17, 1831, a "fight to the finish against the regime," following a series of seizures and prosecutions of its drawings by King Louis-Philippe's government. When its director, Philipon, was sentenced to a jail term for the first time in November 1831 for a drawing alleged to mock the king, he angrily declared in *La Caricature* of November 24, 1831:

> I will pay with six months of my liberty for my first effort to establish for us a right which is uncontested in England. But this right will be established, nonethe-

less, because we are a people ready to march without fright and without discouragement toward the goal of liberty. . . . Despite our respect for the judgment, we protest, like Galileo, who struck the ground and cried "Still, it moves" [a reference to Galileo's private disavowal of his Inquisition-forced recantation of his belief that the earth revolved around the sun]. Men of power, you want to hide your hideous nakedness under the royal mantle. You demand, shivering, an asylum in the inviolability of the monarch. Well, you will be chased from the temple which momentarily serves you as a place of refuge and you will find us always at the door, armed with a whip which will lacerate you. Our catcalls have irritated you! We will hoot at you, make fun of you. You will no longer dare show your odious faces in public, because the people will know them by heart. They will have seen displayed in the [print shop] boutiques your portraits faithfully rendered. I am condemned. Wait, before rejoicing, until my two hands are paralyzed.

Forty years later, the monarchist *Le Triboulet* responded in the same manner to a campaign of repression directed against it by a republican government. "The reader can be assured that as long as *Triboulet* knocks about the world," it reported on April 20, 1879, "it will never quit the correct path. One will find it always on the breech, indefatigable in defending its faith and principles. It will spare no danger to brand the face of the charlatans and farceurs who try to parry its blows."

EVASION AND PICTORIAL CRITICISM OF CENSORSHIP

Caricature journals often went far beyond breathing defiance and actively sought to undercut and ridicule efforts to ban the publication of drawings. Several journals simply sold banned drawings under the counter or offered to mail them in sealed envelopes to customers who requested them. However, by far the most common technique was to replace a forbidden caricature with a largely blank page which contained a furious denunciation of the government's action, often accompanied by a detailed written (and therefore immune from censorship) description of the banned drawing, tactics which effectively focused public attention on the government's repression. This technique was pioneered by *Le Charivari* in the immediate aftermath of the September Laws of 1835 and was repeated by dozens of other caricature journals during the next forty five years. On several occasions the ingenuity of the journals succeeded in making the government look completely absurd. Thus, *Le Grelot* of June 23, 1872, replaced a forbidden caricature with a detailed description of the banned drawing, complete with an indication of precisely where each element of the design would have appeared (fig. 9).

Figure 9. Caricature journals often protested censorship bans by publishing written attacks on censorship where forbidden drawings were to have appeared. Left: Le Grelot, in its issue of June 23, 1872, retaliated by printing on its front page a written description of exactly what a forbidden drawing urging preparation for military revenge against Prussia would have contained and where each element in it would have appeared. Right: Le Sifflet of August 1, 1875, made a similar protest under the heading "Drawing forbidden by the Censor." It briefly described a planned anti-Bonapartist caricature and asked its readers to understand that "if we are obliged to publish idiotic drawings, it is not our fault."

Usually the descriptions of banned caricatures succeeded in transmitting to readers the intended point, thereby making the government appear foolish by acting in a repressive manner while nonetheless failing to obtain its goal. Thus, during the highly unsettled political period of the early 1870s, when a monarchist-dominated although formally republican government frequently banned caricature attacks on the three royalist parties which claimed a right to the throne, *Le Grelot* reported, on March 17, 1872, being forbidden to depict the Bourbon pretender as a cook pursuing the chicken-people of France. On March 3, 1872, the same journal reported a ban on a drawing depicting a man of the people attempting to shovel into a vast wastebasket various emblems of the recently fallen regime of Napoleon III, complete with a dog which was raising its leg on the assembled mass while undertaking "an exercise familiar and hygienic." "We have vainly searched the motive of this interdiction," *Le Grelot* remarked. "It is so difficult to understand the decisions of the censorship." A few years later, republicans had consolidated their control and amnestied many of those jailed and exiled for their participation in the 1871 Paris Commune, a working class–influenced rebellion which in its final days was responsible for the burning of some of Paris's finest buildings amidst brutal suppression of the revolt. *Le Triboulet* described, on October 26, 1879, a forbidden caricature: it depicted a Parisian offering to an amnestied Communard a can of petrol, with the caption, "Dear sir, remember that you have forgotten to burn the Louvre." On July 6, 1979, *Le Triboulet* even used a series of uncensored caricatures to protest the censorship, captioning each one, "To our great surprise, the censorship has not suppressed the above drawing."

Another technique used to protest censorship decrees was the publication of caricatures that had obviously been mutilated by the censors. Sometimes banned portions of drawings were replaced by the notice "forbidden by the censor," while at other times caricatures were published with obviously missing or obscured parts. Thus, on August 4, 1872, *L'Eclipse* published a caricature by André Gill, which depicted President Adolphe Thiers presiding over the successful raising by France of a large indemnity imposed by Prussia as the result of its victory in the Franco-Prussian War of 1870–71 (fig. 10). France's surprisingly quick success in paying the indemnity guaranteed an early removal of Prussian troops from French soil and was widely viewed as a triumph for Thiers, a conservative republican, and the fledgling Third Republic. In the original drawing, Thiers was shown surrounded by the three frowning pretenders, representing the fallen Bourbon, Orleanist, and Bonapartist dynasties. Although the censors would not allow their depiction, *L'Eclipse* was able to publish the caricature with their bodies and faces covered with clouds, but their feet remaining in clear view, a clue to alert

Figure 10. Right: On August 4, 1872, L'Eclipse published this drawing, which portrays President Thiers successfully "delivering" from Mother France payment of a large indemnity owed to Prussia as a result of the French defeat in 1870. At the bottom of the caricature appear clouds which obscure all but the feet of three people and the bedraggled feathers and claws of a bird. Left: in the original drawing, the figures depicted are three discouraged-looking royalist pretenders, along with the symbolic (but sadly bedraggled) eagle which represents the deposed Napleon III. Since artist André Gill's republican sympathies were well known and the rapid collection of the indemnity was regarded as a blow to the royalists, readers of L'Eclipse could probably figure out what had been "clouded out."

LA DÉLIVRANCE, PAR GILL

LA DÉLIVRANCE

readers that the illustration had been mutilated by the censors. Since three pairs of feet as well as the bottom of a bedraggled eagle (the emblem of Napoleon III) were clearly visible in the published caricature, the complete message of the mutilated drawing was not difficult to decipher.

As a result of the personal authorization rule and attempts by caricature journals to undermine it, bizarre looking caricatures were sometimes published with faces missing from the drawings. Former President Thiers's refusal to authorize his portrayal resulted in the publishing by *Le Sifflet* of March 11, 1877, and *Le Carillon* of February 2, 1877, of caricatures with his face blacked out, while similar refusals from republican leader Leon Gambetta resulted in *Le Jeune Garde* of August 17, 1879, and March 23, 1879, appearing with blank spaces in place of his head (fig. 11). Similarly, on February 20, 1870, a caricature by André Gill was published in *L'Eclipse* with a hole instead of one of the six characters who were to be depicted (fig. 12). As the accompanying text made clear, the missing person was the reactionary Catholic journalist Louis Veuillot, editor of *L'Univers,* with whom Gill had had a long-standing feud.

The origin of Gill's feud with Veuillot was a caricature which Gill had published in *La Lune* on April 21, 1867, which mocked Veuillot's odd combination of bitterness and self-righteous religiosity by depicting Veuillot as an ugly, angry "angel." Although Gill had obtained Veuillot's prior oral authorization, after the portrait appeared, Veuillot brought suit against *La Lune* on the grounds that he had not given written approval (as was technically required) for the drawing. As a result, *La Lune*'s editor was jailed for a month and fined one hundred francs. Gill's anger at Veuillot continued for many years. On February 17, 1878, *La Lune Rousse* published a Gill drawing which portrayed Veuillot as an ugly cleric. The drawing clearly lacked Veuillot's authorization, as a result of which the issue was seized and Gill was fined 100 francs. Gill had the last laugh, however, by using his "Rocambole" trick of 1867 (see chapter 1); on February 24, *La Lune Rousse* published Gill's drawing of Veuillot's unmistakable face in the guise of a portrait of "Niniche" (Anna Judic), a popular actress and dancer who combined a sense of the risqué with the naive. Since the drawing was accompanied by the required authorization from Anna Judic, Veuillot was helpless. Gill accompanied the drawing by a note to Judic, apologizing if the drawing did not "absolutely resemble" her, and explaining that, "I have had a bad hand for a couple of weeks." An equally inventive way around the authorization rule was used by the caricaturist Henry Oulevay of the journal *Le Monde pour Rire.* When Oulevay's caricature of Havin, the editor of the journal *Siècle,* was rejected by the latter as making him look too ugly, Oulevay redid the

Figure 11. Caricature journals sometimes protested the authorization rule, whereby they could only publish portraits with the written consent of the subject, by publishing caricatures with holes or blackouts when authorization was denied. Left: Le Sifflet of March 11, 1877, blacked out what had been the face of former president Aldoph Thiers. Right: La Jeune Garde of August 17, 1879, left a hole where republican politician Leon Gambetta's face was to have appeared. Center: Le Sifflet of August 25, 1872, also replaced a censored drawing with a hole but did not explain who was to have been portrayed, although it jokingly said the missing face would appear if a mixture of water, hydrochloric acid, chicken blood, warm rum, and other ingredients were poured on the paper.

Figure 12. Between 1852 and 1881 in France, all living subjects of a caricature had to give their approval before they could be the subjects of a published drawing. Right: On February 20, 1870, L'Eclipse published a caricature with a blank where caricaturist André Gill had originally planned to depict the reactionary journalist Louis Veuillot. Left: Veuillot's face appears in the original drawing. Veuillot refused to give his authorization, but the text accompanying the published drawing made clear who the missing man was.

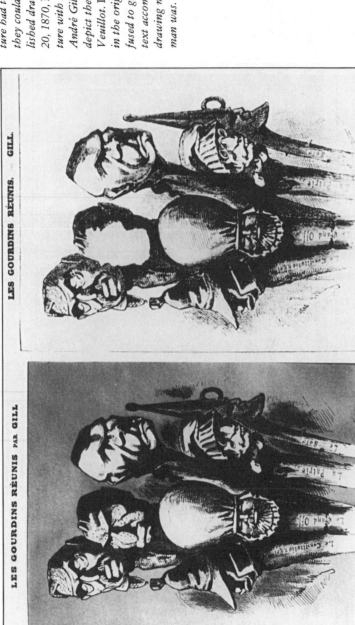

LES GOURDINS RÉUNIS PAR GILL

LES GOURDINS RÉUNIS. — GILL.

drawing, obtained Havin's written approval, then published the original drawing accompanied by Havin's authorization.[15]

While many techniques used by caricature journals to oppose or evade censorship amounted to relatively frontal assaults, the journals also cloaked their political messages in pictorial "allusions," thus avoiding confrontation with the censors. As discussed in chapters 3 and 4, during the 1820–48 period, caricaturists, when subject to censorship, often hid political commentary behind widely recognized symbols, e.g., the *éteignoir,* or candle snuffer, which extinguishes lumière (both light and enlightenment)—as a general symbol of reaction. Political comment also masqueraded as social commentary, as in the famous "Robert Macaire" cartoons of Daumier, published between 1836 and 1842, which collectively painted a devastating portrait of the government of Louis-Philippe while never overtly targeting it. Although the harsh censorship of Napoleon III between 1852 and 1868 made even criticism by allusion virtually impossible, a loosening of censorship controls after 1867 made this technique again a frequent one. Although André Gill was the master of allusion, as demonstrated in his "Rocambole" and "Melon" caricatures, many other caricaturists also used it between 1868 and 1881. Especially popular was the use of animals as stand-ins for political figures. Thus, *Le Triboulet* announced on April 6, 1879, that since the censorship made overt depiction of republican politicians impossible, "so that our readers can recognize these individuals which we put in the pillory, we will disguise them as pigs, donkeys, parakeets, geese. . . . As for the pig, the entire democratic party can protest against that emblem without our protests." On August 10, 1879, the journal published pictures of various animals, such as an oyster, with captions along the lines of "[Minister of Public Intruction] Jules Ferry will not see his head in this." *La Jeune Garde* announced a similar policy of only depicting animals on August 24, 1879. On May 2, 1880, it published a hilarious caricature which used the animal motif to satirize the "personal authorization rule (fig. 13)." Entitled "Liberty of the Crayon," it depicted a group of animals in a zoo, with the caption reading, "It is forbidden to throw stones at the animals—without their permission."

As these drawings suggest, protests against censorship were often among the subjects of caricatures. Perhaps the clearest expression of the hatred artists felt for censorship appeared in the French journal *Le Sifflet* of November 11, 1875. It depicted two censors attempting to cut *Le Sifflet* to shreds but instead cutting off each other's heads with their huge pairs of scissors in a drawing sarcastically titled "Terrible Accident!!!" (fig. 14). André Gill expressed his contempt for censorship in a drawing published in *L'Eclipse* of January 28, 1872, which included a picture of a huge enema

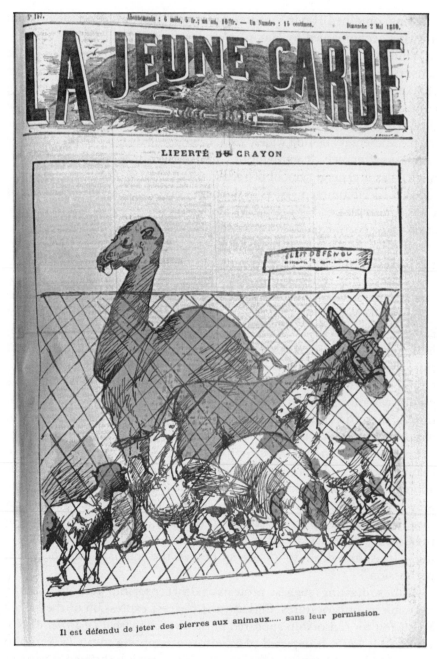

Figure 13. La Jeune Garde *of May 5, 1880, ridiculed the personal authorization rule by portraying animals in a zoo, with the legend, "It is forbidden to throw stones at the animals—without their permission." The drawing is labeled, "Liberty of the Crayon."*

Figure 14. Caricature journals which suffered from censorship developed a bitter hatred for that institution. This hatred was brilliantly expressed by the French caricature journal Le Sifflet *on November 14, 1875, which portrayed censors at work. They are trying to censor* Le Sifflet *but mistakenly cut off each others' heads with their huge scissors. The caricature is ironically captioned "Terrible Accident!!!"*

syringe, accompanied by the clear suggestion that the censors were, to use a euphemism, full of fecal matter. Gill wrote that both "hygiene and friendship" suggested the need for "our good friends of the censorship [bureau]" to obtain a "refreshening" as they "have been very overheated for some time." The theme that the authorities had a grossly exaggerated fear of caricature was addressed in a drawing on the cover of *L'Assiette au Beurre's* issue of May 8, 1909 (fig. 15). Commenting on the recent one-year jail sentence given to artist Aristide Delannoy for a drawing deemed an "insult" to the military, the drawing depicted a crowd of aristocrats, bourgeoisie, and policeman withdrawing before the "dangerous humorist" and crying "Watch out! . . . Watch out! . . . He's sharpening his crayon!" A similar theme was addressed in a caricature published by *Le Petard* on October 27, 1878, which portrayed firemen and a priest equipped with holy water rushing to put out the "fire" which had been created in a French town by a recent anticlerical drawing appearing in *Le Petard's* sister publication *Le Sans-Culotte* (fig. 16). The caption sarcastically reported that the inciendiary journal immediately "inflamed the brains of all the inhabitants" and that the priest and firemen were unable to stop the progress of the "horrible conflagration."

A number of caricatures addressed the theme that repression would backfire or otherwise fail. Thus, *La Caricature* of August 19, 1832, and *Le Triboulet* of August 22, 1880, published virtually identical caricatures which depicted a huge bear (the government) smashing with a great rock of repression a fly (the caricature journal), which was alighting on the nose of a leading government official, who was certain to be pulverized along with the pesky insect (fig. 17). *Le Triboulet* of July 6, 1879, presented the theme of caricature emerging triumphant in the form of a clown (its mascot) who succeeded in nailing up the jack-in-the-box of censorship, while a Gill caricature of January 27, 1878 (fig. 18), showed himself foiling the censor by presenting her with a childish stick drawing that had nothing conceivably objectionable in it.

In contrast to these drawings, most caricatures dealing with censorship portrayed the authorities as successfully wreaking various sorts of havoc on artists, writers, and drawings and subjecting artists to humiliation and servility. A Grandville caricature published in *Le Charivari* of November 8, 1835 (fig. 19), portrayed an ugly-looking group of censors pouring over a batch of caricatures and declaring, "Ah, this is too much, depicting us in caricature! Let's teach the artists a lesson. Cut!" *Le Charivari* of April 28 and May 1, 1851, showed government officials smashing a lithographic stone and the *Le Charivari* mascot with a sledgehammer and a club (fig. 20), while *Le Triboulet* of November 2, 1879, showed the censor splattering one of the

Figure 15. After artist Aristide Delannoy was sentenced to a year in jail for a caricature published in 1908 (fig. 75), L'Assiette au Beurre published a special issue on May 8, 1909, to raise money to help support Delannoy and his family. The cover of the issue ridiculed the government's prosecution of Delannoy, depicting a crowd of aristocrats, bourgeoisie, and forces of order withdrawing before the "dangerous humorist" and crying "Watch out! . . . Watch out! . . . He's sharpening his crayon!"

Figure 16. Caricaturists throughout Europe suffered governmental censorship or other forms of repression during the nineteenth century and frequently had the same response as their French colleagues to this treatment. Top: *In this carica-* ture, Le Petard *of October 27, 1878, ridiculed the exaggerated fears which many had about caricatures by depicting the priest and firemen of a French town rush- ing to put out the fire created in the "brains" of the villagers by the appearance of an issue of the anticlerical* Le Sans Culotte. Bottom: *The German journal* Simpli- cissimus *brilliantly satirized the similarly exaggerated fears of Prussian officials who banned its sale in state railroad stations. Railway officials are shown remov- ing a copy of* Simplicissimus, *which is dripping blood and regarded as so danger- ous that it can only be handled at a distance with a huge pair of tongs.*

Figure 17. Caricature journals often argued that censorship and repression would backfire on the government. Left: The monarchist Le Triboulet, a frequent target of prosecutions by the republican government during the 1878–81 period, warned on August 12, 1880, that in expelling its editor, Harden Hicky, the government was like a bear using a rock to crush a fly, which is alighting on the nose of republican politician Leon Gambette (who therefore would also suffer the consequences). Right: In a caricature published on October 5, 1879, Le Triboulet suggested that it was rolling in money due to increased subscriptions resulting from government harassment.

Figure 18. Censorship led to much frustration among caricaturists. In these drawings, two artists suggested how the censors can be foiled. Top: *In a caricature, from* La Jeune Garde *of March 30, 1879, the artist suggested that censorship, known as "Anastasie," could be directly confronted and outwitted by a clever enough drawing, since "Anastasie, you're nothing* chouette *[meaning both "good" and "owl," i.e., intelligent]".* Bottom: *In this caricature, from* La Lune Rousse *of January 27, 1878, André Gill suggested that the censors can be foiled by presenting Anastasie with a stick drawing, which could not conceivably present any excuses for the use of her huge scissors.*

Figure 19. Grandville frequently attacked government harassment of caricature during the 1830–35 period. Top: In this drawing, which appeared in La Caricature *of January 5, 1832, shortly after editor Charles Philipon was sentenced to six months in jail for a caricature (fig. 41, right) Grandville suggested that censorship was being resurrected although it had supposedly been abolished in 1830. Wielding a huge scissors as he emerges from a coffin is Minister of the Interior d'Argout, the chief censor, whose large nose made him a favorite subject for caricaturists. Bottom: This caricature, which appeared in* Le Charivari *of November 8, 1835, shortly after the reimposition of censorship of caricature in the 1835 September laws, portrays a group of censors as ignorant buffoons.*

L'hercule des Champs-Elysées.

UN EXERCICE DES CHAMPS-ÉLYSÉES.
Léon Faucheux dit le vigoureux brisant d'un seul coup une pierre lithographique du Charivari.

Figure 20. *Following the prosecution of* Le Charivari *for an 1851 caricature (fig. 52), the journal published several caricatures ridiculing the authorities for a gross overreaction.* Top: *This caricature, by Daumier, which appeared on April 28, 1851, shows Interior Minister Leon Faucher smashing the* Le Charivari *mascot over the head with a huge club.* Bottom: *In this caricature, Faucher was depicted by* Le Charivari *on May 1, 1851, as personally breaking one of the newspaper's lithographic stones.*

journal's drawings with the contents of an enema syringe (fig. 21). *La Charge* of August 8, 1870, depicted caricature journals kneeling in humiliation before an ugly old schoolmistress representing the censorship bureau, who punishes them by making them wear signs reading "disobedient" and "incorrigible" for drawing her much as she looks (fig. 22). A caricature in *L'Eclipse* of December 17, 1871, showed a caricaturist's crayon shooting its brains out in despair over the work of the censors, and a drawing in *Le Grelot* of December 28, 1873, depicted an artist's crayon bound and gagged, while a new press law threatened to wreak similar havoc on the printed word by cutting an author's pen in half with a huge scissors (figs. 23 and 24). Gill, in *La Lune Rousse* of July 8, 1878, depicted censorship as a vicious dog breaking an artist's pen with his teeth (fig. 21), while Alfred Le Petit in *L'Eclipse* of October 1, 1871, portrayed it as forcing artists to walk a tight-rope supported at both ends by a pair of open scissors.

The theme of the servility of caricature in France compared to the printed press was depicted in a Gill drawing published in *L'Eclipse* of September 9, 1872 (fig. 25). It portrayed a government minister closing his eyes to whatever abuses might be committed by a proud, smiling pen while unblinkingly staring at an artist's crayon, which kneels in submission and supplicatingly addresses him with a prayer for equal treatment. The humiliation of the crayon in France compared to its proud independence in England was depicted in a *Le Petard* drawing published on February 2, 1878, shortly after the English caricature journal *Punch* was banned from France (fig. 26). Punch is depicted assertive and smiling, while French caricature, as represented in a self-portait by artist Alfred Le Petit, is shown tearing its hair over the harassment of the censors, represented by an ugly old woman wielding a huge scissors.

Similar giant pairs of scissors were a common symbol in caricatures of censorship. A famous caricature by Grandville published in *La Caricature* of January 5, 1832 used this device (fig. 19), and it continued to be used throughout the 1815–1914 period. Thus, Gill, in a March 4, 1877, drawing, published in *La Lune Rousse,* depicted censorship as a huge scissors monster threatening himself and his paper; *Le Trombinoscope* of July 1874 portrayed censorship as a large scissors bird which devoured caricatures (fig. 27); and *La Jeune Garde*'s November 9, 1879, front page simply showed a huge pair of scissors with legs cutting apart one of its issues (cover illustration). *Le Cri-Cri*'s front page of September 29, 1872, showed two men with obscured facial features pointing to a huge scissors, under the heading, "Here's the rub" (fig. 28).

After 1850, the huge scissors was most often wielded in caricatures attacking the censorship by an ugly old woman, "Madame Anastasie," who became

Figure 21. Caricature journals endlessly depicted censorship as subjecting them to numberless indignities. Top: *André Gill in* La Lune Rousse *of July 8, 1878, depicted censorship as a vicious dog, wearing a studded collar labeled "Censorship," breaking the artist's crayon with its teeth.* Bottom: Le Triboulet *of November 2, 1879 portrayed "Madame Anastasie," the symbol of censorship, supervising the splattering of a* Le Triboulet *caricature with the contents of an enema syringe.*

Figure 22. Left: In La Charge of August 8, 1870, artist Alfred Le Petit portrayed censorship as an ugly old schoolmarm who made caricaturists do penance by kneeling and wearing signs reading "disobedient," "incorrigible," and so on for the "crime" of drawing her as she was. Right: André Gill, in La Lune Rousse of May 26, 1878, commemorated an international exhibition held in Paris by suggesting as an exhibit in the French section a "product of the censors"—a caricaturist with his arms and legs cut off and his crayon tied behind his back.

Figure 23. Left: In Le Grelot *of December 28, 1873, caricaturist Alfred Le Petit suggested that censorship in effect bound and gagged the crayons of artists (detail from fig. 24, at left). Right:* Artist Alphonse Humbert, in L'Eclipse *of December 17, 1871, suggested that censorship is enough to drive an artist's crayon to suicide.*

Figure 24. Le Grelot *of December 28, 1873, protested a proposed new restrictive press law by suggesting that it would destroy liberty of the pen (represented by the feather quill) in the same way that censorship had already destroyed liberty of the crayon.*

Figure 25. *French caricaturists often complained that having to submit their work to the censors while writers were freed from the need for prior government approval was unfair discrimination against their craft. André Gill graphically presented this complaint in* L'Eclipse *of September 29, 1872. Newly appointed censorship chief Interior Minister Victor Lefranc is shown closing his eye to the activities of a proud pen, while staring at a kneeling, humiliated crayon, who pleads with Lefranc to "accord me, like my sister, the Pen, the simple right to speak freely."*

Figure 26. The contrast between French and English treatment of caricatures was depicted by Le Petard on November 11, 1877. In response to the French banning of the British caricature journal Punch, (fig. 3, right), British caricature is portrayed as proud and independent, even when faced with the ugly Anastasie, while French caricature, represented by a self-portrait by Alfred Le Petit, is reduced to tearing his hair in despair.

Figure 27. Le Trombinoscope *devoted its entire issue of July 1874 to censorship, describing it as a "famous libercidal machine" which was the daughter of the Inquisition. The front cover of the issue is illustrated with this drawing, which portrays censorship as a sort of huge scissors bird which enjoys slicing up caricatures.*

Figure 28. Right: In this caricature from Le Cri-Cri of September 29, 1872, censorship is shown as responsible for literally "effacing" the features of the two men in the drawing—who no doubt are the two artists listed at the top, next to the heading, "Here's the rub." At the bottom of the drawing, Le Cri-Cri complained that, "The censors have refused us three drawings this week!!!!!" Left: Here André Gill in L'Eclipse of September 1, 1872, blamed censorship for the odd state of the gentleman on the left, who is missing certain vital connections in his body.

a household name in France. All of the censors were, of course, male, but "France" had always been portrayed as a woman, which may be the explanation of the sex of the "censorship"; the origins of the name are obscure, but possibly are linked with a woman of the same name who was a seamstress, another profession identified with scissors. A special July 1874 issue of *Le Trombinoscope* on "Anastasie Censure" described her as an "old shrew who is distinguished by two qualities which are key among the servants devoted to arbitrariness: a great malevolence and an absolute lack of spirit." A classic drawing of Anastasie by Gill (fig. 29), which appeared in *L'Eclipse* of July 19, 1874, was inspired by the *Le Trombinoscope* description. Gill produced a number of other drawings of Anastasie, as did other leading French caricaturists, with Anastasie typically depicted as shackling, harassing, or dueling with caricaturists, as in brilliant drawings by Alfred Le Petit in *Le Grelot* of July 20, 1873, and by Charles Gilbert-Martin in *Le Don Quichotte* of June 19, 1875 (figs. 30–33). Fittingly, as the end of caricature censorship approached, a cartoon published in *La Silhouette* on April 4, 1881, showed the new press law as a scythe about to cut Anastasie's neck as she went about her work of destroying caricatures (fig. 67). The front page of a special censorship issue of *Le Rire* published on December 14, 1901 (devoted mostly to attacking the still-existent theater censorship), featured Anastasie clipping the wings off an innocent cherub (fig. 34).

DEFENSE OF CARICATURE ELSEWHERE IN EUROPE

Just as the fears of and repression directed against French caricature were common to other European regimes in the nineteenth-century (see chapter 1), the protests of French caricature journals against the persecution of drawings also had their counterparts in other countries. In praising the value of caricature, the German journalist Maximilien Harden, a leading critic of the regime of Emperor Wilhelm II (1888–1918), declared that "no other sort of publication can have such an effect on public opinion as the illustrated satirical magazine, which appeals to the most brilliant and to the simplest mind, and with its scornful challenge and raucous laughter, attracts attention everywhere." Swiss caricaturist Rudolphe Toeppfer declared that good drawings could repair "the ill which is caused in the inferior classes of society by so many morally vicious and deleterious books."[16]

The common problems that censorship caused for artists and journalists were perhaps most clearly depicted in two parallel cartoons from France in 1871 and Portugal in 1906 which portrayed caricaturists trying to walk on eggs to avoid forbidden topics (fig. 35). The grossly exaggerated fears which

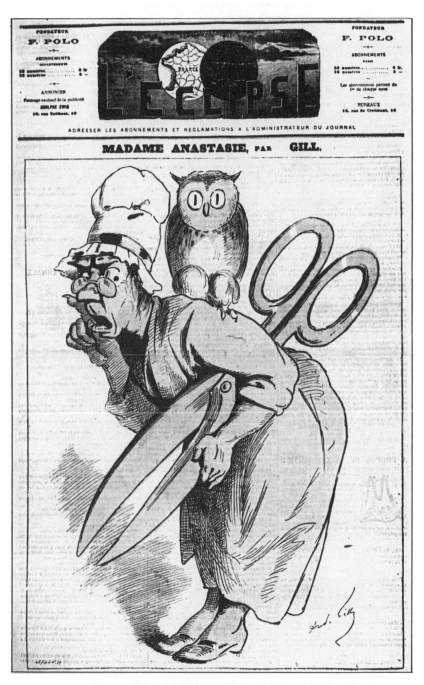

Figure 29. Probably the single most famous depiction of "Madame Anastasie," the personification of censorship, was André Gill's portrait in L'Eclipse *of July 19, 1874. It was apparently inspired by the July 1874* Le Trombinoscope *issue on censorship, which at one point said that the censor was an "old shrew who is distinguished by two qualities which are key among the servants devoted to arbitrariness: a great malevolence and an absolute lack of spirit." The owl is apparently intended to suggest that Anastasie could even spot political allusions in the dark.*

Figure 30. Following the censors' refusal of a caricature planned for its June 19, 1875, issue, Le Don Quichotte *published the following week a drawing depicting censorship as a horrid old woman (Madame Anastasie) using her scissors as a sort of Don Quixote in reverse, attacking the windmill—symbol of truth and beauty. This drawing is accompanied by both written and poetic attacks on censorship, with the latter advising the censor to "thrust, without superfluous words, your huge scissors into your stomach. . . . You would destroy an abuse!"*

3ᵉ ANNÉE — N° 119. DIX CENTIMES. DIMANCHE 20 JUILLET 1873

LE GRELOT

RÉDACTION
30, RUE DU CROISSANT, 30
PARIS
—
ABONNEMENTS
Un an.................... 5 fr.
Six mois............... 4
Trois mois............. 2
—
ADRESSER
Lettres et mandats à M. MADRE,
directeur-gérant.

ADMINISTRATION
39, RUE DU CROISSANT, 39
PARIS
—
ABONNEMENTS
Un an.................... 5 fr.
Six mois............... 4
Trois mois............. 2
—
ANNONCES
M. A. RAMBOUR, régisseur,
8, place de la Bourse.

LE BOULET, PAR ALFRED LE PETIT

Figure 31. This self-caricature by French artist Alfred Le Petit was published in Le Grelot *on July 20, 1873. Le Petit, whose caricatures were frequently censored by the French authorities between 1870 and 1881, showed himself, crayon in hand, shackled by censorship as personified by a ball and chain surmounted by Madame Anastasie. An article in* Le Grelot *of December 1, 1878, could have served as the caption to this caricature, as it declared that to speak of freedom of caricature as "tempered" by censorship was like speaking of the "liberty of the convict being moderated by the ball and chain attached to his foot."*

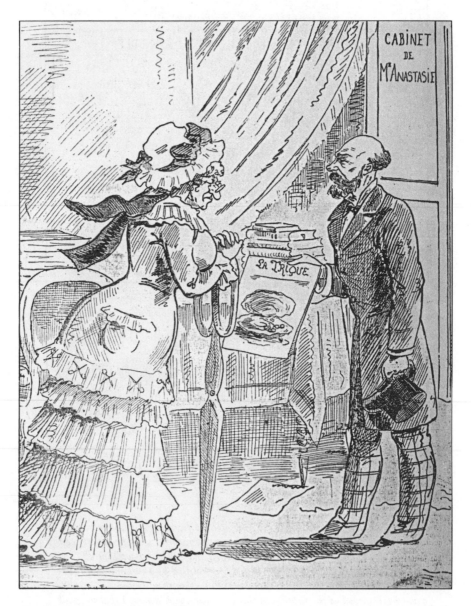

Figure 32. In this drawing, published in La Trique *of June 25, 1881, the journal's editor is shown visiting Madame Anastasie with a caricature. Clearly this is a French version of "casting pearls before swine."*

uxième Série. — N° 33 Paris et Départements : 10 c. le numéro 'Dimanche 20 juin 1880

LE DROIT DU PEUPLE

ILLUSTRÉ

ADMINISTRATION :
1, CITÉ BERGÈRE, 1
PARIS

RÉDACTION :
1, CITÉ BERGERE, 1
PARIS

L'Archange Saint «MITCHELL» terrassant le Démon de la Censure

Figure 33. The Bonapartist Le Droit du Peuple (1876–81), *which championed the claim of the heirs of the deposed Emperor Napoleon III to the right to rule France, was repeatedly censored during the Third Republic and ultimately ceased publishing apparently due to censorship harassment. In this caricature published on June 20, 1880 the journal's spirit was still feisty, as it suggested that "Mitchell" (apparently one of its contributors) would triumph over the censorship-demon Anastasie (whose scissors have already been broken), much as Saint Michael had conquered Satan.*

Figure 34. On December 14, 1901 the caricature journal Le Rire *published a special issue on the subject of censorship, which had been abolished in 1881 for caricature but would remain in effect until 1906 for the theater. The issue featured a collection of previously published nineteenth-century caricatures attacking censorship, as well as some specially commissioned new ones, including the cover drawing which depicted Anastasie using her huge scissors to clip the wings off an innocent angel.*

Figure 35. Similar censorship restrictions produced similar artistic protests in different countries. Left: André Gill portrayed himself in a caricature from L'Eclipse of November 26, 1871, as blindfolded and forced to walk through an egg minefield of various subjects forbidden to him: the government, the laws, the police, Bonapartism, etc. Right: The Portuguese journal Parodia made the same point in a caricature published on March 2, 1906, obviously "borrowed" from Gill's earlier caricature.

German authorities had of caricature was brilliantly satirized by *Simplicis-simus* in 1898 when, after the Prussian authorities banned the journal from sale in state railway stations, railway officials were depicted removing the magazine holding it at arm's length with a large pair of tongs (fig. 16). Similar fears of the Austrian authorities were caricatured by a *Simplicissimus* drawing from 1896, commenting on its ban from sale there, which depicted Austrian gendarmes slashing an advertising poster with their swords and chaining and locking up a pile of its issues (while the *Simplicissimus* bulldog-mascot urinated on a policeman). Similar themes appear in a Russian caricature of 1905, published in *Zhupel* (eventually suppressed by the regime), which depicted the censorship as a horrifying creature wearing a military hat subjecting *Zhupel* to minute scrutiny and in a Portuguese caricature of 1902, in which a censor is shown finding a political "allusion" in every conceivable drawing and is pleased only with a completely blank page. After *Simplicissimus* artist Thomas Theodor Heine was sentenced to six months in jail for an 1898 drawing which mocked German Kaiser Wilhelm II's foreign policy, Heine published a brilliant caricature of himself in shackles, under military supervision in jail, under the heading, "Here's how I'll be doing my next drawing."

3

Censorship of Caricature before 1830

Although the French government before 1789 was theoretically an absolute monarchy, in practice the writ of the king was often not completely reflected in practice, and this was certainly the case with regard to attempts, dating from the sixteenth century, to impose censorship upon illustrations.[1] The king's powers were effectively limited in a number of ways: for example, some regions in France retained significant powers of self-government, and special privileges had traditionally been granted to the Catholic Church and the nobility, which, as King Louis XVI was to learn in 1789, could be threatened only at the risk of calling into question the entire nature of the essentially medieval social and political system. With regard to attempts to control the circulation of "subversive" drawings and caricatures, probably the most important factors limiting the king's authority were the lack of forms of communication and transportation faster than the horse, and the relative absence of a centrally controlled, efficient administrative bureaucracy which could actually enforce the royal will throughout his entire kingdom.

The perceived need for control of imagery originated with the invention of the printing press in the fifteenth century. The simultaneous advances in engraving techniques and the subsequent outbreak of religious dissent during the Reformation combined to produce throughout western Europe a historically unprecedented production and circulation of caricatures and drawings motivated by opposition to the existing political-religious establishment. Before the rise of the printing press, the creation of images, as

well as books and newspapers, was restricted to individually crafted and relatively nonreproducible objects, such as paintings, sculptures, and illuminated manuscripts, which remained stationary in churches, palaces, and private collections of the wealthy. However, the printing press made possible the mass reproduction and circulation of engravings which could circulate throughout Europe as book illustrations or as separate prints. Political and religious dissidents were quick to realize the propaganda potential which such relatively cheap and mass-circulation images could provide as an aid in rallying public support, especially among the vast majority of the population which was illiterate. Just as the Catholic Church had regarded church paintings and sculptures as a pedagogical *Biblia pauperum* ("Bible for the poor"), which could instruct the uneducated, religious dissenters, notably Martin Luther, seized upon the use of image to denounce the papal "anti-Christ," and political dissenters soon adopted the same technique. Thus, Luther, who enlisted such leading artists as Lucas Cranach the Elder and Hans Holbein the Elder to create antipapal caricatures, expressed pride that he had "maddened the Pope with those pictures of mine."[2]

Everywhere in Europe, the authorities reacted to the spread of hostile caricatures, as they did to the circulation of opposition printed matter, by imposing strict censorship controls. In most countries, these repressive actions succeeded in destroying large numbers of hostile caricatures and intimidating and jailing many artists and printsellers, especially as the reach and effectiveness of governmental authority increased with the end of the chaotic period of the religious wars of the sixteenth and seventeenth centuries, and with the growing centralization and bureaucratization of state power in the eighteenth century. While censorship authorities never entirely succeeded in suppressing clandestinely circulated opposition prints, by 1775, as historian Ralph Shikes notes, government edicts had largely "stilled lips and paralyzed pen and burin" in most of Europe. Thus, in Germany, caricature historian William Coupe concludes, most eighteenth-century political prints were "innocuous affairs, insipid representations of the European powers engaged in card games and the like." Among the major European countries, there were two outstanding exceptions to this general rule: in Great Britain, political prints blossomed in the eighteenth century, due to the abolition of censorship of both drawings and of the printed word in 1695; and in France, where despite strict censorship controls, illicit caricatures which mocked high officials of the realm continued to circulate widely during the eighteenth century. André Blum, a leading historian of the subject, has noted, "It was said that France was an absolute monarchy tempered by songs; one could add: also by caricatures."[3]

As elsewhere in Europe, the earliest French restrictions on freedom of the image date back to the sixteenth century. As historian Alfred Soman writes, "there was no essential distinction between censorship of the pictorial (or the dramatic) and the verbal [i.e., printed]," and as another historian has observed with regard to caricature during the sixteenth century, "one only laughed with the king's approval." During the reign of Francis I (1515–47), for example, an illustrator was condemned to death, along with an author and printer, for publishing pictures and text which defamed the king. When religious and political struggles between Protestants and Catholics and between the crown and members of the nobility unleashed a flood of widely circulated vituperative caricatures during the second half of the sixteenth century, formal censorship of pictures was imposed. On January 17, 1561, shortly after the outbreak of the civil strife known as the Wars of Religion that was to convulse France for thirty years, King Charles IX (1560–74) extended previously decreed censorship rules for the printed word to encompass "cards and pictures," threatening those who failed to submit such drawings for approval by governmental officials with the "pain of the gallows." After civil war broke out, the government forbade the sale of all pictures of "battle, descriptions of beseiged towns or other scandalous paintings," apparently in an effort both to safeguard military information and to avoid inflaming passions.[4]

These decrees failed to end the distribution of subversive images, however, and other similar edicts followed. Thus, in 1581 the Parlement of Paris, in response to the distribution of playing cards and caricatures which brutally lampooned King Henry III (1574–89), outlawed subversive drawings. The flood of images attacking the authorities reached their height during Henry's reign; he had been implicated, as heir to the throne, in the Saint Bartholomew's Day Massacre of 1572, when thousands of Protestants throughout France had been murdered, and ordered the assassination of his rival, the Duc de Guise, in 1588. Historian J.-H. Mariejol notes that during this period, "engravings and images illustrated the texts and spoke to the eyes" in hundreds of pamphlets "which flew from one end of the realm to the other and crept in everywhere." Another historian, L'Abbé Reure, relates that anonymous engravings against Henry III were an "effective instrument for the preaching of revolt" and "the work of demolition," which served as "the press of the illiterate" and "placed under the eyes of everyone what the book had said to those who knew how to read."[5]

Although Henry III left France in the throes of a bloody civil war when he was assassinated in 1589, his successor, Henry IV (1589–1610), presided over the restoration of monarchical authority and peace in France. The end of

the Wars of Religion with the granting of religious freedom to Protestants in the 1598 Edict of Nantes, together with the king's great personal charisma and a period of economic prosperity resulted in a considerable diminution of the production of new opposition caricatures, while most existing unauthorized prints were destroyed in a major government search conducted in 1594 (although Henry used caricatures himself to mock his largely discredited foes). The relative lack of caricatures criticizing the authorities continued under Louis XIII (1610–43) and the early rule of Louis XIV (1643–1715), when the primary focus of caricaturists was on fashion and mores of the time and on attacks on Spain, France's leading rival in Europe. A full-blown eruption of opposition prints surfaced again only as a result of Louis XIV's revocation of the Edict of Nantes in 1685 and his constant post-1665 wars against France's neighbors.

Louis XIV had an especial hatred of caricatures and reportedly not only burned those which attacked him but also those which defended him. In 1685, the year of the Nantes revocation, a new decree reiterated previous demands that all prints be submitted to the authorities before being published, and in 1694, two people were executed for publishing a drawing that showed Louis XIV in the guise of a statue enchained by four women whose names, engraved in the statue, were those of three of his mistresses as well as his wife, Mme. de Maintenon, widely reputed to be the power behind the throne. This engraving, which historian René de Livois reports "amused all Paris," must have been especially annoying to the king, as it parodied a statue that he had had erected in his honor at the Place des Victoires, in which he was surrounded by four enchained slaves who symbolized his vanquished foreign enemies. Despite such measures, illicit caricatures which mocked monarchs and other high officials of the realm continued to circulate. Among the favorite targets after the death of Louis XIV in 1715 were Philippe II, Duke of Orleans, who served as regent for the young Louis XV (1715–74) between 1715 and 1723, and John Law, controller general of finance in 1720, whose bizarre monetary schemes led to a huge speculative crash and a severe discrediting of the regime.[6]

From the time of Louis XIV, most illicit opposition caricatures were sold "under the counter." The large majority of them were smuggled into France after being printed in Holland, often by French Protestant refugees who fully enjoyed the absence of Dutch censorship controls. According to historian Jules Fleury, the flood of caricatures emerging from Holland attacking Law created a "whirlwind of papers, a swarm of motion which obscured the sky, almost as thick as an invasion of grasshoppers in oriental countries." When artists and printers responsible for such censorship contraventions

were caught in France, they suffered severely, and thousands of caricatures were destroyed by the authorities. While apparently no printers or engravers of caricatures were killed for their audacity between 1694 and the French Revolution, many who were alleged to have violated the pictorial censorship laws were dispatched to the Bastille or other jails. Even those who escaped jail sentences suffered the seizure and destruction of their goods, or as in one extraordinary incident at Strasbourg in 1728, perpetual banishment from their hometowns. In the Strasbourg case, a Protestant print seller named Tschernein was accused in his trial of committing a "horrible impudence" by selling caricatures, alleged to mock the Catholic Church, of a character of which, the prosecutor charged, there could be "nothing more scandalous, more injurious to our religion, more impious." Tschernein was sentenced to be led before the cathedral, naked save for a shift, by a rope around his neck, where he was forced to kneel and ask forgiveness from God, the king, and the courts, and then was permanently expelled from Strasbourg.[7]

The authorities continued to intensify their attempts to supress the trade in forbidden prints without ever succeeding. Thus, in 1722, the government established a special tribunal—bitterly denounced by one observer as a "new inquisition"—to judge "engravers and printers who have published and distributed prints against the Regency [of Philippe II]." In 1741 the censorship staff was beefed up, and one censor was given the full-time job of controlling pictures, engravings, and sculpture. Ultimately the attempts to control the publishing and distribution of subversive pictures did not succeed because the caricatures met a demand, which reflected a slowly growing public discontent which was to explode in revolution in 1789. Further, the government's attempts to ban and seize offending pictures often backfired by making the regime appear ridiculous and heightening public curiosity about and demand for the banned drawings. The Count de Maurepas, who was dismissed in 1749 from his post as a minister under Louis XV for writing a satirical epigram directed against the king's mistress, noted in his diary in 1730, "One cannot conceive why the ministry forbids these joking caricatures, why it punishes by exile and jail these engravings which are more funny than criminal. Authority should not be used against trifles. One looks at these engravings with curiosity and buys them because they are forbidden, since the French like to have what is forbidden."[8]

Although politically dissident caricatures clearly continued to circulate in France—far more so than in most other European countries—during the period leading up to the French Revolution of 1789, it should be emphasized that most caricatures were not political but rather dealt with modes, manners, fads, and fashions. Thus for two years in the 1770s, the main focus

of French caricatures was on women's hairstyles. Furthermore, many political caricatures ridiculed opposition figures rather than the government and met with much the same reaction from the dissidents as from the authorities. One of the major targets of caricaturists was the leading Enlightenment spokesman Voltaire, who complained in his correspondence that they had made him look "ridiculous from one end of Europe to the other," and plaintively asked one artist to stop circulating a print which he complained portrayed him as a "crippled monkey, with a bent head and one shoulder four times higher than the other."[9]

CENSORSHIP OF CARICATURE DURING THE FRENCH REVOLUTION AND THE RULE OF NAPOLEON

The outbreak of the French Revolution in 1789 and the execution of King Louis XVI in 1793 destroyed, both in symbol and reality, the existing legal order in France, and much of the period before Napoleon Bonaparte's military takeover in late 1799 was consumed by an unsuccessful attempt to replace it with a stable substitute.[10] The early days of the Revolution were characterized by a general sense of joy and goodwill, in which freedom of expression was highly valued as a general symbol of the new order of things, available to all almost without limit. However, internal bickering within the revolutionary factions, combined with Louis XVI's plotting to restore his authority, serious monarchist revolts in parts of France and the outbreak of war with other, still royally ruled, European countries in 1792, fostered a succession of short-lived constitutional experiments and a steady drift toward repression. This culminated in the infamous Reign of Terror, directed by the extreme-left Jacobin party in 1793–94, during which thousands of alleged dissidents were executed. The so-called Thermidorean reaction of July 27, 1794, against the excesses of the Jacobin led at first only to a new wave of executions, now of Jacobin leaders, including their high priest, Robespierre, but after political passions had either cooled down somewhat or been intimidated into relative silence, a relatively calmer period between 1795 and 1799 of five-man rule known as the Directory was inaugurated.

Although Directory rule was certainly far more tolerant than had been the Reign of Terror, it was occasionally punctuated by repressive crackdowns and was marked by a sense of general political exhaustion and a relative turning away by the masses from political concerns to more frivolous matters like food and dress. While the masses focused on private concerns, the five Directors were plagued by internal bickering, revolutionary plots by

groups on both right and left, rampant electoral and financial corruption, and military reverses in the continuing wars with European monarchies. When General Napoleon Bonaparte, a hero of the Italian campaign, overthrew the regime on November 9, 1799, there was little public reaction. Napoleon quickly inaugurated a period of one-man rule, lasting until 1814, and proclaimed himself emperor in 1804. Napoleon was obsessed with the need to eliminate dissent, to centralize authority, and to increase and standardize the efficiency of the bureaucracy. Controls over both the press in general and caricature in particular soon reached previously unknown extremes of effective repression, which were to be reached again in France only during the Second Empire of 1852–70, presided over by Napoleon III, who, in many areas, including repression, modeled himself after his namesake uncle.

While the French authorities were never able to completely prevent hostile caricatures before 1789, the massive wave of satirical drawings which flooded the country after the effective collapse of censorship controls amidst the revolutionary agitation of that year demonstrated that repression had certainly dampened the expression of dissatisfaction or driven it underground. Despite the revolutionary atmosphere which made "liberty" almost a word of worship, fear of images remained so strong that the provisional government of Paris reimposed prior censorship of prints and caricatures on July 31, 1789, and assigned its administration to a member of the Royal Academy of Painting named Robin. This action occurred barely three weeks before the printed word was legally freed from such restraints with the adoption by the national legislature of the Declaration of the Rights of Man on August 26, 1789. This declared that "all citizens can speak, write, and publish freely" since "the free communication of thoughts and opinions is one of the most precious rights of man." Although, at least in Paris, censorship of images apparently formally remained in effect despite this stirring declaration, in practice caricature censorship seems never to have functioned, apparently because, taking advantage of the revolutionary atmosphere and the general confusion, caricaturists and printers refused to cooperate. For example, despite a law passed July 19, 1793, which mandated compulsory deposit of all prints with the government (for archival, not censorship purposes), all such deposited drawings were nonpolitical despite the massive circulation of political caricatures. Cooperation with the censorship was easy to avoid, given the general turmoil of the times and the great demand for political prints, and also because most political caricatures were

circulated as separate prints, which were published anonymously and distributed surreptitiously, and were thus extremely difficult to trace back to a source.[11]

Just as the revolutionary fervor led to an explosion of the printed press, with almost six hundred newspapers emerging between 1789 and 1792, this period also saw an unprecedented flood of caricatures in France. Although during the first years of the revolution, the predominant tone of these caricatures was more mocking than violent, as the struggle grew increasingly bitter, drawings of an increasingly violent character emanated from all sides of the revolutionary struggle in growing profusion. As Jules Renouvier, a nineteenth-century scholar of the history of art during the French Revolution notes, "From the first days of the Revolution, they [caricatures] arrived in great numbers and did not cease to arouse the public at each stage of the drama which unveiled." Although there were episodic police confiscations of caricatures, directed largely against those attacking the royal family during the first years of revolutionary moderation and then against royalist prints after the revolution turned radical after 1791, such measures were largely ineffective until repressive pressures increased markedly after 1792. One Parisian noted that, "Caricatures on all candidates have been exhausted. The voice of calumny is indefatigable." Another observer complained in 1791 that it was "incomprehensible that the government of Paris, responsible for taking away mud and filth from the streets, does not burn the disgusting caricatures which cover the quays" since they were "a thousand times more revolting than the badly swept streets." Such caricatures were clearly in great demand and, as the Goncourt brothers wrote in their 1864 history of French society during the Revolution, served as newspapers "for those who could not read" and as a sort of "school for the people." An almanac published in 1790 reporting on the great success of a print merchant named Basset, noted that as well as "serving his country in making caricatures against the aristocrats" he had served himself well: "At first thin and wan like a priest of today, he found the way to become large and fat like a priest of days past."[12]

As the revolutionary strife increased and the tide shifted toward the Jacobins, Paris was engulfed in violently antimonarchical caricatures which provoked bitter protests from royalists. Historian Catherine Clerc writes that from the royalist standpoint, the flood of caricatures "destroyed the traditional monarchical principle" even "more surely than could 1,000 armed uprisings." Thus, monarchist sympathizer Boyer de Nimes wrote in 1792 (a year before his own execution), that:

No revolution ever produced so many ephemeral products, more ridiculous and

shameful works, which seemed to appear, only to be lost in an ocean of oppro-
brium and forgetfulness, and which could be compared to those clouds of insects
which men only discover by their bites. . . . Never did one see caricatures ex-
pand with such profusion as those which attacked the royal family in the two
weeks preceding the shameful day of June 20, 1792 [when an abortive anti-
monarchist insurrection erupted in Paris]. . . . When the Jacobins wanted to
make major moves, to whip up the people they had caricatures made. . . . One
cannot deny that these means were as perfidious as their effect was prompt and
terrible.

Even some republican sympathizers felt compelled to denounce the increas-
ingly bloodthirsty character of some of the caricatures. Thus, a man named
Lubin told the Commune of Paris in April 1794, during the Reign of Terror,
that "these productions, far from enlightening and instructing the people,
only tend to mislead, degrade and insult them. Let such productions disap-
pear, let them no longer soil the eyes of republicans." Some Jacobin-inspired
caricatures, such as those depicting decapitated heads with obvious approval,
were so extreme that the Jacobin government banned them.[13]

While Jacobin caricatures proliferated, royalist caricaturists were silenced
or forced underground or into exile by increasing repression, including laws
such as those passed in 1792–93 which threatened arrest and possible death
to those committing such offenses as publishing works which "seek to bring
about the dissolution of the national assembly, the reestablishment of roy-
alty or any other attack on the sovereignty of the people" or who by "con-
duct, reflections, words or writing show themselves partisans of tyranny or
federalism or enemies of liberty." As the Reign of Terror of 1793–94 ap-
proached, the number of new caricatures of all kinds decreased sharply.
Many journalists were executed during the Reign of Terror, and at least two
caricaturists were executed for drawings. One of them was an artist by the
name of Hercy who caricatured Robespierre "guillotining the executioner
after having guillotined everyone else in France." He obtained, as French
historian Arsène Alexandre delicately puts it, "as payment for his work the
personal knowledge that the executioner still had someone left to kill."[14]

One of the clearest demonstrations of the revolutionary authorities' rec-
ognition of the power of images was their attempts to destroy monuments
which dated from the monarchy and to subsidize the publication of carica-
tures which would support the revolutionary ideology. Thus, in 1790 the
statue of Louis XIV surround by enchained slaves on the Place des Victoi-
res was ordered demolished, and in August 1792 all statues, bas reliefs, and
other monuments made of metal in public places which offended "the eyes
of the French people" were ordered melted down to be used to make can-
nons. In an attempt to make a more positive use of images, the controlling

Committee on Public Safety commissioned the leading artist Jacques-Louis David on September 12, 1793, to "use his talents and the means in his power to produce many engravings and caricatures which can awaken public feelings and make evident how atrocious and ridiculous are the enemies of liberty and the Republic." David and others created as a result of this mandate a series of ten often-scatological prints directed against the English, printed in an edition of one hundred copies, for which he was handsomely paid.[15]

After the fall of Robespierre on July 27, 1794 (9 Thermidor), and the subsequent rise of the Directory to power, political caricature further diminished in both numbers and intensity, partly no doubt out of fears of reprisal but also due to a general political exhaustion. The vast majority of published prints in the 1794–1800 period reflected the relatively frivolous climate of the period, when the intense political concentration of the previous five years was replaced by an obsession with fashion, fads, eating, and drinking. Such nonpolitical caricatures proliferated in huge numbers; one German visitor to Paris in 1796 compared one quay to a "gallery of prints," since print merchants "had tapestried all the walls of the houses," while a Paris newspaper reported in January 1797 that "all Paris is inundated with caricatures" mocking such targets as fashions of the day and similar subjects.[16]

Although caricature under the Directory was overwhelmingly nonpolitical, political caricature was certainly more free than it had been under the Reign of Terror. If, as historian André Blum has noted, caricaturists under the early Directory usually abstained from political caricature, "as if the scaffolds [of the Reign of Terror] were still standing," some political prints, reflecting a wide range of viewpoints, were published subsequently. They were generally characterized more by a spirit of laughter than hatred, unlike the dominant tone of caricatures from 1791–94, but nonetheless concern was expressed by some that tolerance for political caricatures might prove destabilizing. Thus, a newspaper, the *Courrier Republican,* publicly denounced to the police in early 1797 two caricatures of obvious Jacobin inspiration, which it complained were designed to "pit the different classes of society against one another by false and atrocious depictions." It warned that what at first appeared to be "only a very innocent weapon against the ridiculous could soon become a dangerous weapon in the hands of the eternal enemies of the social order." Although in general the Directory displayed considerable tolerance for political caricatures, even those which mocked the Directors themselves, occasional repressive measures were taken. Thus in February, 1797 the police seized engravings of the former royal family, and in May 1798, the authorities, according to a police report, took measures to "make disappear" caricatures which portrayed the Directors as "dancing and whose goal was to degrade the constituted authorities."[17]

The modest freedom allowed to political caricatures under the Directory was almost totally annihilated during the fifteen-year rule of Napoleon Bonaparte (1799–1814). As a result of fierce repression directed against hostile caricatures and enforced by legions of secret police, caricature under Napoleon either reflected his political views completely or else focused almost exclusively on clothing, eating, drinking, and living well, since, as French historian John Grand-Carteret has noted, "to ask more would not have been wise." The July 1874 issue of *Le Trombinoscope* noted wryly that Napoleon "felt with regard to the press sentiments analagous to those which prowlers of the night have for electric light." The English author William Makepeace Thackeray, writing about restrictions on the printed word and image under Napoleon, noted:

> As for poor caricature and freedom of the press, they, like the rightful princess in a fairy tale, with the merry fantastic dwarf, her attendant, were entirely in the power of the giant who ruled the land. The Princess Press was so closely watched and guarded (with some little show, nevertheless, of respect for her rank), that she dared not utter a word of her own thoughts; and as for poor Caricature, he was gagged, and put out of the way altogether.[18]

One of Napoleon's first moves after seizing power in 1799 was to reduce the number of daily political newspapers in Paris from seventy-three to thirteen (by 1811 this number was reduced to four) and to forbid print sellers from displaying "anything contrary to good morals or against the principles of government." Thereafter, Napoleon, who wrote to his police chief Joseph Fouché in 1805 that he would "never allow a journal to say or do anything against my interests," demonstrated an obsessive concern with eradicating opposition writings and caricatures. He devoted enormous time and attention to making sure the press reflected his views, thus carrying out his own maxim that to allow press freedom "would be to condemn oneself to depart to live on a farm 100 leagues from Paris." In 1810, Napoleon established a formal system of press censorship, although in practice an informal censorship had been well-established long before then. Under a decree of October 14, 1811, the government began to publish lists of all books and engravings which were authorized for distribution.[19]

Napoleon's concern with caricatures was at least as great as with the written press. He was apparently deeply angered by the flood of hostile caricatures, often targeting him personally, which emanated from England. He lodged diplomatic protests with the British government against these caricatures, which he claimed were made "in the pay of the emigration," and in 1802 even tried to have inserted into the Treaty of Amiens with England a

clause providing that persons who ridiculed his person or policies should be treated as a murderer or forger and subject to extradition. Within France, satirical sketches of Napoleon were punishable as lèse-majesté, and the very few hostile caricatures which did circulate provoked severe police measures. Historian Catherine Clerc notes that Napoleon's concern over caricatures reflected "the importance of the image in the culture of the period, more oral than written, which conferred upon it a power to be feared," and that the role of everyone involved in the production and distribution of caricatures during his rule was "very delicate and perilous," as they risked, at any moment, denunciation, seizure of their goods, and imprisonment. The result was that Napoleon's seizure of power on November 9, 1799 (18 Brumaire), had a drastic and immediate effect on the display of caricatures. Thus on January 15, 1800, one Paris journal reported that while three months previously the quays of the city had displayed caricatures mocking the Directory, such as depicting them dressed up in Spanish costumes, now one could only find prints such as those portraying generals, including Napoleon, "all dressed in uniforms of command, with a virile aspect, their eyes all inflamed with glory and their faces serene with liberty."[20]

When "subversive" caricatures were spotted, the police undertook immediate raids and investigations. They seized caricatures favorably depicting elected members of the overthrown legislature and periodically confiscated prints which similarly portrayed members of the deposed royal family. However, Napoleon personally complained to Fouché in March 1810 that engravings of the royal family were still being sold in the streets and that "everyone is astonished that the police don't prevent it." In 1811, the censorship suppressed several illustrations from a book which recalled past kings of France, including the sixteenth-century Henry IV, while during the same year French authorities in occupied Italy destroyed hundreds of prints and snuffboxes which bore portraits of Pope Pius VII, by then one of Napoleon's leading foes. French caricatures which directly attacked Napoleon were very rare and seem to have been completely eliminated by harsh repressive measures between about 1805 and the growing domestic opposition which followed the failure of Napoleon's Russian campaign in 1812–13. One such caricature was reported circulating in late 1803, when Napoleon was planning an invasion of England. It depicted Napoleon admiring the quality and workmanship of a coat being made for him by a tailor but unable to get his arm into the sleeve. The caption read, "Never shall I pass that *manche* [meaning both 'sleeve' and 'the English Channel']." Another dissident caricature reported circulating in December 1804, shortly after Napoleon crowned himself emperor in the presence of Pope Pius VII, depicted a coronation scene with a pistachio (*pistache*) nut underneath it,

with the intended meaning of *Pie se tache* ("Pius soils himself"). Attempts to track down such reported caricatures sometimes failed, leading Fouché to defend himself by reporting that sometimes "one hears reports of libel and caricatures which have never existed."[21]

Napoleon's appreciation of the power of caricatures was reflected in his habit of frequently commissioning prints designed to foster morale in France and to attack his foreign enemies. He instructed Fouché on May 30, 1805, "Have some caricatures made; an Englishman, purse in hand, begging different powers to receive his money, etc. . . . The immense attention which the English direct to gaining time by false news shows the extreme importance of this work." Napoleon's hand was no doubt partly responsible for the enormous flood of anti-English caricatures appearing in France during his rule. Thus, on June 30, 1803, the *Gazette de France* reported, "There does not pass a day without being displayed at M. Martinet's [the leading store for sale of caricatures in Paris] some new caricature destined to fill in the historic omissions which are made in England."[22]

Censorship of Caricature during the Restoration, 1814–30

The 1814–15 period in France was highly confused politically.[23] The major developments were the deposition and exile of Napoleon in the spring of 1814 following French military defeats, the subsequent restoration of the Bourbon Monarchy under King Louis XVIII, the Hundred Days of Napoleon's return to power in the spring of 1815 following his escape from Elba, the final defeat of Napoleon at Waterloo, and the second restoration of Louis XVIII in June 1815. Louis ruled as a constitutional monarch, whose powers were broad but somewhat limited by the need for general support from a legislature which was elected by the wealthiest 0.3 percent of the population. While during the First Restoration Louis pursued a general policy of reconciliation, the Second Restoration was marked by a period of severe repression in 1815–16. Although Louis slowly adopted a somewhat more conciliatory policy after 1816, he was surrounded by ultrareactionary elements of the prerevolutionary nobility and clergy who constantly pressured him to ignore the revolutionary principles of liberty and equality. They were able to take advantage of the 1820 assassination of the heir to the throne to drastically shift French politics to the right, including the first imposition of censorship of drawings since it had been abandoned in 1814. Louis's brother and successor, Charles X (1824–30), was a dedicated reactionary whose rule continued the post-1820 trend of increasing conservatism and repression. In 1829, Charles threw down the gauntlet to the liberal

opposition by appointing the notoriously reactionary Prince Jules de Polignac as prime minister, although he could not possibly gain majority support in the legislature. In the infamous July Ordinances, of 1830, Charles attempted to dissolve a newly elected legislature which was controlled by the liberal opposition, to reimpose press censorship (which had been abolished for the printed press, although not for drawings, in 1822), and to further reduce the electorate. The result was the July Revolution, which deposed the Bourbon dynasty and led to a five-year period of explosive freedom of caricature.

Louis XVIII's constitutional charter, proclaimed in June 1814 and re-invoked in July 1815 after the One Hundred Days, seemingly abolished all censorship by proclaiming that the French "have the right to publish their opinions" subject only to possible prosecution for the "abuse of that liberty." In between these two constitutional pledges, Napoleon, in a bid to gain liberal support, announced on March 24, 1815, at the beginning of the One Hundred Days, that censorship was abolished, a promise followed up in his constitutional decrees of April 22, 1815. These pledges were not kept with regard to the printed word. Louis XVIII's press law of October 21, 1814, whose provisions were reinvoked in a royal ordinance of August 8, 1815, imposed prior censorship on newspapers, a practice which Napoleon effectively maintained during his return to power by assigning police to unofficially "inspire" the editing of newspapers.

None of these laws or practices of 1814–15 specifically referred to drawings or caricatures, and the result was that, perhaps by default, artists had complete freedom from prior control over their work for almost six years, until censorship of caricatures was specifically prescribed in an 1820 law. The result of this freedom, dating from the first ouster of Napoleon in the spring of 1814, was an enormous profusion of openly political and often violently polemical caricatures. Although during his fifteen years of rule only a handful of caricatures against Napoleon produced in France had seen the light of day, after his exile to Elba in 1814 scores of bitterly mocking and hostile prints appeared and continued to circulate in great numbers until his death in 1821. Louis XVIII and his regime in turn became the target of similar depictions until the imposition of prior censorship of caricature in 1820. Since governments came and went with such great rapidity in 1814–15, one artist decided to save himself some work, while staying on the side of successive regimes, by changing only the caption beneath one caricature, so that during the One Hundred Days a group of French citizens were

100

portrayed toasting the return of Napoleon, while after Waterloo the same print was issued with the legend "Viva the King [Louis XVIII]."[24]

As this incident suggests, prints hostile to Napoleon diminished during the One Hundred Days, and prints which mocked Louis XVIII were especially in evidence during that same period, but the absence of censorship controls led to the open circulation even of materials mocking the regime of the day. Thus, *Le Nain Jaune,* a pro-Bonapartist newspaper which pioneered the regular inclusion of caricatures as a supplement to the printed word, noted on May 15, 1815 (during the Hundred Days), that caricatures had clearly benefited from Napoleon's abolition of censorship and that "the print merchants display without any constraint before the eyes of the public portraits of the [deposed] Bourbons and caricatures of all types. There are even among them those in which the [Napoleonic] government is not spared."

Some of the attacks on Napoleon after his downfall were so violent that they led to complaints from caricaturists. Thus, at a meeting of caricaturists in August 1814, one artist expressed his "indignation" at the "disgusting productions which each day adorn our walls and which violate both good taste and good sense" and demanded that some action be taken to curb the "vile hucksters" responsible for such works, who threatened to "heap discredit and scorn" on the profession of caricaturists.[25]

The restored Bourbon regime also became the target of extremely bitter attacks, which continued to spread in profusion long after they reached their peak during the Hundred Days. While most of these hostile depictions took the traditional form of separately published caricatures that were displayed and sold by print sellers, probably the most influential and widely distributed pictures which mocked the Restoration regime were published in *Le Nain Jaune.* This periodical, founded in December 1814, published a twenty-four-page issue in a book-sized format every five days, and published nine large, handcolored, foldout caricatures on a once-monthly basis until it was suppressed during the Second Restoration in July 1815. Although the text of *Le Nain Jaune* was subject to censorship, by clever use of irony, allusions, and allegories the journal was able to successfully mock the regime with both text and images far more directly than was the more carefully censored nonsatirical political press.[26]

No doubt part of the tolerance shown to *Le Nain Jaune* during the First Restoration reflected the fact that King Louis XVIII personally enjoyed satire and was himself appalled at the extreme attitudes of the so-called ultra monarchists, who were literally more royalist than the king. Louis even secretly contributed to the journal, via its well-known drop box, in which people could anonymously drop off suggestions and articles. When his

nephew reproached him for subscribing to *Le Nain Jaune,* he declared, "It teaches me many things neither you nor anyone else would dare tell me." *Le Nain Jaune* had an unusually high (for the period) press run of four thousand copies and exerted considerable influence. Thus, one government minister wrote in his memoirs that *Le Nain Jaune* had a more profound and harmful influence than the illegal clandestine press, and press historian Emile Hatin wrote in 1864 that "none of the journals of the epoque rained more murderous blows on the government." The journal's caricatures were an especially powerful and popular weapon against the monarchy. Thus, *Le Nain Jaune* informed its readers that the public was "very avid" to obtain its caricatures and that after its first caricature, satirizing the royalist press, had been published, it had been unable to satisfy the "daily demands" made for it.[27]

Le Nain Jaune became especially famous for inventing and caricaturing two new royalist "orders" as a means of ridiculing, behind a veil of irony, the supporters of the prerevolutionary regime and thus by indirection the restored monarchy of Louis XVIII. One of these orders was that of the *girouette* ("weathervane"), which was announced during the Hundred Days. The journal typographically awarded varying numbers of small weathervanes to Bourbon officials and others who had become notorious for changing their political views as government policies and regimes changed. Thus, *Le Nain Jaune* declared, and illustrated with the appropriate number of weathervanes, that "only one weathervane will be attached to the name of a political man whose opinions have changed just once; two weathervanes will decorate the names of recidivists; three, five, seven weathervanes indicate those more versatile people." Perhaps even more effective and far longer-lasting as a satiric device was the creation of the Order of the *Eteignoir* ("candlesnuffer"), inaugurated during the First Restoration. Playing on the double meaning of the French word *lumière* to indicate both "light" and "enlightenment," the candlesnuffer, which extingished *lumière,* became a symbol of reactionary attempts to turn back the clock and stifle liberty. Thus, in a famous caricature published on February 15, 1815, various figures representing reactionary members of the ancien regime were depicted wearing candlesnuffers for hats (fig. 36). Thereafter, for a hundred years or more, the *éteignoir* was repeatedly used in caricatures designed to ridicule monarchs, nobles, clergy, and others associated with reactionary politics.

The relative tolerance for *Le Nain Jaune* and to some extent for other critical newspapers during the First Restoration, when the general orientation of Louis XVIII was one of reconciliation, did not survive the Second Restoration. The reinstalled Bourbon regime felt both more threatened and more angry in the aftermath of Napoleon's defeat at Waterloo in June 1815.

Figure 36. Top: *This caricature, from* Le Nain Jaune *of February 15, 1815, depicts a ceremony of the imaginary "Order of the Candle Snuffer [Eteignoir]." Symbolic representatives of the ancien régime all wear on their heads* éteignoirs, *which extinguish* lumière *(meaning both "light" and "enlightenment"), as an indication of their reactionary politics.* Bottom: *A caricature from* Le Miroir *of April 4, 1822, attributed to Delacroix, uses the device of the "backwards walking" crayfish to symbolize the reactionary policies of the Restoration regime. The crayfish in the background is mounted by an* éteignoir-*shaped person who appears to be a cleric and flies a flag bearing scissors, the symbol of censorship. Another scissors hangs around the cleric's neck. In the foreground, the parasol used by one of the figures also represents an attempt to block out the* lumière.

In July 1815, *Le Nain Jaune* was suppressed by royal decree. Although its editors succeeded in reestablishing the paper as *Le Nain Jaune Refugié* in Brussels in March 1816, the exile version, which was smuggled into France, lasted only six months, at least partly due to French, Russian, English, and Austrian diplomatic pressure on the Dutch government (which then ruled Belgium) and partly due to the repressive attitude to the press of the Dutch King William I.

Meanwhile, in France in July 1816, the police raided the offices of the Pellerin Company in Epinal, a major publisher of popular prints, as well as those of some of its distributors, and seized many pro-Napoleonic prints. The head of the company was fined six hundred francs and sentenced to a four-month jail term (which was subsequently suspended). The regime became so sensitive to pictures that in July 1817, the newspaper *Le Constitutionnel* was suppressed for supposedly suggesting there was a depiction of Napoleon's son in a drawing by the well-known artist Isabey. Several attempts to create successor journals to *Le Nain Jaune* in France were crushed by repressive measures. The most significant of these papers was *L'Homme Gris* of 1817–18, which published in almost every issue a drawing which depicted in grotesque fashion representatives of the ruling orders, and especially the clergy. Seven out of the fifteen issues of *L'Homme Gris* (which was apparently able to avoid press censorship laws by technical evasions) were ordered destroyed as seditious, and the paper collapsed under this repressive weight at the end of 1818. Its successor, *Le Nouvel Homme Gris,* succeeded in carrying on its tradition for twenty-one issues in 1818–19. A variety of other "subversive" visual imagery, including separately published prints of Napoleon, as well as jewelry, busts, and snuffboxes with depictions of the fallen Emperor, also periodically triggered police raids and prosecutions after the One Hundred Days.[28]

The examples of *Le Nain Jaune* and *L'Homme Gris* as well as the continued profusion of hostile separately published caricatures convinced the government to begin specifically targeting caricatures through regulations and legislation. This need seemed especially pressing since existing laws only referred to seditious cries and writings, with no mention of drawings, and because the recently developed technique of lithographic printing was not covered by existing laws. (Since 1810, the laws had required other types of printers to be licensed by the government and, since 1793, they had required that other forms of prints be deposited with the government before publication. This regulation did not authorize censorship but did allow the government to know immediately when a "dangerous" print was being published and thus facilitated the taking of quick measures against it.) These omissions were first addressed in a royal ordinance of October 8, 1817,

which specified that in order to avoid the difficulties "which could result from the clandestine use of lithographic presses" all lithographic printers had to be licensed by the government and that all lithographic prints had to be deposited with the government before publication.

Another significant indication of the growing fear that the regime had of caricatures was contained in the major press reforms of May–June 1819. The laws eased restrictions on the printed word by the abolition of press censorship but imposed harsh postpublication penalties for offenses and, for the first time since 1814, specifically made drawings subject to the same postpublication reprisals as the written press. The 1819 laws declared that among those subject to stiff penalties for a wide range of possible offenses—including attacking "the person of the king, the succession to the throne," and members of the royal family—would be anyone who produced, sold, or exhibited materials which committed the specified offenses "by writings, printed matter, sketches, engravings, paintings, or emblems."[29]

The ending of press censorship in 1819 fostered an enormous growth of opposition journals. This, along with other policies of reconciliation toward liberals pursued by King Louis XVIII and his leading minister and favorite, Elie Decazes (premier, 1819–20), compounded a growing panic among ultrareactionary elements in France which had been festering as a result of ever-increasing liberal victories in French legislative elections after 1816. The assassination on February 12, 1820, of the duc de Berry, the king's nephew and, at the time, the last of the royal line, proved a godsend to these elements, who especially blamed the tolerant press law of 1819 for the murder and successfully used the crime to drastically shift French politics to the right. Typical of their campaign was a caricature which showed Louvel, the duke's assassin, reading opposition newspapers as he sharpened his knife with a grindstone, above the caption, "Your pen in the hands of this ferocious monster transformed itself into a dagger."[30]

As a direct result of the assassination, Decazes was forced out and the government introduced a law to temporarily reimpose press censorship. The press law as submitted by the government to the Chamber of Peers three days after the assassination proposed censorship only for newspapers and periodicals, with no mention of drawings. However, on February 28, 1820, the duc de Fitz-James successfully offered an amendment from the chamber floor to add to the bill that "no printed, engraved or lithographed drawing may be published, displayed, distributed or sold without advance authorization of the government," with those defying the law subject to a penalty of up to six months in jail and a fine of up to 1,200 francs. Fitz-James argued that images constituted a threat "perhaps as dangerous" as the written word and therefore should be treated similarly. Referring to the ultras'

clamor against the press, he declared, "If the pernicious doctrines which they [newspapers] have propagated have been judged capable of shaking the social order, if the poison of the calumny distributed with an atrocious perfidy has been able to corrupt hearts, lead spirits astray and even place a dagger in the hands of a scoundrel, could one believe that the images displayed each day before the eyes of the people were not capable of the same results?" Fitz-James declared that children were especially susceptible to the harmful effects of images, since they were "sheltered from the danger of the [written word published in] journals [by their illiteracy]," but subversive designs could "dry up in its flowering the hope of the country." He specifically attacked anticlerical designs, which he suggested could lead children to respond with "laughter and scorn" to religious depictions, as well as to "those ignoble caricatures" attacking the king and his family and supporters, who had "been delivered to the scorn of the populace" in prints which for months had "dirtied the walls of the capital" and "fatigued the eyes of all honest people." Fitz-James also expressed particular alarm at drawings which lionized Napoleon, asking why efforts were being made to "concentrate on his head alone all the harvests of laurels gathered by our best generals?" Fitz-James's amendment was adopted immediately by the Peers, by voice vote and without discussion, and the entire bill, with the new provision for censorship of drawings, was passed by the upper house on February 28, by a vote 136 to 74.[31]

When the press law was subsequently considered by the Chamber of Deputies, the government endorsed the Fitz-James provision and clearly indicated it intended to pursue censorship of images, especially those which evoked memories of the French Revolution and Napoleon, in a purely political manner. Thus, during debate on March 30, when opponents of the provision protested that its unlimited reach could lead to the banning of all depictions of French military history (for fear memories of Napoleon would be summoned up), Baron Etienne Pasquier, the minister of foreign affairs, declared that the government would not ban "masterpieces of art or those which represent heroic action" but only images capable of "nourishing or reviving in the hearts of Frenchmen sentiments which should be effaced, for their own happiness as for that of their country."[32]

The Fitz-James provision provoked strong opposition from several deputies, especially General Maximilien Foy and Count Stanislaw de Girardin, who complained that among its other failings the measure could seriously harm the entire industry connected with producing prints and caricatures, was so broad-sweeping it could be used by governmental officials without limit, was an absurd overreaction to harmless drawings, and was unnecessary since the 1819 press law authorized prosecutions of any seditious draw-

106

ings which were circulated. General Foy warned that the proposal could result in the "great detriment to an important branch of industry," which, as Count Girardin pointed out, produced annual revenues of five to six million francs and supported in Paris alone a "mob" of over twenty thousand artists, workers, and printers, including, especially, large numbers of women and children employed in hand-coloring prints. Girardin declared that the entire Saint-Jacques quarter of Paris was inhabited almost entirely by print workers and that as a result of the Fitz-James proposal "the ateliers will be deserted and the industry will go search for a country in which it can develop without worry." The mere discussion of the proposal, Girardin said, had led Paris print sellers to stop selling their wares. "All the shops of the print sellers which displayed with such brilliance all that could flatter and offer noble consolations to the national pride, are empty today and bereft of their most beautiful ornaments."

The threat to the print industry was especially great, opponents argued, because of the sweeping provisions of the measure. Clearly alluding to the government's concern over prints which celebrated Napoleon, Foy complained that by including all graphic works, the proposal threatened to take away from the French public the numerous engraved or lithographed designs in which "they are happy to see retraced our military deeds and our heroic sadnesses," such as the defeat at Waterloo, which "remains to us a precious memory equal to our more glorious memories." Girardin similarly argued that the lack of restrictions in Fitz-James's proposal would inevitably result in the disappearance

> not only of caricatures denounced by the noble peer but also lithographed drawings which could help console us for recent defeats by the memory of older victories. . . . The provision could at least have been limited to caricatures alone and not extended to all forms of engraving. This would have been a case of separating the wheat from the chaff and not requiring that the study of a plant and the portrait of a prince be submitted to the censors before a merchant is allowed to exhibit them for sale.

Joining in the opposition on this point, Louis Admirault declared that he would not have been greatly concerned had the Fitz-James amendment "only attacked low caricatures, which we would willingly abandon to the will of the police." However, he protested, "Here there is no distinction and to attack these vile conceptions it is necessary to strike an art in which we distinguish ourselves among the nations and which we risk thus retarding in its progress by humiliating and discouraging the estimable artists who ply this trade with glory."

The opponents of the measure also attacked it as an overreaction which was unnecessary given the provisions of the 1819 press law and which the government had not even considered necessary to include in its original proposal. Further criticisms centered on the fact that the provision had been hastily adopted on the floor of the House of Peers, without any consideration by legislative committee. Girardin declared that when the amendment was passed by the Peers in the aftermath of the Berry assassination, it had gotten approval by an "agitated assembly that without doubt could never have been obtained if the amendment submitted to its deliberation could have been discussed in the calm of legislative committees." Ridiculing the perceived threat posed by caricatures, Girardin asserted that England, considered the classic land of liberty, would be surprised to learn that France's legislature was "getting ready to make war on engravings of all types, and in order to kill them before they are born, on all the caricatures which French gaiety could inspire." Such doings, he suggested, would likely make Fitz-James the subject of English caricatures "which will not fear at all in St. James Street and Picadilly the inquisitorial reaches of the French police and which will even succeed in deceiving the active surveillance of the numerous customs agents, if it tries to breach our frontiers."

Fitz-James's proposal, Girardin added, would only deprive the French people of their "very innocent recreation" of admiring caricatures, and "if they allow themselves to laugh while looking at a caricature which places the toadies in a reprehensible position, this laughter, without doubt has nothing very reprehensible in it." Under the 1819 law, he pointed out, the police were expressly charged to ensure that "obscene or seditious engravings cannot be exhibited for sale or sold [without risking prosecution]," so the censorship proposal would only augment, without reason "the severity in a law already too severe." Admirault opposed adopting the Fitz-James amendment on the grounds that it had formed no part of the original bill and declared there was no need for it since caricatures which "outrage religion and morals" were already "under police control." He suggested that the creators of such works would be "more punished when they will be obliged to suppress them [by postpublication prosecutions] after having paid the cost [of producing them], which one will spare them by censorship." Admirault concluded that the law would be ineffective in any case since "the productions will easily be done in secret" and "you will have done nothing against scandal, but might rather encourage it by the attraction attached to forbidden fruit."

Despite an almost complete lack of defense of the Fitz-James proposal in the Chamber of Deputies by government officials and their backers, aside from Pasquier's previously quoted assurance that censorship would be limit-

ed in effect, all attempts to amend and defeat the measure were rejected and the deputies passed the bill on March 30 by a vote of 245 to 136. It was promulgated by King Louis XVIII on March 31.

The 1820 bill ushered in a period of sixty years of almost continuous censorship of caricature. Another equally decisive turning point in the history of censorship of images in France came two years later, when the supposedly temporary provisions of the 1820 law were replaced by a measure which made censorship for drawings permanent, while abolishing at the same time such restrictions for the printed word. This drastically different treatment for crayon and pen was included in the new press bill introduced by the government to the Chamber of Deputies on December 3, 1821, which provided that "no engraved or lithographed drawings can be published, sold or exhibited without prior authorization from the government, under penalty, for ignoring this provision, of a jail sentence of three days to six months and a fine of 10 to 500 francs, plus possible prosecution resulting from the subject of the drawing." In proposing the measure, Count de Serre, the minister of justice, declared that the artistic censorship provision of the 1820 law had proven "so evidently in the interest of morals and public tranquility, without being contrary to liberty," that it should be made "definitive."[33]

The proposal aroused extremely bitter debate when it was discussed by the deputies in February 1822, with much of the discussion centering on the differential treatment of pen and crayon. General Foy pointed out that article eight of the constitutional charter guaranteed the right of Frenchmen to "have their opinions printed and published" and noted that the laws of 1819 and 1820 treated engravings and lithographs exactly as they treated other forms of expression of opinion. When censorship had been imposed on drawings and newspapers in 1820, he declared, it had been done by means of a "law of exception," but now the government wished to impose a "general law" which deprived art of the "general shield provided by the charter to the publication of opinions." Count Girardin asked, "When you abolish the censorship of writing why do you continue to exercise it for engraved or lithographed drawings? Why would you submit so fecund a branch of our industry to ministerial arbitrariness?" Deputy Jacques Manuel, a leading liberal spokesman, also denounced the proposal, declaring that engravings and lithographs "are like any other means of expressing thought. The charter gives the right to publish one's thoughts. Here is a severe attack on this provision of the charter. It is necessary to contest that an image, an exhibited engraving, is not a means of expressing thought, or else to agree that the article carries an attack on the charter."[34]

The government's position on this issue was presented in the Chamber of Deputies by Claude Jacquinot-Pampelune, who maintained that article eight

of the charter only extended to "the publication of writings by means of the press; it cannot be applied to the publication of caricatures, engravings and designs because that is not a means of manifesting an opinion." Jacquinot-Pampelune declared that artistic censorship had proven its value since 1820, as before then "ignoble caricatures" had "outraged morals and the royal majesty," but since then "scandalous drawings" had been prevented without in any way "shackling the productions of genius," which "has never been done and will never be done." Deputy Jacques Floirac, responding to those who maintained that censorship threatened the entire engraving and lithographic industry, proclaimed, "Perish commerce and the artist if they are destined to propagate impiety and to corrupt morals." But, in fact, he maintained, censorship of drawings would only improve artistic quality, since "the human spirit submitted to wise rules thinks before producing and rejects that which is abjectly harmful or scornful, rising to high thoughts and creating works truly worthy of immortality." In the Chamber of Peers, Count Joseph Portalis spoke for the government, agreeing with Jacquinot-Pampelune that the post-1820 censorship of art had "imposed no shackles on the industry of engraving," while imposing "some modesty on the corruption of the same."

Opposition legislators disagreed. Girardin complained that censorship had outlawed many "superb engravings" that were in "great demand" and which contained "nothing contrary to good morals or public order" but simply expressed opinions contrary to the political views "which are now in favor." Apparently referring to bans on prints which fostered Napoleonic sentiment, Girardin maintained that as a result of the 1820 law, when purchasers tried to buy prints "which make the heart of all the brave palpitate, reanimate French sentiments, console a defeat by the contemplation of 30 victories, the print merchants will tell you, 'It is forbidden that we exhibit such engravings.' " He asked, "Is it necessary to prevent artists from reproducing victories dear to the lover of glory and country, or the witness of a sadness which has nothing guilty in it? I ask you, how will public tranquillity be compromised at the sight of a weeping willow which shades newly moved earth [i.e., a grave]?" Another deputy, Bernard Chauvelin, also expressed concern that the censors would ban drawings with "a certain political tendency" and that they would refuse authorizations to artists "known for retracing the glorious deeds of the nation" which have a tendency "unfavorable to certain prior or antecedent ideas [i.e., those of the Revolution, critical of the preceding and subsequent periods of monarchical rule]."

Much of the other discussion of the 1822 proposal to make censorship of drawings permanent largely retraced the debate of 1820. Opponents of the measure declared that the proposal threatened ruin to the French printmak-

ing industry, was unnecessary given the ability of the police to prosecute designs after they appeared, and would simply drive unauthorized prints underground. Thus, Chauvelin argued, "There are not lacking in Paris police personnel and informants who visit the places in which engravings and lithographs are displayed and who could seize those which could be contrary to morals or religion or to all which should be the object of public respect." He maintained that the proposed measure "would be deadly to the productions of genius and of the arts." General Horace Sebastiani supported Chauvelin, declaring that there was no need for preventive censorship of drawings since there existed a "luxury" of means to punish dangerous art by police measures to "withdraw them and bring them before the courts," while the proposed measure would "place shackles everywhere" and hinder the "perfection of the arts" by forbidding "the publication of numerous important works which contain illustrations." Girardin also maintained that the courts could easily control "licentious or seditious" drawings and that censorship would only lead to good fortune for the print industry "of Amsterdam and London, which you would make to the detriment of your printers and booksellers."

After considerable debate in the Chamber of Deputies and perfunctory discussion in the Chamber of Peers, the provision extending censorship of drawings was passed in both houses by voice vote. It thus became part of the press law which was promulgated on March 17, 1822, and technically remained in effect until it was repealed on October 8, 1830, (although, in practice, censorship of drawings was not enforced after King Charles X was overthrown in the revolution of July 1830). As the 1822 parliamentary debates suggest, the 1820 law establishing prior censorship of designs and its subsequent extension in 1822 led to a significant shift in the predominant emphasis of French caricature for the next ten years. While between 1815 and 1820, politics played a leading role in caricature, between 1820 and 1830 caricaturists focused on fads of the day, fashion, and mildly erotic depictions of women (although many of the latter were forbidden by the censors or prosecuted when they clandestinely circulated).

Political caricature by no means disappeared after 1820, but as the result of censorship it became impossible to publish drawings which were viewed as posing direct political threats, such as those clearly ridiculing the monarchy, glorifying Napoleon, or threatening France's diplomatic relations with other countries. For example, as King Louis XVIII was notoriously fat and afflicted with gout, and as he was widely regarded as having been restored to France "in the baggage wagons" of Napoleon's conquerors, it became virtually impossible to legally publish caricatures which depicted wagons or gout-sufferers. Throughout the 1820s, prints as well as medals, statues, snuff-

boxes, jewelry, and even canes with carved heads which sought to glorify Napoleon were episodically forbidden and scores of prosecutions were launched against those accused of manufacturing or distributing them. Thus, in June 1820 a print seller was fined six hundred francs for selling an engraving depicting Napoleon and members of his family. On many occasions three-month jail terms were the penalty for such offenses, such as the case of a jeweler convicted in February 1822 of having sold a gold trinket which had Napoleonic designs on its five facets. The authorities kept an especially careful watch on the Pellerin firm in Epinal as a result of its suspected pro-Napoleonic sympathies, forbidding it, for example, to publish in 1828 a print entitled, "Napoleon on Horseback" on the grounds that they were "coarse prints destined for the lower classes of people."[35]

The precise rules concerning images of Napoleon shifted from time to time in ways difficult to decipher. Thus, the Pellerin company was authorized in 1820 and 1821 to publish prints of Napoleon's retreat from Moscow and of the battle of Waterloo, since they depicted defeats and Napoleon was not personally portrayed, but the authorities investigated the firm when they discovered the company was distributing the Moscow print without cost in rural areas. In 1825, the sale of Napoleonic busts was authorized, but merchants were forbidden to advertise their sale by crying out, "Buy the bust of his majesty the emperor." On September 8, 1829, the minister of the interior directed his prefects to protect, by tightening their enforcement of censorship, the ruling dynasty against attempts to "recall the insignia and the memories of the usurpation [Napoleon's rule]." The prefects were instructed that Napoleon could be portrayed in illustrations in which he was depicted as "a general, representing battles and bearing a historic character" since such battles "belong to France and the government which has adopted their glory is far from wishing to forbid their memory." However, the directive continued, "all other portrayals must be strictly banned" such as depictions of "Bonaparte under all forms, in his public as well as his private life," the reproduction of his "isolated feats of arms, incidents or episodes more or less apochryphal and too often in opposition to history," as well as all "lithographs of diverse format which only attempt to recall to the imagination and the memory of the people the insignia and the memories of an illegitimate power." This confusing directive was immediately followed by a rash of prosecutions for the selling of unauthorized prints and other visual depictions of Napoleonic imagery, although in several cases those implicated were either acquitted or given very light sentences, suggesting that the courts were losing sympathy for the regime. On June 14, 1830, six weeks before the government was to be toppled, the interior ministry sent its prefects yet another confusing directive which seemed to signal a reversal in

direction. It excused from the requirement of submission to censorship what it termed "printers ornaments" such as "vignettes, flowers and tailpieces" and in general urged the prefects to "use much wisdom and judiciousness" in enforcing censorship, "as it is important not to shackle by too frequent investigations a branch of commerce which like the others, has need of protection."[36]

Aside from banning depictions mocking the king and glorifying Napoleon, the censors in the 1820s also periodically proscribed a variety of other topics. For example, in 1823, an illicit engraving, "Four Sergeants of La Rochelle," of men who had been executed for allegedly participating in an antigovernment plot within the military, was ordered destroyed by a Paris court, and in 1826 an engraving depicting the funeral of the great liberal spokesman General Foy, which had attracted thousands of people, was seized and two street hawkers were sent to jail for six days each for having sold it without authorization. Growing criticism of the influence of the Catholic Church, and especially of the Jesuits, upon Charles X, led to severe censorship of caricatures touching on this theme in the late 1820s. Thus, in the September 8, 1829 ministerial circular to the prefects, instructions were given to insure that the clergy was treated with great respect and protected from depictions which subjected them to "reprobation and scorn." In addition the prefects were instructed to place a complete ban on illustrations which could tend to insinuate against ministers of religion "accusations of calumny or of the claimed intervention of clergy in politics," since such portrayals were "a weapon which the disturbers of public order would wish to use." Apparently reflecting this directive, of three caricatures by the well-known artist Henry Monnier banned from an illustrated 1828 version of the fables of La Fontaine, one depicted a decrepit Napoleon, and another portrayed a fat priest in the form of a rat sitting in front of a table overflowing with food, with the caption, "The rat who has withdrawn from the world." Another forbidden caricature, by the emerging young artist Grandville, depicted a family of beetles dressed up in clerical garb (fig. 37). It was banned from the 1829 book which made his reputation, *Metamorphoses du jour,* along with another caricature which was apparently viewed as posing problems for French foreign policy.[37]

In perhaps the most sensational case involving censorship of caricature before the 1830 revolution, one of the editors of the pioneering satirical caricature journal *La Silhouette* was harshly punished in 1830 for publishing a small woodcut (fig. 37) which had not been submitted to the censorship, which portrayed a person with a striking similarity to King Charles X above the simple caption "a Jesuit." *La Silhouette,* which survived for barely a year after publishing its first issue in January 1830, was the first French journal

Figure 37. Toward the end of the 1820s, censorship became increasingly sensitive to anticlerical caricatures as a result of the campaign of opposition identifying King Charles X with the Jesuits and secret clerical conspiracies. Left: This caricature, by Grandville, which depicts a "family of beetles" in clerical garb, was censored from the 1829 book which made his reputation, Les Métamorphoses du Jour, and could only appear when censorship was abolished as a result of the 1830 revolution. Right: The "Jesuit" drawing, published in the pioneering caricature journal La Silhouette in May 1830, shortly before the Revolution, was prosecuted because the journal had printed it without submitting it to the censors and because it bore an unmistakable resemblance to King Charles X. As a result, an editor of La Silhouette was fined and sentenced to a six-month jail term.

which published caricatures in each issue and also the first to regularly use lithography. It appeared in a small format, approximately the size of a modern news magazine such as *Time,* with eight pages of text and two caricatures in each issue. The staff and contributors included many current and future giants in French letters, journalism, and caricature, including the young Honoré de Balzac, the future press magnate Emile de Girardin, the soon dominant figure in nineteenth-century French caricature Charles Philipon, and most of the caricaturists who were to dominate the pre-1850 period, including Grandville, Daumier, Charlet, Gavarni, and Monnier. Before dying for lack of subscribers and finances in late 1830, *La Silhouette* shared, for two months, its printers and much of its staff with *La Caricature,* which Philipon founded in November 1830. Philipon later referred to *La Caricature* as "*La Silhouette* by another name."[38]

Although officially a nonpolitical journal, *La Silhouette* quickly displayed increasing hostility to the regime of Charles X. In its fourth issue, *La Silhouette* denounced the censorship of Monnier's drawings from the fables of La Fontaine. It described in detail the rejected caricatures and reported that the responsible minister had even refused to discuss the matter with Monnier on the grounds of lack of time. "What does he get paid 100,000 francs for?" *La Silhouette* demanded. "Isn't it to listen to the requests of artists as well as the supplication and orders of the gentlemen of the Congregation [a reference to an organization of clerics and laymen allegedly under strong Jesuit influence who liberals alleged were controlling the French government]? Another subject for caricature. M. Henry Monnier will not lack for them."

La Silhouette ran into its own difficulties with the authorities as a result of the "Jesuit" caricature, by Philipon, which it published in April 1830. The caricature led to a prosecution of two *La Silhouette* editors, Victor Ratier and Benjamin Louis Bellet, for violating the censorship laws and also for offense to the person of the king, by presenting his portrait in a "grotesque and derisory manner." During the trial, held on June 25, just one month before the July Revolution which overthrew Charles X, the government's lawyer declared that the 1822 censorship law required the submission to the censors of all images, that the portrayal of the king was an attempt to ridicule him, and that the appellation of "Jesuit" was meant to defame him. The defense attorney, Wollis, argued that the portrait was not of the king, maintaining that the government's delay in seizing the issue of *La Silhouette* for several days after its appearance suggested that even the government was uncertain of the portrait's resemblance to the monarch. He added that to the extent the picture resembled the king, this had been unknown to the editor, who saw it only in reverse on the woodcut, which was presented to him simply as a caricature of a Jesuit. Wollis declared to subject every picture to an exam-

ination to determine if it resembled the king would be itself an insult to the monarch. "What a question to debate," he stated, "whether the dignity of the monarch is well enough represented because his eye is too little or his mouth too open."[39]

With regard to the claim of violating the censorship law, Wollis cited the ministerial circular of June 14, 1830, which exempted "printers ornaments" from the censorship requirement and claimed that the Jesuit caricature fell within this category. Apparently this argument proved convincing, as Bellet and Ratier were both acquitted of violating the censorship laws. However, while Ratier was also acquitted of offense to the king, Bellet was convicted on this charge and sentenced to six months in jail and fined one thousand francs.

La Silhouette denounced the prosecution and the verdict in its columns. In an article published on June 24, shortly before the trial, *La Silhouette* declared that its staff was as "innocent as lambs" and that a lithographic crayon "could never replace the dagger of Ravaillac nor the knife of Jean Chatel [two assassins famous in French history]. A little black ink will never create an infernal machine [i.e., a bomb], and whatever magnifying glass one uses one cannot find that pens can, like the teeth of Cadmus [a hero of Greek legend who killed a dragon whose teeth sprang up as warriors] turn themselves into a army of combatants." While denying that the "Jesuit" represented the "sacred person of our august monarch," whose "traits we revere," *La Silhouette* declared that if the denomination of "Jesuit" was an honorable one, as the government clearly believed, then the authorities themselves were responsible for staining its honor by bringing an "inopportune" prosecution. After the verdict, on July 1, *La Silhouette* renewed its claim made in court that the portrait was an innocent one of a Jesuit, and that only the government's actions had identified it with Charles X. However, on August 15, after the July Revolution, the journal proudly republished the woodcut, with the legend, "Portrait declared resembling Charles X, by verdict of the police correctional court." It announced that separate prints of the illustration would be sold to benefit the widows and orphans of those killed in July.

Police documents which were published in an 1829 book clearly suggest that the Restoration police devoted considerable time and energy to trying to track down illicitly distributed political prints. These documents show that when the police learned in 1823 that the exiled artist Jacques-Louis David was attempting to publish and sell banned engravings of his famous painting depicting the coronation of Napoleon, they assigned a band of informers and investigators to the case and unsuccessfully pursued it for two years. The police agents repeatedly reported to their superiors that they had successfully infiltrated and gained the confidence of a network of printers

and merchants who were involved in publishing and distributing the work, that they had obtained secret passwords needed to gain access to this network, and that they were on the verge of seizing copies of the print. For example, in August 1824, the police supervisors were informed that members of the David family living in Paris "are completely our dupes" and had even agreed to pay police agents commissions for each copy of the engraving which the agents could sell for them. However, somehow the police were never able to actually get their hands on any of the engravings, apparently because their agents had been recognized as such from the beginning and had themselves become "dupes." Thus, in July 1825, police agents reported that the David family was treating them with "the greatest defiance" and that they could not obtain "good information" because "we and our agents are known because of the various activities which we have previously undertaken."[40]

As the David case illustrates, the imposition of prior censorship of drawings between 1820 and 1830 did not completely stifle the circulation of opposition caricatures and prints, since such material continued to be published and circulated clandestinely. Ironically, England, which had been the source of so many anti-Napoleonic caricatures between 1800 and 1815, served during the Restoration as a major center for the publishing and smuggling into France of pro-Napoleonic prints, as well as other banned drawings, such as those attacking the Jesuits and Louis XVIII. Aside from such illicit political prints, however, in many cases the French censorship itself, through some mixture of tolerance and incompetence, allowed a number of clearly critical drawings to be published. The *éteignoir* continued to be featured in many caricatures, for example, and became such a widespread symbol of reaction that it was commonly drawn on the walls of Paris by street urchins, prefiguring the similar pervasiveness of the pear as a symbol of King Louis-Philippe in the 1830s.[41]

Other pictorial conventions used to attack the Restoration regime were scissors (as discussed in chap. 2), and crustaceans, which have the appearance of walking backwards, and thus typified reaction. One of the most famous of such caricatures, attributed to the well-known painter Eugène Delacroix, appeared in *Le Miroir* of April 4, 1822 (fig. 36). It depicted a huge crayfish, surmounted by various representatives of reaction, including a priest in the form of an *éteignoir* carrying a flag with a scissors on it, and a noble shown crying out, "Backward march." In some cases depictions may have simply slipped by the censors, as it became fashionable for caricaturists to draw a tiny crayfish in an obscure corner of an otherwise seemingly innocent picture. The tidal wave of crayfish finally became so tiresome, that *Le Miroir* noted in 1822, "All crayfish having met with accidents, society, con-

vinced henceforth of the inconvenience of walking backward have, it has been said, renounced crayfish and declared that from now on its members will search for the gloom supplied by owls and moles." Thereafter, owls and moles replaced crayfish in the corners of caricatures along with other animals representing gloom and reaction such as bats and snakes. A final animal which joined the aforesaid in serving to ridicule the regime was the giraffe, which after 1827 was often used to represent the increasingly reactionary King Charles X. Since the Pasha of Egypt had given Charles a giraffe as a gift in that year, and since Charles had an unusually long neck, everyone soon saw the king in every caricature with a giraffe in it. While some of these drawings appear to have been approved by the censors, at least one did not: shortly before the July Revolution of 1830 overthrew Charles, the censorship forbade a caricature showing a giraffe, with Charles's unmistakable teeth, being led by a rope around the neck by a rotund priest, with the caption, "The stupidest beast one has ever seen."[42]

The Struggle over Freedom
of Caricature during
the July Monarchy, 1830–48

The 1830 July Revolution in France, provoked by Charles X's repressive July Ordinances, brought about the downfall of the Bourbon monarchy and its replacement by King Louis-Philippe of the cadet Orleanist dynasty. Demands for liberty and for social reforms were among the leading cries of the revolution, which was largely organized by the liberal press. Most of the revolutionaries who fought on the Paris barricades were working class artisans such as printers and masons who had been denied the right to vote under the Restoration government. Under these circumstances, the new regime was inaugurated amidst widespread expectations of significant social and political reforms. But these hopes were soon dashed, as the July Monarchy quickly made clear that its constituency was restricted to only a tiny, wealthy fraction of the population, not much larger than that which had been served by the Bourbon dynasty. The attitude of the regime was summed up by Prime Minister Casimir Périer (1831–32), who declared, in response to demands by a legislator for significant reforms, that "the trouble with this country is that there are too many people like you who imagine that there has been a revolution in France."[1]

The perceived betrayal of the reforms that the martyrs of the "glorious days" of the July Revolution had died for was especially symbolized by the absurdly minute expansion of the suffrage in April 1831 (from the 0.3 percent of the population eligible to vote under the Restoration to 0.5 percent of the population) and by a massive crackdown on the press. Between 1830 and 1833, there were over 300 prosecutions against Parisian newspapers alone, which yielded over 100 convictions and punishments totaling about 50 years in prison and fines of over 300,000 francs. The press prosecutions

were highly unpopular, as was evidenced by an acquittal rate of over 60 percent, even though jury membership was, like the suffrage, restricted to a tiny, wealthy percentage of the population.[2]

The July Monarchy turned an especially deaf ear to the crushing poverty of the vast majority of the population. As would be the case in France until 1884, it remained illegal to form trade unions, and workers were advised by Prime Minister Périer that they should realize "that their only salvation lies in patient resignation to their lot," and by François Guizot, the dominant politician of the 1840–48 period, that they should "get rich" if they wanted to vote.[3] The reaction of the July Monarchy to the numerous strikes, demonstrations, and uprisings of the 1830–34 period, generally provoked by economic misery and the lack of any peaceful channels for the disenfranchised to express themselves, was almost exclusively fear and repression, with frequent use of troops, massive arrests, and hundreds of deaths. In 1834–35 the regime greatly stepped up the level of its repression with the 1834 passage of a law which virtually outlawed all political organizations and the enactment of the 1835 September Laws, which, among other provisions, restored censorship of drawings, which had been abolished in 1830. After 1835, opposition was largely silenced or driven underground, although it did not disappear. In February, 1848, new repressive measures by the regime provoked a revolutionary outburst which overthrew Louis-Philippe and led to the formation of the short-lived Second Republic and an equally short-lived new freeing of caricature from censorship.

PHILIPON VERSUS PHILIPPE IN FRANCE, 1830–35

Since press liberty was one of the major organizing cries of the July Revolution, the press, not surprisingly, at first appeared to be one of the most significant beneficiaries of the revolt. Among Louis-Philippe's earliest actions was the issuance of ordinances in early August which annulled all existing press convictions and freed those jailed as a result of them. Further, the Constitutional Charter promulgated on August 7 contained in article seven the declaration that "Frenchmen have the right to publish and to have printed their opinions, while conforming with the laws" and that "censorship can never be reestablished." The revolution and its immediate aftermath was accompanied by an explosion of caricatures which ridiculed Charles X, reflecting the effective collapse of censorship of caricature with the demise of the Bourbon dynasty. Thus, *La Caricature* of November 24,

1831, referred to the appearance of three hundred caricatures on the theme of the fall of Charles X, which were characterized as a "profligacy of anger and hatred." The outbreak of caricatures was so astounding that a book of them was published in London in 1831, under the title *A Collection of 24 Caricatures Which Have Appeared in Paris Since the Late Revolution.* Its declared purpose was to "spread the means of judging how far our sprightly neighbors are likely to succeed in a species of satire that, until now they have had but little opportunity of practicing, for during the former government the police was constantly on the alert to seize any similar effusion of public opinion."

Although censorship of drawings no longer operated after July 1830, the 1822 law which mandated it remained in effect until it was officially abolished and postpublication prosecutions of caricature offenses were made subject to jury decision, under the law of October 8, 1830. This official ending of censorship resulted from a successful amendment, originally proposed in the Chamber of Peers by Baron Prosper de Barante on September 18, to a press law submitted by the government. Barante demanded that the censorship of drawings be officially suppressed as not in harmony with the lack of censorship of the printed press. He declared that the fallen government had "much abused this power," while noting that dangerous caricatures could still be prosecuted after publication under the 1819 law. Under a system of censorship, if dangerous caricatures slipped through the controls it would be difficult to prosecute, Barante declared, "Since the guilty party can say to the administration: you prosecute me for the publication of an engraving that you seem to have approved by your silence [in not censoring it]." Barante's proposal was introduced in the Chamber of Deputies by Bertrand Villemain on October 4, who argued that censorship was "always odious and now impossible" and that juries were more able than magistrates to discern "the malignity which is hidden under these caricatures" and any threat that they might pose to "public morals and decency."[4]

Villemain's argument may have been a disingenuous attempt to gain conservative support. However, his position was fully accepted by government spokesmen and others who in fact were highly offended by the cascade of caricatures, which by October were beginning to attack the new government. These conservatives realized that censorship had fallen into disrepute and disrepair and believed that post publication prosecutions might actually be facilitated by a clear return to the 1819 law. The duc de Broglie, who served as minister of public instruction, declared that "the government cannot prosecute when censorship is not organized" and that the government did not intend to reconstitute it because, he asked rhetorically, "Where

would it find the censors?" The current situation resulted thus in complete impunity for drawings and "the walls witness clearly that this license is greatly used," he added. Since censorship was not functioning, de Broglie maintained, the best recourse was to formally abolish it and to have the courts begin to prosecute "these drawings, which are really abominable," after their publication. While Minister of the Interior François Guizot limited himself to declaring that "it is important that the word censorship no longer be found in any of our laws" and "it should be exercised no more on engravings and lithographs than on writing," most other speakers clearly adopted de Broglie's view that ending the nonfunctioning censorship was especially desirable because it might facilitate post publication prosecutions. Thus, the Count de Sainte-Aulaire stated that "censorship is a very bad thing" but urged action to "provide a means of sweeping the streets free of scandal," and Count Simeon backed the proposal while declaring, "There is grounds to hope that the government will employ the means of [postpublication] repression which the law places at its disposal to stop the publication of drawings which too often offend public morals."

The October law formally abolishing prior censorship of caricature proved, in retrospect, to be the high point of press liberalization under the July Monarchy. Between the end of November 1830 and the first week of April 1831, four press laws were passed which imposed restraints on the press in general and which were to prove of considerable significance with respect to caricature in particular. These laws reflected an increasingly conservative direction of the new government, which was particularly alarmed by a wave of strikes and street demonstrations provoked by continuing economic problems (which had helped bring about the July Revolution), by popular demands for harsh punishments for Charles X's ministers (which led to disorders in Paris in mid-October and late December), and by mounting anticlerical agititation (which culminated in serious rioting in Paris in mid-February, 1831). The law of November 29, 1830, made punishable attacks by the press against "royal authority," the "inviolability" of the king's person, the order of succession to the throne, and the authority of the legislative chambers, on penalty of up to five years in jail and a six thousand–franc fine. Under this law and that of April 8, 1831, material deemed as constituting such offenses could be seized by the police, and if a judicial prosecution followed, all those involved in its publication and distribution, including the printer, publisher, editor, artist, and/or author could be punished. The law of December 14, 1830, reintroduced, at a lower level, the hated security deposits (supposedly a guarantee of paying any possible fines for violating press laws which were often set so high that the poor were effectively prevented

from publishing newspapers) and special taxes required of the press under the Restoration regime. Although the December 14 law required security deposits only of the daily political press, under the law of April 18, 1831, this requirement was extended to all political newspapers, whatever their publication schedule. The law of December 10, 1830, completely forbade the posting of any writings, engravings, or lithographs dealing with political news or themes, except those emanating from governmental authority, in any street or other public place.[5]

The legislative debate over the December 10 law banning the posting of writing or images treating political matters in public places did not explicitly focus on caricatures, which, as noted in the debate over the October 8 law, had been widely posted in the streets at the time of the July Revolution and thereafter. However, the discussions on the December 10 law were highly revealing in that the legislators' attempts to distinguish posters and placards from the periodical press paralleled arguments that were used repeatedly to distinguish caricatures from printed matter, namely, that posters, like caricatures, constituted appeals to the emotions rather than to reason and therefore were not forms of expression of opinion protected by the charter. The debate over the December 10 law also clearly reflected the growing fear of the lower classes. These elements of the population were viewed as both especially volatile and threatening to political stability and also especially susceptible to being influenced by posters and caricatures. And particularly when these images were displayed in public, they were seen as far more accessible to the poor and illiterate than was the far more expensive printed periodical press, which was usually read indoors by individuals or small groups of the relatively respectable middle and lower-middle classes.

Minister of the Interior Marthe Montalivet, in introducing the political poster ban proposal to the Chamber of Deputies on November 24, 1830, praised the printed press as contributing to social progress "especially because it only appeals to the intelligence" and acts by "the slow but profound power of meditation" but declared that posters were intended "most often to produce a sudden and violent impression" and when placed before "a mass of readers, more or less provoke public disorder." Defending the bill before the Chamber of Peers on December 4, Montalivet maintained that "the freedom to put up posters, that is to harangue citizens with writings, to gather them and to provoke them in broad daylight into political discussions, has never been one of those freedoms guaranteed by the charter." A supporter of the bill, deputy Dugas-Montbel, agreed, arguing that it was time to "place an end to the scandal of these inciendiary posters with which our most cruel enemies dirty the walls of the capital each day" and which threatened to "excite hatred

and obscure all judgment" as they were read by crowds of people gathered at random.[6]

The fear of a lower-class insurrection pervaded the discussion of the bill. Thus, deputy Felix Barthe defended the proposal on the grounds that the wealthy had no need to get their news from posters since they could subscribe to newspapers, while for the poor the placard was a harmful means of instruction, since it appealed to the passions of those "whose habits make them easily susceptible to being led astray by this powerful means of agitating them and not educating them," one which could "perhaps lead them to disorder, instead of leading them to the love of work." The Marquis de Maleville argued that posters were especially dangerous because their "bad doctrines and perfidious insinuations" did not address the "classes of society most interested in public tranquillity" but rather "those who are the easiest to seduce and especially to the youth whose ardent imagination likes to rush" into adventures. Ironically, the supposed major role that posted caricatures and written incitements to insurrection had played in the July Revolution was put forward as a major reason to ban such posters by the government which presumably partially owed its birth to them. Thus, deputy Thomas Jollivet urged adoption of the bill precisely because posters had been so influential in bringing the former government down. "Do not forget the July Days," he declared. "It is because we knew the power of the poster, the force of the weapon, that we could overthrow the regime."

Amidst the ambiguous political circumstances which existed at the end of 1830, as a government formally committed to freedom of the press was clearly backing away from this commitment, *La Caricature* was founded by Charles Philipon, a member of the staff of *La Silhouette*. *La Caricature* was to become the most important journal in the history of French caricature, due to both its extraordinary political role and the high quality of its art. Philipon, who was only twenty-eight when *La Caricature* (1830–35) published its first issue on November 4, 1830, has been justly termed "the creator of modern political caricature," by caricature historian Emile Bayard; he also characterizes *La Caricature* as "the most fearful of the weapons which the republicans brandished against Louis-Philippe," a judgment supported by many others.[7]

La Caricature was published weekly in a format about the size of a modern tabloid newspaper, consisting of four pages of text and two inserted lithographs, which were often hand-colored. The prospectus for *La Caricature* declared that "caricature has become a power" in France, as the July Revolution had "proved the great importance of the crayons of our illustrators." While the orientation of the early issues of *La Caricature* focused on literature and general humor, the journal gradually became more overtly political

and critical of the July Monarchy, especially after the first prosecution was launched against Philipon, for a caricature entitled "Soap Bubbles," in early 1831. In response to this prosecution, Philipon boasted in *La Caricature* of April 28, 1831, "*La Caricature* has now made felt in France the influence which artists have long had in England. The power of this genre of opposition was unknown before the July Revolution because censorship, abolished for the typographical press, always existed for prints and lithographs. We have revealed this power in striking, with a weapon which was unknown until now, the enemies of our liberties." Although Philipon was acquitted in the "Soap Bubbles" trial held in May 1831, he was later convicted in three other prosecutions. While still imprisoned, he founded at the end of 1832 the most long-lived (and the only daily) caricature journal of nineteenth-century France, *Le Charivari* (1832–93). *Le Charivari* was published in a tabloid-sized format, with three pages of text and a black-and-white lithograph on the third page. It had a somewhat less political focus than its sister publication, *La Caricature,* which continued to be published weekly until forced to close by the reimposition of censorship of caricature in 1835.[8]

Although Philipon was himself a caricaturist, his major contribution as founder, editor, and guiding genius of the two journals was the recruiting, inspiring, and nurturing of a brilliant group of artists, including Daumier, Grandville, Traviès, Monnier, Gavarni, and others who were to dominate French caricature for the next forty years. Many of these caricaturists were even younger than Philipon—in 1830, Daumier was only 22 for example, while Grandville was 27, and Traviès was 26—as well as gifted with such enormous talent and audacity that Daumier biographer Howard Vincent has declared "they had knives in their brains." While usually leaving the actual production of caricatures to his staff, Philipon was a writer and editor of great talent and wit, who not only wrote much of the editorial content of his journals but also was a constant source of ideas for caricatures and their legends for his staff and a constant goad to others to do their best work. Daumier himself admitted, "If Philipon had not been behind me to prod me unceasingly like one does to an ox with a plow, I would never have done anything." In 1841, Honoré de Balzac, who wrote for *La Caricature* in its early days, recognized Philipon's role by addressing him as the "Duke of Lithograph, Marquis of Drawing, Count of Woodcut, Baron Burlesque, Sir Caricature." Even an extremely hostile account, by nineteenth-century historian Paul Thureau-Dangin, contains considerable admiration for Philipon, declaring that, "He knew how to group, launch and inspire those artists which he employed, to inoculate them with his gall and his audacity, furnish them with ideas and legends, brave prosecutions and condemnations, and thus this obscure man became one of the most dangerous adver-

saries of the new king, preventing the monarch from acquiring that prestige required to truly establish himself."[9]

Aside from his inspirational role as editor and his recruitment of a brilliant team of caricaturists, another element in Philipon's success was his adoption of lithography to reproduce caricatures. Invented in the late eighteenth century in Germany, the new technique spread so rapidly in France after 1815 that the number of licensed lithographic presses in Paris alone mushroomed from seven in 1819 to ninety-eight in 1840, and the number of prints annually deposited with the government skyrocketed from 1,644 to 5,133 during the same period.[10] In comparison to the older techniques of wood and copper engraving, lithography was easier and faster for the artist to execute, cheaper for the publisher to use, and capable of producing far more copies. Thus, while a copper engraving deteriorated after a few hundred pressings, a lithographic press could print over one thousand copies per hour with no difficulty. Before lithography, caricatures could only be published in limited editions and were usually only sold as separate prints at expensive prices by print sellers. Thus their circulation was greatly limited by their cost and limited form of distribution. Due to the laborious production process and the costs of using engravings, the few journals, such as *Le Nain Jaune,* which published caricatures before 1830 did so only episodically and could not use them to comment on extremely current subjects. With lithography it became possible to include highly topical illustrations on a weekly or even daily basis in periodicals, as well as to produce larger numbers of less expensive and more up-to-date separately sold prints, and thus to circulate them more widely and on a more timely and regular basis. The practice of regularly including lithographed caricatures was pioneered in *La Silhouette* and refined to perfection by Philipon's journals. Inevitably, especially given the high level of politicization of the French public, the authorities viewed lithography as a potentially highly threatening invention. As historian Michel Melot notes:

> Lithography was an effective educational tool for the direct and immediate instruction of a whole new sector of the public that had only recently become socially and politically aware—the new urban and rural middle classes, who had few formal qualifications but were extremely active and eager to learn—and it could even be used for the illiterate lower classes, whose ideological and intellectual appetites could be satisfied solely by imagery. . . . By aiming itself at a poorly educated public and by producing a cheap and widely available product, lithography itself soon . . . became suspected of being vaguely subversive (in the aesthetic as well as the moral sense) by the conservative sectors of society.[11]

Philipon's success above all reflected his ability to artistically capture the political mood of the times, especially the widespread and growing anger of many French who felt that Louis-Philippe was betraying the promises of the 1830 revolution for political freedom and social reforms. After an initial flurry of violent and often brilliant artistic attacks against the fallen regime of Charles X, Philipon and his crew turned to lampooning the new regime in what became variously known as the "war between Philipon and [Louis-] Philippe" and "the campaign of disrespect." The result, as one American living in Paris wrote, was that the new king gained the same enjoyment of his royalty as "one seasick has of the majesty of the ocean" as he was "lampooned in the newspapers, caricatured in the printshops, hawked about town, placarded upon the walls of every street, and gibbetted upon every gateway and lamppost of the city." French theater director and playwright Juan de Grimaldi, who suffered severely from the Spanish drama censorship as a leading impresario in Madrid, wrote in 1837 of the situation in France, "It is not possible to have an idea of the lack of self-control in the press or in the sellers of etchings in the five years following the [1830] revolution. Not a single day went by without a new caricature, without a new article, sometimes serious, sometimes ribald, to stir up against the person of the king hate and scorn, ridicule or anger."[12] Many of the caricatures published in *La Caricature* and *Le Charivari* or separately published by Philipon's publisher, his brother-in-law Gabriel Aubert, combined brilliant wit and artistry with bitter hatred and scorn for Louis-Philippe and his government of an intensity never witnessed before in legally published drawings in any country. The king was repeatedly compared to a Judas betraying the constitution and France and several times was depicted physically assassinating French liberty—as in a print published in *La Caricature* of February 13, 1834, which led to an unsuccessful prosecution of three staff members of the journal (fig. 43). Other drawings, such as a *La Caricature* print of December 4, 1834, clearly suggested that the death of the king and members of his government—whether political or physical was unclear—was desirable.

As the nineteenth-century account of Jules Brivois points out with regard to the role of *La Caricature,* "Never by pen and crayon was war led with so much life, spirit, verve, and bitterness as that waged by *La Caricature* against the government, by Philipon on Philippe. One of the two had to succumb. *La Caricature* succumbed, but it left us with an unperishable monument." Another nineteenth-century account, by Armand Dayot, records that, "The most fearful and effective of the weapons adopted by the republicans against Louis-Philippe was the journal of Charles Philipon: *La Caricature.* It struck him mortal blows." Dayot adds that Philipon's "intrepid artists, obeying

with a completely military discipline the ardent inspiration of their director," formed a "true holy battalion" directed against the regime and "threw themselves into the political battle at the risk of their freedom, armed with their terrible crayons, only stopping before the bodies of their adversaries." Art historian Henri Beraldi writes that Philipon fought a "war to the death" with the regime and that if caricature had never before had the "aggressive power of the drawings" of *La Caricature,* this was above all because "those who made them knew how to draw." Even the extremely hostile account of historian Paul Thureau-Dangin declares that the Philipon caricatures were "perhaps even yet more dangerous" for the regime than the printed word and had "such audacity, such importance, a power so destructive, that history cannot neglect these illustrated papers, which from other points of view it would be tempted to scorn."[13]

The greatest contribution to the war against Louis-Philippe was Philipon's invention, first introduced during one of his many trials, of the pear as a representation of the king, whose head bore at least a passing resemblance to what soon became the "first fruit of France." The pear imagery was used in scores of cartoons by Philipon's artists to depict the king in all sorts of ludicrous and repressive postures. Instead of asking "Have you seen the latest issue [of *La Caricature*]," Parisians inquired of each other, "Have you seen the latest pear?" The pear was depicted as a ball and chain around the liberty of France in one *La Caricature* print (fig. 38), while in others two workers were shown hanging a pear in effigy and a man was depicted about to cut the neck of a pear with a knife (an allusion to castration, given the phallic connotations sometimes clearly imputed to the pear). In a print published in *La Caricature* on June 7, 1832 (fig. 39), for which Philipon and Aubert were unsuccessfully prosecuted, a gigantic pear statue was depicted on the Place de la Concorde with the inscription: "The *expiapoire* [*expiatoire,* "expiatory," and *poire,* "pear"] monument is raised on the site of the Revolution, exactly where Louis XVI was guillotined." Accused by the prosecutor of "a provocation to murder," Philipon responded, "It would be at most a provocation to make marmalade."[14] On February 26, 1834, *La Caricature* published a Grandville print which showed pear trees being watered with blood and surrounded by stacks of corpses. *Le Charivari* twice published typographic pears on its front page to protest government repression (fig. 40), and when *La Caricature* was forced to close by the reimposition of censorship of caricature in 1835, its final issue of August 27 published the text of the relevant portion of the new law in the form of a pear, with the legend "Other fruits of the July Revolution."

The pear quickly became a ubiquitous symbol of popular imagery, literature, and graffiti which was scrawled all over the walls of Paris (fig. 38) (in

Figure 38. La Caricature's *constant depiction of King Louis-Philippe as a pear greatly discredited the monarch and made* la poire *a ubiquitous element in street graffiti.* Top: *In* La Caricature *of January 17, 1833, street urchins are shown drawing pear graffiti, while being told by the woman on the left to "make your filth elsewhere, rascals!"* Bottom: *This drawing, from* La Caricature *of December 28, 1833, depicts French liberty constrained by a pear ball and chain.*

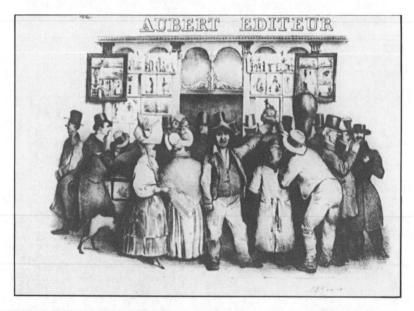

Figure 39. Top: La Caricature *editor Charles Philipon was acquitted on January 28, 1833, upon being prosecuted for this drawing, which appeared in* La Caricature *on June 7, 1832. It depicted a gigantic pear statue, obviously representing King Louis-Philippe, on the Place de la Concorde, with the inscription: "The* expiapoire *[expiatoire, "expiatory," and* poire, *"pear"] monument is raised on the site of the Revolution, exactly where Louis XVI was guillotined."* Bottom: *Published in* La Caricature *of December 22, 1831, this drawing was seized but apparently never prosecuted. It depicts a crowd gathered before the print shop of Aubert, Philipon's printer, examining caricatures of King Louis-Philippe. The center figure, facing the reader, is saying, "You have to admit the head of government looks awfully funny."*

Figure 40. Le Charivari *and* La Caricature *used typographical pears on several occasions to express their disdain for the regime's repression. Left and center: These "pears" appeared in* Le Charivari *of February 27, 1834, and May 1, 1835, to protest, respectively, a jail term and fine imposed on* Le Charivari, *and a police ordinance restricting the distribution of satirical pamphlets. Right: This pear, which is headed "Other Fruits of the July Revolution," was published in the final, August 27, 1835, issue of* La Caricature, *which voluntarily closed down as a result of the censorship of drawings about to be imposed by the September Laws. The text of the pear is that of the impending censorship provision.*

one drawing published in *La Caricature,* an urchin is shown drawing the pear on the king's back). In one *La Caricature* article published in 1832, entitled "The Invasion of the Pear" (*L'Envahissement de la poire*), a journalist reported that the mayor of Auxerre, a town one hundred miles from Paris, had added to the post-no-bills sign, "nor any pears." Philipon boasted in *La Caricature* of January 31, 1833, that "the pear has taken domicile on all our walls, on all the facades," while the English writer Thackeray later wrote that everyone who visited Paris during the 1830s "must recollect the famous 'poire' which was chalked upon all the walls of the city and which bore so ludicrous a resemblance to Louis-Philippe." Similarly, German journalist and poet Heinrich Heine wrote in 1832 that Paris was festooned with "hundreds of caricatures" hanging "everywhere" featuring the pear as the "permanent standing joke of the people," that "the pear, and always the pear, is to be seen in every caricature" and that "the glory from [the king's] head hath passed away and all men see in it is but a pear." Baudelaire recalled in 1857 that the "tyrannical and accursed pear became the focus for the whole pack of [opposition] patriotic bloodhounds." One Frenchman, Sebastien Peytel, even wrote a book in 1832, entitled *Physiology of the Pear,* which amounted to a grand collection of all puns and other variations on the pear theme (Peytel was executed in 1839 for murdering two people, including his wife, but it was widely believed that the harshness of the penalty resulted from his book).[15]

The pear even entered popular literature. In Stendhal's *Lucien Leuwen,* completed in 1837, a conservative general stationed in Nancy complains that his officers "all subscribe to the *National* and the *Charivari,* all the filthy sheets," and that "all the young men of this town" are "rabid republicans," who, if he glances at them, "hold up a pear, or some other seditious emblem. Even schoolboys display pears for my benefit." Hugo's *Les Miserables* contains an unlikely although endlessly repeated (and usually unattributed) anecdote in which Louis-Philippe comes across a young boy "stretching upon tiptoe to make a charcoal sketch of a gigantic pear" on the gateway of the king's palace at Neuilly, whereupon the king "helped the boy, completed the pear, and gave the youngster a gold louis [coin], saying, 'The pear [i.e., the king's portrait] is on that too.'" Although the pear was devoured by the September Laws of 1835, it survived Louis-Philippe and entered French history as one of the dominant images of his reign. Baudelaire, in his recollection of the period, declared that "it is the olympian and pyramidal Pear, of litigious memory, that dominates and crowns the whole fantastic epic."[16]

As the inventor of the pear and director of the war of caricatures against Louis-Philippe, Philipon suffered most severely from the government's repressive reprisals. These measures began almost immediately after the ap-

pointment of the Casimir Périer ministry in March 1831, which signaled a clear decision by the king to back the repressively oriented faction known as the Party of Resistance over the desires of the Party of Movement faction to support social reform. Between March 1831 and the passage of the September 1835 laws which led to its closure, *La Caricature* reported twenty-eight seizures of its issues and of separate prints published by Philipon's printer, Aubert, of which all but a handful occurred in the fifteen months between March 1831 and June 1832. It is impossible to precisely determine the targets of every seizure, because *La Caricature* did not report them all in detail. Not all concerned drawings, as in at least two instances the seizures were provoked by articles published in *La Caricature*. However, based on reports in *La Caricature,* it can be established that at least seventeen caricatures were among the targets of these twenty-eight seizures (in a few cases, a single seizure of *La Caricature* resulted from two caricatures published in the same issue), of which at least five were published by Aubert but not printed in *La Caricature*.

Accounts in *La Caricature* and in *La Gazette des Tribunaux,* a newspaper which reported all significant press trials, indicate these twenty-eight seizures led to only nine prosecutions, as the government did not press charges in most instances. As editor of *La Caricature,* Philipon was personally prosecuted, always for caricatures, in six of these cases, and was acquitted four times (once on appeal from an original conviction); *La Caricature* reported on May 24, 1832, that after one acquittal a juror even signed up for a subscription. Philipon was convicted twice, on November 14, 1831, and on March 7, 1832, receiving sentences in each instance of six months in jail and a two thousand–franc fine. In addition to the caricature trials, Philipon was convicted on June 8, 1832, of failing to pay the security deposit required of all political newspapers (Philipon maintained *La Caricature* was a satirical journal and had no political program), and was sentenced to one month in jail and a two hundred–franc fine for this offense. He was as a result incarcerated for thirteen consecutive months in 1832 and early 1833.

Even Philipon could not keep track of the mounting repression, later writing that, "I could no longer count the seizures, the arrest warrants, the trials, the struggles, the wounds, the attacks and the harassments of all types, any more than could a [carriage] voyager count the jolts of his trip." An examination of *La Caricature* clearly confirms this statement. Thus, the issue of June 14, 1832, reports the twenty-third seizure, yet two months later the seizure of the August 9 issue was reported as the twenty-first confiscation; subsequently *La Caricature* reported the correct count was twenty-two seizures! Philipon repeatedly complained in *La Caricature* about the heavy burden of prosecutions and penalties and asked for help from his readers,

who voluntarily contributed at least two thousand francs to defray fines between December 1831 and May 1832. Thus, on July 26, 1832, he bitterly referred to the "twenty seizures, six prosecutions, three convictions, over 6,000 francs in fines [a figure apparently including fines assessed on other staff members and assessed court costs], 13 months of prison, persecutions" and other forms of harassment, "all in the space of a year" as an "incontestable proof of the profound hatred of the regime for us." Philipon's biographer declares that the harassment was so great that "the days he spent in prison were his calmest days." The impact of the fines was unquestionably enormous, since with only about 1,000 subscribers and a subscription price of 52 francs a year, the fines alone wiped out the equivalent of almost 10 percent of a year's total income and added considerably to the annual production costs of 40,000 francs required to publish *La Caricature*.[17]

La Caricature and *La Gazette des Tribunaux* reported on a number of the prosecutions against Philipon in great detail, making it possible to reconstruct most of his trials. The first prosecutions brought against him, tried on May 23 and November 14, 1831, were for two similar caricatures which he drew himself, the "Soap Bubbles" print separately published by La Maison Aubert in February and a caricature entitled "Replastering" published in *La Caricature* on June 30, 1831 (fig. 41; another *La Caricature* drawing from the same issue was also cited in the second prosecution but the focus of the trial was almost entirely on "Replastering"). Both prosecuted prints had the same message: that Louis-Philippe had betrayed the promises of the July Revolution. In "Soap Bubbles," a man unmistakably resembling the king was shown blowing bubbles (destined, of course, to explode) with labels such as "freedom of the press" and "popular elections," while in "Replastering" the king was portrayed as a mason effacing from a wall the promises of July. The mason's trough of plaster was labeled "Dupinade," a reference to Dupin, a popular vaudeville character noted for the disastrous results of his good-natured bumbling.

In both of these trials, Philipon was charged with injury to the person of the king, in violation of the press law of November 29, 1830. Philipon's defense, made by himself and his lawyer, Etienne Blanc, was similar in each case, and consisted of three arguments: (1) that the regime was grossly overreacting to drawings which provided a harmless outlet for discontent less threatening than other forms of expression; (2) that the caricatures spoke a truth which Philipon was entitled to say under the constitutional charter by drawings as well as words and which had been said in print without similar reprisals; and (3) that the king himself was not personally depicted or attacked in the caricatures, which lacked any royal insignia or regalia, but rather only used his resemblance to symbolically represent the government

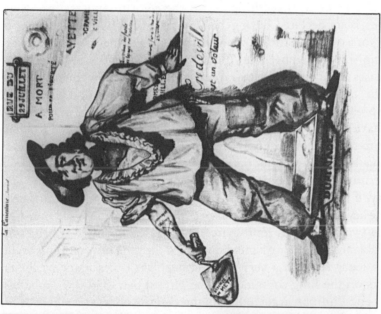

Figure 41. La Caricature editor Charles Philipon was twice convicted for publishing drawings and on both occasions was sentenced to six months in jail and fined two thousand francs. Right: One of these convictions was on November 14, 1831, for offense to the king, occasioned by this print published in La Caricature on June 30, 1831. King Louis-Philippe is portrayed as a mason who is effacing the promises of the July Revolution. Left: Just five months earlier, on May 23, 1831, Philipon was acquitted on the same charges for a caricature of the king separately printed by Aubert in February 1831, which had the identical theme: the promises of the July Revolution, like "liberty of the press," are destined to last only as long as soap bubbles.

in a form which would be widely recognized. With regard to the first point, Blanc told the court in May 1831 that the government's charge was a "severe accusation addressed to a frivolous satire" and suggested that the laughter it provoked might even divert discontent from more dangerous channels. "Better the sketches of Philipon than periodic upheavals," he argued, and asked the jury to respond to the indictment by saying, "I laughed, thus I was disarmed" and to "let Philipon return to his crayons." With regard to the second argument, that Philipon had the right to express his views with images, Blanc declared, during the May trial, that Philipon's philosophy was that "for a man who thinks, mute suffering is a crime, or at least cowardice." During the November trial, Blanc declared that the argument that the promises of July had been betrayed had been said many times by print journalists "in terms one thousand times more energetic and never have they been prosecuted for it." Philipon himself declared in May, "It is a fact: Promises have not been kept; hopes have not been realized. I said it. I have the right to say it." He declared that the government's argument amounted to stating that "if the charter permits one to write one's opinion, it does not at all permit one to lithograph them. . . . I truly hope the charter will be a reality; if I didn't believe it, I would do something else than caricature."

The key argument in both trials was that the depictions of Louis-Philippe in the two caricatures represented only the government via the symbolic resemblance of the king but did not attack the king himself. This argument, which today reads as a very strained one, was necessitated by the ban on attacks on the king contained in the November 1830 law. In both trials, Blanc and Philipon argued that, in the absence of royal insignia or regalia, the caricatures could not be said to attack the person of the monarch. Otherwise, Philipon declared during the May trial, echoing the argument made by Blanc during the trial of *La Silhouette* in June 1830, every "grotesque, satiric or offensive image" would have to be brought to trial for a grave debate to determine if it was the king's "nose, his mouth, his eyes which one ridicules." During the November trial, Philipon first introduced his famous depiction of the king as a pear to make this point. First drawing a face similar to the king's, he drew three more sketches, in which the first drawing slowly was transformed into a pear, to make the argument that if all drawings simply resembling the king could be prosecuted, then soon:

> You would sentence a man to two years in jail because he created a pear which demonstrates a certain similarity with the king! In this case you would have to convict all caricatures which depict a head which is narrow at the top and broad at the bottom! In this case, I can promise you will have more than enough to do, as the malice of artists will find a great amount of pleasure in demonstrating this

proportion in any variety of bizarre circumstances. Then see how you will have raised the royal dignity! See what reasonable limits you will have placed on liberty of the crayon, a liberty as sacred as all the others, because it supports thousands of artists and printers, a liberty which is my right and which you cannot deprive me of, even if I was the only one to use it.

The May trial ended in an acquittal for Philipon, although the "Soap Bubbles" lithographic stone was ordered destroyed. However, in November, Philipon was convicted and sentenced to six months in jail and a fine of two thousand francs. In reporting the sentence in its issue of November 17, 1831, *La Caricature* sneered, "That's a little costly for a cheap government." Philipon's forecast that pears would soon be persecuted soon came true; *La Caricature*'s November 24 issue, which reproduced his courtroom sketch of the king's head being transformed into a pear, was seized by the authorities (fig. 42).

Few new arguments emerged in Philipon's subsequent trials for the publication of caricatures. He was next prosecuted for such an offense on January 31, 1831, in connection with a caricature by Traviès, entitled "Liberated People," which had been published in *La Caricature* on October 27, 1831. The drawing depicted the French people as impoverished and crushed under the burden of governmental taxes, repression, and corruption. Philipon was acquitted of the charge of inciting scorn and hatred for the government, perhaps because the jury was sympathetic to the fact that he was already in jail at the time of the trial, especially since when he appeared in court he complained that he was suffering from an illness that threatened the loss of his vision. He declared that the caricature only presented the truth as he saw it and attributed the prosecution to the alleged recent vow of an unnamed "man of power," that *La Caricature* would be destroyed within a month. Complaining that he was being prosecuted under a law which "likens authors to robbers caught in *flagrante delicto*," Philipon said another conviction "would ruin me and kill me." However, he was again convicted and sentenced to another six months in jail and an additional fine of two thousand francs on March 7, 1832, for offense to the king and to a member of the royal family in connection with two rather anodyne lithographs published in *La Caricature* on Janury 12, 1832. One of these caricatures depicted a figure resembling the king adding an enormous sack representing royal expenses to the back of a Frenchman already crushed by a heavy load of taxes and other burdens. The other was a parody of a coat of arms (featuring, for example, a rocking horse, cardboard castles and paper hats and chickens) entitled, "The Arms of the *Grand Poulet*," a derisory term meaning "fat little chicken" which was widely applied to the king's son and heir, the duc

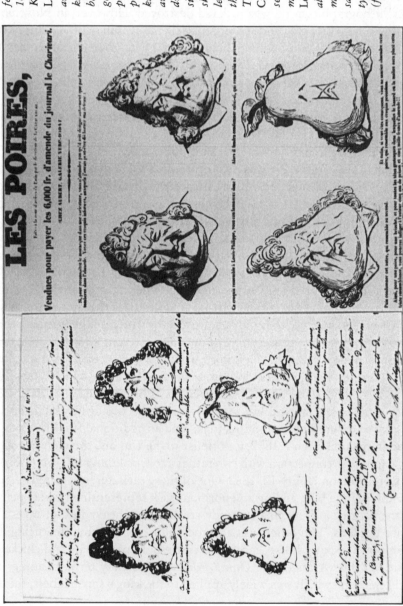

Figure 42. While unsuccessfully defending himself on November 14, 1831, for a caricature alleged to injure King Louis-Philippe (fig. 41, right), La Caricature editor Charles Philipon argued that he had not depicted the king's person but only his resemblance, as a means of symbolically targeting the regime in a form which people could recognize. Left: If every portrait with a resemblance to the king could be prosecuted, Philipon argued in court, then eventually even a drawing of a pear would be liable, since, as he demonstrated with four sketches, if the drawing at the upper left could be prosecuted, then so could the other three, which resemble it. These drawings were reproduced in La Caricature of November 24, 1831 (and seized by the government). Right: A more refined version was published in Le Charivari of January 17, 1834, and also sold separately as a poster to raise money to help Le Charivari pay the same fine that was protested in the typographic pear of February 27, 1834 (fig. 40, left).

d'Orléans. On May 21, 1832, Philipon was tried again in connection with this same issue of *La Caricature,* as it was alleged that copies had been mailed to subscribers after it had already been condemned. He was acquitted after claiming that the copies had been sent by mistake by a staff member acting without his instructions, as he had been in jail at the time; his lawyer argued that in any case Philipon could not be convicted twice for the same offense.[18]

Philipon's last trial came on January 28, 1833, in connection with his "pear monument" drawing (fig. 39), which had been published by *La Caricature* on June 7, 1832, together with accompanying text that suggested it would be a fitting memorial to a king who was a "pacific Napoleon" and a "moral Louis XIV" whose "inexhaustible kindness" had granted him "13 months free lodging in one of the royal castles [Sainte-Pelagie Prison]." The drawing had appeared at a time when Paris was under a state of seige due to antigovernment disturbances, suppressed at the cost of about one hundred fifty killed and five hundred wounded, associated with the funeral of General Lamarque, a Napoleonic hero. Philipon was acquitted after he was able to prove in court that he had sent instructions to *La Caricature* from Dr. Pinel's mental hospital not to print the drawing, given the tense political situation, but that his courier had been arrested and unable to deliver the message.[19]

The last trial of *La Caricature* (in which Philipon was not personally charged, apparently for technical reasons) came on April 4, 1834, in connection with its issue of February 13, which contained two of the most brutal caricatures it had ever published attacking the king (fig. 43). One showed a figure resembling Louis-Philippe fleeing, knife in hand, after murdering a woman representing French liberty; it was a protest against a new law regulating street sales of newspapers and prints. The other suggested the king's shadowy hand was somehow involved in a recent duel in which a legislator had been killed. *La Caricature*'s lawyer made the usual argument that the depictions did not represent the king, but rather "the system materialized," an argument apparently accepted by the jury, which returned an acquittal.[20] In reporting this verdict on April 10, 1834, Philipon virtually crowed in delight. Commenting on the charge of offense to the king, he declared, "How terrible! As if *La Caricature* ever occupied itself with such personalities. I beg you! Would *La Caricature* permit itself such tasteless jokes, such improprieties vis-à-vis its king? Shame! She shudders with indignation at the thought!"

In this final trial of *La Caricature* and in a number of other cases, Philipon's associates were prosecuted in addition to or instead of him. Daumier spent five months in jail and was fined five hundred francs for "provoking hatred and contempt against the government of the King and for offenses against the person of the King" as a result of his lithograph, "Gargantua" (pub-

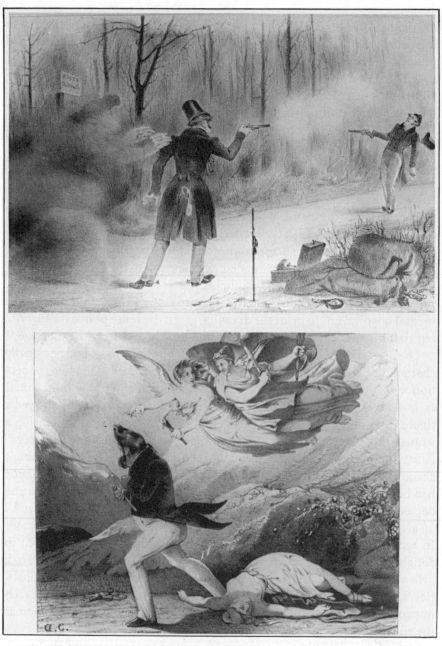

Figure 43. La Caricature was prosecuted but acquitted for two of its most audacious draw-ings, which were published in the issue of February 13, 1834. Top: This caricature implies that the king, suggested in the shadowy figure at the left, was somehow involved in the recent death of a legislator in a duel. Bottom: Another drawing portrays King Louis-Philippe fleeing, knife in hand, after having assassinated French liberty.

lished by Aubert's company as a separate print in December 1831), which depicted a bloated King Louis-Philippe seated on a toilet throne, consuming food and tribute being supplied by the poor people of France and excreting honors and gifts to his aristocratic supporters (fig. 44). In *La Caricature* of December 29, 1831, Philipon sarcastically denied that Daumier had portrayed the King in his drawing, since "far from presenting the air of frankness, liberality and nobility which so eminently distinguishes Louis-Philippe from all other living kings. . . . Mr. Gargantua has a repulsive face and an air of voracity that makes the coins shiver in his pocket." *La Caricature*'s publisher, Aubert, was prosecuted eight times between 1831 and 1834, and the paper's lithographic printer, Delaporte, was tried four times in 1831–32, before apparently deciding to switch to safer printing jobs (both were convicted only once, for their role in publishing Daumier's "Gargantua," but although they were each sentenced to six-month jail terms and five hundred francs in fines, apparently only the fines were enforced).[21]

Between March 1833 and July 1835, staff members of *Le Charivari* were prosecuted in six different instances, leading to five convictions and sentences totaling seventeen months in jail and fines of 18,500 francs. The fines imposed a heavy burden on a journal which was already in financially precarious straits, as it cost 120,000 francs to publish annually and obtained less than 100,000 in francs in revenues, from about 1,500 subscriptions at 60 francs a year. Philipon was never prosecuted in the *Charivari* trials, as others officially served as the responsible editors, and in every case the formal charge involved a published article rather than a caricature. However, in the case of the infamous "red issue" of July 27, 1835, discussed below, a drawing was clearly a major reason for the prosecution. To help pay the costs of a large fine imposed on December 9, 1833, *Le Charivari* published in its issue of January 17, 1834, a reproduction of Philipon's infamous November 1831 court-produced pear sketch and announced that poster-size versions were for sale at La Maison Aubert (fig. 42).[22]

Although Daumier and Philipon were the only caricaturists associated with *La Caricature* and *Le Charivari* to be prosecuted and jailed during the 1830–35 period, others were affected by the repression. Thus, Traviès, best known for his drawings of the hunchback dwarf Mayeux, drew at least two caricatures inspired by Philipon which led to seizures of *La Caricature*. Aside from the October 27, 1831, "Liberated People" sketch discussed above, the authorities also seized *La Caricature* of December 22, 1831 (fig. 39), because contained Traviès's print, "You must admit the head of government has a funny head," which depicted a crowd examining caricatures ridiculing Louis-Philippe displayed at Aubert's print shop (no prosecution was ever brought, however). The most prolific and well-known caricaturist in Philipon's sta-

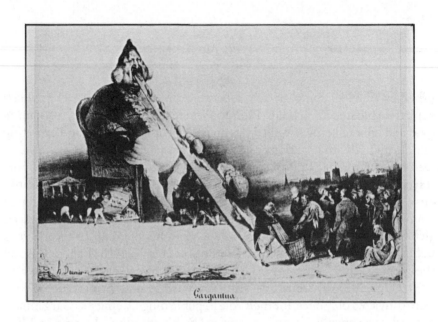

Gargantua

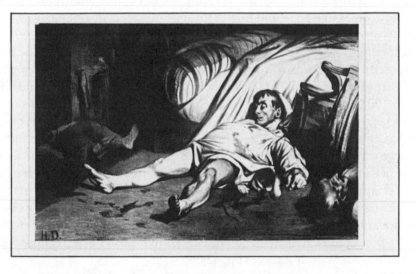

H.D.

Figure 44. Two of Honoré Daumier's most famous lithographs attracted the anger of the regime of Louis-Philippe. Top: Daumier was sentenced to six months in jail and fined five hundred francs for this caricature, separately printed by Aubert in December 1831. It portrays the king on a toilet throne, consuming tribute from the poor people of France, on the right, and excreting graft and boodle to his aristocratic supporters on the left. Bottom: This drawing, "Rue Transnonain," one of Daumier's masterpieces, was seized by the government, but never prosecuted, after it appeared in October 1834 as a separate print in the "Association Mensuelle" series. It depicts the aftermath of a brutal government massacre in a house on La Rue Transnonain in Paris, where about a dozen civilians had been slaughtered in April 1834, during the course of the government's suppression of an uprising. ("Rue Transnonain, Le 15 Avril 1834," courtesy of the National Gallery of Art, Rosenwald Collections.)

ble, at least until 1834, was Grandville, whose contemporary fame far exceeded Daumier's and who one anonymous poet saluted as the "king of caricature" in an "Ode to Grandville" published in *La Caricature* of April 12, 1832. One of Grandville's caricatures led to a seizure of *La Caricature* which was never followed up with a prosecution. Entitled "Power Uses Men," it appeared on August 9, 1832, and depicted Louis-Philippe as a knife-grinder, sharpening a man's head on a grindstone surrounded by discarded bodies (fig. 45).

Another of Grandville's caricatures led to a police raid on his house from which the artist barely escaped bodily harm. During the week of September 25, 1831, Aubert separately published two prints by Grandville (fig. 46): one, entitled "Order Reigns in Warsaw," attacked Russia's brutal suppression of the Polish revolution of 1830; the other, captioned "Public Order Reigns Also in Paris," depicted the bloody police reprisals taken in France against demonstrators protesting Russia's actions and what was viewed as Louis-Philippe's feeble and callous response to Poland's plight (Foreign Minister Horace Sebastiani had characterized the situation in Warsaw with the words used as Grandville's title for the print on Poland). The Grandville prints apparently had a great impact; they can be seen among the prints displayed in Traviès's "funny head" drawing of December 22, 1831 (fig. 39), and were recalled forty years later in the memoirs of French writer Charles Blanc, who wrote of Grandville, "I remember the incredible sensation produced by one of his caricatures that depicted a policeman wiping his sword, red with blood, and saying: order also prevails in Paris." Although no prosecution resulted from this print, some policemen took a decidedly dim view of it and illegally raided Grandville's apartment. According to an account published in 1853, they were only dissuaded from assaulting the artist by a neighbor, who with a lawbook in one hand and two pistols in the other, convinced the police that "they had no right to take the law into their own hands and to violate a private domicile." Grandville's response to this affair was to publish another print (under a pseudonym) entitled "Oh the villainous *mouches* [both "flies" and "spies"]." It portrayed an artist in his studio being threatened by a swarm of flies dressed in the same police uniform depicted in "Public Order Reigns Also in Paris," a copy of which was dimly suggested hanging in the artist's studio.[23]

Philipon and those associated with him were by no means the only targets of prosecutions directed against political caricature during the early July Monarchy. Between August 1831 and January 1833, at least ten other prosecutions were brought against a total of about thirty print merchants for selling politically offensive caricatures (most of which depicted members of the deposed Bourbon royal family). However, convictions were obtained in

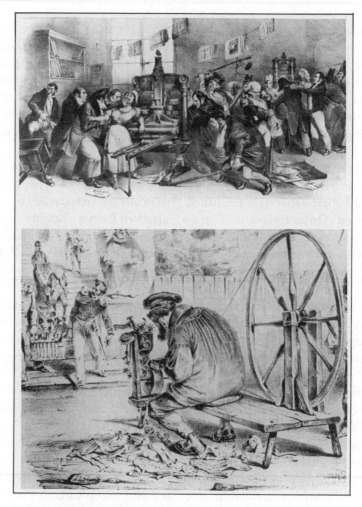

Figure 45. The abuse of power by the government of Louis-Philippe was a common theme in Grandville's caricatures during the 1830–35 period. Top: *In a drawing separately published in November 1833, in the "Association Mensuelle" series, Grandville portrays top government officials destroying the presses of an opposition printer. The king is shown shutting the mouth of the woman printer who represents French liberty, at center left, while Interior Minister d'Argout wields his scissors at the extreme left. The newspaper hanging in the middle at the top right is* La Caricature, *which features a pear on its cover; hanging above the press is a copy of* La Charivari. Bottom: *This drawing, published in* La Caricature *of August 9, 1832, was seized but apparently never prosecuted. Entitled "Power Uses Men," it portrays Louis-Philippe as a knife grinder, sharpening a man's head on a grindstone surrounded by discarded bodies, while fresh "raw material" is arriving on the left.*

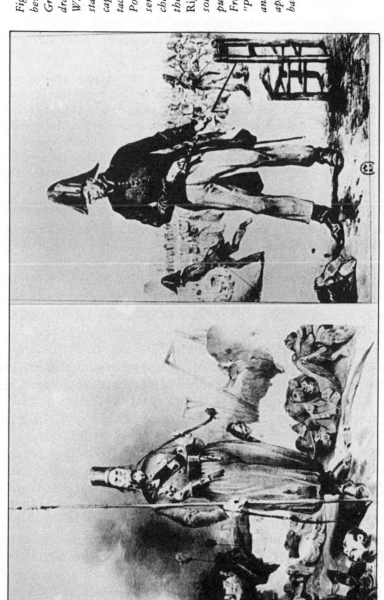

Figure 46. In September 1831, Aubert's print shop published two Grandville caricatures. Left: This drawing, entitled "Order Reigns in Warsaw," depicts a Russian soldier standing amidst broken bodies and decapitated heads. The print was an attack on the Russian suppression of the Polish Revolution of 1830 and the insensitivity of a French official who characterized the Polish situation in the words used to caption the print. Right: Grandville showed a French soldier wiping his sword of blood after putting down protests in Paris against French foreign policy. It is captioned, "Public Order Reigns Also in Paris," and led to a police raid on Grandville's apartment from which the artist barely escaped injury.

only three of these cases, two of which led to fines of one thousand francs, and the other to a fine of one hundred francs and a jail term of six months for a Parisian print seller named Collette, who was convicted on January 29, 1833, of selling a lithograph offensive to Louis-Philippe and his family. In one of the cases leading to an acquittal, lawyer Etienne Blanc (who often defended Philipon) declared, in response to the government complaint that Bourbonist lithographs were published with the "intent" to disturb the public peace, that his client, the print merchant Fonrouge, had no such purpose:

> One must distinguish between the citizen and the businessman. It is as a merchant that Fonrouge appears here. Ask him if he likes better [the Bourbon pretender] Henry V or Louis-Philippe, he will respond that he likes better the engravings which sell well. . . . When you ask him what was the intent of the images, the answer will be "to be sold" and nothing more. Leave these images in peace. They are always innocent and will no more facilitate the return of the fallen dynasty than prosecutions could prevent it. It is an industry. Let it be free.

In another of at least three cases involving Fonrouge, the print seller was acquitted after arguing that the prints involved had been seized from his bedroom and had not been among the "200,000 prints of all types" available for sale in his shop. In a sly allusion to the intense police surveillance of print merchants, which drew appreciative laughter in the courtroom, he declared that the authorities knew that prints kept in his private quarters were not for sale "because the police commissioner has often paid me the honor of such visits."[24]

Aside from incessant prosecutions and seizures, Louis-Philippe's government further harassed caricature in 1834 by requiring all hawkers of newspapers and prints to obtain government authorization before selling their wares in the streets, and subjecting every separately sold print to a stamp duty, with a government stamp affixed to the face of the print. The hawkers law, which was promulgated on February 17, 1834, was justified by the regime on grounds of the special danger that sales of images and writings in the public streets posed by stirring up the poor (who could not afford to purchase annual subscriptions to periodicals and thus relied upon buying them from hawkers, who often attracted working class crowds with their oral pitches for their goods). In introducing the bill in the Chamber of Deputies on January 24, 1834, Minister of Justice Felix Barthe justified it as a necessary measure to foil the efforts of those "factions" which especially sought to "corrupt that useful part of the population which lives by working with its hands" and to lead astray those "most easily exposed to the seduction of sophisms" by selling in the streets "shameful" materials

which "address the worst passions" and show no respect for "the laws, the constitution, the king." Supporting the bill on behalf of a legislative committee, Deputy [and soon-to-be Minister of Justice] Jean-Charles Persil similarly declared that the law was intended to put an end to those who "especially address the working class" by peddling printed matter which "destroys in them all affectionate feeling toward the royal power." Persil denied that the bill amounted to censorship, since the hawker, not his materials, had to gain authorization, but he declared it "most reasonable" that the measure would "force the hawker to censor himself, for fear of not obtaining authorization or losing it if he has it already." Only a week after the hawker bill was promulgated, the government showed that it meant business: police armed with clubs brutally attacked a gathering in Paris on February 23, 1834, during which anti-government prints were being distributed, trampling women and children and clubbing bystanders.[25]

The 1834 print stamp tax was introduced as an administrative regulation, via a dubious interpretation of the December 14, 1830 law, which had clearly intended to require only newspapers to display the tax stamp. The stamp severely defaced prints and thus largely torpedoed a scheme by which Philipon had hoped to raise money to pay his legal expenses with a sort of print-of-the-month club, established in 1832, known as L'Association Mensuelle. The government had already seized several of these prints, which often attacked various forms of governmental repression, such as a caricature by Denis Raffet entitled "Analysis of Thought," portraying government bureaucrats scrutinizing publications with a microscope and other devices, and Grandville's "Descent into the Workshops of Press Freedom" depicting governmental officials raiding and destroying a print shop (fig. 45), which was producing, among other items, *La Caricature* and *Le Charivari*. Daumier contributed several of his masterpieces to this series, including his "Hands Off the Press!" lithograph of March 1834. The last of the twenty-four prints in this series published between 1832 and 1834 was perhaps his greatest masterpiece, "La Rue Transnonain," published in October 1834 (fig. 44). It depicted the aftermath of a massacre which had occurred six months previously, in which government troops slaughtered about a dozen civilians inhabiting a house in Paris from which snipers had allegedly fired during an uprising. When the print was displayed at Aubert's, huge crowds gathered to admire it; government agents soon seized the stone (as they had earlier done with "Gargantua") and all available prints, with the result that today it is a prized collector's item.[26]

In addition to prosecuting and harassing political caricature, the government of Louis-Philippe also displayed its appreciation of the power of the genre by adopting the sincerest form of flattery—imitation. In 1832, a con-

servative caricature journal, *La Charge,* was founded under government inspiration in an attempt to combat *La Caricature.* Although *La Charge* pledged in its prospectus of October 1832, to criticize the regime when it made errors, the journal clearly indicated its basic orientation by justifying the creation of a new caricature journal on the grounds that existing caricature outlets had created a "lacuna" by "only attacking, politically speaking, the king and his ministry." Such an approach was "incomplete," *La Charge* argued, since "the angry claims by the factions which trouble the state," such as the republican and Bourbonist opposition, "loan themselves well, also, sometimes to satire. . . . Aren't they equally worthy of attracting the picturesque verve of our illustrators?" In one of its first issues, published on October 21, 1832, *La Charge* declared that while good caricature was praiseworthy, such required "wit, talent, accuracy, but also justice"; it declared, "Of what importance is all the wit in the world, if it is used for an unworthy purpose? Or rather, it matters greatly, because in that case it is the worst thing which exists under the sky." *La Charge* showed its editorial orientation even more clearly in an attack on opposition journalists published on May 19, 1833: "There is running throughout Paris an epidemic disease against which they have forgotten to establish sanitary precautions. . . . This epidemic is called journalism. . . . Periodicals pustulate; it is a regular pest; the air is impregnated with them. Soon each inhabitant of Paris will put out his own paper." *La Charge* published on a weekly basis for only slightly over a year (from October 1832 until February 1834). It resembled *La Caricature* in format, with each issue including one caricature which often depicted republican politicians in grotesque ways and seems to have always come from the same anonymous artist. It attracted little attention and vanished almost without leaving a trace. Historian Georges Vicaire has commented that "its chief merit is that it is extremely rare and is difficult to find a complete collection of it."[27]

The excuse that the French government was seeking to end opposition political caricature altogether presented itself on July 28, 1835, the fifth anniversary of the July Revolution that brought Louis-Philippe to power. On that date a gruesome attempt on the king's life by a Corsican radical named Giuseppe Fieschi, using a battery of guns which became known as the "infernal machine," miscarried, leaving the king only slightly bruised but forty other people killed or wounded. *La Caricature* and *Le Charivari* had the unfortunate timing to joke about assassination of the king shortly before the Fieschi affair, as in a report in *Le Charivari* on July 26, that the king had just returned to Paris "with his superb family, without being in any way assassinated." The next day, one day before the Fieschi attack, *Le Charivari* celebrated the anniverary of the July Revolution by printing a special issue in red

ink (which quickly became notorious as the "red number"), which was entirely composed of accounts published in other newspapers over the past five years of incidents such as the suppression of the Lamarque funeral uprising, the Rue Transnonain massacre, and other disorders, in which troops and police had killed over five hundred people and wounded or arrested thousands more. These accounts were collected under a title reading, "Monarchical catacombs," and described as a "small mortuary table of the subjects of his majesty who have perished as victims of public order, . . . serving as notes for the history of the pacifying system under which we have the honor to die." The issue also included, in red ink, a caricature depicting a vaguely human figure, clearly intended to represent Louis-Philippe, walking through a mass of cadavers and parts of bodies, above the legend, "Personification of the most sweet and humane system." The issue was immediately seized by the authorities.

Just as the assassination of the duc de Berry in 1820 had provided an excuse for a crackdown on the press and the introduction of censorship of caricature, the Fieschi attempt became the justification for similar developments in 1835. On August 4, barely a week after the attempt, the government introduced at an emergency session of both legislative chambers new press laws which the liberal author and statesman Alphonse de Lamartine termed a "law of iron, a reign of terror for ideas."[28] The proposal greatly expanded the number of press crimes (it became illegal, for example, even to advocate republicanism or a return of the Bourbon dynasty), increased penalties and speeded up trials for press offenses, greatly increased the security deposit required of newspapers and reintroduced prior censorship of caricature (as well as of the theater, which had also been abolished in 1830).

Le Charivari and *La Caricature,* correctly seeing the caricature censorship provision as aimed squarely at them, provided a blistering running commentary on the proposals as they were considered, passed by both chambers and promulgated on September 9, 1835 (whence they became popularly known as the September Laws). They referred to the proposals as "an insult to public reason," "these monstrous ineptities," "this coup d'état in 100 articles," "the infernal laws," "the savage laws," a law of "pressicide," "the most inequitous, the most vicious, the most oppressive law" of the last thirty years, and "a scandal, an immorality, a shame, an ineffaceable stain."

While reporting the legislative debate in the Chamber of Deputies on the proposed laws, *Le Charivari* termed them "infernal seances," and while commenting on the hasty approval of the proposals by the Chamber of Peers, it declared, "The Peers of France swallow a law as rapidly as they debate a glass of champagne," and thus demonstrated in their "blind and servile" actions that they played "in the political organization, the role that a

wart or boil plays in the organization of the human body."[29] On August 8, *Le Charivari* captioned its attack on the proposals as "Discussion of the law which forbids free discussion," while on August 21, its heading read, "The press will soon be free . . . to die." On August 11, *Le Charivari* declared that the regime sought to kill political caricatures but would fail because although the right to publish could be destroyed, "One cannot erase so easily the mores of the nation. . . . POLITICAL CARICATURE WILL SEE THE DAY DESPITE CENSORSHIP." On August 18, it complained that the Paris police were already seizing from stores and reading rooms caricatures which had never been legally condemned. It asked, if the authorities could legally do this already, "What is the purpose of the infernal laws?" and declared, if they could not, "they have swindled us like in an American treaty [with the Indians]." *La Caricature* also maintained a steady attack on the proposed laws, declaring in its issue of August 20 that given the role of demands for press freedom in bringing about the July Revolution, the proposed laws amounted to a form of "parricide," in which "the July Monarchy will have killed its mother."

The legislative debate on the caricature censorship provision (quoted in full in chap. 1) was extremely bitter in the Chamber of Deputies (it was approved virtually without discussion by the Chamber of Peers). In introducing the measure to the deputies on August 4, Minister of Justice Jean-Charles Persil declared:

> For a long time, public decency has been offended by the spectacle offered in our streets. Obscene engravings, images which shame our morals; caricatures which attack citizens in the sanctuary of their private life, insolent lithographs which bring derision, ridicule and scorn on the person and the authority of the king and his family; . . . all these offenses are witness to the insufficiency of our legislation. . . . We must have recourse to the legislature and demand to put the government in a position to resist this torrent of immorality and sedition.

The floor manager for the bill in the Chamber of Deputies, Paul Sauzet, defended the measure in similar terms on August 18 as designed to place an end to "great scandals" and demanded by the "imperious commands of the necessities of public order." He added:

> For a long time, public opinion has grown indignant at the outbursts which have profaned the art of illustration. Everywhere our streets and our squares offer the degrading spectacle of a mute, living revolt against the established order. Everywhere the most gross outrages against the king, the courts and the laws. The public street has become a danger for family mores. . . . It is necessary to put an

end to these outrages which corrupt the spirit of the population in degrading with impunity the royal majesty.

The duc de Broglie, who served as prime minister and foreign minister, urged support for the measure on the ground that "disgusting obscenities of infamous baseness" were degrading "the most brilliant promenades" of Paris and ruining France's reputation as a "civilized country" proud of the "elegance of its mores, the delicacy of its taste."[30]

Debate focused on whether censorship of drawings violated article seven of the charter, which guaranteed the right to publish "opinions" and promised that censorship could never be imposed. Supporters of the measure maintained that the charter provision only referred to the printed press and that drawings and stage performances were simply not the expression of "opinions" addressed to the mind but rather overt actions which sought to incite behavior by "speaking to the eyes." Thus, Minister of Commerce Charles Duchatel denied that "one can compare drawings and engravings to an opinion published and printed" and declared that imposing censorship on the former would violate the charter "neither in its spirit nor letter."

Opponents of the caricature censorship provision argued that it simply could not be reconciled with the charter. Thus, Eléonor Valaze, while condemning "unworthy" drawings which "soiled" the eyes, said he could nonetheless "not believe" that supporters of the provision would legislatively "change the charter in adopting an article which reintroduces censorship." Similarly, Alexandre Glais-Bizoin said the measure would "annihilate" the charter and change it from guaranteeing that "all Frenchmen have the right to print and publish their opinions" to granting them the right only to "publish the opinions of the ministers and the majority." The chamber voted to halt Glais-Bizoin's lengthy address after he warned that while a return to the Reign of Terror of 1793 was not threatened with regard to human life, "adopt the law which you demand and perhaps one day political thought will find a Robespierre to execute it." Deputy Charles Comte declared, with regard to governmental promises that censorship would be liberal, that "if the Charter had said that in the future the censorship will be liberal I could vote for the article, but it says in the future the censorship can never be reestablished." The debate reached extraordinary intensity when Jules Dufaure declared that existing laws could punish any obscene or seditious images after they were published but that "images are like writings and that which you ask appears to be forbidden by the charter; when it said censorship cannot be reestablished it speaks of the censorship then existing, which affected images as much as writings [in fact, in 1830 only images were subject to censorship]. Read the law: see if the charter banned establishment

of censorship for all means of publication." At this point, Achille Vigier, a supporter of the bill, interjected, "For opinions! [i.e, in his view drawings were not expressions of opinions]" to which Dufaure responded, "For all means of publishing opinions!" Minister of Public Education François Guizot thereupon waved a copy of the "red issue" of *Charivari* and yelled, "See that! Is that an opinion?"

Aside from challenging the constitutionality of the caricature censorship provision, opponents of the measure attempted to limit its effect by amending the proposal to require prior government approval only of public display of drawings but not of their publication or sale and to exclude from censorship nonpolitical matter such as illustrated scientific texts and the designs printed on textiles. However, every attempt to limit the reach of the censors was defeated. Minister of the Interior Adolphe Thiers strongly opposed such limiting measures on the grounds that if, for example, scientific texts were excused from the censorship requirement, "people will use the most innocent emblems, scientific emblems, to make the most scandalous and outrageous caricatures. . . . However innocent are your intentions, they will become in the hands of factions a certain means of making outrage and calumny prevail. . . . Under a scientific appearance, people will hide the most dangerous engravings."

The fact that Thiers and many other supporters of the September Laws, including Persil, had fought for freedom of the press during the Restoration led Glais-Bizoin to bitterly attack those who had abandoned their principles. He told government supporters who complained about being attacked in the press:

> To hear your language the victims [of the September Laws] are sitting where you are; the opposition is a cross for you. Your life is only a long sacrifice. Oh! You are right. You are making the greatest sacrifice that has ever been given to humanity to make; it is the renouncing of all your sentiments, of all your convictions. . . . It is with a profound sadness that we see the chiefs of that opposition of 15 years [under the Restoration] come successively to this tribune to abjure, to anathematize all the principles, all the sentiments which had placed them so high in our esteem.

Despite the heated debate, the caricature censorship provision was approved intact by a voice vote of the Deputies on August 29, after all amendments to it were defeated, and the entire bill was approved by a vote of 226 to 153 on September 1. The censorship provision was approved by voice vote in the House of Peers on September 9, and the entire measure was approved on the same day by that body by a vote of 101 to 20. The "September Laws" were promulgated later on September 9 by King Louis-Philippe, thereby

152

creating what historian J. L. Talmon has termed a change in the scope of allowable political debate so great that it amounted to a "change of regime." Minister of the Interior Thiers dispatched three circulars to his prefects in September and October, 1835, which instructed them on how to interpret the new law. Although during the parliamentary debate Thiers had vigorously opposed any limitation on the reach of the censorship proposal, the thrust of his circulars was to urge the prefects not to seek to enforce literally some provisions of the new law in such a way as to "uselessly trouble commerce." Thus, he informed the prefects that while the new law covered all images "of whatever nature and kind" which were published, displayed, or sold, including those which had been produced before the new law was enacted, there was no need to bring prosecutions against previously published materials, "printers' ornaments" in books or "hand made images, castings, impressions on cloth and wall paper" solely because they had not been submitted to censorship authorities "unless they present one of the crimes forbidden by law" such as "offense to the king" or "attack on good mores." On the other hand, strict enforcement of prior censorship was demanded with regard to all new, mass-produced materials such as engravings, lithographs, prints, or emblems "multiplied by printing."[31]

As the debate on the September Laws proceeded in the legislature, *La Caricature* reported its imminent demise in its issue of August 20, which complained that while the "infernal law mutilates other journals, it clearly kills *La Caricature*." However, the journal declared proudly, it had been "assassinated, not defeated. . . . She [*La Caricature*] has promised you to fight to the end. She has kept her word, succumbing under the weight of censorship." *Le Charivari* prophesied on August 23 that while *La Caricature* "will cease to fight, it will not be killed, because it will always be imperishable in France; it will await better days; it will wait to arm itself again with its crayons which the law strangles and with which it would have strangled the law. Let us hope it will not have to wait a long time." *Le Charivari* would continue, it added, because while *La Caricature*'s heavily political orientation would make "all struggle between it and censorship impossible," for *Le Charivari* "political caricature is only one of the accessories of its grotesque museum." On August 29 it repeated this pledge, declaring, "We will allow *La Caricature* to be devoured by the infernal minotaurs; but we can affirm to our subscribers that they will not swallow *Le Charivari*," although, even while "confining itself exclusively to its literary speciality, it will always fear, even in speaking of theaters and comedians, of [inadvertently or in the eyes of the regime] committing an offense, direct or indirect to the person of the king."

La Caricature's last issue was dated August 27, 1835, although according to *Le Charivari* of September 9, the final *La Caricature* actually appeared only on September 8, after the Chamber of Deputies had passed the September

Laws, but before they were passed in the House of Peers on September 9 and promulgated the same day. *La Caricature*'s spirit remained defiant to the end. As noted above, it published the text of the caricature censorship provision of the laws in the form of a typographic pear (fig. 40); it also issued a final, prophetic denunciation of the September Laws:

> After four years and ten months, *La Caricature* succumbs under a law which reestablishes censorship. . . . To break our crayons it took a law especially made for us, one which makes materially impossible the work which we have continued despite seizures without number, arrests without cause, crushing fines and long jail terms. . . . We have unmasked the comedians of 15 years, all apostates of liberty [a reference to politicians of the July Monarchy who had abandoned their liberal views proclaimed under the Restoration]; we have attached them to the pillory of our journal, we have pitilessly delivered their portrait to the laughter of the people they have exploited. They can today break the signboard which our justice has nailed to their head, but it will not be so easy to efface or eliminate the memory of the stigmata of shame with which we have marked them for five years. From the judgment which our enemies today apply to *La Caricature,* we appeal without fear to the future. . . . We believe we are leaving a book which will be consulted by all those who will write or who will wish to study or know well the first years of the reign of Louis-Philippe. If we are not wrong, if *La Caricature* survives the period it wishes to depict, . . . we can console ourself for the confiscation which steals from us the fruit of so many toils, cares and worries.

In reporting the death of *La Caricature* on September 9, *Le Charivari* declared that its deceased older sister "is proud of having been the first to succumb, . . . to have been there in the frontmost ranks, to draw first upon itself the terrible discharge of the infernal laws. It is a final service which it renders to the cause." *Le Charivari* also quoted from another republican newspaper, *La National,* its final tribute to *La Caricature:* "Philipon, in inspiring the artists who surrounded him, became himself the most ingenious, the most inexhaustible, the most luminous propagator of ideas who has ever acted on any people in speaking to the eyes. They have made this law in part to escape from Philipon and his friends, the illustrators. They suppressed *La Caricature* because they could not fight with it."

CENSORSHIP OF CARICATURE AFTER THE SEPTEMBER LAWS, 1835–48

As in 1820, the imposition of prior censorship of drawings in 1835 drastically changed the nature of French political caricature during the following decade. Although, again as after 1820, caricaturists were still able to make

critical allusions to the general state of political and social affairs, direct and overt criticism of the king and his ministers became impossible, and the pear was consigned to oblivion. Thus, on September 20, 1835, eleven days after the September Laws went into effect, *Le Charivari* (which was continued, even as *La Caricature* ceased publication, and maintained a circulation which grew from 900 to about 3,000 during the 1835–47 period) reported that in a page of small sketches and vignettes, many of animals, the censors had forbidden three small pears in one spot and a sketch of a monkey eating a pear in another. On September 24, the journal bitterly protested that the censors had even forbidden a sketch showing a young woman surrounded with various animals, including a white rabbit, viewed from behind, squatting on its paws underneath a table. *Le Charivari* complained that the ban was apparently imposed on the grounds that the rabbit somewhat resembled, as it put it, "a pear on which one had planted ears." Censorship interference with *Le Charivari* was so intense that shortly after passage of the September Laws it added "censorship permitting" to its masthead slogan announcing it would publish "a new drawing every day." On November 6, 1835, the masthead was changed to read "publishing each week one or several drawings," including lithographic caricatures "when the censor wishes to allow it." *Le Charivari* announced that rather than attempting to replace banned caricatures at the last minute with poor quality substitutes, it would no longer promise a new illustration each day but would instead include additional and more varied textual material. It concluded:

> In short, the question for our subscribers can be translated into these simple terms: To receive a little less lithography, but to receive only interesting prints which leave nothing to be desired artistically; and instead of mediocre drawings and drawings without any purpose to receive, . . . a text more complete, more elegantly printed, in which finally, to the good or bad qualities we have been able to offer until now, we will naturally offer the precious advantage of a greater variety.

Altogether, the censors banned over 430 drawings submitted to it (some of which were later approved with revisions) between the inauguration of the September Laws and their abolition as a result of the February 1848, revolution which overthrew Louis-Philippe. The censors were especially sensitive to any depictions which impugned the legitimacy of the regime, such as those of members of the deposed Bourbon dynasty or of the Bonapartist pretender, Napoleon's nephew Louis Napoleon Bonaparte. They also occasionally struck out more unpredictably, such as with a series of bans imposed in 1842 on drawings portraying a train wreck, and an 1844 ban on a caricature showing English tourists describing France as "today truly a great

nation for petit pâté." While over the thirteen-year period between 1835 and 1847 the average number of drawings rejected annually was about thirty-five, the censorship rate varied considerably, reflecting changes in the general self-confidence felt by the regime. Thus, in the immediate aftermath of the September Laws, betwen 1835 and 1837, an average of about fifty drawings per year were rejected. However, during the period of surface political calm after 1840, as the government felt an increased (although false) sense of security, the rejection rate dropped to about half this level, with an average of only twenty-eight prints censored per year between 1841 and 1847. Even during this period, however, the regime was jumpy enough to ban, in 1843, importation of the British caricature journal *Punch,* due to that journal's critical comments on French foreign and domestic policy (fig. 3). The magazine responded by publishing a cartoon showing its namesake character being turned back by a French customs official, accompanied by a letter from Punch reporting that he had been informed that "it is henceforth not permitted that your blood shall circulate in France." According to Punch, among the sins the French authorities had, correctly, accused him of were questioning "the born right of every Frenchman to carry fire and bloodshed into every country he can get into" and denouncing "what is as dear to every Frenchman as the recollection of his mother's milk, an undying hatred to England and all that's English." Subsequently *Punch* published a hilarious phony letter from Louis-Philippe revoking the ban and declaring it was all the fault of some government "asses" and "numbskulls" who had misinterpreted his orders to ban the entry of "certain poisonous prints into the happy paradise of France" by confounding *Punch,* "my best and dearest friend" with "the enemies of all order, all decency, all truth."[32]

The single highest rate of rejection of domestic caricatures by censors came during the last six months of 1840, with an average of nine prints censored per month, three times the overall rejection rate of three per month during the entire 1835–48 period. This period was an unusually tense one, marked by a Middle Eastern foreign policy crisis that threatened war, an attempted coup d'état by Louis Napoleon Bonaparte, (the Bonapartist pretender who was to later rule as Napoleon III), the inauguration of a campaign for reform of the electoral laws and a major wave of strikes in Paris involving twenty thousand workers, which was suppressed by military intervention and hundreds of arrests.

The 1840 political crisis was clearly reflected not only in the record number of drawings rejected in that year (sixty-four for the entire year, of which fifty-six were banned during the last six months) but in the subjects they depicted. Thus, among the rejected prints were several of Louis Napo-

leon, caricatures apparently viewed as inciting class tensions and drawings perceived as criticizing the regime as too passive in the Middle East crisis. For example, Charlet, an artist who suffered eleven censorship rebuffs in 1840 and who was known for his nationalist appeals to the romantic memories of Napoleon I, had several prints apparently rejected as too critical of the regime's foreign policy. One, originally entitled, "Tremble, enemies of France," a line borrowed from a well-known nationalist song, depicted a soldier and a worker clasping hands, while trampling on a poster bearing the date "1815," a reference to the treaty of that year which signaled the end of the Napoleonic Wars and cost France both territory and prestige (fig. 47). The drawing was approved only after the "1815" was almost obliterated and it was retitled, "To Arms, Citizens! Form Battalions!" a somewhat less specific patriotic appeal borrowed from "La Marseillaise." Another banned drawing of 1840 by Charlet portrayed a peasant warning his reluctant plow horse, "You like to kick? Reform awaits you! And the reform of the slaughterhouse isn't far!" The censors no doubt regarded this as an appeal in support of the electoral reform campaign and even a call to revolution and refused to approve even a toned-down version which continued to use the word *reform* in the caption.[33]

Aside from the banning of specific prints, the September Laws clearly held down the number of caricature journals published during the 1835–47 period, even though during the same period the total newspaper circulation in France rose from 42 million copies to almost 80 million and the number of annual newspaper subscriptions in Paris rose from 70,000 to almost 200,000. With the failure of *La Charge* in 1834 and the closure of *La Caricature* in 1835, *Le Charivari* was left as the only caricature outlet in September 1835. For nine of the next dozen years, it was either the only caricature journal or one of only two or three such periodicals, and none of the total of eight other caricature journals founded between 1836 and 1847 lasted for more than a few years. In contrast, with the abolition of the September Laws in 1848, eight new caricature journals were begun within a single year.[34]

One of the most unusual results of the September Laws was the founding in March 1836 of a French caricature journal in exile, *La Caricature Française*.[35] It was published anonymously (by the Bonapartist intriguer Ida Saint-Elme) in London, in order to escape censorship, at an office it dubbed "The Crowned Pear." This now extremely rare tabloid-sized weekly, which lasted only six months, consisted of four pages of text and included on the title page a woodcut caricature which was often copied from drawings previously published in Philipon's journals (fig. 48). *La Caricature Française*'s inaugural issue declared its purpose was to bring back to life in

TREMBLEZ, ENNEMIS DE LA FRANCE !

Figure 47. During the tense year of 1840, which was marked by a major foreign policy crisis as well as considerable domestic strife, French censors banned a record number of caricatures (sixty-four compared to a yearly average of thirty-five during the 1835–47 period). The most censored artist of 1840 was Charlet, who was well known for his romanticized appeals to the memories of Napoleon and of past French military glory. This Charlet caricature was banned until its title, "Tremble, enemies of France!" was toned down and the "1815" on the map being trampled at the bottom was made virtually unreadable; its appeal to French military action to redress the loss of French prestige and territory in 1815 was regarded as too critical of the foreign policy of Louis-Philippe. (© The Detroit Institute of Arts; gift of Mr. and Mrs. Bernard F. Walker.)

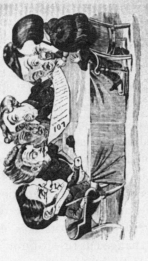

Figure 48. After passage of the 1835 September Laws stifled political caricature in France, La Caricature Française was published in London for a brief period in 1836 as an opposition caricature journal in exile. Its front-page caricatures were often copied from prints which had earlier appeared in Philipon's journals. Left: In the issue of November 5, 1836, the Grandville caricature from Le Charivari of November 8, 1835 (fig. 19, bottom), was copied. Right: The March 1836 issue featured a copy of Daumier's caricature from La Caricature of October 8, 1833, which shows King Louis-Philippe being crushed in a printing press, above the caption, "Ah! So you wish to meddle with the press!!"

England the tradition of French caricature, which had been "gagged and finally killed under the savage laws of intimidation of the fabricants of political opprobrium" in France. It continued:

> Assassinated on its native soil, *La Caricature Française* retakes a free vigor on the banks of the Thames, under the protective law of a monarchy truly constitutional. Knowing how to appreciate the inestimable happiness of a certain asylum, *La Caricature Française* will never leave its domain to even slightly glean on the political field of Great Britain; *La Caricature Française* will only attack assassins, and subjects for ridicule won't be hard to find with a peculiar government [the July Monarchy]—fecund mine, inexhaustible mine of cowardice, bragging, of all possible iniquities. . . . *La Caricature Française* will be nobly repaid for its efforts if it contributes to maintaining the horror and scorn which such a state of things inspires in all Frenchmen worthy of this fine name, if sometimes a ridicule well taken leads to an outburst of native gaiety in the saddened hearts of the politically proscribed.

Another of the few new caricature journals published during the 1835–47 period was *La Caricature Provisoire* ("provisional") (1838–39), founded by Philipon, and which, after he no longer directed it, was retitled *La Caricature, Revue morale, judiciare, littéraire, artistique, fashionable et scénique* (1839–43).[36] The "New Caricature" or "Nonpolitical Caricature," as it became known, published four pages of text and one or two drawings in each issue. Some of its illustrations had previously been published by *Le Charivari,* and many of them were by artists who also worked for *Le Charivari,* including Daumier, Traviès, Gavarni, and Monnier. In fact, the journal apparently was never able to escape from *Le Charivari*'s shadow and was purchased by and merged with the latter journal beginning in January 1844. In the first issue of *La Caricature Provisoire* (November 1, 1838), which was originally published in the Netherlands and only later in France, Philipon declared it would "regather and resume" the campaign previously led by "that young phalange of artists" whose works for the "old *Caricature Politique*" had been crushed only by a "law of censorship, conceived and voted expressly against it." However, he said the journal would use the title "*provisoire*" for several reasons, including because: "by respect for the venerable September Laws, it will provisionally abstain from politics proper (proper here perhaps not being the proper word). But these laws cannot last until the end of the world. One gets tired of everything, even good laws. A day will come, perhaps soon, when the crayon will recover its liberty." In its eleventh issue, of January 13, 1839, the journal referred to itself as "entirely nonpolitical," and although in July 1839 it changed its title to omit "*provisoire*," this

was not because politics could now be treated but because "it is henceforth too sure of living well and for a long time not to proclaim itself definitively."

That Philipon clearly remained acutely aware of the limitations imposed by the September Laws was again apparent when he announced the formation of a new caricature journal, the *Journal pour Rire* (later renamed the *Journal Amusant*) in early 1848. Writing just a few weeks before the revolutionary outburst which ended both the reign of Louis-Philippe and prior censorship of caricature, Philipon declared that the new journal would provide "gaiety always, with as much spirit as possible, but politics never . . . thanks to the September Laws."[37]

The impact of the September Laws was also apparent in the orientation of *L'Illustration, Journal Universel* (1843–1944), a profusely illustrated and highly successful magazine oriented toward the middle classes of the July Monarchy.[38] *L'Illustration* published drawings by most of the well-known caricaturists of the day, including Cham, Grandville, Nadar, and Daumier but is generally not classified as a caricature journal because it scrupulously avoided critical or satirical drawings, instead boasting that it provided simply an accurate "mirror" of the times. By so limiting itself, *L'Illustration* almost entirely avoided the censorship problems that plagued other illustrated journals (indeed, its assiduous "neutrality," which in practice meant it supported whatever government ruled at the time, eventually led to its suppression for collaboration with the Germans after the liberation of Paris in August 1944). In response to criticism of its political "neutrality," *L'Illustration* declared in 1845, in tones which no doubt reflected an acute awareness of the dangers involved in illustrated political comment, that:

> several times demands have been made upon *L'Illustration* that it take part in political struggles. *L'Illustration* will be very careful to avoid responding to this provocation. Outside of questions which directly interest the humanity, morals and national sentiment common to all parties, it wishes to continue to play the role of reporter, which is the only path which can offend no belief and which is able to serve all those who wish to be enlightened. *L'Illustration* is not a political tribune; its sole ambition, in conformity with its goals, is to reflect, as in a faithful mirror, the men and the things of its time, in the interest of its current readers and for the instruction of those who will take the trouble to examine later its pages written with no other passion than that of the truth.

The government's powers of repression were a constant presence for illustrated journals during the 1835–47 period not only as a result of censorship but also due to periodic prosecutions of caricature journals and artists. On October 28, 1835, *Le Charivari* editor Claude Simon was sentenced to

two months in jail and a five thousand-franc fine for the infamous "red issue" of July 27. The formal charge, that of incitement to hatred and scorn of the government and the king, was based only on the text of the "red issue" and not on the caricature portraying a figure resembling Louis-Philippe walking through a mass of cadavers. However, the government prosecutor, Plougoulm, in his trial pleading, prominently referred to the drawing, which he described as "none other than the caricature under which before the laws of September 9 *Charivari* habitually represented the person of the king." The "red issue," he declared, had the "criminal" intention of presenting to France "in red ink, in characters of blood" the argument that "for five years the government has only spread blood" and that responsible for these actions was "the king himself; . . . yes gentlemen, the king; because the caricature that you have under your eyes isn't equivocal." Plougoulm added that while the government was not charging *Le Charivari* with complicity with the Fieschi attempt, which occurred on the day following publication of the "red issue," "without doubt if this frightful crime had succeeded" the contents of the issue "would have become the manifesto and the program necessary for the crime." In response, *Le Charivari*'s lawyer pointed out that the articles reprinted in the "red issue" had all previously appeared in other journals without leading to prosecutions. He asked, "Since when is the color of ink a crime?" and denied that the caricature depicted the king. Plougoulm replied, "It cannot be said that the caricature does not represent the king; that is evident to all eyes."[39]

In two subsequent prosecutions in 1839 and 1842, two editors and a printer of *Le Charivari* were sentenced to a total of thirty-eight months in jail and twelve thousand francs in fines for the publication of articles mocking the king and another public official. In the 1839 case, *Le Charivari* editor Jean-Chrysostome Beauger was sentenced to six thousand francs in fines and a jail term of eight months for having published a hilarious satire which brought together three subjects: the recent arrest of a man who happened to be named Louis Philippe for stealing an umbrella (an object popularly associated with the king), the brutality of the Paris police, and their recent false arrest of two people they had confused with those they were seeking. In *Le Charivari*'s satire, King Louis-Philippe was reported arrested and beaten by the police in a case of mistaken identity but typical brutality, an account guaranteed to raise the hackles of the king as well as the police. Although both this prosecution and that of 1842 were brought as a result of articles rather than caricatures (which, as of September 1835, of course, had to be approved by the government before publication), they served as warnings to *Le Charivari* that the government was keeping it under close watch. Perhaps not coincidentally, each prosecution followed shortly after *Le Charivari* had

published many cartoons in the Daumier "Robert Macaire" caricature series, which, as pointed out below, were thinly disguised sociopolitical attacks on the regime. In August 1847, amidst growing agitation for electoral and other reforms—which was no doubt related to an increase of the rejection of drawings by the censors—from twenty-one in 1846 to twenty-nine in 1847— another issue of *Le Charivari* was seized. However, before the editors could be tried, for seeking to trouble the public peace by inciting class conflict, the 1848 revolution apparently intervened.[40]

Another journal which sometimes published caricatures hostile to the government, the Bourbonist *La Mode,* also suffered on a number of occasions during the 1835–47 period. In 1838 the editor of *La Mode* was sentenced to a year in jail and an astounding fifteen thousand-franc fine for reproducing (apparently with authorization) a painting by Coypel, *The Coronation of Joas,* which was accompanied by a commentary in which the authorities detected an allusion to a king usurper which they took as a reference to Louis-Philippe. *La Mode* retaliated by raising money to pay the fine by selling to subscribers a deluxe reproduction of the painting. The journal was also prosecuted on five other occasions during the 1835–47 period, leading to additional fines of twenty thousand francs and additional jail terms of almost four years. In 1841, the caricaturist August Desloges and a bookseller were each sent to jail for a month and fined six hundred francs for a technical violation of the press laws. The offending print by Desloges showed an oriental king described as a mythical king of China, who no doubt (equipped as he was with an umbrella) symbolized Louis-Philippe.[41]

As in the 1820s, despite censorship and prosecutions, hostile political caricature was not completely silenced during the decade following passage of the September Laws. So long as caricatures did not directly attack governmental figures, the censors appear to have been quite tolerant, except during periods of great political tension, as in 1840. Even in that year the censors banned only 64 drawings out of a total of 7,796 submitted to them, a rejection rate of less than 1 percent (this does not, of course, include drawings never submitted due to their certain rejection).[42]

Le Charivari indicated its intent to evade the September Laws only a week after they were promulgated when on September 17, 1835, it declared defiantly that it would remain true to its principles, since although there were now "things that one can no longer say, . . . one will think them no less." It added that although "censorship can efface some *dessins* ("drawings") of *Le Charivari* it cannot efface the *dessins* ("purpose") of *Le Charivari*. We have a good and abundant supply of them, on which it will break her teeth, dog that she is!" The journal even expressed its defiance with a poem which declared that "censorship in vain devours us" with its "foul ink," while *Le*

Charivari "onward, sketching" with "our crayons defying her scissors, erasers and wipers" would "continue to harass the censors."

After September 1835, *Le Charivari*'s artists turned their talents to "social" (i.e., overtly "non-political") caricatures which portrayed the corruption, hypocrisy, and money-grubbing atmosphere which permeated France during the 1830–48 period of get-rich-quick entrepreneurialism and early industrialization. These cartoons, focused on imaginary symbolic social types, taken individually were usually not viewed by the censors as subversive (although some of them were vetoed), yet when examined as part of a collective series they painted a devastating portrait of the times, and inevitably of the government which tolerated and encouraged and was intertwined with such behavior.

While many artists, including Grandville, Gavarni, and Monnier used such social caricatures to criticize the regime, the most famous of the social caricaturists by far was Daumier, of whom Balzac declared, "That lad has some Michelangelo under his skin."[43] Charles Baudelaire, a contemporary of Daumier, wrote that each morning the caricaturist

> keeps the populace of our city amused, . . . supplies the daily need of public gaiety and provides its sustenance. . . . There can be no item of the fearful, the grotesque, the sinister or the farcical, . . . but Daumier knows it. The live and starving fellow, the plump and well-filled fellow, the ridiculous troubles of the home, every little stupidity, every little pride, every enthusiasm, every despair of the bourgeois—it is all there. By no one as by Daumier has the bourgeois been known and loved (after the fashion of artists). . . . Daumier has lived in intimacy with him, he has spied on him day and night, he has penetrated the mysteries of his bedroom, he has consorted with his wife and children, he comprehends the form of his nose and the construction of his head, he knows the spirit that animates his house from top to bottom.[44]

The most famous cartoon character Daumier used to drive home his "nonpolitical" satire was "Robert Macaire," a figure well known from his portrayal on the stage (before the imposition of theater censorship in 1835) by the famous actor Frédérick Lemaître. "Macaire," as portrayed in over one hundred caricatures published by Daumier in *Le Charivari* between 1836 and 1838 and another twenty in 1840–41, with captions provided by Philipon, was the archetypal bourgeois swindler who appeared in various guises such as the corrupt banker, the feverish speculator, the hypocritical politician, the quack doctor, and the shylock lawyer. Philipon quite openly declared his purpose of evading the September Laws when the first Macaire cartoon was published in *Le Charivari* on August 20, 1836:

Since this censorship, instituted to protect virtue and morality, forbids us to satirize political Robert Macaires, it compels us to take on the social Macaires. We now propose to publish a gallery in which the numerous varieties of this last species will successively appear. . . . It is dedicated to those bankers, philanthropists, or contractors whose cash boxes, like prisons, are ever ready to receive but never to render up.

In the November 1, 1838, inaugural issue of his *La Caricature Provisoire,* Philipon (who no longer directed *Le Charivari* after 1837) again indicated the possibility of using "nonpolitical" caricatures to make his points, since if politics was forbidden as a subject to be satirized, there were still plenty of available targets: "Moral, literary, theatrical, artistic, industrial, medical, surgical, agricultural, somnambulist, anabaptist, etc. The field, believe me, is rich, very rich everywhere, in vices, in absurdities, in swindling, in follies of every kind."

The Macaire cartoons were fantastically successful, especially since, as caricature historian Edward Lucie-Smith notes, the public gained from viewing them a sense of forbidden pleasure; the caricatures "encouraged a kind of complicity as readers followed their adventures week by week." When the 1836–38 series was first published in *Le Charivari,* the journal's circulation increased markedly, and the Macaire caricatures were subsequently gathered together, with twenty-five hundred additional copies sold as sets. An additional six thousand crude copies of Daumier's originals were sold in France, and additional copies were sold in Belgium and Holland. Even Karl Marx took note of the Macaire phenomenon, writing that the regime of Louis-Philippe was "no more than a joint stock company for the exploitation of the French national wealth" and that the king was "a director of this company, a Robert Macaire on the throne."[45]

Aside from evading the September Laws, through "nonpolitical" caricature, caricature journals were also free during the 1835–47 period to attack censorship laws and administration with words, which were not censored in advance. *Le Charivari* did so repeatedly during the period. On September 11, 1835, two days after the September Laws were promulgated, the newspaper reported sarcastically that the speed with which "the laws of pressicide" were passed suggested that the country had been in imminent peril and that "every night we slept on a volcano." With their passage, it continued, "calm will be reborn as if by enchantment" and "instead of sleeping, as formerly, on our guard, we can henceforth sleep on our pillows."

On September 16, *Le Charivari* inaugurated a tradition that was to be used by French caricature journals for the next forty-five years: replacing a forbidden drawing with a written description of it, accompanied by a denuncia-

tion of censorship. This device was repeated on a number of occasions during the next few months. On November 6, it reported that a drawing with fifty-eight small vignettes had been forbidden because one of them "depicted a sort of fantastic pot whose cover slightly resembled the head of a Jesuit" and four days later it reported that a "nonpolitical" series of sketches had been banned because one of them showed a "young man seated before a table on which is placed an enormous brioche" (both a French roll and a "blunder"; the term had been used to symbolize ridiculous royalty ever since Queen Marie Antoinette had advised those lacking bread to eat brioches). *Le Charivari* commented acidly that the veto placed on "this revolutionary brioche" demonstrated that "what we are allowed to draw becomes lessened with each day; it is the same with the intelligence of the censors." In a lengthy article published on November 5, 1835, announcing the censorship-induced suspension of its attempts to publish daily caricatures, *Le Charivari* complained that "three out of eight" of its allegedly completely nonpolitical drawings were being forbidden by the censors "under the pretext of brioches, carafes, pendulums, butter jars, crouched Turks, rabbits viewed from behind, etc." On November 8, 1835, *Le Charivari* published a Grandville caricature depicting the censors as ugly buffoons and ignoramuses (fig. 19), and accompanied the drawing with a declaration that the "sole condition" to qualify to be a censor was "not having the vaguest idea, in order to judge the ideas of others." The censors had approved Grandville's print, it added, out of "stupidity rather than magnanimity" since the depiction had "so flattered them that these gentlemen, no doubt, don't recognize themselves."

Le Charivari periodically returned to the theme of the deficiencies of censorship until the September Laws were abolished in 1848. Thus, on July 4, 1840, it reported having a "score to settle" with the censors, who, acting with "stupid arbitrariness" under the September Laws ("may the devil take them away") had banned an anodyne drawing mocking the state of preparedness of bourgeois members of the National Guard. *Le Charivari* not only published a full-page detailed description of the banned caricature, but also printed small woodcut vignettes of parts of the drawing that had not been censored (fig. 49). It also published two small illustrations mocking the censors, including one which depicted a censor dressed in slippers and nightcap "bringing to his patrons the clippings of the day." *Le Charivari* declared:

> We ask only if censorship is not as useless as it is odious, since in forbidding us to publish a drawing, it has no right to prevent us from placing in the same place where it would have been a detailed and complete description. Moreover, with other vignettes and images approved by it, we can reestablish picturesquely,

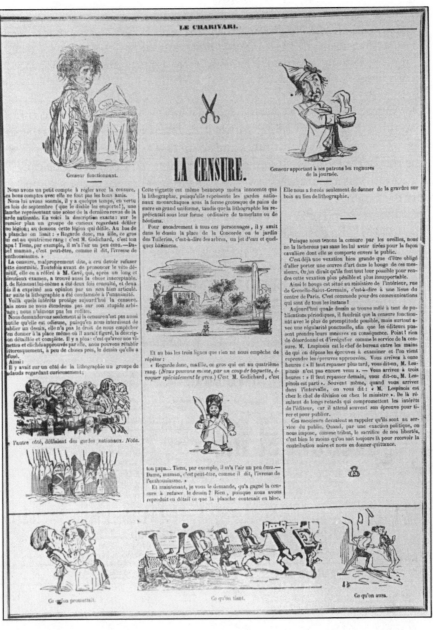

Figure 49. Le Charivari *of July 4, 1840, ridiculed censorship by providing an extensive written description of a banned drawing, accompanied by bits and pieces of the original illustration which had been separately approved by the censors. The original drawing had mocked the state of preparedness of the National Guard. The two vignettes at the top mock the censors, depicting a censor at work in his nightgown, at the left, and "bringing to his patron the clippings of the day," at the right.*

nearly entirely, the illustration which it banned. . . . What has the censorship gained by refusing this drawing? Nothing, since we have reproduced in detail all that the drawing contained. It has only forced us to give the illustration in wood-cuts instead of lithography.

On August 26, 1840, *Le Charivari* again denounced censorship, this time for banning a drawing by Charlet entitled "La Marseillaise" (similar in theme to fig. 47) which depicted workers and soldiers tearing up a poster representing the "treaties of 1815" and demanding "our old frontiers or death." The caricature was apparently viewed as dangerously critical of the regime's failure to challenge the 1815 frontiers, especially as it appeared during a period of widespread popular criticism of the regime's perceived passivity during the 1840 Middle East crisis. However, *Le Charivari* described it as a "beautiful composition which sums up perfectly the current situation and the movement of public opinion." *Le Charivari* added that "certainly one knows that censorship is very stupid, very barbarous, but we could have never thought it this barbarous and stupid. . . . What does censorship protect if not foreign interests and the 1815 treaties?" Ridiculing the government's foreign policy, *Le Charivari* concluded that the regime "is afraid of war, even in a picture."

5

Freedom of Caricature from the Second Republic to the Third, 1848–71

FREEDOM OF CARICATURE UNDER THE SECOND REPUBLIC, 1848–52

On February 24, 1848, King Louis-Philippe abdicated as the result of an uprising in Paris which reflected growing unrest over his regime's increasing rigidity, corruption, and repression. The immediate impetus for the revolt was the government's ban on a Paris "political banquet" planned to demand political reforms, which had been scheduled for February 22, and the killing and wounding of about eighty demonstrators on the Boulevard des Capucines the following day. As in 1830, the dominant slogan of the uprising was the demand for "liberty." Within two weeks the succeeding provisional republican government promised universal manhood suffrage, freed all political prisoners, and abolished all restrictions on the press and on freedom of association. Thus, on March 6, the government formally announced the abolition of the September Laws, declaring that they were "a flagrant violation of the sworn constitution which, from their inception, have provoked the unanimous reprobation of the citizens." On March 29, the new government declared that all citizens had the right and the duty to make their opinions known via the press "or by any other means of publication." The new constitution of November 4, 1848, confirmed this right, and while noting that it could be limited by "the rights or the liberty of others and public security," added that the "press cannot, in any case be submitted to [prior] censorship."[1]

During the early days of the revolution, France, and especially Paris, was caught up in an atmosphere of effervescence and utopian hopes for social and political reform reminiscent of July 1830. Flaubert recounted, "Infor-

mality of dress masked the differences in social rank, hatreds were hidden, hopes took wing, the crowd was full of good will. Faces shown with the pride of rights won. There was a carnival gaiety, a bivouac feeling; there could be nothing as much fun as the aspect of Paris on those first days." This explosion of hope and good feeling was especially reflected in a proliferation of newspapers, which were freed not only from the constraints of the September Laws but also from other restrictions such as the security deposit requirement and press taxes. One observer, reflecting on the astounding creation of almost two hundred newspapers during the first four months of the new regime, spoke of an "infinite number" of journals, while another recalled the "pell-mell of multicolored titles," the "hubbub of criers in the streets and on the boulevards," and the varied "hopes and formulas thrown to the winds of the sky!"[2]

Caricature was naturally affected by this atmosphere of hope and freedom. *Le Charivari* proclaimed triumphantly on February 26 that "censorship is placed on the [execution] block" and that "political caricature is reborn." It promised the next day, in large letters placed on its third page, the traditional space reserved for its drawings, that that spot would "soon return to its beautiful days" in which "our old friend caricature will retake possession of its whip," but asked its readers for patience since "the crayon does not work as quickly as the pen, especially when the hand is burdened by the rifle of the national guard." As in previous years when a regime had tumbled and prior censorship of caricature was abolished (i.e., 1814 and 1830), the new freedom resulted in a flood of political caricatures. During 1848 alone, at least eight new caricature journals were founded, increasing the number of such outlets from three in 1847 to eleven in 1848, and equaling in a single year the total of all caricature journals founded during the previous twelve years.[3]

Some bitter images were published attacking the fallen government, but in comparison to the treatment accorded previously to Louis XVI, Napoleon, and Charles X, Louis-Philippe got off rather lightly. One of the few truly memorable caricatures of him from this period was a Daumier cartoon, published in *Le Charivari* on March 7, 1848, which portrayed the king fleeing France, cashbox in hand, declaring, "All is lost save for the money." Soon the artists of *Le Charivari* and other journals turned to other subjects. Daumier especially mocked the rapidly growing and exaggerated panic of the middle and upper classes over minor street disorders and lower-class demands for social reforms. In the spring of 1848 he published a series of seven caricatures on this topic, entitled "Alarmists and Alarmed," for example depicting the bourgeoisie crying "fire" when a match was lighted in the street and terrified by the wooden swords of children playing soldier. Meanwhile,

Cham (Amédée de Noé), a rising star at *Le Charivari,* concentrated on poking fun at leftish socialists and utopians, especially the anarchist philosopher and journalist Pierre-Joseph Proudhon, whom he portrayed 180 times during 1848–49.

Cartoons in *Le Charivari* which mocked the new government apparently greatly annoyed some of its thinner-skinned members and supporters. On April 20, Louis Blanc, a socialist leader of the opposition to Louis-Philippe who served on the governing council of the new regime, wrote the newspaper with a bitter protest which complained of the "unjust attacks of *Le Charivari*" and claimed he had had to "energetically intervene with many workers, who in response to an article directed against me, wished to break the presses of *Le Charivari.*" He declared that "the people are indignant to see the same sarcasms which were launched only two months ago against royalty, as rewards for those republicans whose zeal in serving the interests of all has only been crushing fatigue and frightful perils." He closed on the threatening note that he was writing *Le Charivari* "very convinced that you only have to be informed in order to make this state of things cease."[4]

As Blanc's letter and Daumier's "Alarmists and Alarms" caricatures suggest, the euphoria of early 1848 lasted for only a short period. Growing social and political tensions, coupled with severe economic difficulties, climaxed in a workers' uprising in Paris in June 1848, which was brutally suppressed and followed by about three thousand executions and twelve thousand arrests. Thereafter, the regime moved steadily to the right, with a government spokesman publicly declaring in July 1849 that "the peril" threatening society "is principally born from the deplorable direction which the press has followed for some time." Press laws were steadily tightened, with security deposits reintroduced in August 1848 and greatly increased in July 1850 (along with the reintroduction of special press taxes); new press offenses were added in laws of August 1848 and July 1849. By November 1850, an opposition newspaper could truthfully declare that "a skillful and systematic campaign has been opened against all that is energetic and independent in the press." Over fifteen newspapers were administratively suppressed in 1848–49, and many others were crushed by a campaign of judicial harassment, in which 335 prosecutions were brought against 185 republican newspapers between December 1848 and December 1850, and over 50 printers were prosecuted between 1849 and 1851.[5]

This growing climate of repression not only affected the written press but also the illustrated press and the subjects it depicted. The most notable political caricatures of the 1848–52 period warned of the threat to French freedoms posed by the new press laws and especially by the barely disguised authoritarian predilections of Napoleon's nephew, Louis Napoleon Bona-

parte, who was elected president in December 1848 (fig. 50). The most important new caricature journal of the Second Republic was *La Revue Comique,* founded in November 1848 to warn of the Bonapartist menace and to support the presidential campaign of another candidate. *La Revue Comique* ridiculed Louis Napoleon week after week, often comparing him adversely to his uncle (fig. 51).

Daumier, in *Le Charivari,* made his most important contribution during this period by inventing the character of "Ratapoil" ("Hairy Rat" or "Ratskin"), a sleazy combination of thug and agent provocateur equipped with a club and Louis Napoleon's beard and mustache. The Ratapoil character was used by Daumier and other caricaturists in over one hundred cartoons in 1850–51 to presciently warn France against Louis Napoleon's plans.[6] Thus, in a cartoon published in *Le Charivari* on September 25, 1851, Ratapoil was portrayed offering a woman symbolizing French democracy his arm but being rebuffed with the comment, "Your passion is too sudden for me to believe in it." When the historian Jules Michelet visited Daumier's studio and saw the statuette upon which Daumier based his Ratapoil cartoons, he exclaimed, "Ah! you have completely hit the enemy! Here is the Bonapartist idea forever pilloried by you!" When Michelet was fired from his teaching post at the College de France in 1851 for his liberal views, Daumier responded with a caricature depicting a repulsive priest replacing him and lecturing to empty benches. Michelet wrote Daumier a note thanking him for a drawing which "has clarified the question better than 10,000 articles."[7]

The growing climate of repression which marked the Second Republic after June 1848 increasingly affected publishers of prints and caricature journals. In July 1849, the French legislature passed a so-called colportage (streetseller) law, which required all persons who hawked pamphlets, songs, and prints dealing with political matters to have them individually approved by local authorities. A series of directives from the interior minister to the prefects concerning this new law repeatedly urged its strictest possible enforcement; for example, a June 12, 1851 dispatch demanded that the prefects "exercise an indefatigable surveillance with regard to colporteurs who sell in your department writings or engravings whose sale you have not formally approved." The prefects were instructed to approve only the sale of materials "which are useful or completely inoffensive" and not to approve anything which was "contrary to society, order, morality or religion." They were told not to restrict their bans only to materials found "seditious or immoral" by the courts, but also to include "dangerous" materials, which, while not declared illegal, could "produce the most pernicious effects on the minds of inhabitants of the countryside, if they are sold and distributed at a low price." A dispatch dated September 21, 1849 demanded

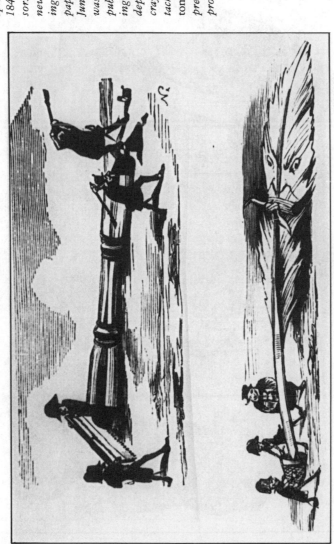

Figure 50. La Revue Comique *was the most audacious and political of the crop of new caricature journals which sprang up in the aftermath of the 1848 revolution, which abolished censorship of caricature. However, the new government soon began prosecuting and suppressing opposition newspapers and caricature journals. On June 18, 1849, six months before it was suppressed,* La Revue Comique *published these two prescient drawings. Top: Government minions are depicted backing away at an artist's crayon as the regime increases its attacks on freedom of caricature. Bottom: Here the quill pen, the symbol of press freedom is gagged and in the process of having its point capped.*

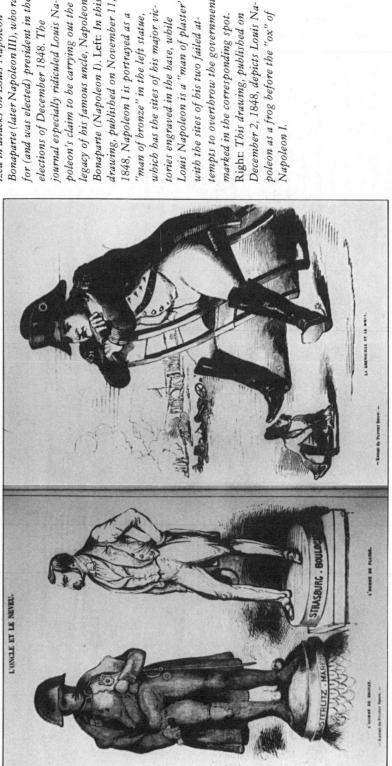

Figure 51. La Revue Comique specialized in attacks on Louis Napoleon Bonaparte (later Napoleon III), who ran for (and was elected) president in the elections of December 1848. The journal especially ridiculed Louis Napoleon's claim to be carrying out the legacy of his famous uncle, Napoleon Bonaparte (Napoleon I). Left: In this drawing, published on November 11, 1848, Napoleon I is portrayed as a "man of bronze" in the left statue, which has the sites of his major victories engraved in the base, while Louis Napoleon is a "man of plaster" with the sites of his two failed attempts to overthrow the government marked in the corresponding spot. Right: This drawing, published on December 2, 1848, depicts Louis Napoleon as a frog before the "ox" of Napoleon I.

that the prefects examine individually each item to be sold and not give blanket authorization to requests such as for the right to sell "portraits of 'celebrated men'" since colporteurs had "in the shelter of that permission" been known to "sell engravings and lithographs representing persons whose name alone is a menace to our institutions or to the cause of order." The new law was enforced by a commission which approved and disapproved each submitted work; according to its secretary, "in the interests of persons easy to seduce, such as workers and inhabitants of the countryside, the commission did not fail to ban the sales of three-quarters" of the materials submitted to it. Almost 160 prosecutions were brought annually for violations of this law between 1852 and 1870."[8]

The stress in the law and in the interior minister's instructions on the banning of the sale of "dangerous" images reflected that fact that the left republican opposition had placed a high priority on selling inexpensive political prints, such as those which depicted their leaders and which portrayed Jesus as a radical republican. In 1852, shortly after Louis Napoleon's coup, a government official stationed in Lyon testified to the success of this campaign and the demand for such prints when he reported, concerning surveillance of radicals, "Each time that police investigation brings us into their homes we find portraits of revolutionaries hanging on the wall as if they were the house deities." Although obviously many such prints escaped police controls set up after passage of the July 1849 law, according to one leftist paper, by January 1850, popular prints and almanacs were everywhere being "suspended, confiscated, ripped up, torn to shreds." Partly due to such harassment, which continued for many years, the number of print hawkers fell from 30,000 in 1849 to 500 in 1874. In the village of Brazey-en-Plaine, the authorities further showed their sensitivity to the political image in 1850 by whitewashing a café wall decorated, according to an official report, with a "man of the people" dressed in a red cap, and "a woman dripping blood from her breasts who stands for the regeneration of [the radicalism of the French revolutionary year of] 1793." The very color red became increasingly viewed as subversive after June 1848, with countless charges brought against people for displaying red flags, hats, ties, or headscarves, or even for resorting to such clearly "dangerous" tactics as picking and exhibiting red flowers.[9]

Under these circumstances, caricature journals soon began to suffer along with separately sold prints and other images. Philipon clearly reflected the deteriorating climate in July 1849 in a letter to Nadar (Gaspard-Felix Tournachon), the leading caricaturist of *La Revue Comique,* who had suggested some ideas for caricatures. Philipon rejected one of Nadar's ideas because it "could be dangerous for several reasons" and wrote that before publishing Nadar's work he (Philipon) would have to "assure myself that you will not

let yourself be too carried away by your [radical political] opinions."[10] *La Revue Comique* was suppressed by the government in December 1849, shortly after it had published a prescient drawing which depicted government minions hacking away at a caricaturist's crayon (fig. 50).

The increased security deposit and reintroduced press taxes of July 1850 aroused a storm of protest and imposed an especially heavy burden on caricature journals and other small newspapers, which could ill afford the heightened costs it imposed upon them. In introducing the bill, the minister of justice declared that it was aimed at the element of the press which "has contested every principle and scorned every holy truth" while especially addressing "the least enlightened elements of the population." In announcing the closure of his journal, *Le Peuple Constituant,* as a result of the bill, the liberal Catholic Robert de Lammenais declared, "You have to have a lot of money today to enjoy the right to speak: we aren't rich enough. Silence to the poor!" As a direct result of the bill, Cham's caricature journal *Punch à Paris,* named for the famous London magazine, died in June 1850, after having published only six issues. In its final number, the journal told its "100,000 readers" that it could not continue for lack of the required 18,000 francs security deposit and published a picture of "Sir Punch" being hoisted on a sword with the inscription "law on the press" and placed into a common grave of newspapers. Another caricture showed Punch's son entering the house of his English father, who could not recognize his progeny, as his son's body was covered with a French smallpox (the newspaper taxes) unknown in England (in fact, English press taxes were not abolished entirely until 1855). Cham also expressed his anger over the government's actions with an illustration in a book he published in 1850, in which he depicted himself, armed with an enormous crayon, barred from entering the door of political caricature. Aside from *Punch à Paris* it seems likely that one or two other caricature journals, *La Silhouette* (1844–50) and *La Caricaturiste* (1849–50) were also forced to close by the new taxes, as they both published final issues at about the same time the law was passed.[11]

The most spectacular incident of repression directed against a caricture journal during the Second Republic was the prosecution of *Le Charivari* in May 1851, for a drawing published on April 17 (fig. 52) which depicted President Louis Napoleon handing arrows to a man with a bow, representing newly appointed interior minister Leon Faucher, who was shooting at a female head wearing a crown inscribed "Constitution." The drawing was captioned, "The price of an address at the Champs Elysées [i.e., a ministerial appointment]. He who overthrows her completely will be my minister." The caricature, by Charles-Louis Vernier, a *Le Charivari* illustrator who spe-

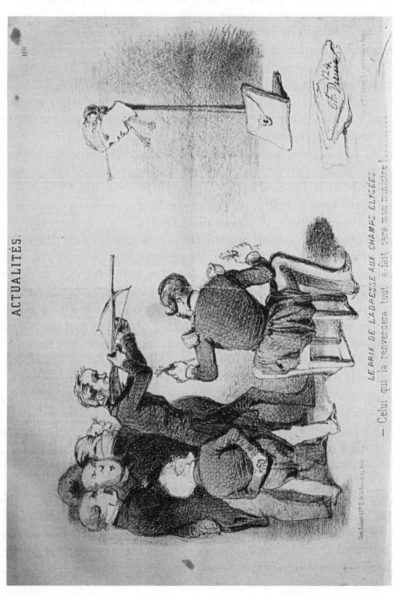

Figure 52. For this drawing critical of French President Louis Napoleon, published in Le Charivari on April 17, 1851, caricaturist Charles Vernier was sentenced to two months in jail and fined one hundred francs and editor Leopold Pannier was given a six-month jail sentence and fined two thousand francs. The caricature depicts Louis Napoleon banding arrows to Leon Faucher, the newly named interior minister, who is aiming at the personification of the constitution and French liberty. Both the drawing and the caption clearly suggested that a willingness to violate the constitution was a requirement to becoming a member of Louis Napoleon's cabinet.

cialized in attacks on Louis Napoleon, was a brilliant commentary both on the avaricious ministers who surrounded the president and on Louis Napoleon's openly proclaimed desire to change the constitution so he could stay in office for more than one term. As French historian Victor Pierre has noted, the caricature was prosecuted because "it was all too true." Vernier was sentenced to two months in jail and fined one hundred francs for offense to the president of the republic, while *Charivari* editor Leopold Pannier was fined two thousand francs and sentenced to six months in jail.[12]

Le Charivari bitterly attacked and brilliantly satirized Faucher and the government for ordering the seizure and subsequent prosecution. It declared on April 18 that Faucher had determined to "prove to all Europe how vigorous he is by engaging in man-to-man combat with the rough sketches on the third page of our journal." On April 20 it declared that as a result of Faucher's actions "society, the family, religion and the ministry of the vigorous have again been saved for this week!" In reporting the jail sentence on May 28, *Le Charivari* reported that its editor certainly would have been acquitted "if the safety of France—what are we saying!—of Europe had not demanded that M. Leopold Pannier spend six months in St. Pelagie;—there he will have time to reflect on the unworthiness on being the editor of a republican newspaper . . . under the Republic."

Le Charivari also quoted reports from a number of other newspapers which offered their moral support. Many republican journals attacked the government for tolerating pro-Bonapartist journals, which openly called for changing the constitution, while prosecuting *Le Charivari* for defending the constitution against such attacks. Thus, Philipon's *Journal pour Rire* was quoted in *Le Charivari* of June 1 as declaring, "It seems that the only seditionists in the Republic are republicans and that the enemies of the constitution are those who seek to maintain it." *L'Evénement* was quoted in *Le Charivari* of April 19 as asking, "Is it that the public streets are not forbidden to imperialist journals but this treatment is reserved only for republican newspapers?" It satirically avowed that the president's nose as depicted in the offending caricature was "completely seditious" as it "pushed energetically toward prolongation [i.e., of his term in power]." On April 21, *Le Charivari* quoted *La République* as declaring, "If there is a trial, it will only be a trial for laughing."

After the sentence was handed down, *Le Siècle* was quoted in *Le Charivari* of May 29 as acidly remarking that the conviction was not expected, given that there were "so many articles against the constitution published by certain tolerated journals." *Le Pays* was quoted in the same issue as asking, "If one begins by striking wit in a country like France, where will things end?"

Six months later, things were to end in a coup d'état and the end of the Second Republic.

THE SECOND EMPIRE AND FREEDOM OF CARICATURE, 1852–66

On December 2, 1851, President Louis Napoleon Bonaparte overthrew the constitutional regime in France by a military coup d'état. *Le Charivari,* the leading surviving politically oriented caricature journal following the suppression of *La Revue Comique* in 1849, was suspended by the regime in the aftermath of the coup, although it was allowed to appear again after about a week. After reappearing, *Le Charivari* reported on December 14 that Paris without *Charivari* and the caricatures of Cham had made everyone crazy. If Paris was somewhat restored to health with the reappearance of *Le Charivari,* however, the journal itself was soon to endure more suffering. On February 17, 1852, about ten weeks after the coup, President Louis Napoleon Bonaparte issued a press decree which reestablished prior censorship of images. The relevant section of the degree, article twenty-two, quoted almost verbatim from the caricature censorship portions of the September Laws. The printed press also was subjected to many restraints, which allowed the regime so much discretion to administratively and/or judicially persecute opposition newspapers that print journalists were forced to censor themselves. One journalist commented that the regime apparently felt "horror" toward the "letters of the alphabet," while another, writing after Louis Napoleon declared himself Emperor Napoleon III on December 2, 1852, lamented that, "In France, there is only one journalist and that is the Emperor."[13]

While the constraints on the printed word were severe, they did not include censorship, so if Napoleon III feared the press in general, it is clear from the requirement of prior censorship of caricatures that he feared pictures even more than words, as had been the case with the French regimes of 1822–30 and 1835–48. Ministerial circulars sent to the prefects on March 5 and March 30, 1852, concerning the implementation of the February 17 edict, repeated the instructions that had been given following passage of the 1835 September Laws: the prefects were told that while the decree literally required prior censorship approval of all published and circulated images, including those produced before its enactment, to avoid unnecessarily troubling commerce, prosecutions need not be brought against previously published materials nor against "the authors of hand-created images, impressions on cloth or wall paper" which had not been submitted to censorship

unless they had a "dangerous character." However, again as in 1835, strict enforcement of the decree was demanded with regard to mass-circulated "engravings, lithographs, emblems or illustrations reproduced by printing" as "it is necessary, Mr. Prefect, to make disappear provocations to vice, to disorder, to debauchery." Some time after the publication of the 1852 decree, a new administrative requirement was enforced, requiring prior written approval from the subjects of all published caricatures. Thus a dual censorship was required, involving approval both by government censors and the subjects of drawings. Victor Hugo, perhaps Napoleon III's most important opponent, who spent the entire Second Empire in exile, explained the regime's particular hatred of pictures as follows: "The government feels itself to be hideous. It wants no portraits, especially no mirrors. Like the osprey, it takes refuge in the night; if one saw it, it would die."[14]

The result of the 1852 decree and its subsequent extraordinarily harsh enforcement was a virtual total absence of critical political and social caricature in France between 1852 and 1866. According to obviously incomplete records in the French archives, between 1854 and 1866 at least 676 illustrations were forbidden by the censors, or an average of at least fifty-two a year, a rate almost 50 percent higher than the average of thirty-six per year forbidden under the July Monarchy between 1835 and 1847. Unlike the situation during the 1820s and the July Monarchy, when it had been possible to engage in sharp pictorial criticism of the regime by social or symbolic satires which targeted the ruling classes, even such critical quasi-political satire was impossible for fifteen years after 1852. Instead, the overwhelmingly dominant theme of caricature became mildly erotic portraits of women and light jests at foibles, fads, and fashions of the day such as air balloons, photography, the crinoline craze of the 1850s and the widespread adoption of macadamized paving of the Parisian streets. Arsène Alexandre, a leading historian of French caricature, writes that the banality of the images of the Second Empire were such that "we even miss the sentimental platitudes" of the similar caricatures which dominated the 1795–99 period of the Directory.[15]

Daumier was reduced to drawing satiric jests on such subjects as the mania for Chinese vases, the new omnibuses, the excitement over the appearance of several comets and women's fashions. Even the most anondyne subjects risked bans. Thus, a print by a pro-Bonapartist firm which depicted a surly gendarme drew a rebuke from the authorities, and in December 1855, two Daumier prints which suggested that milk and sausages were prepared for sale to the public under less-than-appealing conditions were forbidden (fig. 53). In banning the caricature depicting the making of sausages, the censors commented that Daumier had produced a "very villainous image" which would make the public "disgusted forever with butchers." According

180

Figure 53. Censorship of caricature under Napoleon III was so strict that even these two Daumier drawings, picturing the preparation of food in less-than-appealing conditions, were forbidden in December 1855. Top: This drawing portrays how sausages were prepared. The censor remarked that it was a "very villinous image" which would make the public "disgusted forever with butchers." Bottom: This one depicts the "story of making milk."

to an account published in 1874, even the apolitical (if not conservative), middle-class—oriented *L'Illustration* once had a picture forbidden because the censors claimed that, in its portrayal of a war in South America, Napoleon III's features were vaguely similar to those of a dead Brazilian tucked away in the corner of the engraving.[16]

The only directly political caricatures that were allowed were those dealing with foreign policy, and even in this area the twists and turns of the regime's policies had to be faithfully reflected. Thus, in late 1853, as French relations with Russia deteriorated and the Crimean War approached, caricaturists were informed that attacks on Russia could be published, and similar permission was given for attacks on Austria during the Franco-Austrian War of 1859. But a Daumier print of 1859 that was deemed potentially threatening to French relations with Britain and Egypt was forbidden. Meanwhile, the textual material printed in *Le Charivari,* which was among the most liberal newspapers tolerated by the regime and which maintained a modest but respectable circulation of about two thousand, was also kept under careful watch. Thus, in 1852 and again in 1862 *Le Charivari* received official warnings (a prelude to possible administrative suppression) for some of its comments. A history of *Le Charivari* published in 1863 clearly suggested that the journal had to constantly walk on eggs: given the fact that "irony isn't easy to conciliate with the susceptability of gentlemen in office," it related, each article was edited with the care that was "analagous to that one applies to mushrooms," and sometimes published caricatures gave rise to a "mob of questions" from the public because the censors had "cut the wings" off the artists' intentions.[17]

Working under these constraints, Daumier was unable to display his sharp sense of social satire to best advantage. Although he had been the most influential sociopolitical caricaturist in France since the days of Robert Macaire, public favor in the post-1852 period shifted to artists more suited to the production of light sketches of Parisian life, such as Gavarni and especially Cham. In March 1860, Daumier was dismissed from *Le Charivari,* where he had worked for almost thirty years, and in December 1861 the newspaper published an attack on him by Philipon, who claimed Daumier "neglects the minutiae, the details" and "lacked" imagination! Daumier was rehired by *Le Charivari* only in 1863.

Cham became the reigning master of caricature during 1852–66, producing an amazing quantity of light sketches that fulfilled a taste for frivolity and light eroticism that the regime was happy to encourage. French press historian Henri Avenal writes that during this period, "Cham astonished his readers by the prodigious resources of his wit," and "his talent was very quickly the most popular and appreciated, not only in France, but in all

Europe." A leading student of French illustrators, Henri Beraldi, writes that at this time "not a man in France entered a cafe without declaring, 'I must see Cham's production for today. *Garçon! Le Charivari!*' " and that, in leaving, the thought always came, "That Cham is astonishing! How clever he is! What spirit!" But, although, as caricature historian Emile Bayard has written, Cham "summed up precisely the manners of an epoch, its preoccupations, . . . its frivolities and small deeds," his work lacked the fundamental critique of society that Daumier had earlier provided, and his artistry could not bear comparison with Daumier. Thus, although in 1851 an observer declared that, "For some time Cham has disputed with Daumier for the title 'the Michelangelo of Caricature,' " caricature historian Jules Fleury has rightly termed any comparison between the two similar to "comparing a grain of sand to a rock of the cliff."[18]

The harsh restrictions on caricature unquestionably kept down the number of caricature journals published during the 1852–66 period. Compared to the eight journals founded during the year of freedom of 1848 and the total of eleven caricature journals published during that year, only twenty new journals were founded between 1852 and 1866 and the number of caricature journals never exceeded nine in any one year, even though French newspaper circulation in general grew dramatically during the period. *Le Charivari* and *Le Journal pour Rire* (renamed *Le Journal Amusant* in 1856) were the only caricature outlets to last throughout the 1852–66 period. Almost all of the caricature journals founded during the period had extremely brief lives. Two which quite exceptionally lasted for more than a couple of years, *La Lune* (1865–68) and *Le Hanneton* (1862–68), were eventually suppressed. One of the most interesting of the new journals, *Le Boulevard* (1861–63), was forced to close when it could not find a printer. In its final issue of June 14, 1863, *Le Boulevard* reported that this problem had arisen as a result of government threats against printers (who had to have a government license to operate), due to the regime's disapproval of the journal's liberal views, as manifested in such matters as its support for Victor Hugo and for Polish rights (which implied criticism of France's failure to aid the 1863 Polish revolt against Russian rule).[19]

Attempts to defy or subvert the regime's restrictions on caricature before 1867 were virtually nonexistent and extremely short-lived. Thus, *La Musèliere* ("the Muzzle") was itself muzzled in 1855 after publishing only twelve issues when its editor and director were each jailed for a month and fined one hundred francs for publishing an unauthorized illustration. Left-wing caricaturist Pilotell (Georges Labadie) was jailed in 1865, apparently for a similar violation of the censorship rules. Even the completely apolitical *La Vie Parisienne* was prosecuted in 1866 for publishing some sketches which

had not been authorized by the censors, and its owner was sentenced to a month in jail and a fine of one hundred francs. Three other caricature journals of the handful which existed between 1852 and 1866, *Le Gaulois* (1856–61), *Rabelais* (1857), and *Paris* (1852–53), closed down as the result of prosecutions, although in the case of *Rabelais,* text rather than caricatures was the official reason for the repression. An average of seven prosecutions per year were brought during the period for sales of individual engravings which had not been authorized under the colportage law of 1849, with convictions obtained in 90 percent of the cases.[20]

THE WAR BETWEEN NAPOLEON III AND THE CARICATURISTS, 1867–70

Although government regulations concerning censorship of caricature did not change after 1866, artists increasingly attempted to subvert or defy the restrictions during the last few years of the Second Empire, and the result was a series of skirmishes over freedom of caricature somewhat reminiscent of the 1830–35 period. The fundamental factor explaining the growing courage of caricaturists (and print journalists also) during the 1867–70 period was the declining popularity of the regime. This resulted from growing economic grievances and a series of foreign policy setbacks, including the rising power of Prussia on France's eastern border and the humiliating collapse of Napoleon III's imperialistic adventures in Mexico in 1867. The government responded to the rising tide of dissent with a series of promised reforms and marginal concessions, which attempted to bring about a sort of creeping half-hearted democratization by executive fiat but which mostly resulted in only emboldening and whetting the appetite of opposition leaders and journalists.

From the standpoint of the war over freedom of caricature which erupted between 1867 and 1870, the most important of the reforms was the Emperor's Manifesto of January 17, 1867. This promised a forthcoming liberalization of the press laws, which was eventually promulgated on May 11, 1868. Restrictions on the printed word were significantly eased, with the result that four hundred new periodicals were founded in Paris alone within one year. Although the principle of censorship of caricature remained completely intact, the 1867 promise of liberalization combined with the regime's continuing loss of popularity and a genuine, if ambiguous and inconsistent, liberalization of the censorship administration was enough to spur the creation of a raft of new illustrated satirical journals and to greatly strengthen the backbone of opposition artists. In 1867 alone, about fifteen new carica-

ture journals were established, and during the next three years at least another thirty-five were founded, compared to the total of only twenty created during the preceding fifteen years (fig. 54). Although many of the new caricature journals perished after only a short period due to financial failure or government repression, the average number of caricature journals published each year during the 1867–70 period was between twenty-five and thirty, about four times as many as the average of seven published annually during the previous six years. As one journalistic observer noted in 1867, "The success of caricature journals is a symptom which is important to note. The rebirth of caricature announces the revival of the spirit."[21]

Between 1867 and its collapse in 1870, the regime tried to simultaneously liberalize while still retaining a firm repressive hand when it deemed it necessary. With regard to the press, Emile Ollivier, a leader of the liberal parliamentary opposition before his appointment as prime minister in 1870, compared this attempt to loosen restrictions while still exerting control to the efforts of a madman who closed the gates of a park in order "to prevent the birds from flying away." The inevitable result of these contradictory impulses was a growing collision between journalists and the regime between 1867 and 1870. The explosion of periodicals and their growing boldness was met by the "liberal Empire" with 327 press prosecutions between 1868 and 1870, compared to a total of about 150 during the fifteen years between 1852 and 1867.[22]

Many of these prosecutions were brought against caricature journalists and their staffs, with the result that during the 1867–70 period, at least seven caricature journals were suppressed and at least half a dozen of their artists, publishers, and editors were jailed. Many of the new caricature journals and their artists fought a war of subterfuge with the regime by attempting to slip political allusions into their work whenever possible. This technique was facilitated, as caricaturist Charles Gilbert-Martin wrote in his memoirs published in *Le Don Quichotte* on June 4, 1887, by the fact that by the late 1860s the "imperial tyranny had habituated the public to understand a half-word, to read between the lines, to seize in flight the intention dissimulated in the arrangement of a sketch." In a number of cases caricatures were even published without the required prior authorization. French journalist and caricaturist Leon Bienvenu wrote, tongue in cheek, of this period several years later, "It was never realized how far the perfidy of the caricaturists could go. It required a great study of their tricks in order to frustrate their infernal schemes, which they made into a daily game."[23]

L'Image (1867–68), one of the new caricature journals, satirized the regime's campaign of censorship harassment in a sarcastic poem it published on October 11, 1868, entitled "The Illustrator's Commandments." The

Figure 54. The liberalization of the press laws in France in 1868 led to a sudden explosion of written and caricature journals, although a wave of repression was not far behind. Left: L'Image of July 19, 1868, shows a pile of "new journals and brochures" reaching to the sky (including several caricature journals, such as La Gill Revue at bottom left). Right: L'Auvergnat of December 8, 1867, portrays the same theme, with a stress on caricature journals. On the right, Le Hanneton, La Rue, and La Lune are all depicted—and all three were suppressed by the government shortly afterward.

poem suggested that the only way to avoid fines and jail was to "submit patiently" to censorship, "abdicate all talent on its simple command," never "draw any head without its consent," especially never portray the government, and only draw pictures of clothing and bible stories. *Le Bouffon* (1867–69), another of the new journals, painted a word picture of the regime's harassment of caricature publications on February 2, 1868. Editor Lucien d'Hura apologized for a blank page in its previous issue, explaining that "seven trips" to the censors had failed to save the caricature that was to have appeared in it. However, he added that he could not complain too bitterly of the "pecuniary prejudice which this radical measure has cost me" since he knew his readers "will not crush me with their anger" and "also because several of my colleagues [i.e., publishers of other caricature journals] have even more to complain of than me." He explained, "*Le Philosophe,* having no longer been able to obtain authorization to print its engravings, failed to appear this week. *La Rue* published its print but could find no printer for its text. *L'Image* could not obtain authorization to be sold on the public streets. And some officious agents have visited the kiosks to tell merchants not to sell *Le Bouffon,* which had nonetheless obtained authorization."

As *Le Bouffon*'s account suggests, one of the victims of government repression during this period was the weekly *Le Philosophe* (1867–68), which like almost all of the caricature journals of this period had a larger-than-tabloid format (about 18 inches by 13 inches), with three pages of text and one page (usually the cover) devoted to a large colored caricature.[24] *Le Philosophe* had its life cut short by the jailing of its editor and caricaturist, Gilbert-Martin, who was incarcerated for two months and fined two hundred francs for publishing two drawings refused by the censors. One of the banned illustrations, published on January 11, 1868, depicted an Italian brigand, whose head, when viewed upside down, turned into the head of a monk (fig. 55). According to Gilbert-Martin, in his memoirs published in *Le Don Quichotte* on May 7, 1887, his plight was worsened because the public insisted on seeing the pope in the drawing instead of a monk and the issue sold what he termed the "fantastic" number of six thousand copies. Gilbert-Martin declared portraying the pope was not his intention, but the drawing was poorly done and "all satire against the Empire or Rome provoked the craze of the masses."

Another victim of the regime was *Le Hanneton* (1862–68), forced to close by a court decree of July 10, 1868, for publishing political material without having paid the required security deposit.[25] It had previously been fined five hundred francs for publishing two unauthorized caricatures in May 1868. In its final issue of July 9, 1868, *Le Hanneton* protested that

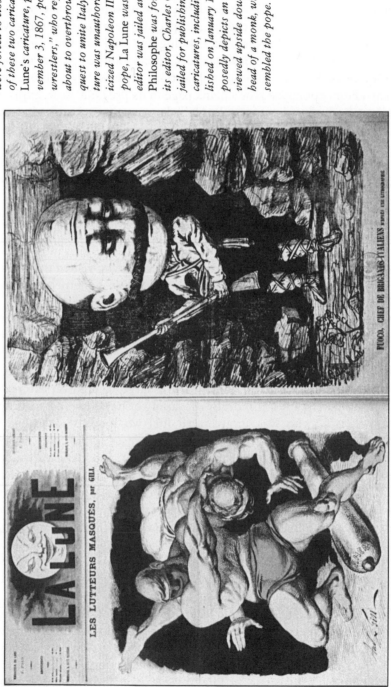

Figure 55. La Lune and Le Philosophe were forced to close down as a result of these two caricatures. Left: La Lune's caricature, published on November 3, 1867, portrays two "masked wrestlers," who represent Garibaldi about to overthrow the pope in his quest to unite Italy. Since the caricature was unauthorized and clearly criticized Napoleon III's support for the pope, La Lune was suppressed and its editor was jailed and fined. Right: Le Philosophe was forced to close after its editor, Charles Gibert-Martin, was jailed for publishing two unauthorized caricatures, including this one, published on January 11, 1868. It supposedly depicts an Italian brigand, but viewed upside down, it turns into the head of a monk, which is into the many resembled the pope.

prosecutions seemed to be "like mushrooms, as soon as there is one, ten of them come up." On July 26, 1868, the editors of the defunct journal sent a letter to other newspapers to inform the public that the journal's staff had suffered the "violent death" of its "adopted child" at the age of seven, due to the July 10 court decree.

La Rue (1867–68), a journal edited by the well-known journalist Jules Valles, wielded extraordinary influence in a career which lasted only seven months.[26] *La Rue,* a bitter critic of Napoleon III, declared its platform was to "sound the attack and lead the assault against all the fortresses, institutes, academies on high, from which anyone who wishes to have a free spirit is shot down." The journal was prosecuted for publishing in its November 30, 1867, issue a bitter written attack by Valles upon the system of military conscription, which allowed wealthy men who had been drafted to pay others (*remplaçants*) to serve in their place. Valles applied the term *cochons vendus* ("sold pigs"), often used to designate *remplaçants,* to also apply to all those who had sold their principles in return for receiving rewards from Napoleon III's regime. Also prosecuted was a caricature by Pilotell, which had not been authorized by the censors but which appeared in the same issue (fig. 56). The drawing depicted a military barracks as the "cell of one condemned to death," an apparent reference to the recent execution of a soldier. As the result of the article and caricature, the journal's publisher, Laurent Limozin, was fined six hundred francs and sentenced to two months in jail, and the journal was ordered suppressed in January 1868. *La Rue* attempted to continue publishing under a new name, but the authorities refused to allow the planned successor journal to publish even a simple lithograph by Gustave Courbet of the anarchist philosopher Pierre-Joseph Proudhon on his deathbed, and the proposed replacement journal was unable to find any printer willing to publish its first issue.

Also killed by the censors were *La Gazette de Java* (1867), which folded after its first and only issue was seized and condemned, and *La Caricature* (1869?), ordered to close in December 1869, for publishing political material without paying a security deposit and for publishing an unauthorized caricature, offenses which sent caricaturist Pilotell to jail for two months and the journal's printer, Kugelmann, to jail for one month. Another victim of the regime was *La Fronde* (1869–70), which was suppressed in February 1870 for publishing political matter without paying the security deposit and whose editor was fined eleven hundred francs. *La Fronde*'s final issue, published on February 15, 1870, before the court order was issued, contained a blank front page, with the sarcastic inscription, "Our front page illustration has been refused by the censors. Long live the Emperor!"[27]

Among the other illustrated journals which had difficulties with the au-

189

Figure 56. *The drawings of radical caricaturist Pilotell (Georges Labadie) often led to official reprisals.* Top: *La Rue's publisher was jailed and the journal was suppressed, partly for printing this unauthorized caricature, which appeared on November 30, 1867. It depicts a soldier's quarters as the "cell of one condemned to death."* Bottom: *Pilotell's own journal,* La Caricature Politique, *was suppressed during the Franco-Prussian War shortly after publishing this caricature on March 11, 1871. It suggests that by ceding Alsace-Lorraine to Prussia, the French government was sawing off one of France's arms.*

thorities during the 1867–70 period but which were not suppressed, were *Le Calino* (1868–70), *La Monde pour Rire* (1868–76), and *La Charge* (1870). *La Monde pour Rire* reported on April 23, 1870, that it had taken a "forced Easter vacation" because the issue had been delayed by a censorship caricature ban, while *Le Calino* reported in its February 1870 issue that its director had been fined one hundred francs and jailed for a month for publishing an unauthorized caricature. *La Charge,* edited and illustrated by Alfred Le Petit, was one of the bitterest critics of the regime. Caricatures planned for at least five of its thirty-seven issues were either forbidden or seized by the government after they were published without authorization; Le Petit was convicted and fined at least twice for such offenses. The most famous of the unauthorized caricatures published by *La Charge* appeared on May 7, 1870. It depicted a large pig standing on a balcony and looking sadly at the Arc de Triomphe (fig. 57). Aside from a heading reading "A Portrait by Alfred Le Petit" and a question mark for a caption, the picture had no explanation, but it obviously was meant to suggest Napoleon III standing on the balcony of the Tuileries presidential palace, watching as his star faded (in French, the Arc de Triomphe is popularly known as the *étoile* or "star"). The issue was quickly seized and Le Petit was fined and given a jail sentence, but although he had to pay the fine, the regime was overthrown in September 1870, before he could go to prison. Le Petit, commenting wryly both on his poverty and the well-known laxness of imprisonment at Sainte-Pelagie (which he later got a chance to enjoy in 1889), declared, "I would have much preferred to keep my money and go to jail."[28]

By far the most important journals which suffered from governmental repression during the years preceding the fall of the Second Empire were *La Lune* (1865–68) and *L'Eclipse* (1868–76), both of which were dominated by André Gill, the brilliant young caricaturist. Gill pioneered the technique of drawing full-page colored illustrations of famous personalities of the day, which when placed on the front page of the large format caricature journals and displayed at newsstands, virtually amounted to political posters. Gill's striking cover caricatures combined with his increasingly clever yet subtle attacks on the regime of Napoleon III, and later on the rulers of the early Third Republic, brought him renown as a master of his craft. He was repeatedly compared to Daumier and was frequently given credit for having almost single-handedly "resuscitated political caricature in France," as a biographical study in *Le Trombinoscope* of April 1882 put it. He was especially admired for his masterful personal caricatures, which, according to painter Gustave Courbet, were "*academiques*" (as good, technically, as the work of France's leading painters). Historian Jules Lermina termed Gill's works "living, striking, portraits, which depict not only the physiognomies, but the

191

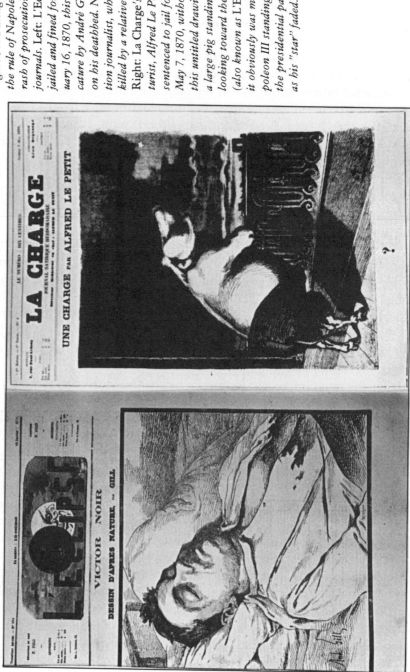

Figure 57. During the final years of the rule of Napoleon III, there was a rash of prosecutions of caricature journals. Left: L'Eclipse's editor was jailed and fined for publishing on January 16, 1870, this unauthorized caricature by André Gill, of Victor Noir on his deathbed. Noir was an opposition journalist, who had been shot and killed by a relative of the Emperor. Right: La Charge's editor and caricaturist, Alfred Le Petit, was fined and sentenced to jail for publishing on May 7, 1870, without authorization, this untitled drawing, which portrays a large pig standing on a balcony and looking toward the Arc de Triomphe (also known as L'Etoile, or the "star"); it obviously was meant to portray Napoleon III standing on the balcony of the presidential palace and watching as his "star" faded.

insides of the man." *La Nouvelle Lune* of May 15, 1885, hailed Gill's personal portraits as having "deflated so many pompous puppets," while caricature historian Arsène Alexandre has characterized them as not only "beautiful portraits" but "pages of combat." Although based on a fervent belief in democracy and a hatred for Napoleon III's repression, Gill's work was always based on wit and mockery, rather than hatred or malice; as caricature historian Emile Bayard has commented, Gill's ridicule "killed with a single jab, rather than a knife blow." During his lifetime and after his tragic death in 1885 in a mental hospital, Gill was hailed as the "Prince" of the portrait, the "Juvenal" and the "d'Artagnon [the model for the Three Musketeers] of the crayon," the "Vasco de Gama of caricature," and a "comic Attila" who "ravaged with the laugh."[29]

Between 1867 and 1879 Gill reigned as the uncrowned but unchallenged king of caricature (fig. 58), whose fame was so great that, as his friend playwright and poet Jean Richepin later wrote, "people turned their heads to watch him pass on the streets" and "he lived in a apotheosis of popularity." One memoir of the period recalls that when a new Gill caricature was about to appear, a "feverish curiosity" gripped Paris. One of Gill's biographers has declared that he was "no less than the graphic historian of the entire politics of an epoch," while writer Georges Courteline concluded that, "Gill by himself was a whole epoch, like Hugo was an entire century." Gill's role was especially great during the 1867–70 period, when his mocking crayon greatly added to the rapid decline of the regime's popularity, and many observers ranked his contribution along with that of Henri Rochefort, the editor of the mordantly sarcastic newspaper *La Lanterne*. Historian Lermina declared that Gill "with Rochefort, was the excellent demolitioner of the man [Napoleon III] of that odious period." Richepin wrote that Gill "held the Empire in check with the point of his crayon," while a journalist writing in *Le Reveil-Matin* of October 19, 1887, declared that Gill "wrote with his satirical crayon the entire history of the Second Empire and implanted well his sharp strokes in the imperial epidermis of the person who reigned at the Tuileries [Napoleon III]."[30]

Gill's prodigious and prolific talent, combined with his strong republican ideology, gained for *La Lune* the previously unheard-of-circulation (for a caricature journal) of about forty thousand copies and soon led to the inevitable difficulties with the authorities.[31] On November 3, 1867, *La Lune* published an unauthorized Gill caricature of two masked wrestlers, with a wrestler wearing red trunks about to overthrow a wrestler with white trunks who had dropped a large club with "amen" written on it (fig. 55). The legend of the caricature was simply "The Masked Wrestlers," with readers told, tongue-in-cheek, that they were "expressly forbidden" to see "any insidious

Figure 58. The fame of caricaturist André Gill after 1867 was unparalleled, and he became a common subject for caricature himself. Left: Here Gill was portrayed by Henri Meyer of Le Diogene of September 14, 1867. Right: In this beautiful self-portrait by Gill, published in La Lune of September 15, 1867, he commented on his fame by presenting his head on a platter of money. The handwritten comments at the bottom are a jest by Gill against the requirement that all subjects of caricature must give their written consent before their portraits can be published. Gill wrote that he "absolutely" refused to give his permission.

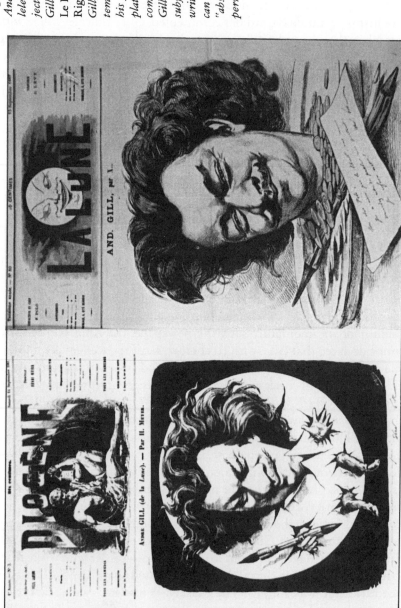

allegory" in the drawing. But the accompanying text made clear that the wrestlers were intended to represent Garibaldi (in red) and the Pope (in white) struggling over the fate of Italy. At this time Garibaldi symbolized enlightenment and liberty to all of liberal Europe, while the Pope not only represented reaction but maintained physical control of Rome only because French troops were stationed there to prop him up. For this impertinent drawing and for the offense of publishing a political article in a journal which had not paid the security deposit required of all political periodicals, *La Lune* was prosecuted. As *La Lune* reported on December 8, 1867, its publisher, François Polo, was sentenced to two months in jail and fined six hundred francs and the journal was ordered suppressed.

Any possibility that the verdict might have been less or might have been overturned on appeal was eliminated when, shortly before Polo's trial, *La Lune* published on November 17, 1867, Gill's famous "Rocambole" drawing. This brilliant caricature (discussed in chap. 1) somehow slipped by the censors, although it obviously depicted Napoleon III in the guise of Rocambole, the half-dandy, half-convict hero of a series of highly popular stories by the well-known author Ponson du Terrail (fig. 2). The authorities were furious, since as Gill's leading biographer, Charles Fontane, notes, "this illustration with its unheard of audacity was the first knockout punch delivered to the Empire."[32] The Rocambole caricature undoubtedly sealed *La Lune*'s fate. The suppression of *La Lune* attracted considerable hostile comment in the press, much of which played on the meaning of lune ("moon"). The satirical Lyon journal *Le Marionette* (which was also eventually suppressed), declared on December 8, 1867, that the permanent "eclipse of the moon" had led people to ask, "What will become of us?" It demanded, "Gentlemen, give us back the moon." *L'Image,* commenting on the same events in its December 29, 1867, issue, reported that the moon had been suppressed and declared, "What a singular epoch. I'm amazed that they still have kept the sun."

Since no law banned a suppressed paper from reconstituting itself under another name, the staff of *La Lune* soon reformed itself under the name *L'Eclipse* (i.e., *La Lune* had been eclipsed, a point graphically depicted in the masthead drawing, which showed *La Lune*'s masthead moon blotted out by a dark sphere).[33] Although in its first issue of January 26, 1868, Polo declared, "We wish to live a long time" and therefore *L'Eclipse* would, "instructed by recent examples, conduct ourselves with an extreme prudence" and would "remain within the boundaries which we are forbidden to cross," Gill's drawings soon involved *L'Eclipse* in what can only be described as caricature guerilla warfare. Gill used every opportunity to sneak hostile political allusions into his drawings, and the censors responded by forbidding both those

drawings which they could understand, and, to be safe, those which they couldn't. Eventually, *Le Trombinoscope* of April 1882 reported, when one of Gill's drawings arrived at the censorship office

> there was no magnifying glass powerful enough to plumb all its depths. The censors got to the point of borrowing from the director of the observatory the most powerful telescopes to scrutinize the hatchings of their *Gillmitaine* [an untranslatable pun meaning something like "fearful Gill drawing"]. They were absolutely persuaded that a drawing most innocent in appearance must hide the most perfidious intention and the public joined in with such eagerness that they also searched for puzzles in all the drawings which Gill's crayon produced. It got to such a point that when the clever artist was lacking for a subject he said to himself, smiling, "I'll make a simple *clysopompe* [an enema device] with no purpose, but the public will certainly find one." Often he was wrong; the public found several. . . . [When Gill dies] he will amuse himself all day by giving seditious shapes and profiles to the clouds which will make Anastasie, powerless, enraged.

Between the inauguration of *L'Eclipse* in January 1868 and its voluntary suspension in August 1870 due to the outbreak of the Franco-Prussian War, at least twenty-five of Gill's caricatures were forbidden by the censors. In at least three cases *L'Eclipse* was prosecuted for publishing unauthorized drawings (fig. 57), and members of its staff were sentenced to a total of five weeks in jail and fined over ten thousand francs.[34] Among the caricatures which were banned outright or underwent forced censorship modification were drawings of lawyers who defended political opponents of the regime, of a journalist shot to death by a relative of the Emperor, of Gustave Courbet after his publicized refusal of an Imperial decoration, and of death wielding its scythe among the tombstones of well-known individuals who had recently died. Referring to the censor's forced modification in the latter design, the journal *Diable à quatre* wryly noted on December 5, 1868, "It appears that death is not kindly looked upon in administrative circles. . . . The censorship must exert itself no matter what. Some censors forbid plays, others novels, only the most rash forbid death." By far the most sensational government action against Gill, and one which severely discredited the regime, was its absurd obscenity prosecution of his caricature of a canteloupe with some humanoid features apparently retreating before an artist's crayon, which was published in *L'Eclipse* of August 9, 1868 (fig. 5; discussed in chap. 1).

Napoleon III's fear of opposition images was so great during the rising tide of opposition which marked the 1867–70 period that censorship bans even affected drawings by well-established "serious" artists, as in the cases

of Courbet's deathbed portrait of Proudhon, and a widely publicized incident involving Edouard Manet. In 1869, Manet's lithograph *The Execution of Emperor Maximilian* was forbidden by the censors (it finally was published in 1884).[35] This ban was imposed for the obvious political reason that the event portrayed was an enormous embarrassment to Napoleon III, whose attempt to establish a French outpost in Mexico had ended with his humiliating abandonment of the Archduke Maximilian of Austria, his hand-picked candidate for the Mexican throne, and Maximilian's subsequent death before a firing squad in 1867. The news of the suppression of Manet's work received wide notice in the press, leading the French newspaper *La Tribune* to comment acidly on January 31, 1869, that "it is to be supposed that before too long the government will be led to pursue people who simply dare to maintain that Maximilian was shot." The young French writer Emile Zola added in comments published in the same paper a few days later:

> I know exactly what kind of lithograph these gentlemen would be delighted to authorize, and if M. Manet wants to have a real success in their eyes I advise him to depict Maximilian as alive and well, with his happy, smiling wife at his side. Moreover, the artist would have to make it clear that Mexico had never suffered a bloodbath and that it is living and will continue to live under the blessed rule of Napoleon III's protégé. Historic truth, thus interpreted, will bring tears of joy to the censors' eyes.

FREEDOM OF CARICATURE DURING THE FRANCO-PRUSSIAN WAR AND THE PARIS COMMUNE, 1870–71

The outbreak of the Franco-Prussian War in July 1870, the subsequent overthrow of the regime of Napoleon III on September 4, 1870, and the civil war of March–May 1871 that ended with the violent suppression of the Commune led to a short-lived but almost total transformation in the form, nature, and quantity of French political caricature. The outbreak of the war and its continuation after the installation of a provisional government of national defense after the overthrow of Napoleon III led virtually every caricature journal to close down, with the exception of *Le Charivari*, because of the disruption caused to ordinary business by the conflict. Thus, *L'Eclipse* announced a temporary cessation (which was to last nine months) on September 18, 1870, since "the decisive hour has come, in which we must put down our pen, some for the rifle of the national guard, others for the carbine of the civilian warrior." Just as the caricature journals were closing, freedom of political caricature became possible, since the new government quickly abolished or let fall into disuse the Empire's restrictions on freedom of the

press and amnestied all those found guilty of press offenses under the fallen regime. As in 1814–15, 1830, and 1848, the abolition of prior censorship of caricature led to a massive flood of cartoons, which took the form of separate prints (*feuilles volantes,* or literally "flying sheets"), since the caricature journals were no longer available as outlets. During the entire period until the collapse of the Commune in May 1871, the *feuilles volantes* remained the dominant form in which caricatures appeared; although scores of new periodicals were founded during the nine months of the Franco-Prussian War and the Commune, only a handful of generally very short-lived caricature journals were among them.[36]

Freed from the restraints of prior censorship, caricatures appeared in Paris literally by the thousands. An entire book consisting solely of a 210-page listing of all the caricatures of the period between July 1870 and May 1871 was published in 1890. It suggests that during the war and the Commune five thousand caricatures were produced in Paris and that another one thousand appeared in the provinces, almost all of them after the overthrow of Napoleon III at the beginning of September 1870, indicating a production rate of over five hundred per month. One eyewitness recalls "mobs gathered around caricatures of the ex-emperor, suspended by ropes, along the boulevards," while another recounts that caricatures made the walls of Paris "burst with laughter" as "ingenious merchants pinned them to storefronts and the doors of houses." An account published in 1872 and extremely hostile to the political tenor of most of the caricatures published during the Commune declared that the "orgy of forms and colors yielded nothing to that of phrases and ideas" and that "an artist during this period would have thought himself lacking in his duties toward the public if he didn't offer at least one new sample of his talent every two days." This outpouring of caricature clearly responded to a public demand which had long been suppressed under Napoleon III. Thus, the artist Faustin (Faustin Betdeber) recalled producing a caricature attacking the dethroned emperor on September 6, and after being unable to sell his drawing to an editor for five francs, succeeding in getting a printer to publish one thousand copies on credit and then ending up selling fifty thousand of the prints within two days.[37]

Aside from the sheer quantity of the *feuille volantes* during the Franco-Prussian War and the Commune, political caricature during this period has attracted attention mostly for its virulent nature. Many of the caricatures attacked the fallen Napoleon III, his wife Eugénie, and the imperial entourage, accusing them, sometimes in brutal or sexually graphic form, of bloodthirsty, repressive policies and of personal corruption and moral bankruptcy. Concerning such caricatures, the liberal historian Jules Michelet wrote in 1871 that "the Emperor was worse than dethroned. He was dishon-

ored, pilloried, stigmatized. . . . He became an anatomy not for the scalpel, but for a transparent light which horribly illuminated his insides, entrails and viscera." The conservative Catholic journalist Louis Veuillot, in a private letter, referred to a "vomiting of caricatures," which included attacks on the Empress Eugénie which had "soiled her with such injuries that all women would prefer death to them." *Le Paris-Journal* of November 17, 1870, called for the "purification of our streets" from the "nauseous caricatures and indecencies which break the heart of all honest people" and impose the "tyranny of filth on all who pass them."[38]

After the initial burst of caricatures, which focused almost exclusively upon the fallen regime, caricatures began to appear which attacked the new government elected in February 1871 (which sat at Versailles outside Paris). The Versailles authorities were castigated for cowardice and for failing to prosecute the war against Prussia with any degree of efficiency or enthusiasm while Paris was beseiged by the enemy in the winter of 1870–71. One of the few caricature journals established during the seige, Pilotell's *La Caricature Politique,* soon fell afoul of the Versailles government for such attacks. His second issue, published on February 11, 1871, was seized due to a cover caricature of a guillotine accompanied by text clearly suggesting some members of the "national treason" government should be executed (fig. 59). On March 11, the journal was suppressed after publishing a caricature (fig. 56) depicting the French government hacking off one of the country's arms (a reference to the cession of Alsace-Lorraine to Prussia in the armistice agreement of February 26). The decree which suppressed *La Caricature Politique,* along with five other newspapers, was issued by General Vinoy, the military governor of Paris under a state of seige imposed by the government. The decree denounced the journals for preaching "sedition and disobediance to laws," including "direct provocation to insurrection and pillage." Vinoy announced that until the lifting of the state of seige "the publication of all journals and written periodicals treating matters dealing with politics or social economy is forbidden."[39]

This decree provoked bitter attacks, both written and drawn, (fig. 59), and was one of many grievances which helped to spark the revolt in Paris on March 18 which led to the establishment of the Paris Commune. The passions engendered by the civil war of the next three months led to repressive measures against caricature and against the press in general by both sides. During April and May, the Commune suppressed about thirty journals deemed hostile to it. On May 6 the Commune banned the sale of prints which threatened public morality, although this only increased the price of such drawings, and on May 18 it ordered that no new journals could be founded until the end of the civil war. Meanwhile, the Versailles govern-

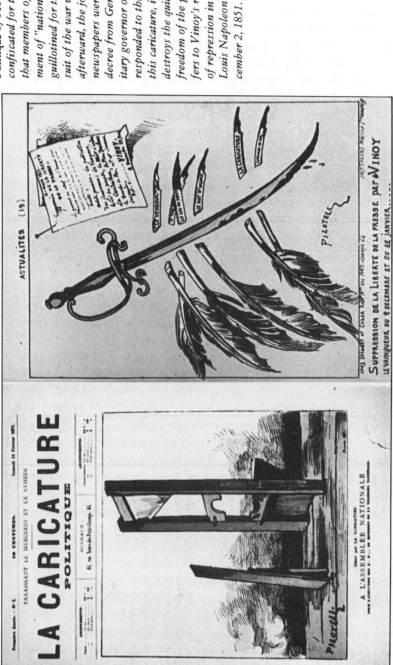

Figure 59. Left: *Pilotell's* La Caricature Politique *of February 11, 1871, was confiscated for the unsubtle suggestion that members of the French government of "national treason" should be guillotined for their lackadaisical pursuit of the war with Prussia. Shortly afterward, the journal and five other newspapers were suppressed by a decree from General Vinoy, the military governor of Paris. Right: Pilotell responded to this decree by publishing this caricature, in which Vinoy's sword destroys the quill pen-symbols of freedom of the press. The caption refers to Vinoy's role in past incidents of repression in France, including Louis Napoleon's coup d'état of December 2, 1851.*

ment banned the importation or sale of all periodicals still published in Paris. A press law passed on April 15 at Versailles modified and liberalized many features of Napoleon III's press decree of February 1852 but left the section dealing with censorship of caricature (which was never even discussed in the legislative debate) untouched. This meant a return to the situation of 1822–30, 1835–48, and 1852–70, in which the printed word was freed from prior restraint but images had to be approved by censors before they could be published.[40]

Most accounts of political caricature in France during the Franco-Prussian War have denounced both the artistic quality and the content of many of the images that were circulated in Paris. Thus, an account by E. Money, published in 1872, when passions were still enflamed over the Commune, asked, "How can men, so-called artists, delight in such blackness?" He declared that political caricature had committed "sins" which had to be atoned for, that the works produced failed to "satisfy the most elementary rule of perspective, of anatomy and of proportion," and that "scandal alone made a success of these works, to which art is completely a stranger," and which "offer interest only to the future pornographer." Art historian Henri Beraldi wrote in 1888 that the caricatures of the 1870–71 period had "no wit," just "low injury and plain filth."[41]

This image of caricature in 1870–71 is greatly oversimplified. It ignores the fact that many published prints consisted of rather good-humored depictions of the difficulties of life in Paris during the seige. For example, of the caricatures by Cham published in *Charivari,* one showed a line of Parisians in front of a sewer, hoping that a rat might emerge to provide some meat to eat, and another portrayed a man eating dinner with his cat halfway down his throat in pursuit of a just-eaten mouse. Further, the outbreak of virulent caricature in 1870–71 must be understood in the context of the fact that similar artistic outbursts had always accompanied a sudden period of freedom after the downfall of a discredited, repressive regime (as in 1814–15, 1830, and 1848), and that they unquestionably reflected a significant segment of public opinion. Although political caricature in 1870–71 may often have been bloodthirsty and hate-filled, in this it only reflected the state of French politics. Political caricature didn't start the civil war, and if the Commune's caricatures were sometimes artistically bloodthirsty, they certainly don't bear responsibility for the very real bloodshed which marked the suppression of Paris by the Versailles government in the "bloody week" of May 22–28. About twenty-five thousand Parisians were killed in these seven days, the vast majority of whom were slaughtered in cold blood.

6

The Final Struggle for Freedom of Caricature in France, 1871–1914

A number of liberal and radical caricaturists and journalists, including Pilotell, fled France for fear of prosecution in the aftermath of the suppression of the Commune, and others were jailed for their political views in the roundup which led to the temporary or long-term imprisonment of as many as fifty thousand alleged Communards. The hopes, among artists and journalists who remained at liberty in France, that complete freedom of the press and of caricature would be restored with the suppression of the Commune were to be dashed. Not only did the April 15, 1871 press law, passed by the French National Assembly at Versailles, which had restored censorship of caricature (while subjecting the printed word to lesser if still considerable restraints) remain in force, but the maintenance of a state of seige in about half of France until 1873 and in Paris and other major radical centers until 1876 allowed local officials to take additional arbitrary measures against the press.

Even after the states of seige were lifted, caricature remained subject, until 1881, to a censorship which was administered in the 1870s with an extraordinary combination of harshness and arbitrariness. Caricature historian Jacques Lethève has accurately characterized the censorship of the 1870s as marked by an "extreme incoherance which betrayed the uncertainties of the regime." The result was an intensified ten-year reprise of the 1867–70 struggle over freedom of caricature and a substantial restraint upon the caricature journals of the period. One clear indication of the impact of censorship was that during the 1872–79 period the average number of caricature

journals published annually was less than twenty, fewer than the average of over twenty-five published yearly between 1867 and 1870, and less than half the average of over fifty which would be published between 1880 and 1885, in anticipation of and under the 1881 law which permanently abolished censorship.[1]

As Lethève suggests, the tyrannical, inconsistent, and often irrational nature of caricature censorship in France during 1871–81 clearly reflected the unstable nature of French politics during the period. The National Assembly elected during the final stages of the Franco-Prussian War in February 1871 was dominated by royalists, but they were divided into two monarchist wings—adherents of the Bourbon dynasty overthrown in 1830 and of the Orleanist dynasty overthrown in 1848—plus a small band of supporters of the Bonapartist regime overthrown in 1870. The monarchist factions were able to unite on May 24, 1873, to force the resignation of National Assembly President Adolphe Thiers, who, although highly conservative, was viewed as "soft" on republicanism. However, the two monarchists groups became deadlocked over choosing a new king. The Bourbonists refused to accept the Orleanist pretender, the comte de Paris. The Bourbon pretender, the comte de Chambord, was twice on the verge of being crowned with Orleanist support during the 1871–73 period but insisted on the impossible condition that the revolutionary tricolor flag be abandoned in favor of the white Bourbon standard, which symbolized the ancien régime. Due to this deadlock, France remained a de facto republic. A republican form of government was finally officially established in January 1875 by a vote of 353 to 352 in the still royalist-controlled National Assembly, as the monarchist factions remained unable to settle their differences.

In the meantime, avowed republicans had been steadily gaining strength as the monarchists squabbled. In legislative by-elections held between 1871 and 1874, 126 republicans were elected, compared to only 33 monarchists and Bonapartists, and, under the 1875 constitution, republicans obtained a majority in the February-March 1876 elections for the lower legislative house (the Chamber of Deputies). However, Marshal MacMahon, the reactionary monarchist president, who had been elected by the Assembly in 1873 to replace Adolphe Thiers, provoked a major crisis by at first refusing to appoint a republican ministry in the aftermath of the 1876 elections and then, on May 16, 1877, by dissolving the Chamber of Deputies and calling new elections for October 1877. These elections returned another republican majority and forced MacMahon to appoint a republican ministry in December 1877, despite conditions of shocking administrative election pressure, purges, and repression (including about twenty-five hundred press prosecutions in 1877 alone).

The republicans sealed their triumph by winning the January 1879 elections for the upper house (the Senate), which quickly led to the resignation of MacMahon and his replacement by republican Jules Grévy. However, until about 1881, the newly triumphant republicans remained extremely wary of a possible royalist resurgence and generally remained on edge, due not only to their recent arrival in power but also to the bitter controversies which raged over granting amnesty to Communards still in jail or exile and over the issue of restricting clerical influence over education. Only with several key democratic reforms in the early 1880s could it be said that the Third French Republic had become firmly entrenched. These included the passage of the landmark press law of 1881, which greatly eased restrictions on the printed word and permanently abolished (at least in peacetime) censorship of caricature.

The War over Freedom of Caricature under the "Monarchist Republic," 1871–77

Although France was a republic, in fact or in legality, throughout the 1871–81 period, before 1878 caricatures forbidden by the censors were almost invariably prorepublican or critical of one or more of the royalist factions, reflecting the royalist domination of the administrative bureaucracy and also the censors' fears of approving caricatures critical of forces which might soon come to power. Thus, the leading victims of censorship during the 1871–77 period were the four most important republican caricature journals, *Le Grelot* (1871–1907), whose leading caricaturist until 1875 was Alfred Le Petit; Charles Gilbert-Martin's Boudeaux-based *Le Don Quichotte* (1874–93); and *L'Eclipse* (1868–1919) and *La Lune Rousse* (1876–79), the two great journals dominated by the leading caricaturist of the era, André Gill.

Many of the minor republican caricature journals also suffered troubles with the censors during this period, including *Le Bacchanal* (1876), *Le Carillon* (1876–83), *Le Cri-Cri* (1872–73, 1876), *L'Eclair* (1877), *La Fronde* (1874–75), *Le Pétard* (1877–79), *Le Peuple Souverain* (1872), *Le Polichinelle* (1874–75), *Le Scapin* (1875–76), *Le Sifflet* (1872–78), and *Le Trombinoscope* (1872–76). Thus, historian Charles Virmaitre records that on one occasion *Le Sifflet* submitted a drawing to the censors that was so complicated "that the illustrator himself could not say what he was trying to represent," yet the authorities declared that while "the drawing is not clear," *Le Sifflet* was "an enemy of the family, of property and of religion" and the caricature "makes injurious allusions against the government. You cannot print it."[2]

Even a lithograph by the renowned "serious" artist Edouard Manet was banned in 1874 because his portrayal of a club-wielding Polinchinelle, a well-known clown character, was deemed to resemble too closely President MacMahon (who was nicknamed "Marshal Baton," due to his authoritarianism and role in repressing the Commune).[3] Manet's intentions remain unclear, as his drawing was modeled on a friend, Edmund André, who resembled MacMahon, and the picture had earlier been displayed as a watercolor without difficulty. However, police raided the lithographic print shop where "Polinchinelle" was being published and seized fifteen hundred copies of it. As the Manet affair suggests, it was virtually impossible to caricature President MacMahon legally throughout the 1873–79 period of his presidency. The censors even banned *Le Carillon* from publishing a drawing of MacMahon on June 2, 1877, although the newspaper published a letter giving his written authorization. On another occasion in 1877, an artist and his printer were prosecuted for publishing a drawing of MacMahon on horseback, which was captioned, "That horse has an intelligent look, indeed!"[4]

While censorship of caricature was arbitrary and harsh throughout the 1871–77 era of the "monarchist republic," it was especially so during two crisis periods. The first, extended, crisis period was that of 1871–75, associated with the post-Commune repression, intense quarreling between the monarchist factions, rising republican strength, and republican outrage over the forced resignation of Thiers. This period was highly colored by the authorities' deep-seated fears of anything that might recall memories of the dreaded Commune. Thus, on December 28, 1871, the military governor of Paris issued a decree under his state of seige powers which forbade the sale or display of "all illustrations, photographs or emblems of a nature to trouble the public peace," including specifically pictures of "individuals prosecuted or condemned for their participation in the recent insurrection." This decree, which was interpreted to include virtually all scenes related both to the Commune and its suppression, was extended to apply throughout France in November 1872, and was supplemented by messages from the interior minister to the prefects demanding harsher general administration of the caricature censorship which were dispatched on January 11, 1872, and on five separate occasions in 1874 (for example, a May 4, 1874 circular demanded a "most vigilant" and "rigorous application" of the law, and a July 8, 1874 message instructed the prefects to submit for the personal decision of the minister "all doubtful cases," including "all prints which present a political character or which could lead to problems from the point of view of morals and religion"). The images targeted by these decrees and messages were highly popular and widely distributed; for example, 200,000 copies of a

single photo of one Commune leader were sold across France at one franc each. The December 28, 1871 decree was followed by what press historian Fernand Drujon has termed several months of "incessant searches and seizures" and an "almost incalculable" number of trials for the sale of images relating to the Commune. These images took the form not only of caricatures and photographs, but also of medals, statues, coins, pipes, cigarette cases, and even tapioca boxes. The display of the Phrygian (red liberty) cap, associated with radical republicanism was formally forbidden also and officials throughout France waged war against the exhibit of busts of "Marianne," the female symbol of republicanism who wore the forbidden headgear. The intensity of the search for subversive images during this period can perhaps best be gauged by the following incident: although *Le Grelot* had been bitterly attacking the renewed censorship for months, on January 7, 1872, it printed a boldface notice to its vendors that the governor's December 1871 decree "does not apply to illustrated publications" since "all our drawings have been preliminarily submitted to the minister of the interior" and *Le Grelot* "only publishes those which have obtained the approval of the minister." Caricature journals were prosecuted on several occasions during the 1871–75 period for defying the censorship law: thus, the editor of *L'Eclipse* was fined three hundred francs and sentenced to a month in jail in late 1872 for publishing an anodyne but unauthorized Gill caricature which depicted American president Grant instructing Thiers in the art of republican governance, and prosecutions were also brought against *Le Trombinoscope* in 1872, and against both *Le Polinchinelle* and *La Fronde* in 1874.[5]

The second intense period of caricature censorship during the 1871–77 period came in 1877, as can be easily demonstrated due to the unusually complete state of archival censorship records for the 1875–77 period. During 1875 a total of 225 illustrations were banned by the censors, but this number dropped to 100 in 1876, apparently reflecting the appointment of republican censors in the aftermath of the republican election victories in early 1876. However, with the growing tension between the republican legislature and President MacMahon, which culminated in the legislative dissolution of May 1877 and the appointment of a monarchist ministry, there was a massive increase in censorship bans, which reached a climax during the period leading up to the October 1877 elections. Thus, during all of 1877 a total of 243 illustrations were forbidden, and during the third quarter of 1877 alone 102 censorship bans were imposed, more than during all of 1876.

The impact of the changing climate can also be traced with regard to particular journals. For example, sixty-seven caricatures submitted by *Le Grelot* were forbidden in 1875, a number which dropped sharply to thirty in

1876 but which increased again to forty in 1877. While seventeen submissions from André Gill's *L'Eclipse* were rejected in 1875 and only seven *L'Eclipse* caricatures were banned in 1876, twenty-five caricatures submitted by Gill's new outlet, *La Lune Rousse,* were turned down in 1877; the journal was repeatedly seized and fined over seven hundred francs in two convictions for publishing unauthorized drawings during the election crisis. Two journals which were founded in 1877 ran into censorship slaughterhouses, with *Le Petard* and *L'Eclair* both suffering twenty-three rejections, and the latter forced to close down after publishing only four months, during which it was fined for printing an unauthorized drawing, and, due to Anastasie, missed two issues and published several others with blank pages or with drawings protesting the censorship replacing the originally planned illustrations. In some of the provinces, blanket bans were imposed on the street sale of opposition caricature journals during the 1877 campaign. Thus, *Le Carillon* (which was fined fifty francs in September 1877 for publishing an unauthorized caricature) reported on August 18 that street sale bans had been imposed in at least seven *departements* (French administrative subdivisions). After the election was over, *La Lune Rousse* reported on December 20, 1877 in "an important notice to our representatives in the *departements*" that the "ban on sale on the public streets of republican journals has been lifted."[6]

Some of the most interesting and incessant harassment of caricature during the 1871–77 period was endured by *Le Don Quichotte,* edited by Gilbert-Martin, the same caricaturist who had been jailed in 1868 for publishing unauthorized drawings while editor of *Le Philosophe.* After enduring sporadic censorship bans before 1877, *Le Don Quichotte* was subjected to intense harassment following MacMahon's appointment of a new prefect for Bourdeaux, Jacques de Tracy, in May 1877, following the dissolution of the legislature. On July 6, 1877, after a caricature was banned which simply depicted an old athlete futilely trying to lift a weight marked "363" (a reference to the 363 legislators who had voted "no confidence" in MacMahon's government), *Le Don Quichotte* announced it would protest by refusing to publish any more caricatures until Tracy was replaced. Gilbert-Martin kept to his pledge of not publishing caricatures for over four months, until Tracy was removed in the aftermath of the October elections. In the meantime he kept up a steady drumbeat of acid and mocking criticism of Tracy, sometimes using clever forms of typographical art (print arranged in unusual shapes) to emphasize his points (fig. 60). In a front-page typographical "picture frame" published on July 20, 1877, Gilbert-Martin asked Tracy, "Do you believe subversion is hidden in circulars about lost dogs?" and in a typo-

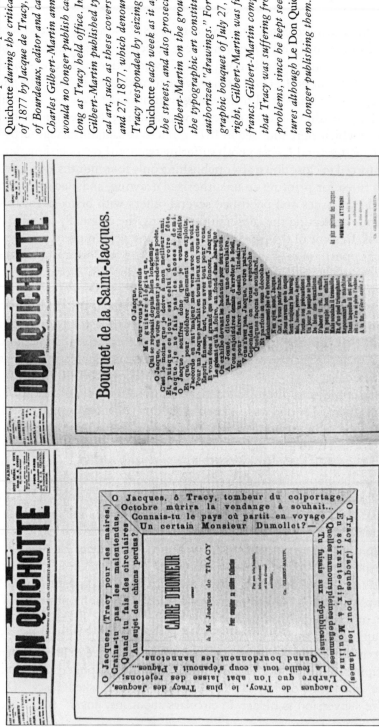

Figure 60. As the result of repeated censorship bans imposed on Le Don Quichotte during the critical election of 1877 by Jacque de Tracy, the prefect of Bourdeaux, editor and caricaturist Charles Gilbert-Martin announced he would no longer publish caricatures as long as Tracy held office. Instead, Gilbert-Martin published typographical art, such as these covers of July 20 and 27, 1877, which denounce Tracy. Tracy responded by seizing Le Don Quichotte each week as it appeared on the streets, and also prosecuted Gilbert-Martin on the grounds that the typographic art constituted unauthorized "drawings." For the typographic bouquet of July 27, on the right, Gilbert-Martin was fined fifty francs. Gilbert-Martin complained that Tracy was suffering from vision problems, since he kept seeing pictures although Le Don Quichotte was no longer publishing them.

graphic "bouquet" published on July 27, he suggested, "Tomorrow you will order the sun to stop." Tracy began seizing issues of *Le Don Quichotte* week after week as soon as they were published, thereby generating a huge demand for them, and initiated numerous prosecutions for the publication of unauthorized "drawings" (i.e., the typographic art).

Even after Tracy's removal, Gilbert-Martin's troubles did not end (partly because he deliberately published without authorization several real caricatures). Altogether Gilbert-Martin was prosecuted over a dozen times between May 1877 and March 1878. He was acquitted in some of the typographic art cases on the grounds that the publications in question were not really drawings and therefore did not require prior approval. However, he was convicted and given fines of fifty francs in two such cases, including the "bouquet" of July 27, and was fined five hundred francs and sent to jail for ten days for two incidents clearly involving the publication of caricatures without authorization. Despite the severe harrassment he endured, Gilbert-Martin had the last laugh on the authorities as the result of his "subversive clysopompe" issue of August 31, 1877. Gilbert-Martin reported that Prefect Tracy had seized some items in the mail a few days before which had been packed in a container similar to those used to convey issues of *Le Don Quichotte*. However, he reported, the seized material was merely some sheets and a *clysopompe* (a device used for enemas) that he had sent to an elderly hospitalized friend. Gilbert-Martin trumpeted this news item on the front page of *Le Don Quichotte*, suggesting that perhaps Tracy thought that even an innocent *clysopompe* posed a threat to the regime. According to Henri Avenal, a leading historian of the French press, the widely reported *clysopompe* affair led to an "outburst of general laughter in France." A biographical sketch of Gilbert-Martin published in the 1880s reports that when President MacMahon came to Bourdeaux to visit Tracy during the 1877 campaign, he was bewildered by popular chants of "*cly-so-pompe*" and that when Tracy sought election to the legislature from a nearby district, he lost after being followed around by political opponents who loudly peddled clysopompes.[7]

As in the 1867–70 war over caricatures, the dominant artist of the 1871–77 period and the target of the most incessant censorship harassment was Gill.[8] As previously noted, Gill's caricatures for *L'Eclipse* between 1871–76 and subsequently for his own journal *La Lune Rousse* were banned by the censors on scores of occasions, often for reasons that can be deciphered but sometimes on grounds that were unfathomable at the time and remain so today. In August 1877, for example, the censors banned from *La Lune Rousse* a drawing which simply depicted a man with a vague resemblance to Napoleon III playing a clarinet in front of a small candle.

In a number of cases, the censors allowed Gill's caricatures to appear but only after undergoing severe mutilation, which sometimes destroyed their original meaning, as in the caricature mourning the forgetting of Thiers' contributions, published in *L'Eclipse* of August 3, 1873 (fig. 1; see chapter 1). Upon the death of Thiers in September 1877, amidst the election campaign of that year, Gill published in *La Lune Rousse* of September 16 a drawing depicting a female France placing a wreath on Thiers in his deathbed (fig. 61). The original had portrayed Republican Leon Gambetta saying good-bye to Thiers, but as Gill reported in *L'Eclipse,* the censors would not allow "this rapprochement between a man who has been president of the Republic and another who could be." On some occasions, censorship mutilations probably backfired, as in the caricature depicting Thiers delivering a baby published in *L'Eclipse* on August 24, 1872 (fig. 10; see chap. 2). In another such instance, on April 27, 1873, *L'Eclipse* published a caricature which showed a government-backed candidate for the legislature drinking a toast "to the health of the republic" next to a glass carried by an unattached arm (fig. 62). The censors had eliminated Gill's original portrayal of an opposition candidate, but given Gill's well-known republican predilictions, it probably required no great skill to guess Gill's intentions, and his candidate in fact won the election.

Curiously, the censors repeatedly allowed publication of caricatures attacking themselves, and some of Gill's finest published work consisted of attacks on Anastasie, for example, his *L'Eclipse* drawing of November 30, 1873, mourning the death of caricature (fig. 63), as well as other drawings previously discussed (see chap. 2). Such drawings, together with those of Gill's caricatures attacking the royalist pretenders and supporting republicanism which were published after being approved by the often inconsistent censors, maintained Gill's position as the leading political caricaturist of his time throughout the 1870s. An English visitor, George Sala, who traveled to Paris in 1878–79 reported that one of Gill's latest caricatures "is selling by the tens of thousands" and that Gill was the "satirical draftsman most in vogue at the present . . . after whom the crowd runs and at whose works they stare at with delighted eyes."

As during the 1867–70 period, Gill was widely credited by his contemporaries with playing a significant role in discrediting the authoritarian regime. For example, one Paris journal wrote in 1881 that Gill had "established the republic with a series of improvised masterpieces," while caricature historian Emile Bayard records that

as soon as the enormous portraits signed A. Gill appeared in the kiosks, anger declined and bursts of laughter so communicative shook the crowd. During the

210

Figure 61. Right: On September 16, 1877, La Lune Rousse published this drawing by André Gill, showing the personification of French liberty saying "adieu" to Adolphe Thiers, the former president who had supported republicanism during the "monarchist republic" of the early 1870s. Left: In the original drawing, Gill had portrayed leading republican politician Leon Gambetta as saying "adieu" and presumably inheriting Thiers' legacy, but the censors would not permit Gambetta's portrayal.

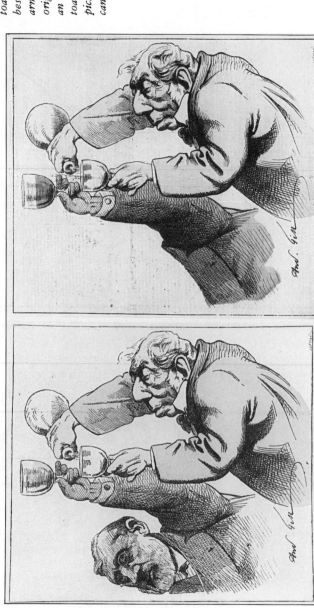

Figure 62. Right: On April 17, 1873, L'Eclipse published this drawing by André Gill, which depicted an "official" legislative candidate drinking "a toast to the health of the republic," beside a mysteriously disembodied arm holding another glass. Left: In the original drawing, Gill had portrayed an opposition candidate joining in the toast, but the censors barred this depiction; nonetheless, the government candidate was defeated.

Figure 63. The constant censorship harassment of the 1871–81 period often inspired artistic protests by caricaturists. Left: André Gill, in L'Eclipse *of November 20, 1873, mourned the "burial of caricature." Gill is shown on the left, accompanied by a dog carrying an artist's crayon; L'Eclipse editor François Polo is on the right, as caricature is carried away in a coffin. Right: Le Sifflet of July 20, 1873, also printed a black-bordered cover as it announced the burial of a censored caricature, which had depicted the visiting Shah of Persia as a cat.*

bad times of May 24 [1873, when Thiers was forced out] and May 16 [1877, when MacMahon dissolved the republican-controlled legislature], the artist rejuven-ated with his always-bursting joy the most demoralized energies; he used ridicule to kill evil. What an excellent manifestation of French wit! How all those draw-ings sang and laughed on the silent page. At first glance, moreover, Gill's carica-ture appeared inoffensive; but it was thus only more dangerous, because soon the crowd deciphered an idea which exploded in contempt of all sanction, all censor-ship. . . . [The censors] ended by forbidding designs which they couldn't under-stand for fear of not having understood the allusion. . . . Nonetheless, how many designs taunted the censors whose perspicacity had been deceived![9]

Even the censors reportedly gave Gill their grudging admiration. Thus, *La Lune Rousse,* of August 26, 1877, quoted a censor as telling Gill that "you have much spirit, but your spirit troubles us. I came into office on May 16; I will leave perhaps; but until then, as censorship is a weapon, I will make use of it."

Journals which were vexed by the censors between 1871 and 1877 com-plained long and loud about their travails. Thus, when *Le Cri-Cri* briefly resumed publication after a three-year hiatus on July 23, 1876, it reported that the "pestering of Dame Anastasie and some court harassment" played a major role in its "forced retreat." *Le Sifflet* of August 20, 1876, complained that Anastasie was keeping for herself alone "the gayness of the image." A number of journals, including *Le Sifflet, Le Grelot, L'Eclair, Le Don Qui-chotte,* and *La Lune Rousse,* frequently provided detailed written descrip-tions of banned caricatures to bring out the absurdity of censoring images but not words (as discussed in chap. 2), and often appeared either with drawings which protested censorship or with written protests about censor-ship to fill in blank spaces left by censored caricatures (figs. 64–65). For example, *Le Sifflet* appeared on July 20, 1873, with a black-bordered front page which contained a written invitation to its readers to attend a funeral service to bury a censored caricature which had depicted the Shah of Persia, then visiting France, in the form of a cat (fig. 63). An accompanying poem termed the forbidden drawing so innocent that the Shah himself "would have laughed." *Le Grelot* also appeared without its usual front-page carica-ture on September 16, 1877, and instead bore a protest explaining that when such events occurred "it's always the fault of Anastasie" as "she only allows publications of the things that please her" and "by unfortunate luck, she always finds herself horribly displeased with us."

Le Grelot was one of the most frequent targets and most frequent critics of censorship. It complained on October 29, 1871, that censorship decisions kept changing with the views of each censor: "Today the chief of the press division is a Bonapartist; he will perhaps be Orleanist tomorrow and tilt

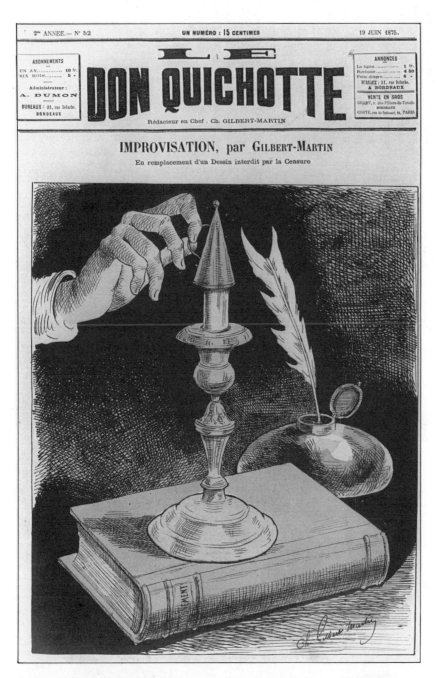

2ᵐᵉ ANNÉE.— N° 52 UN NUMÉRO : 15 CENTIMES 19 JUIN 1875.

ABONNEMENTS
—
UN AN............ 10 fr.
SIX MOIS......... 5 »
—
Administrateur :
A. DUMON
—
BUREAUX : 21, rue Delurbe.
BORDEAUX

ANNONCES
—
La ligne................. 1 fr.
Réclame.................. 4 50
Faits divers............. 6 »
BUREAUX : 21, rue Delurbe.
A BORDEAUX

VENTE EN GROS
GRABY, r. des Piliers-de-Tutelle
BORDEAUX
COSTE, rue du Croissant, 21, PARIS

LE
DON QUICHOTTE

Rédacteur en Chef . Ch. GILBERT-MARTIN

IMPROVISATION, par GILBERT-MARTIN

En remplacement d'un Dessin interdit par la Censure

Figure 64. In response to the censorship of his planned drawing, Charles Gilbert-Martin in Le Don Quichotte *of June 19, 1875, published this drawing which depicted a candlesnuffer (éteignoir) stifling enlightenment, represented by the candle and the book, entitled "Education."*

Figure 65. L'Eclair's life was short-lived due to the intense censorship harassment associated with the crisis French legislative elections of 1877. Twenty-three of its caricatures were refused during the four months it was able to publish and on many occasions L'Eclair appeared with blank front pages or with protest caricatures substituted for those originally planned. Left: In its issue of June 24, 1877, L'Eclair replaced its censored caricature with a huge fig leaf accompanied by a question mark. Right: L'Eclair featured a protest drawing which showed a caricaturist's crayon chained to a post, apparently being bathed in a flood of the caricaturist's tears, in its issue of August 1877. By then, so many issues had been disrupted by censorship that the journal no longer appeared with an exact publication date.

after that toward the legitimists [Bourbonists]. In that case, what will become of us?" The main concern of the censors, *Le Grelot* suggested, was to preserve their jobs, which meant not only pleasing their current masters but also possible future rulers. Thus, in a parody published on March 17, 1872, *Le Grelot* reported on the "nightmare of a censor," in which the leading character was quoted as moaning that he had inadvertently let an anti-Bonapartist emblem appear in a caricature because, "I really believed that day that the future was monarchist. Yes, but they say now that the Bonapartists will return to power. . . . What a life, my God . . . my job! my job! . . . If only I knew what the future would bring." On November 9, 1873, *Le Grelot* lamented that "in their uncertainty, the censors have taken the heroic resolution to forbid all which could touch anyone or anything" for fear of losing their posts under a future regime. Amidst the 1877 barrage of censorship bans, *Le Grelot* screamed, "for seven years, we have been able to observe: THE MINISTERS CHANGE BUT CENSORSHIP REMAINS."

Le Don Quichotte also frequently complained bitterly about censorship. Editor and caricaturist Gilbert-Martin lamented on March 25, 1875, that when he drew a dentist, the censors "see an excitation to hatred against the government." He complained repeatedly about prior censorship imposed on the image but not the written word, asking on July 24, 1874, "Is the crayon more guilty than the pen?" and protesting on June 26, 1875, that censorship was marked by neither "spirit nor logic" and had made illustrated journals "a pariah in the family of journalism." On June 8, 1877, Gilbert-Martin lamented that "the censorship [bureau] refuses a design because it refuses it, without having to furnish any reasons." He complained three weeks later in an open letter to Prefect Tracy that in the past "you have seized my drawing because you understand it; this time you forbid it because you don't." On August 10, 1877, during the period when Tracy prosecuted *Le Don Quichotte* for publishing unauthorized typographic art, Gilbert-Martin declared that the prefect was suffering from delusions and "he would be wise to call a doctor" since he "continues to see illustrations in *Le Don Quichotte* although it has ceased to publish them for five weeks."

Le Don Quichotte and other caricature journals frequently complained heatedly that they were being persecuted for being republican journals in a republic, while periodicals which attacked republican ideals went unscathed. Thus, on March 8, 1878, Gilbert-Martin declared that his journal, "republican and not at all violent," was "innundated with seizures, crushed with fines" while other journals "can deliver with impunity the most odious attacks not only against republicans but against the republic." *Le Rappel* of December 2, 1872 (quoted in *L'Eclipse* of December 8, 1872), reported on the conviction of *L'Eclipse* for publishing an unauthorized caricature by la-

menting, "It is a difficult trade to edit a republican journal; but the difficulty becomes impossible when the journalist wishes to join caricature to prose." *L'Eclipse* complained on January 21, 1872, in an open letter from editor François Polo to the minister of the interior, that "all the suppressions which strike my illustrated publication aim at those subjects who belong to the enemies of the state of things which you serve," such as "clerical intolerance," the "pretensions of the Orleanist party," and the "man of Sedan [Napoleon III]." On February 25, 1872, *L'Eclipse* lamented that the "arbitrariness and idiocy" of censorship by the "magistrates of the republic" might even "make us regret the fall of the [Second] Empire." An ironic letter printed in *L'Eclipse* on November 11, 1872, declared that things had been better under monarchical rule, since at least then one could freely make fun of the enemies of the regime, while under the republic it was "absolutely forbidden to draw the foes of the government," to "second the President of the Republic [Thiers] in mocking his adversaries," or to "laugh at anything—except the republic." On December 22, 1872, *L'Eclipse* complained that the censorship bureau was being controlled by a former functionary of Napoleon III who was demonstrating "sincere devotion" to all "regimes which have fallen and which occur—except that under which we live."

L'Eclipse and the other major journal which featured Gill's drawings, *La Lune Rousse,* were probably the most constant and bitter enemies of Anastasie. On December 22, 1872, *L'Eclipse* lamented that despite three revolutions (those of 1830, 1848, and 1870) which were supposed to have "crushed censorship under reclaimed rights," the "phoenix of arbitrariness has been reborn—not from its own cinders, but from the cinders it creates from books, drawings, our rights and our freedoms!" On August 3, 1873, *L'Eclipse* reported that its large collection of refused designs by Gill was becoming "an artistic curiosity of very great interest." On March 22, 1874, the journal reported a new addition to this collection. It bitterly protested the suppression of a Gill caricature of Victor Hugo, which had been presented to the censorship with a note from Hugo, who termed it a "beautiful" and "charming" illustration. *L'Eclipse* lamented, "Gill has once more deceived himself. He made a great illustration about a great book. But he forgot that his work was to be delivered to small men who only serve petty hates." In an April Fool's issue published on April 4, 1875, *L'Eclipse* reported that a drawing had been refused for "not having a sufficiently accentuated satiric tone" by a censor who urged the paper to "have a little audacity, by God!" and to demonstrate "a vigorous republican note."

When *L'Eclipse* reduced its size in 1876, Gill departed and the journal declined into insignificance. But in the same year he founded *La Lune*

Rousse, which continued the struggle against censorship, especially during the 1877 election campaign. On August 26, 1877, the journal described three recently refused drawings and denounced the practices of the censors as amounting to the

> suppression of *La Lune Rousse* without a trial. *La Lune Rousse* will not be eclipsed in the middle of the battle. We are here, we will stay. Until the end! When the public finds a fantasy drawing in the place of one more or less political, it will be because censorship has used its arbitrary weapon against us. We will hold on during this fierce little war which has been declared against us and which we accept.

Although this issue appeared without a caricature, it was seized and *La Lune Rousse* was fined one hundred francs, supposedly for another article, which had been previously published in 1869 without any legal repercussions. On November 18, 1877, two weeks after publishing a cross to mark its tenth refused drawing within a couple of months, *La Lune Rousse* reported the second and third refusals in its "new series" of banned caricatures but again promised "we will not let ourselves be beaten by this systematic harassment." The journal promised to "fight until the end," and accurately predicted "our end, we believe, will come later than that of the [MacMahon] government."

CENSORSHIP OF CARICATURE UNDER THE "REPUBLICAN REPUBLIC," 1878–81

MacMahon's resignation came in January 1879, immediately after the republican victory in the Senate elections of that month. The republican control of the Senate, and of the presidency, with MacMahon's replacement by Jules Grévy, consolidated the increasing control which moderate republicans had exercised over the government since MacMahon had been forced to appoint a republican ministry in December 1877. Yet, although republicans had made freedom of expression one of their major demands and campaign promises, censorship of caricature was not abolished until 1881, and after a sharp decline in censorship rejections in 1878, by 1880 such bans reached levels comparable to those of 1871–75 and 1877. Thus, although the number of censorship rejections dipped drastically to 73 in 1878 (compared to 243 under the monarchist-oriented ministries of 1877), they climbed to 127 in 1879 and then skyrocketed to 226 in 1880 (compared to 225 in 1875 and 243 in 1877).[10]

The explanation for this phenomenon appears to be threefold: (1) during

the 1878–81 period the moderate republican ministries felt extremely inse-
cure, as they came under attack from both right and left and attempted to
further consolidate their power while attempting to deal with such ex-
tremely contentious issues as demands for amnesty of the Communards and
the question of church-state relations, especially with regard to educational
policy; (2) the republican ministries were faced with the previously almost
unknown phenomenon (with a few minor exceptions, such as *La Charge* of
1832–34) of openly royalist caricature journals, which they seem to have
feared and hated as much as royalist regimes had disliked republican carica-
ture outlets; and (3) in anticipation of the abolition of caricature censorship,
which was finally enacted in 1881, there was an explosion of caricature jour-
nals in 1880–81, many of which flouted the censorship rules and/or special-
ized in erotically suggestive art.

Among the targets of censorship and prosecutions during the 1878–81
period were, among republican journals, *Le Carillon, La Lune Rousse, La
Nouvelle Lune* (1880–93), *Le Père Duchêne Illustré* (1880), *Le Pétard*
(1877–79), *Le Sans-Culotte* (1878–79), and *Le Titi* (1878–80); among
monarchist journals, *Le Droit du Peuple* (1876–81), *La Jeune Garde*
(1877–80), *Le Monde Parisien* (1878–83), *Le Triboulet* (1878–1921), and
La Trique (1880–81); and among "erotic" periodicals, *Le Boudoir* (1880),
L'Evénement Parisien Illustré (1880–82), and *La Vie Parisienne* (1863–
1949). While, as will be discussed below, the monarchist journal *Le Tri-
boulet* suffered most severely from prosecutions, many republican journals
were also hauled into court, usually for publishing unauthorized caricatures.
La Lune Rousse was fined seven hundred francs for such offenses in March
1878 and April 1879; *Le Titi* was convicted three times in 1879 and
fined a total of one thousand francs, and its editor was jailed for a month;
Alfred Le Petit's two journals, *Le Pétard* and *Le Sans-Culotte,* were each
convicted and fined once in 1878, and both ceased publishing in 1879 partly
due to censorship problems; and Henri Demare, the leading caricaturist of
Le Carillon, and his editor Louis Lambert were each sentenced to jail terms
of six days and fined one hundred francs for "outrage to public morals" for a
Demare drawing published on September 28, 1879, entitled "Question of
the Pretenders." Aside from suggesting that the monarchist pretenders
were all alike and that none of them would be pleasant alternatives for
France—a suggestion hardly threatening to the republic—the "pretenders"
caricature was so anodyne as to be almost unintelligible (fig. 66), and *Le
Carillon* bitterly protested the sentence, especially because it claimed the
drawing had twice been authorized by the censors.[11]

Republican caricature journals were bitterly critical of the maintenance of
censorship under republicans who had been expected to immediately abol-

Figure 66. Left: Le Carillon's caricaturist Henri Demare and his editor were both sentenced to short prison terms for this drawing, published on September 28, 1879. Le Carillon vociferously maintained that the print, entitled "Question of Pretenders," had been approved by the censors, but the pair were nevertheless prosecuted for publishing an unauthorized drawing. Although at least to modern eyes the caricature is not clear, it apparently suggests, in a rather vague and anodyne manner, that the monarchist pretenders to the French throne were all about the same in their unpleasantness. Right: On November 25, 1879, Le Carillon published this drawing by Demare, depicting the two men in jail with a crayon and a pen in their manacled hands. In the background can be seen a caricature much like the one that led to the prison sentence.

ish it. Although formerly forbidden artistic criticisms of fallen dynasties was generally, if not always (as the "pretenders" caricature demonstrates), allowed after 1877, criticism of the sitting republican ministries and illustrated comments on contentious issues like the church-state relationship were often banned, leading republican caricature journals to publish cries of outrage accusing republican ministers of having abandoned their beliefs once in power. On January 27, 1878, *Le Grelot* called upon Hector Pessard, the republican functionary and former journalist recently appointed to head the censorship office, who was reputedly "sympathetic" to the complaints of journalists, to simply stop enforcing censorship; it declared there was no need for a law to abolish an institution established by a decree "promulgated by bandits in the aftermath of the crime of [Louis Napoleon's coup of] December [1851, which was followed by his February 1852 press decree which remained the legal basis for the censorship after 1871]." In the meantime, it lamented that, after having had "for seven months almost all of our drawings torn by the repugnant paws of May 16, we have the right, it seems to us, to some other consolation than that accorded us presently, which consists of seeing them eliminated by the sympathetic pen of M. Pessard." It claimed that one of Pessard's censors, in refusing a sketch critical of the new republican government, had told *Le Grelot* that it could "attack, if you wish, our adversaries," but not "a republican minister who employs functionaries like me, oh! . . . that would be in bad taste, unseemly, inadmissible in the end." *Le Sans-Culotte,* in its issue no. 30 of 1878, also attacked Pessard, terming him "one of those versatile beings who turn in the wind of power like a weathervane. If he defends liberty under the regime of May 16, then, as soon as he has received his piece of the pie, he shows himself more reactionary than his predecessors. No one brings more shackles to the liberty of the press and of the crayon than this liberal of papier-mâché."

The departure of Pessard later in 1878 had little effect on censorship. On March 30, 1879, *Le Grelot* reported that five sketches had been refused for a single issue and that the only explanation for the continuation of censorship had to be that Bonapartists had cleverly disguised themselves as republican ministers, taking their names, habits, and "finally introducing themselves in their skins." On March 20, 1881, only four months before censorship was abolished, *Le Grelot* appeared without its normal front-page caricature. It complained that this lack was due to "censorship, which has not yet expired under the blows of the energetic republican majority which we have enjoyed for four years now" and which for two weeks "has refused us with a touching unanimity all drawings which we have submitted." *Le Grelot* added, "Not being able to cheer up the days of our readers in giving them gay caricatures, we will try to procure for them good nights with our soporific prose. We

hope they will pardon us for the insufficiency of the compensation given the excellence of the intention." Similar complaints about republicans betraying their principles once in office were a staple of the republican caricature press. *La Lune Rousse* of April 20, 1879, reported that a prior issue with an unauthorized anticlerical caricature had been seized, and exclaimed:

> One sees it: the more things change, the more they stay the same. As under the Empire [of Napoleon III], as under the May 16 regime [of MacMahon], censorship continues to submit to clerical influence. That which was comprehensible under regimes cynically tyrannical becomes fantastic under a regime which calls itself republican. . . . In spite of their liberal displays, this government obstinately retains the functionaries and institutions of despotism.

Reporting the censoring of another anticlerical caricature on May 11, 1879, *La Lune Rousse* declared, "If things continue like this, we will ask for a return of the liberties of the regime of May 16." On October 19, 1879, while reporting yet another instance of censorship, *La Lune Rousse* demanded, "How can a government which claims to be republican have the impudence to retain, despite the unanimous protests of the press, an institution as reactionary and despotic as censorship?"

La Nouvelle Lune, another republican victim of censorship, complained in its issue of September 5, 1880, that the government was "authorizing pornographic slop in a pile of disgusting papers, but forbidding political drawings which are scarcely dangerous." *Le Titi* declared on March 19, 1879, in response to prosecutions for publishing unauthorized caricatures, that its only offense was seeking to "graze a little like a free flower." It especially attacked republican officials like Minister of Education Jules Ferry for refusing to give their authorization for caricatures of themselves. Thus, on May 3, 1879, *Le Titi* declared that "these parvenu *messieurs* don't like it any more than their monarchist predecessors did when one tells the truth about them" and that such ministers were "even more snobbish and even less approachable than those of the Empire!—O shame!" *Le Titi* returned to this theme on June 7, 1879, lamenting that so-called reformists like Ferry "are at the same time despots and tyrants when it is a question of their portrayal."

While the republican censorship of the 1878–81 period clearly did not treat republican caricature journals gently, the censorship scissors was even harsher toward the group of monarchist caricature journals that were founded after the first republican-controlled ministry took power after the elections of early 1876. The sudden emergence of five such journals within four years highlighted the almost complete prior absence of conservative caricature journals in nineteenth-century France. The previous lack of such

223

journals probably was due to two factors: (1) satirical political journals, by nature, thrive on opposition to the government in power, and the almost continuous control of the French government by highly conservative forces before 1875 therefore did not provide fertile ground for conservative caricature outlets; and (2), in general, conservatives and monarchists disdained the popular press and appeals to mass support as beneath them, and this was especially the case with caricature journals, which had so often subjected them to "undignified" attacks. Thus, the leading history of the French press notes that in general conservatives scorned the popular press

> both as a class and as an intellectual reflex. As for the legitimists [monarchists] and the very large majority of the Catholic notables, their aristocratic conception of social life made it difficult for them to see in the newspapers anything other than a necessary evil: for them, who had often accepted the condemnation of freedom of the press pronounced by the Syllabus [of Errors, a widely publicized encyclical issued by Pope Pius IX in 1864], the popular newspapers were the somewhat diabolical agents of the Revolution, bearers of lies, agents of political anarchy, of social disorder and moral corruption.

The emergence of a monarchist caricature press after 1875, then, reflected changed political circumstances as the abolition of royalist rule and the coming of republican politicians to power on the basis of democratic election both provided targets for conservative satire and made clear that conservatives would have to appeal to the masses if they were to have any chance to regain power. By 1906, a conservative Catholic author could write, "It is depressing that the Church has not understood or has understood so late the considerable importance of the press of our epoch. It is more worthwhile to create newspapers than to build cathedrals or convents."[12]

The first of the new conservative caricature journals to emerge, the pro-Bonapartist *Le Droit du Peuple* had numerous drawings forbidden and eventually shut down in early 1881, after slightly more than four years of publishing, apparently due to the incessant censorship harassment. In 1880 alone, twenty-two of its drawings were forbidden and the journal was fined a total of five hundred francs in three prosecutions for publishing unauthorized caricatures. On February 21, 1880, *Le Droit du Peuple* asked its readers "not to get angry at us if the illustrated part of our journal is today reduced almost to nothing," while on October 8, 1880, it published a caricature which was accompanied by the remarks, "O miracle . . . Anastasie has authorized our drawing!" On several occasions in 1880, the journal's caricaturist, Japhet, told his audience that the time was approaching when the journal might have to cease publication, rather than yield to the "stupid demands" of

the "pestering and idiotically draconian" censorship since any "illustrator worthy of dignity can do nothing more than break his pen and throw his crayon to the winds" (February 1, December 26, 1880). *Le Droit du Peuple* published its last issue on February 16, 1881, one week after Japhet told his reader that, "My modest crayon is decidedly impotent against the invulnerable scissors of old Anastasie."

La Jeune Garde (1877–80 and 1885–1905), another Bonapartist journal, had similar troubles with the authorities. It suffered numerous censorship bans and was convicted three times within six months in 1879, resulting in a total of 1,150 francs in fines. *La Jeune Garde* was at first defiant, declaring, for example, on March 30, 1879, that "if the censorship hopes to beat us it is deceiving itself" as "we will remain in the breaches to combat the current regime, forever and no matter what, as we have justice on our side, even if the republicans today have force on theirs." On August 24, 1879, the journal indicated it was being worn down by censorship, even if its spirit remained defiant, as it announced that to avoid future censorship problems it would henceforth only print pictures of "donkeys, pigs, geese, turkeys, etc." and would leave its readers "free to recognize in the guise of these diverse domestic animals the personification of this or that member of the government." However, Anastasie continued her harassment of *La Jeune Garde,* and on June 6, 1880, the journal suspended publication for what proved to be five years, since "liberty of the crayon no longer exists for *La Jeune Garde*" and therefore it would not retain "the interest and character which it must offer to respond worthily to the benevolent sympathies of its subscribers and readers."

The monarchist *Le Monde Parisien* also endured frequent censorship bans of its illustrated attacks on the republic and its leadership, with twenty-eight of its caricatures refused in 1880 and 1881. On many occasions *Le Monde Parisien* published caricatures which had been forbidden or not submitted to the censors, with the result that it was prosecuted about a dozen times between mid-1879 and the abolition of censorship in mid-1881; its editors were fined a total of over seven thousand francs and sentenced to seven months in jail (including two especially harsh sentences for written material) as a result of what the journal termed, on October 2, 1880, their "weekly promenade" to the French courts. *Le Monde Parisien* was also openly defiant with its words. Thus, on October 2, 1880 it declared that despite the government's actions, "We will not be silent and we will continue to loudly declare, by pen and by crayon, the deserved disgust which the republic and its officials inspire in us." On April 2, 1881, following a three-thousand francs fine and three month jail term handed down for a poem, the journal declared, "We will continue the struggle until our last breath. . . . We will

seize your [the government's] absurdities and unveil them. It is there that the battle wounds you, gentleman of power. . . . You are petty, small-minded and ridiculous."

La Trique, another monarchist journal, also had many skirmishes with the censors in its short life of less than one year. Shortly after its second issue was seized and publication of its third issue resulted in a fine of fifty francs for printing unauthorized caricatures, *La Trique* complained on November 22, 1880 that its street vendors had been warned by the police not to sell the journal under threat of having their licenses withdrawn. On several occasions, *La Trique* promised that readers who sent postage would be sent forbidden drawings via sealed envelopes (which were inviolable under French law); one such offer, on November 15, 1880, was accompanied by the comment that it could subsequently be observed if government officials, who "have already violated liberty of conscience, liberty of thought, liberty of property, liberty of struggle" will also "violate the secrecy of the mails." On the same day, *La Trique* also sarcastically thanked Minister of Interior Jean Constans for what was reported as a massive police operation undertaken to seize its previous issue; Constans, it reported, "has made for us a magnificent advertisement which our resources could not have permitted us to purchase in order to call the attention of the public to *La Trique.*" On June 25, 1881, less than five weeks before censorship was abolished, *La Trique* reported that it had been forced to entirely black out a caricature of Grévy at the last minute to avoid a police seizure and that the censors would not even allow a drawing to appear which only depicted Grévy's feet. It declared that henceforth it would portray only "mollusks and plants," and "we will see if in each oyster or each pickle Anastasie will have the irreverent perspicacity to recognize the great liberal [Grévy] who hasn't hesitated to place his hand on our property to force upon us a respect which we will be henceforth ashamed to accord him."

Probably the most important antirepublican caricature journal, *Le Triboulet,* a weekly which interspersed caricatures throughout sixteen pages of text published in a format approximately the size of a modern newsweekly, faced the most sustained and intense governmental harassment during the 1878–81 period. Faced with repeated censorship bans, *Le Triboulet* often replaced forbidden designs with written descriptions of them and just as often simply published them anyway or refused to even submit drawings to the censors. For such offenses as well as for a couple of cases resulting from alleged written defamation of government officials, *Le Triboulet* was prosecuted by the government thirty-seven times between April 1879 and the abolition of the censorship in July 1881 and was fined a total of 200,000 francs. One of its editors was jailed for six months at Sainte-Pelagie. Occasionally, *Le Triboulet* found a sympathetic judge, however: in its issue of

August 1, 1880, *Le Triboulet* reported that it had been convicted in a single prosecution for publishing forty-four unauthorized designs but had been fined a total of just fifty francs, or slightly over one franc for each contravention of the censorship.

The climax of the government's campaign against *Le Triboulet* came in August 1880, when the newspaper's founder and director, the wealthy Baron James Aloyius Harden-Hickey, an American citizen who had been born in Ireland and had lived in France for many years, was expelled from France with only twenty-four–hours' notice. The explusion of Harden-Hickey, a well-known and successful author under the pen name Saint-Patrice, led to thunderous denunciations in *Le Triboulet*. In its August 15, 1880, issue, the newspaper termed the action typical of "all the lowness of which a weak, pusillanimous and cowardly government can be capable," but one which left *Le Triboulet* "persuaded more firmly than ever that in religion and monarchy alone can be found the true principles of liberty, soiled so miserably by the feet of the [republican] men who formerly called themselves its defenders." The expulsion of Harden-Hickey was denounced by so many other newspapers of all political orientations that *Le Triboulet*'s August 15, 1880, issue contained a special eight-page supplement filled with excerpted attacks on the government. Thus, the conservative *Le Figaro* termed the expulsion an act of "childish simplicity" and "colossal stupidity," while the republican *La Verité* characterized the decision as marked by the "most odious arbitrariness," which reflected "the negation of the republican idea."

The royalist caricature journals and those who supported them only became more envenomed in their hatred for the republic as a result of the repressive treatment they suffered. In responding to Anastasie's attacks, they echoed one major criticism of censorship that was also made by republican caricature journals after 1877, namely, that republicans in power were betraying their oft-stated belief in freedom of expression by continuing to employ such measures. Needless to say, while stressing the hypocrisy of republican politicians, the royalist journals did not mention the fact that the politicians and newspapers they supported had been, when in power, quite happy to employ or support the use of censorship against republicans.

The theme of republican betrayal was pervasive among the royalist caricature journals and their supporters. Thus, *Le Droit du Peuple* published a blank front page on January 11, 1879 where a forbidden caricature was to have appeared, with the comment that the drawing had been banned "by the censorship formerly so detested, decried and ridiculed by the republicans," and on January 2, 1881, shortly before publishing its final issue, the journal reported that it had become a "sad victim of the famous republican liberalism." *Le Monde Parisien* complained bitterly on August 14, 1880 that it was

being persecuted "at the very moment in which the word 'Liberty' is displayed in huge ironic letters on the walls of all our monuments," and added on October 23, 1880, in reference to the regime, "There is only one thing which equals their stupidity, that's their bad faith." *La Trique* of October 22, 1880 demanded to know "how the patent enemies of the empire and the monarchy, the same people who did not have words of disgrace energetic enough for the decrees, laws and ordinances they called tyrannical and arbitrary, could be the first to use them today?" Commenting on the expulsion of *Le Triboulet* editor Harden-Hickey, the noncaricature journal *La Gazette de France* declared that, while in opposition the republicans "paid court to all liberties, but when they are in power they deny their programs, violate all rights and give to the country the spectacle of the most shameful apostasies and the most miserable recantations." Several conservative members of parliament also took up the theme of republican betrayal. Thus, during a parliamentary debate in the Chamber of Deputies held on June 8, 1880, Emile Villiers, while attacking the "abuse" of the law to harass *Le Triboulet*, declared that people had been led to believe that "the Republic meant the suppression of arbitrary rule" and the rule of liberty, yet by using Napoleon III's 1852 decree as the legal basis of censorship of caricature, republican authorities were enforcing "precisely the least liberal" legal remnants of "the monarchy and the empire." He concluded that, as a result, "It wasn't worth the trouble, in truth, to change the regime."

Complementing the theme of republican hypocrisy in continuing to employ censorship was a second major theme of the royalist caricature journals and their supporters: that the republican censors discriminated politically in their decisions, allegedly allowing complete license for republican journals to attack the Catholic Church, the monarchist pretenders, and all that was held sacred by the right, while almost totally gagging royalist imagery. Thus, Baron Gustave Cuneo d'Ornano attacked the government's harassment of *La Jeune Garde* in the Chamber of Deputies on December 8, 1878, declaring that "there is no liberty if it doesn't exist equally for everyone," and that the republican government "authorizes the most shameful caricatures" against religion and past regimes, while drawings were banned only when "they target republican officials." The *Conservative Union*, a noncaricature journal which defended *Le Triboulet*, similarly declared in April 1879 that under the republic "one can outrage with ignoble caricatures religion and its ministers, but it is forbidden to tell the truth, even while laughing, to the powers of the day."[13]

Le Triboulet attacked censorship on August 10, 1879, for prosecuting its political caricatures while authorizing what it termed "filthy drawings which outrage sight as much as thought" and "oblige us to hold our wives,

our sisters, our daughters closer to us in the streets to spare them these impure images" which "insult and scorn all that we have elevated to respect and love." *La Jeune Garde* of October 5, 1879, lamented that "the magistrature appears to move only when it is a question of prosecuting *Le Triboulet,* and as for censorship, it only has scissors for *La Jeune Garde." Le Droit du Peuple* similarly complained on March 28, 1880 that "the censorship which shows us its teeth has only smiles for the republican journals," and it lamented on December 26, 1880 that it was impossible to publish caricatures unless they "shamelessly ridicule religion and all that is respectable."

During the parliamentary debate on censorship of caricature held on June 8, 1880, Villiers declared that the "capricious" republican censorship allowed shameful and illegal attacks on the clergy, yet banned from *Le Triboulet* drawings, even of "monkeys and other animals," whose "innocuousness cannot seriously be contested by anyone, which can offend no social institution, but which only excite the suspicion, the concern, of those who govern us." It was, he proclaimed, "a singular arbitrariness which protects insults to the great national institutions and only strikes manifestations of French wit, disagreeable to a fleeting government. . . . Some have said, with regard to the trials of *Le Triboulet,* that since the coming of republican institutions, wit, in France, has lost its rights. I ask the minister [of the interior] to give them back." Deputy Robert Mitchell, a Bonapartist, declared that he did not support the political tendencies of the monarchist *Le Triboulet* but that otherwise he supported Villier's complaints. He declared that "censorship, as practiced today," was applied in an "absurd," "odious," "arbitrary," "incoherent," and "ridiculous" manner which made it into a "monopoly of calumny in the hands of the government" while making "inviolable" government officials such as Chamber of Deputies President Leon Gambetta and even the "nose" of Education Minister Jules Ferry. The regime, he complained, "authorizes the injury and defamation of its enemies while preventing them from defending themselves. . . . I search vainly for the source of this respect that the government has for apes, at the same time when the Catholic clergy is odiously and daily outraged with the consent of the censorship which protects monkeys."[14]

THE END OF CENSORSHIP (1881)
AND THE DECLINE OF POLITICAL CARICATURE

By 1881, two developments combined to bring about the right political conditions in France for the final abolition of censorship of caricature. First, both the right and the left were in agreement upon their disdain for Anasta-

sie. While the monarchist caricature journals rarely went so far as to support their republican brethren in specific controversies with the censor, republican journals even denounced censorship of monarchist caricatures. Thus, *La Lune Rousse* of August 17, 1879, termed the prosecutions of *Le Triboulet* "deplorable" and, even from the standpoint of the government, "absurd," since they "achieve precisely the opposite goal they seek" by stimulating public interest in the forbidden drawings and increasing the circulation of *Le Triboulet*. Similarly, on May 7, 1880, *Le Don Quichotte* attacked the repression of *Le Triboulet,* declaring that "all decisions which can be taken by the government without giving any reasons are an affront against justice and to our [republican] principles" and that it was "shameful that the republican government would retrieve from the arsenal of [Napoleon III's regime of] December 2 a disgraceful weapon in order to use it against its enemies."

The second reason why the atmosphere was ripe by 1881 for the abolition of censorship was that the stability of the republican regime seemed increasingly ensured, especially with the decline in the controversy over the Communards with passage of amnesty bills in 1879 and 1880 and with a temporary easing of the church-state controversy. Symbolically, the growing consolidation of republican power was reflected, during the 1878–80 period, by the adoption of *La Marseillaise,* which had been banned under the Second Empire, as the national anthem; the proclamation of July 14, Bastille Day, as a national holiday; and the return of the seat of the legislature from royalist Versailles to republican Paris.

Under these circumstances, the moderate republicans who held power were increasingly embarrassed by the controversy over censorship of caricature, since freedom of expression had always been a central tenet of republicans. Leon Gambetta, the dominant figure in the republican government, had declared while serving as minister of the interior under the provisional government established after the overthrow of Napoleon III that, "It is not proper for those who have always demanded press freedom while in opposition to restrict or mutilate it [while in power]." Press tycoon Emile de Girardin, whose politics were malleable but generally sympathetic to moderate republicanism, denounced in 1880 the harassment of *Le Triboulet* and urged the abolition of the caricature censorship, arguing that the republican government had not suffered from tolerating the "most violent and most injurious" written attacks and that the continued banning of "more or less witty satirical drawings is an inconsistency which nothing can justify and which diminishes authority, when the contrary form of conduct, that of disdain, would enlarge it. What then are the dangers which the crayon poses that the pen does not?"[15]

It is clear from documents in the French archives that the republican

ministry was increasingly embarrassed after 1878 by the growing criticism of continued caricature censorship. In January 1878, just one month after MacMahon had been forced to appoint a republican government, a document was drawn up in the interior ministry summarizing the history of caricature censorship, and during the next two years other memoranda were drafted with the apparent goal of providing a defense against charges that the regime was enforcing censorship in a discriminatory manner with regard to the clergy and monarchist parties, and especially with regard to *Le Triboulet*. For example, a document dated November 8, 1878, apparently composed by the head of the censorship bureau and addressed to the minister of the interior, provided a list of caricatures which had been authorized although they allegedly ridiculed republicans in an attempt to prove that censorship was being enforced in a fair manner. In response to the charges of tolerating vicious illustrated attacks against clerics and monarchists, the document declared that caricatures were never approved if they attacked "religion itelf, its principles, dogmas, that which concerns the fundamentals, that which makes the grandeur," and that no satires against monarchists were approved if they went beyond "a more or less lively allusion." The memo declared that in carrying out its admitted "task of protecting its adversaries" from such assaults the government had acted with a "rare enough abnegation," but the regime could not "in order to be agreeable to its enemies forbid engravings which plead the cause of or conform to general opinion" as it was a "government of liberty" and therefore could use the censorship only with "great care and a grand impartiality." A government prosecutor asserted such impartiality in fact was being practiced during a court session in April 1879, when on the same day both the left republican *La Lune Rousse* and the monarchist *Le Triboulet* were prosecuted for publishing unauthorized drawings. However, *Le Triboulet* complained that its fine of five hundred francs compared to the two hundred francs assessed against *La Lune Rousse* proved the government was discriminating against the right, and French archival records suggest there may have been considerable truth to this claim. While in 1877 and 1878 republican caricatures were banned far more often than monarchist illustrations, after 1878 the reverse became increasingly true: by 1879 about twice as many monarchist as republican caricatures were rejected and during the first half of 1881 this ratio climbed to seven to one (no doubt partly reflecting the increase of monarchist caricature journals and the decrease of republican ones, as leading republican outlets such as *La Lune Rousse, Le Petard, Le Titi,* and *Le Sifflet* lost their audience and/or their sense of purpose with the political triumph of their principles).[16]

As demands mounted for an end to censorship, a legislative commission

was established in 1879 to draft a new press law. Shortly before the commission reported, the government made clear that the proposed new law would abolish, with offical support, caricature censorship. Minister of the Interior Jean Constans, during a legislative debate on June 8, 1880, termed caricature censorship "detestable" and pledged that the government would soon "in agreement with the commission" ask for an end to the practice. The commission report of July 1880 in fact proposed a drastic liberalization of existing restrictions on the press, including an end to censorship of illustrations. In words that truly must have been music to the ears of caricaturists, the chairman of the commission, deputy Eugène Lisbonne completely adopted their basic argument, declaring, "If the journalist no longer has to submit his articles to the censorship scissors, only arbitrariness could maintain that there is a difference between the pen of the writer and the crayon of the illustrator."[17]

Final abolition of caricature censorship was not effected until the new press law was promulgated on July 29, 1881, and the republican government continued to rigorously enforce it until literally the last moment. Thus, *Le Monde Parisien* was prosecuted for publishing an unauthorized caricature in April 1881, after the Chamber of Deputies (but not the Senate) had already passed the new press law, and the last censorship ban was imposed (on *Le Triboulet*) on July 21. *Le Monde Parisien's* front page of April 30 contained, instead of the usual caricature, the comment that, "Anastasie, that moribund, has again done her work." Meanwhile, the impending demise of censorship led to a flood of new caricature journals, which increased from twenty-six in 1879 to forty-nine in 1880, and in 1880–81 alone about forty caricature journals were founded. Between 1881 and 1914, at least another 130 were begun, so that altogether between 1880 and 1914 about as many caricature journals were founded in just twenty-five years as had been created in the preceding sixty-five years (fig. 67). Many of these journals were extremely ephemeral, however, with most of them folding after only a few years due to poor quality, an overly specialized orientation—as in one short-lived journal entitled *Anti-Concierge* (1881–82)—and an oversaturated market. While over forty caricature journals were published each year during the 1880–83 period, there was a considerable shakeout during the following years, until fewer than twenty-five such journals were published annually during the mid-1890s. Thereafter a slow recovery increased the yearly average to about thirty caricature journals during the 1900–1914 period.[18]

The impending and actual end of censorship was enthusiastically greeted by caricature journals. *La Silhouette* of April 4, 1881 hailed Anastasie's impending demise with a caricature depicting the new press law as a scythe which would decapitate her (fig. 68), and accompanied the drawing with a

*Figure 67. The explosion of carica-
ture journals that followed the aboli-
tion of censorship of caricature in
1881 is depicted in this drawing by
Jules Grandjouan, which appeared in
Le Rire of August 16, 1902. Many of
them were erotic rather than political
in nature. The two children in this
caricature ask, "In which magazine can
we get the largest number of naked
women for ten cents?" Le Rire is de-
picted at the top center.*

Figure 68. An impending press law that would abolish censorship of caricature was welcomed by La Silhouette *of April 4, 1881, which showed the law as a scythe about to cut the neck of Anastasie, who is busy at work destroying caricatures.* La Silhouette *described censorship as an "old woman with a bottom of lead, eternally armed with scissors of the same metal," who "devours drawings the same way that phylloxera [an insect] destroys the vine."*

withering attack which termed censorship a "bull enraged at the red flag of intelligence" which sought to "cut the wings of whatever seeks to elevate itself." *La Silhouette* pointed out that censorship seemed about to "definitively disappear, and for good this time," but noted that in the past it had shown remarkable recuperative powers. "If one placed on a very hot grill Saint Laurence, a dozen salamanders and a dozen censors," *La Silhouette* declared, "I would bet that Saint Laurence would be grilled, that the salamanders would be roasted and that the censors would all have the fine look of having taken a cold bath." *Le Triboulet* of July 31, 1881, welcomed the formal end of censorship with an article entitled, "Anesthetized Anastasie." It declared, "Censorship is dead; may the devil take away the hideous shrew, whose implacable scissors cut into the spirit [of illustrators] like the snout of a hog removing pearls from a dungheap. Ah! God! The crayon is finally freed!" *Le Monde Parisien* paid its tribute to the new law on August 6, 1881 by publishing a caricature of the burial of censorship.

Although the abolition of censorship unleashed a huge wave of new caricature journals, it did not lead to a glorious new era of political caricature. Most of the new journals focused on far more frivolous matters such as fantasy, social life, fashion, manners, cabarets, and especially women and eroticism, sometimes carried to the verge of or over the edge into pornography. Erotic caricatures and writings were so characteristic of the first wave of new periodicals established in 1880 in anticipation of the new press law that one journal termed it the "year of pornography." A number of journals suffered severe reprisals for publishing such material, including unauthorized erotic caricatures. For example, *L'Evénement Parisien Illustré* (1880–82) was convicted seven times within a three-month period in late 1880, including at least once for a caricature, and was forced to temporarily close down after receiving sentences which totaled over four years in prison and fines of almost six thousand francs.[19]

While the caricature of mores flourished after 1880, political caricature thereafter both declined in quality and played a considerably less significant political role than it had enjoyed previously. Thus, art historian Henri Beraldi wrote in 1889 that political caricatures played only a "meagre" place in daily preoccupations, that people "hardly glanced at them" while passing street kiosks and that they "are without influence upon events and take on an artificial importance only when gathered together in the boxes of a collector." Similarly, caricature historian Arsène Alexandre, who helped found *Le Rire* (1894–1940), one of the leading caricature journals, wrote in 1894 that, judged by the past standards of French caricature, it had to be concluded that "political caricature no longer exists among us; or at least that it is at present in a state of lethargy," as contemporary caricatures "are hardly ever inspired

by any ardent passion" and "have nothing remarkable in their execution." Writing in 1898 amidst the explosion of overheated but mediocre caricatures that marked the Dreyfus Affair, John Grand-Carteret, a leading historian of French caricature, was reduced to asking, "Oh where are you, Caricatures of the great days? Where are you, masters of the caricature?"[20]

Among the reasons for the decline of the quality and significance of political caricature after the 1870s were the relative stabilization of the regime as republican rule consolidated, and also the replacement of personalized royal or presidential rule by the relatively faceless and collective rule of parliamentary politicians. Although political passions were occasionally excited by such sensational developments as the Boulanger and Dreyfus affairs (discussed below), generally after 1880 politics was drained of its formerly impassioned struggles over the basic principles and form of government, such as republicanism versus monarchy. Political battles were reduced to fights over relatively petty matters of personal interest between more or less anonymous parliamentary spokesmen, none of whom had the general public recognition of past royalty or even of presidents like MacMahon and Thiers. Such developments made it far more difficult for caricaturists to simply and powerfully capture the political struggles with their crayons and also tended to significantly reduce public interest in their work.

Perhaps the clearest single indication of the rapid decline in the caricaturists' appeal after the consolidation of republican power in early 1879 was the failure of Gill's *La Lune Rousse* at the end of that year for lack of money and subscribers. Charles Fontane, Gill's leading biographer, writes that after 1879 "the time for beautiful calls to arms, of great blows of the crayon were gone," while the newspaper *La France* commented on May 3, 1885, on the occasion of Gill's death, that he had "made with his crayon an incessant guerilla war against the [monarchist] government," but that "when the republic was proclaimed, he almost had no more reason to live." Gill himself recognized that the victory of his political ideas cost him the ruin of his career. He commented that, after 1879, "People no longer want caricature, it irritates the serious," and he wrote President Grévy a touching appeal for financial assistance in 1880, in which he stated that "the work of crayoned satire, which I pursued in the difficult times, no longer, thanks to you [i.e., the republican triumph], has a reason to exist."[21]

This decline of political caricature which accompanied republican triumph in 1879 was compounded by the subsequent rise of collective, legislative-dominated parliamentary government, which was marked by a relative lack of ideals, personal color, or dominant political figures. Thus, caricature expert Paul Gaultier declared in 1906:

We are no longer in the time in which the drawings of Daumier could raise against the throne a swarm of libertarian passions, when a band of frenzied caricaturists could lead a mad dance around the "pear" . . . because we are no longer in the time in which the fate of the country depends upon one or a few personalities. From the individual, the satire of that order has become collective, like politics itself. . . . Politics is now presented only in groups, most often without placing a name on the people involved. The political effacement of personal caricature before the caricature of mores, . . . reflects the growing supremacy of the legislature over the executive on the one hand and on the collective over the individual on the other. . . . How can one attack a government which is subdivided into groups, subgroups, commissions and committees of all sorts? . . . Among the mob of parliamentarians who frequent the Palais-Bourbon [site of the legislature], characters are rare indeed. . . . Mediocrities dominate, lawyers without clients, doctors without patients, writers without talent, veterinarians without jobs, who make of politics a trade, a way of earning bread or a stage. The contrast between the political caricature of today and formerly reflects . . . especially the contagion of personal interest which has exercised its ravages. With weak intelligence, precarious will, mediocre in all and for all, without generosity or ideals, our "dear sovereigns" appear to us, in caricature, as in life, haunted by the greed for power, preoccupied uniquely with personal interests, in a tumult of promises and protests, which only too accurately, sums up politics for them.

Similarly, Arsène Alexander, writing in 1894, noted that:

Nowadays in the great body of French society hardly anyone believes in politics; the general belief is that only a conflict of interests rather than a conflict of convictions is involved and therefore that, if business goes on fairly well, there is no special need of exciting oneself for or against either events or persons. Changes of ministry? There are two or three every year. It comes to be almost a matter of the almanac. The ministers themselves? They are generally good fellows enough, without any great brilliancy, neither handsome nor ugly, neither good nor bad, who come up from time to time, and from time to time retire for a chance to rest. . . . Political indifference, or rather the very obvious absence of any political passion which prevails upon the public, is partly the reason that humorous draughtsmen during these last few years have devoted themselves much more willingly to pure fancy and to the study of manners.[22]

While the end of the great political battles of the 1815–80 period and the rise of relatively colorless and collective parliamentary government thereafter unquestionably contributed to the decline of French political caricature after 1880, probably the single greatest explanation for this decline was, ironically, the end of censorship and the general press tolerance of the pe-

riod. It was precisely the struggle against censorship or the constant threat of prosecution, as in the 1830–35 period, that had given caricature its bite and forced artists to resort to clever stratagems, while the new political tolerance allowed caricaturists to rely on heavyhandedness, to the detriment of cleverness, and assimilated artistic opposition into the general mass of accepted political dialogue, with no special claims to public attention or sympathy. Caricaturist Alfred Le Petit declared, "We battled against censorship, but the day it was suppressed, political caricature was dead," while art historian Henri Beraldi suggested in 1889 that "it is possible that the very use of the [new] liberty has left us bored by the exaggerations of caricature." Arsène Alexandre, writing in 1894, partly explained the lack of strength in French political caricature of his day by noting that "it takes a sanguinary struggle and merciless persecution to bring out the strength of political caricaturists." Philippe Roberts-Jones, a leading modern historian of French caricature in the late nineteenth-century, declared in 1960, "It is curious to note that, if political caricature expresses itself more freely [after 1881], it loses, in some measure, its interest. Being less menaced, it became less inventive and less subtle. . . . It no longer seeks to find the strength of its arguments in an ironic allusion, in the intelligence of a composition or in an audacious comparison, but in the violence and overheating of its drawing."[23]

HARASSMENT OF POLITICAL CARICATURE IN FRANCE, 1881–1914

Although caricature became incomparably more free in France after 1881 than it had been before, the authorities still wielded some weapons to curb what they viewed as artistic excesses. The authorities, for example, claimed, on dubious legal grounds, to retain the right to administratively ban the sale of journals they deemed offensive from the public streets. This sanction did not prevent the publication of the material involved, its circulation to subscribers or sales in bookstores, but nonetheless dealt a serious blow to caricature journals by making display in the crucial street kiosk sales venue impossible and, as a purely administrative matter without criminal sanctions, could not be challenged in court. Complaining about such bans on May 24, 1891, *Le Balai* protested, "A satiric journal can only live if displayed." A similar administrative weapon was a ban on sales at state-owned railway stations, a revenue source so critical for caricature journals that one magazine termed it the equivalent of "condemning these [banned] journals to death."[24]

Although the 1881 press law eliminated many political offenses, it still authorized postpublication prosecution of writings and images for a few

such "crimes," for example, insulting the president or the army. The 1881 law and later supplementary measures passed in 1882 and 1898 also authorized a broad range of vague and thus potentially abusable obscenity prosecutions. Seizures of publications prior to a conviction was authorized only in the case of allegedly obscene matter and not for any political offenses. In 1893 and 1894, in response to a series of bombings attributed to anarchist terrorists, additional laws were passed—dubbed by the left the *lois scélérat* or "villainous laws"—which provided criminal penalties for journalists and others found guilty of "incitement to theft, murder, incendiarism, or crimes against the security of the state."

Most of these measures were used, rather sporadically, at one time or another against political caricature journals after 1881, and all of them at least made artists and editors think twice about what they published. During the period between 1881 and 1885 when French politics was relatively stable and the new wave of caricature journals focused overwhelmingly on mores, there were no major instances of political harassment of caricature, and in general civil liberties were further expanded, for example by the legalization of trade unions in 1884. However, during the Boulanger Affair, which dominated French politics between 1886 and 1891, caricature again returned to a focus on politics and the nervousness of the regime was reflected in the most significant wave of persecution of caricature journals of the entire 1881–1914 period.

General Georges Boulanger was the prototypical "man on horseback," a handsome army officer who was appointed minister of war in 1886 and who captured the public imagination and served as a rallying point for a disparate coalition of all those who had grievances against the republic. The right saw him as a stalking horse for a monarchist restoration, while elements of the left hoped he would address the social grievances of the poor which had been ignored by the governing moderate republicans, and others were attracted by his nationalist appeals for revenge against Germany for the loss of Alsace-Lorraine in the 1870 war. Although Boulanger was dismissed as war minister in 1887 and later fired from his army command, his popularity continued to grow and by 1889 a Boulangist coup d'état was widely feared. Although the Boulangist movement largely collapsed when he fled France in 1889 after the government began legal proceedings against him for treason, Boulangist agitation continued until he killed himself in 1891 while still in exile.

The Boulanger Affair spawned a massive upsurge in political caricature and led to the formation of a number of new caricature journals, including on the pro-Boulangist side *La Charge* (1888; same name as the journal of eighteen years earlier), *Le Pilori* (1886–1905), *La Bombe* (1889–90), *Le Diane*

(1888–91), *Le Tour de Paris* (1886–89), *Le Balai* (1891), and *L'Assaut* (1889); on the anti-Boulangist side appeared *Le Boulangiste* (1886) and its successor *Le Barnum* (1886), *Le Troupier* (1887–92), *Le Grincheux* (1888), and *La Griffe* (1889). Among already established journals, *Le Triboulet* was notable for its support of Boulanger, while *Le Grelot, La Silhouette,* and *Le Don Quichotte* were markedly anti-Boulangist. Altogether an estimated two thousand caricatures and other visual images related to the Boulanger affair were produced by 1889 alone, although few, if any, of them were striking or original in any way, and most substituted bombast and personal insults for cleverness.[25]

The French government was deeply shaken by the support Boulanger received and on a number of occasions took actions of dubious legality to suppress Boulangist imagery. For example, in October 1888, shortly before a series of parliamentary by-elections in which Boulanger had entered his candidacy, the interior minister directed a nationwide seizure of two pro-Boulangist caricatures. Shortly after Boulanger's sweeping by-election victories of January 1889, officials throughout France were directed to seize all Boulangist propaganda, "especially including" all portraits and photographs of the general. Although in March 1889, a Paris appeals court ruled that such seizures were in violation of the 1881 press law, virtually every pro-Boulangist caricature journal subsequently reported some form of apparently illegal harassment by the authorities.[26] This usually took the form of police demands that newspaper vendors stop selling their publication, sometimes accompanied by seizures and threats to withdraw vendors' licenses. For example, *L'Assaut* reported on September 15, 1889, that the police, behaving like "truly ferocious beasts," had seized and ripped to pieces copies of its previous issue at kiosks throughout Paris and had threatened to expel vendors from their stands unless they immediately removed "this filth." *L'Assaut* added that the police had "absolutely forbidden" the sale of all illustrated journals which criticized the government, while all "the colored insanities, all the true filth" produced "against General Boulanger and his friends could be complacently displayed in broad daylight." *L'Assaut* demanded that all illustrated journals be treated the same and demanded to know "why one forbids *L'Assaut* when one tolerates [the anti-Boulangist] *Le Troupier?*"

Complaints similar to that lodged by *L'Assaut* were periodically registered by other pro-Boulangist journals. For example, *La Bombe* of July 28, 1889, published an open letter from editor Paul de Semant to Paris police chief Caubet, in which he complained of police threats and seizures directed against the journal's vendors. He termed the harassment illegal and declared

that Caubet was "either a cretin completely ignorant of the law" or had deliberately "outrageously violated the law." Semant added:

> Either my drawing is illegal or it isn't. If it is, let them prosecute me (it is an honor to be prosecuted by such a government!). But to forbid the display of a journal or to seize it, you know well, Caubet, you have the right to do this only in the case of a pornographic journal, which is not and never will be the case with *La Bombe*. You are then reduced, Caubet, you and your patrons to this: you have come to intimidate the unhappy sellers of journals, not daring to risk the formidable kick in the lower parts which a jury of the Seine [Paris] would inevitably inflict upon you. . . . *La Bombe* will only sell better. If you desire a small commission, I am at your service.

Despite this letter, *La Bombe*'s issue of September 15, 1889, was seized (apparently without any ensuing prosecution) for its front-page caricature of a woman representing the French republic leaning on Boulanger for support while standing on a grotesque depiction of the head of leading republican politician Jules Ferry. *Le Balai,* whose name referred to the broom with which Boulanger had promised to sweep France free of parliamentary corruption, complained about harassment of its vendors in almost every issue it published in May and June of 1891 (fig. 69). On June 7, 1891, it published a protest caricature by Alfred Le Petit, who formerly had supported republican causes, which depicted a policeman pointing to a copy of *Le Balai* on display at a newsstand and demanding that "this filth" be removed or else "you will be given the broom."

Le Petit had earlier been jailed as the result of the first post-1881 postpublication prosecution of a political caricature. On October 28, 1888, his journal *La Charge* (identical in name to Le Petit's outlet which had been prosecuted by Napoleon III in 1870) published a pro-Boulangist drawing which portrayed the general protecting the republic against the threats of three generals who, although shown pledging to kill all French voters who dared to support Boulanger, were wearing headgear that suggested that they secretly favored a monarchist restoration (fig. 70). Le Petit and his editor, E. Roger, were prosecuted for insult to the army as the result of a complaint lodged by the minister of war. During the trial, Le Petit maintained that he had intended no insult to the army but was simply expressing a political opinion, while his lawyer, Vergoin, complained that Le Petit's drawing was like many others that had not been prosecuted. Vergoin added that if anyone had been unfairly caricatured it had been Boulanger and complained that no prosecutions had been launched to support him. However, the prosecutor declared

Figure 69. Pro-Boulangist caricature journals repeatedly complained of harassment during the 1886–91 period. Left: This September 15, 1889, issue of La Bombe was seized for its portrayal of French liberty standing on a grotesque depiction of republican politician Jules Ferry, while leaning on Boulanger for support and looking for assistance to a personification of Russia. Right: Le Balai of June 7, 1891, complained about what it termed constant police harassment, by depicting a policeman ordering a merchant to stop selling "this filth" while ignoring the cries of a man in the background, who informs him about rampant financial corruption.

Figure 70. Caricaturist Alfred Le Petit was jailed for two months and fined five hundred francs for this drawing, published in La Charge of October 28, 1888, which suggested that, to prevent General Boulanger from winning elections, three French generals, one of whom is labeled a "traitor to the republic," would kill Boulanger's supporters. Boulanger holds French liberty in a protective embrace on the right. At the left of the caricature, La Charge reproduced a note from Boulanger congratulating Le Petit for his drawings and a response from Le Petit congratulating Boulanger for his politics.

that Le Petit's caricature had crossed all acceptable boundaries and had slurred the patriotism of the army and that Boulanger alone, as a private person, could initiate a prosecution of caricatures which offended him. Le Petit and Roger were both convicted by a jury and were each sentenced to two months in jail and fined five hundred francs. In another prosecution of a pro-Boulangist caricature journal, the editor of *Le Pilori,* Armand Mariotte, was acquitted in August 1886 after being charged with incitement to overthrow of the republic, apparently for his writings rather than *Le Pilori's* drawings.[27] In its issue of August 22, 1886, *Le Pilori* hailed the verdict as the "justice of the people" and pledged to continue to strive for the goal of "the destruction of the republic," and to "nail above its door [i.e., pillory] as one does with birds of prey, the rodents who have attached themselves to the flanks of France."

The general nervousness of the government as a result of the Boulanger affair may have contributed to some otherwise almost inexplicable harassment inflicted upon *Le Courrier Français* (1884–1913) during the 1887–91 period.[28] *Le Courrier Français* was the most important caricature journal of the 1880s. It was published in a tabloid format of eight pages, and while typical in its focus on mores and women, it was unusually noteworthy for the high quality of its illustrations, many of which were contributed by the leading graphic artists of the time, including Jean-Louis Forain, Louis Legrand, and Adolphe Willette. *Le Courrier Français* was essentially apolitical, but it did publish a few pro-Boulangist drawings and had a general undertone which was critical of bourgeois sexual morality and hypocrisy, factors which probably combined in the late 1880s to attract the hostile attention of the authorities.

The first thunderbolt struck with the seizure of the December 4, 1887, issue, which contained a Willette cover drawing of a naked woman sitting in front of a guillotine, saying, "I am the Holy Democracy: I await my lover." This apparent suggestion that a republican form of government would inevitably lead to another Reign of Terror was no doubt viewed by the regime as lending moral support to the Boulangist cause, but it was certainly not obscene, as the government alleged, and when the authorities recognized this and decided not to prosecute, *Le Courrier Français* republished it. Subsequently, three other issues of the journal were seized (June 24, 1888, March 30, 1890, and November 9, 1890) for allegedly obscene drawings. Another issue (September 13, 1891) was prosecuted for an allegedly obscene poem by Raoul Ponchon, and on at least two occasions (July 1, 1888, and September 27, 1891) *Le Courrier Français* announced it was not publishing a drawing for fear of prosecution. In its issue of September 27, 1891, the journal reported it had already begun to publish a Willette drawing "when a person

belonging to the official world, seeing the first proofs, warned us that we would surely be prosecuted if we let this illustration appear." *Le Courrier Français* explained that although it regarded the threat of prosecution made before publication as illegal, it had decided not to publish the Willette drawing and to foreswear the "useless bravado" of defying the authorities and the "too easily gained publicity achieved by seizures and convictions" in order to avoid compromising the pending prosecution of the poet Ponchon by committing what might be seen as a "new provocation."

Of the four issues of *Le Courrier Français* seized for allegedly obscene caricatures, two of them, including the Willette "guillotine" issue, either were not prosecuted or eventuated in acquittals, but the other two issues both led to convictions for the well-known artist Louis Legrand (two other artists, including Forain, were acquitted for other drawings which appeared in the same issues). Legrand was fined one thousand francs for his drawing in the issue of March 30, 1890, which satirized author Emile Zola's notoriously "realistic" style by depicting the writer examining the buttocks of a rather overweight, naked woman, with a magnifying glass. For his contribution to the issue of June 24, 1888, Legrand was fined five hundred francs, and also given a two-month jail sentence, and the journal's editor, Jules Roques, and its printer, Lanier, were also jailed and fined. These harsh sentences issued to Legrand and his two colleagues created the greatest cause célèbre of the 1880s resulting from the prosecution of art in France. Legrand's offense was the publication of a drawing entitled "Prostitution," which depicted a naked woman sitting on a bed in the grip of a dark figure intended to represent death; it clearly was a commentary on the social evils of prostitution and could not reasonably be construed as pornographic. Legrand satirized his conviction by publishing in *Le Courrier Français* of April 7, 1889, another drawing entitled "Prostitution," which portrayed the same scene he had depicted earlier, except seen from the back, so the woman's nudity was no longer visible (fig. 71).

Although Legrand, Roques, and Lanier were acquitted in the original trial, with the court finding that it had not been established that Legrand's drawing "had sought to suggest the idea of an act of debauchery" they were convicted as the result of an appeal brought by the government, which resulted in the finding that the illustration "overtly offends modesty" by the depiction of a nude woman in a manner "calculated to elicit lustful ideas." The original prosecution of Legrand and the harsh sentences ultimately handed out aroused enormous protest in the French press and among French artists, who complained that the drawing was not obscene, that far more pornographic images were allowed to circulate freely, and that the prosecution was motivated by the personal and political bias of Justice Minister Jean Ferrouil-

Figure 71. Left: The well-respected artist Louis Legrand was jailed for "obscenity" for this drawing, entitled "Prostitution." It appeared in Le Courrier Français of June 24, 1888, and was clearly an attack on the social evils of prostitution, showing death with a grip on a prostitute. Right: Legrand satirized the prosecution by publishing the same scene, viewed from the back and thus avoiding any nudity, in Le Courrier Français of April 7, 1889.

lat. Thus, in response to the original prosecution, the newspaper *La Justice* declared on July 10, 1888, that the case raised the question of "whether we are living in a republic or if attempts are being made to lead us back to the tradition of the Empire and the regime of arbitrary rule"; *La France* of July 6, 1888, protested that the government was showing a great deal of severity toward an artistic journal "after having been so indulgent toward porno-graphic caricaturists whose works are plastered everywhere with impu-nity."[29]

After the appeals court convictions in September 1888, *Le Courrier Fran-çais* filled its pages for weeks with quoted denunciations of the verdict, which was termed "stupefying" by *La Justice,* "hypocritical" by *La Lanterne,* "arbitrary" and "inequitable" by *Le Gaulois,* "scandalous" by *La Cocarde,* and "ridiculous" and "odious" by *La France. Gil Blas* declared that the same court which condemned *Le Courrier Français* would, to be consistent, have to prosecute the "author of the Bible," while several artists declared that the verdict would inevitably lead to the closure of the Louvre. Painter Jean Beau-duin declared that Legrand's drawing would inspire "disgust for the flesh rather than ideas of lust," and artist Paul Chenay termed it an attempted "lesson in morality." Sculptor L. Baillif declared, "Either the first court was composed of imbeciles, which I don't believe, or the second one was." Sev-eral comments suggested that the government was largely motivated by its perception that *Le Courrier Français* was pro-Boulanger. Thus *La Presse* declared that "rascals publish filth and obscene caricatures against General Boulanger and, far from punishing them, the government supports them with secret funds," while *Le Courrier Français* was only guilty of the "regret-table habit of saying nothing bad about Boulanger"; similarly *La Cocarde* declared that the president of the appeals court was a rabid anti-Boulangist who seized every opportunity to strike "those journalists guilty of sympathy toward General Boulanger."[30]

Although the Boulanger issue died with the general himself in 1891, the nervousness among the authorities fostered by Boulangism was furthered in the early 1890s by a financial scandal (the Panama Affair) and by a series of bombings, attributed to anarchists, which killed about ten people between 1892 and 1894. The bombings set off an anarchist scare which led to the passage of the *lois scélérat* and almost certainly contributed to the difficul-ties faced by the two most radical caricature journals of the early 1890s, *Le Père Peinard* and *Le Chambard Socialiste.* The editors of the anarchist *Le Père Peinard* (1889–94 and 1896–1902) were convicted seven times be-tween 1890 and 1892, apparently in each case for writings alleged to incite violence, and received sentences totaling almost eleven years in prison. *Le Père Peinard* was forced to close for two years in 1894 when its editor, Emile

Pouget, fled France to avoid a trumped-up prosecution in the notorious "Trial of the Thirty," in which a jury rejected the government's attempts to round up and convict in one mass trial an assortment of alleged anarchists, most of whom were intellectuals who had no links either with each other or with any illegal activities. Pouget was sentenced to five years in jail for contempt when he failed to appear at the trial, but was acquitted after he returned to France, and he was able to publish *Le Père Peinard* again, without hindrance, in 1896. Radical caricaturist Maximilen Luce, who contributed many cartoons to *Le Père Peinard,* was among those arrested in the 1894 roundup of anarchists and was freed upon his acquittal in the Trial of the Thirty only after being jailed for forty-five days.[31]

Several other artists and journalists fled France to escape prosecution during the anarchist scare, including the artist Camille Pissarro, another contributor to *Le Père Peinard,* and the leading caricaturist Theophile Alexandre Steinlen, whose drawings frequently graced a number of important journals, including *Gil Blas Illustré* (1891–1903) and (under a pseudonym) the Marxist *Le Chambard Socialiste* (1893–95). *Le Chambard Socialiste* was distinguished in two ways: first, by being perhaps the only openly socialist caricature journal of the early 1890s—its announced program was to denounce "social inequities and their authors, the exactions of exploiters, the dirty tricks and corruptions of the government"—and second, by the extraordinary beauty and incisiveness of Steinlen's drawings, which brilliantly critiqued France's social ills and the government's dedicated avoidance of tackling them. Thus, on January 28, 1894, a Steinlen drawing showed a poor family gathered around an infant's coffin, while a dog wearing a handsome jacket proudly looked on nearby; the caption read, "Nice society! . . . where the dogs of the rich are happier than the children of the poor." Another Steinlen drawing, which appeared on March 3, 1894, portrayed a workingman being led away by two police, and the caption read, "Pennyless! Ah! If instead of bread I had stolen one hundred million." In November 1894 the editor of *Le Chambard Socialiste,* Gerault-Richard, was sentenced to a year in jail for an article alleged to defame Casimir-Périer, the French president (1894–95). Especially given *Le Chambard Socialiste*'s political orientation and its powerful graphic attacks upon the flaws in French society, including the *lois scélérat,* political motives were almost certainly involved in this harsh sentence. Gerault-Richard obtained the last laugh when Casimir-Périer suddenly resigned in January 1895, and the editor was freed in a general political amnesty (fig. 72). In another incident of censorship perhaps connected with the anarchist scare, the government forbade in 1893 the display on the streets of a rather anodyne poster advertising a new caricature journal, *L'Escarmouche,* apparently because its captionless portrayal of

Figure 72. Left: Le Chambard Socialiste, *a socialist caricature journal of the mid-1890s, attacked the antianarchist laws of 1893–94 with this caricature, published on September 8, 1894. The hangman of liberty assures a worker that "I'm not strangling your freedoms, I'm only suspending them."* Right: *the issue of January 26, 1895, celebrates the early release of editor Gerault-Richard from a jail sentence for defamation of President Casimir-Perier, whose resignation was followed by an amnesty for political offenders.*

workers inside a bar watching as troops with bayonets marched by was perceived as antimilitary.[32]

During the Dreyfus Affair, which dominated French politics between 1896 and 1899, there was another explosion of political caricature, reminiscent of the Boulanger caricatures both in quantity and in general lack of quality or cleverness. The Dreyfus Affair cannot be easily summarized but, stripped to its most basic essentials, it centered on bitter divisions over what turned out to be the falsified court-martial treason conviction of a Jewish army officer. Republicans and liberals gradually began to view the entire affair as a gross miscarriage of justice which amounted to an attack upon fundamental republican precepts, while an opposing coalition of monarchists, reactionary Catholics, anti-Semites, and fanatic patriots viewed the growing demands for review of the conviction as an attack upon the honor of France and especially of the army, resulting from an international Jewish conspiracy to disrupt French society. The caricatures of the period frequently featured brutal personal attacks, and many of the anti-Dreyfus drawings, including those of several leading artists such as Forain, Willette, and Caran d'Ache were characterized by a crude anti-Semitism. Caricature historian John Grand-Carteret, writing in 1898, characterized the general run of the Dreyfus imagery as marked by a "diminished caricature, lowered down a level," which substituted personal assaults for "the idea, formerly triumphant among the masters of the crayon."[33]

Presumably because of some combination of internal government divisions, the realization that caricature had declined in importance and posed no real threat, and an increased acceptance of freedom of expression relative to the time of Boulanger, the government left caricature journals on both sides of the Dreyfus case entirely alone. Even the anarchist caricature journal *La Feuille,* edited by Zo d'Axa (whose journal *L'En Dehors* had been prosecuted out of existance in the early 1890s) and illustrated by Steinlen, was unmolested. On two occasions, the government did, however, ban anti-Semitic posters; in one case the poster involved an advertisement for Henri Rochefort's notoriously anti-Semitic newspaper, *L' Intransigeant;* in the other, further publication of a series of posters known as the "Musée des Horreurs" was forbidden. The posters depicted individuals active in the pro-Dreyfus movement in extremely derogatory and grotesque fashions, as in a portrayal of Emile Zola as the "king of pigs," engaged in daubing excrement on a map of France.[34]

The general level of French political caricature was considerably raised after 1900 by the appearance of *L'Assiette au Beurre* (1901–12), a weekly of unexcelled graphic quality published in a format about the size of a modern newsweekly and typically consisting of twelve to sixteen pages of cartoons

by a single artist on one theme.[35] Although *L'Assiette* had no coherent political program, it brutally and incisively lampooned and savaged all of the pillars of the French establishment and highlighted the ignored social grievances of the poor. *L'Assiette* was never prosecuted, but on at least five occasions between 1901 and 1905 the authorities effectively forced the editors to modify cartoons, confiscated issues after they had been distributed, and/or forbade street sales or public display of particular numbers. In every such occasion, the government apparently acted to prevent what it feared would be damage to relations with France's European allies.

One such instance resulted from an anti-British issue of *L'Assiette au Beurre* published on September 28, 1901, designed by Jean Veber. Filled with bitter attacks on the use of concentration camps by the British during the Boer War, the issue's most sensational caricature depicted "impudent Albion" (an ancient name for Great Britain) in the form of a woman displaying her backside to the world, upon which could be seen the features of King Edward VII. King Edward personally complained about this drawing to French Ambassador Paul Cambon, who wrote to his son that the caricature was "scandalous" but "very well done" and displayed an "exact resemblance" of the king. Either in response to British protests or out of its own desire to preserve a recently fashioned Franco-British entente, the French government refused to allow sales of the caricature on the public streets unless it was modified. *L'Assiette au Beurre* responded, as demand for the issue led to a dozen reprintings, by progressively covering up Edward's features by clothing Albion's backside, first with a transparent polka-dotted slip, and later with thicker and opaque ones (fig. 73). No doubt due to the enormous publicity aroused by the controversial caricature, the September 28 issue eventually sold an unheard-of 250,000 copies and was acclaimed by *L'Assiette au Beurre* as a "success without precedent." The authorities subsequently banned from street sales—sometimes seizing issues to enforce their decrees—two other issues critical of Britain (those of June 28, 1902, and January 3, 1903), two issues which bitterly attacked Russian Tsar Nicholas II (February 4, 1905, and November 11, 1905), and one issue which portrayed Portuguese King Carlos I, during his visit to Paris, as resembling a pig (November 25, 1905) (fig. 74).[36]

L'Assiette au Beurre harshly criticized the government for the street sales bans, which apparently directly contravened the 1881 press law. In response to the "Impudent Albion" affair and the subsequent seizures and bans on the two other anti-British issues, *L'Assiette* declared on May 2, 1903, that the French police appeared to be "in the pay of foreigners" and had acted with a "stupid imbecility" that threatened press freedom. It added, "We inform our vendors that no one has the right to seize magazine issues which violate no

Figure 73. The French government, apparently fearing diplomatic complications with Britain, refused to allow L'Assiette au Beurre *to sell on the public streets its original issue of September 28, 1901, which consisted of pictorial attacks on British policy.* Upper left: *The features of King Edward VII are shown on the behind of "impudent Albion" (Albion is an ancient name for Great Britain). Record demand for the issue led to a dozen reprintings and sales of 250,000.* Upper right and bottom: L'Assiette *progressively covered up Edward's face with each reprinting, apparently in response to continued government actions, and by the final printings, Edward's face was completely obscured.*

Figure 74. Left: In apparent fear of diplomatic complications, the French government forbade street sales of L'Assiette au Beurre's issue of November 11, 1905, because of the cover portrayal of Russian Tsar Nicholas's head held on a pike by his subjects. Right: Similarly, L'Assiette au Beurre's November 25, 1905, issue was forbidden as a result of its depiction of Portuguese King Carlos I as a piggish-looking fat man during his visit to Paris.

law. Paris is not Saint-Petersburg!" In response to the seizures of the issues attacking the Russian and Portuguese monarchs, *L'Assiette* of December 9, 1905, lamented:

> We have in sum fallen to such a degree of subjugation, ignobility and servility that the most inoffensive caricature is forbidden by the all-powerful Police whose Arbitrary actions mock the laws and suppress all our liberties! . . . The [Second] Empire, we are repeatedly told in every way, was the regime of the Arbitrary; the Republic is the regime of Liberty. But it is easy to see that procedures of the republican government are the same as those of the imperial government. If we have outraged the Tsar or Carlos I, then prosecute us before a jury; that's the Law. Any other procedure is arbitrary, illegal, intolerable.

Although no caricaturist was ever prosecuted for his contribution to *L'Assiette au Beurre,* two of the most prolific contributors to the journal, Aristide Delannoy and Jules Grandjouan, were prosecuted and sentenced to jail for caricatures which they published elsewhere. Since the caricatures that they were prosecuted for were very similar to those published, without repercussions, in *L'Assiette,* it seems likely that the differential reaction of the authorities reflected the fact that *L'Assiette* was a relatively expensive journal with a predominantly middle-class audience, while the journals which were prosecuted had a more proletarian orientation. The prosecutions of Delannoy and Grandjouan occurred between 1907 and 1911 and, in every case, involved allegations of insult to the military, at a time when the government was especially nervous over a widely publicized left-wing campaign which urged young soldiers to refuse orders to act against workers during labor disputes. The antimilitarist campaign had followed a series of brutal army actions against strikers which resulted in the deaths of 19 workers and the wounding of about 700 between 1906 and 1908; the government responded to the campaign with frequent prosecutions and jailings of journalists and orators who supported it.[37]

Delannoy, who drew eight complete issues for *L'Assiette,* was sentenced to an astounding term of one year in jail and a fine of three thousand francs, as was his editor, Victor Meric, for a caricature published in the May 1908 issue of *Les Hommes du Jour* (fig. 75), which portrayed French General d'Amade as a bloody butcher for his role in the colonial subjugation of Morocco and which was accompanied by an article terming d'Amade a "bandit in uniform." Delannoy's biographer, Henry Poulaille, recalls his interest in the artist as stemming from this caricature, which struck him as "an irrefutable witness against the army." At the trial, the French prosecutor demanded a condemnation of those whom he called the "disorganizers of the

Figure 75. For this cover portrayal in Les Hommes du Jour of May 1908 of General
d'Amade as a bloody butcher surveying the carnage he had created during the con-
quest of Morocco, caricaturist Aristide Delannoy and editor Victor Meric were each
sentenced to a year in prison and fined for "insult" to the military. Delannoy was re-
leased after less than four months in the Santé Prison, in June 1909, however, be-
cause he was in poor health and the government feared that if he died in prison he
would become a martyr. (Delannoy died at the age of 37 in 1911.)

nation," while Delannoy defended his drawing as an accurate depiction of French crimes in Morocco, declaring, "I don't have two moralities and I approve of no crime." Delannoy's lawyer declared that in Belgium even caricatures which portrayed the king with blood on his hands were not prosecuted and he urged the jury to give France "as much freedom as they have in Belgium."[38]

Delannoy had earlier drawn a cover for *Les Hommes du Jour* which depicted Prime Minister Georges Clemenceau's head being waved on the end of a pike and which sold twenty-five thousand copies. There was widespread suspicion that the d'Amade prosecution was a delayed reprisal for the earlier drawing, and the severe sentence attracted considerable attention and widespread denunciation among liberals and radicals. The socialist newspaper *L'Humanité* reported the verdict in its issue of September 27, 1908, under the heading "worse than under the [Second] Empire" and its account termed the verdict yet another "condemnation for crimes of thought." The League for Liberty of Art declared that the only issue involved in the prosecution was that "in a free country, all opinions must be free, and art, considered simply as one means of expression of thought, must be as free as thought itself." *L'Assiette* denounced the sentence on several occasions and devoted its entire issue of May 8, 1909, to raising money to support Delannoy's family; one caricature in the issue, under the heading "Republican progress," depicted French officials asking Delannoy in his jail cell, "Would you prefer censorship, as under the Empire?" A meeting was held in Paris on June 9, 1909, to protest the sentence; it was advertised by a poster entitled "Imprisoned Art," designed by Grandjouan, which declared that "it is inadmissible that in France in 1909 an artist can still be condemned and jailed for having expressed his thought in a simple drawing."[39]

During his stay in jail, Delannoy's health, already fragile as the result of tuberculosis, worsened, and he was released after four months, following a protest made by his fellow prisoners, at least partly because the government feared his death in jail would make him a martyr. In December 1910, Delannoy was indicted for another antimilitary caricature, which had appeared in the journal *Pioupiou de l'Yonne* of October 1910, but he died on May 5, 1911, at the age of thirty-seven, before he could be tried. A committee was formed after his death, with the support of a number of noted artists and writers, including Anatole France, Octave Mirabeau, Luce, Forain, and Paul Signac, to assist his family. *L'Assiette au Beurre* declared on April 27, 1912, that Delannoy's jail term "had caused the death of the artist," while Meric wrote in his memoirs published in 1930 that "free and treated with care, [Delannoy] without doubt would have lived" and that "it was prison which killed

him." Delannoy's biographer, Poulaille, concurs, declaring that the artist wielded a "crayon of combat which cost him jail and his life."[40]

Jules Grandjouan, *L'Assiette au Beurre*'s single most prolific contributor, with almost eight hundred drawings and thirty-five complete issues to his credit, was prosecuted half a dozen times between 1907 and 1911 for a total of about ten antimilitarist drawings. Among the outlets they appeared in was *La Voix du Peuple,* the journal of the leading trade union confederation in France, which was edited by Emile Pouget, the former editor of *Le Père Peinard.* In 1907 he was prosecuted for a caricature (which had earlier been published unhindered in 1902) which depicted an army medical examining board stamping on the arm of a healthy conscript, "Good for killing." In 1908 he was again called before the courts for a drawing which showed the parents of a draftee pushing and spitting on their son for shooting strikers, and he was again prosecuted in 1910 for an antimilitary caricature published in *La Voix du Peuple.* Until 1911, Grandjouan was acquitted or let off only with fines, but he fled France in December of that year to avoid an eighteen-month jail term handed down by a Paris jury for two drawings published in a special antimilitarist issue of *La Voix du Peuple* of March 1911. One of the drawings depicted a soldier refusing to obey orders to suppress a strike, while declaring, "I have a weapon to defend my country and not to be the assassin of my comrades." *L'Humanité* of September 29, 1911, characterized the sentence as "pitiless," in an account that was headed "Verdict of Madness." While abroad, the French Lithographic Federation collected money to assist Grandjouan, but he asked that the funds be used to furnish issues of *La Voix du Peuple* to young draftees. Grandjouan returned to France in 1913 after receiving a presidential pardon. He died in 1968, at the age of 93.

Conclusion

Three major conclusions emerge from a study of censorship of caricature in France between 1815 and 1914: (1) the authorities greatly feared the power of hostile caricatures; (2) regulation of freedom of the crayon often changed as a result of the volatile political climate in France, which led to repeated cycles of liberalization and repression as the symbolic value placed on "liberty" repeatedly collided with the fears of the authorities; and (3) governmental regulation significantly determined the nature of French caricature during much of the nineteenth century, so much so that the history of caricature reflects, in an extraordinarily sensitive way, the political climate in France in general and the tolerance of various regimes in particular.

The almost continuous imposition of prior censorship of caricature before 1881 clearly reflected that, in the aftermath of the French Revolution and the gradual emergence of public opinion as an important political factor, the authorities conceived themselves as being involved in a vast struggle for control over the minds of their subjects. Precisely because caricature was viewed as being especially accessible to the masses, including the feared, illiterate rabble at the bottom rungs of the social scale, and because it was also viewed as being especially effective in transmitting a message, caricature was subjected to far greater control than was the printed word.

The printed press was by no means free of significant regulation (at least before the liberal press law of 1881), even if it was freed from prior censorship after 1822. The press was subjected to enormous administrative harassment and to vast numbers of postpublication prosecutions, which ensured, as one journalist noted during the extraordinary harsh press controls of the Second Empire, that before writing a word "you had to turn your pen around seven times between your fingers, since before the courts you could

sin by thought, by word, by act or by omission."[1] But while the authorities felt that they could take the risk of having occasional subversive attacks appear in print, clearly they were not willing to run the same risk where drawings were involved, given their perceived greater effect and accessibility. Although no doubt both the government and caricaturists exaggerated the importance of political cartoons, during at least three periods— 1830–35, 1867–70, and 1871–77—caricatures significantly discredited the regimes of Louis-Philippe and Napoleon III and the monarchist-dominated early days of the Third Republic, especially during the presidency of Marshal MacMahon.

For similar reasons to those which caused especial fear of caricature, it should be noted that restrictions on the theater in France generally paralleled those governing caricature (and remained in effect even longer, as prior theater censorship was abolished only in 1906).[2] The theater, also, was accessible to the illiterate and semiliterate, and the influence of live drama was considered far greater than that of the printed word, especially since, even more than was the case with caricature, large numbers of people watched the same events together. Even after the abolition of caricature and theater censorship, nationwide censorship was imposed in 1916 on a new medium, the cinema, which was seen as more threatening yet. (Censorship of this new medium was maintained after World War I, although censorship of the printed and illustrated press, temporarily reimposed during wartime, was abolished with the end of the war. The latter was again temporarily imposed during World War II.) Thus, if caricaturists felt they were being discriminated against, the reasons for this differential treatment, from the standpoint of the authorities, were quite logical. Forms of expression viewed as even more threatening than caricature or the theater faced greater barriers yet in nineteenth-century France: for example, before 1848 only the wealthiest 1 percent of the population could vote under any circumstances, and until 1884 it was completely forbidden to organize trade unions.[3]

Aside from the enormous fear which caricaturists evoked from the ruling classes, the second major conclusion that emerges from a study of censorship of caricature in nineteenth-century France is that the regulation of caricature was repeatedly adjusted in response to changing political developments. French politics in general in the 1815–1914 period was extraordinarily volatile, and this volatility was reflected not only in changes in the regulation of caricature but in frequent reversals and changes in direction in many different areas of French life. The rules affecting censorship of the theater moved in virtual tandem with the regulation of caricature: prior theater censorship was abolished in 1830, restored in 1835, ended again in 1848, reinstated once more in 1850, terminated again in 1870, put back in place in 1874, and finally

ended for good in 1906. Similarly, it has been pointed out that "in the nineteenth-century [in France], all political changes were soon accompanied by a modification of the press laws [for the printed word]."[4]

The explanation for the volatility of the censorship regulations regarding caricature (and the theater and printed press) is that the general question of "liberty" was always of enormous symbolic importance in nineteenth-century France. A large and growing segment of the population was always demanding more liberty during this period, thus keeping the issue of censorship always alive and increasingly controversial. Every change of government in France brought about by internal revolution or by foreign overthrow of the existing regime (1814–15, 1830, 1848, and 1870) was accompanied by demands and expectations for more liberty and by attacks on the tyranny of the departing rulers. In each of these four cases, the replacement regimes, in a bid for popularity and/or in a deluded belief that they actually believed in freedom of expression, abolished censorship of caricature.

This opening of the gates to free expression of caricature led to a cycle which was repeated four times between 1815 and 1881. After an initial outburst of attacks against the fallen regime (Napoleon I, Charles X, Louis-Philippe, Napoleon III), caricature inevitably turned its crayon against the new governments, which soon showed their lack of real belief in freedom of expression by initiating postpublication prosecutions and suppressions of caricature (1815–20, 1830–35, 1848–52, and 1870–71). Each new regime soon decided to stifle hostile caricature altogether, and, taking advantage of some dramatic development (assassination plots in 1820 and 1835, Louis Napoleon's coup of 1852, the Paris Commune of 1871), reimposed prior censorship of caricature, only to have this measure abolished in the name of liberty by successor regimes, with the permanency of the 1881 law reflecting a permanent settlement of the form of government in France. Thus, the volatility of the rules regulating French caricature reflected both the volatility of France's political order in the nineteenth century and the frequent collision between the concept of censorship and the symbolic value widely placed on liberty.

The parallel developments of 1815–30 and 1830–48 have an almost eerie similarity, with the Restoration period prefiguring the events that were to occur during the July Monarchy in an extraordinary way. In 1814, as later in 1830, the collapse of the existing regime led to the abolition of censorship of caricature and a subsequent flood of bitter pictorial attacks which excoriated the fallen government (that of Napoleon in 1814, that of King Charles X in 1830). However, caricaturists soon began to direct their attacks on the new

regime (that of King Louis XVIII after 1814 and that of King Louis-Philippe after 1830). After a brief period of tolerance, the new regimes began to prosecute and suppress caricatures, at first on a postpublication basis. However, after five years in power (in 1820 and in 1835, respectively) the new governments took advantage of the hysteria touched off by major assassination plots to restore censorship of caricature. During most or all of the remaining period of the new governments (between 1822 and 1830 under the Restoration and between 1835 and 1848 under Louis-Philippe) caricature remained subject to prior censorship, while the less-feared printed word was not subject to prior scrutiny (although newspapers were often prosecuted after they appeared). The imposition of prior censorship of caricatures in 1820 and 1835 eliminated all legally published imagery directly critical of the ruling monarchs and their regimes, but in both periods, either because of censorial tolerance or incompetence, caricaturists were still able to direct generalized and allusive satires against the regimes that were clearly understood and widely circulated. In both cases, about ten years after restoring censorship of caricature, the regime was violently overthrown, largely in reaction to its repressive policies, and it was succeeded by a new regime, at first pledged to liberty. In each case, censorship of caricature was abolished as one of the first actions of the new government, and in each case this measure was revoked after about five years as the cycle began anew.

A final conclusion which emerges from this study is that government regulation largely shaped the nature of caricature throughout the period. When caricature was free of regulation and the political climate was highly contentious, caricature focused on politics (1815–20, 1830–35, 1848–52, 1870–71, and periodically after 1881, as during the Boulanger crisis). When caricature was subjected to prior censorship, the major focus of drawings shifted to fads and foibles of everyday life, and often to eroticism. As one historian of French caricature has noted, "When politics muzzles them, caricaturists move on to smut [*grivoiserie*]."[5] Even during periods when censorship was imposed, opposition caricatures sometimes continued to circulate either through clandestine means or as a result of the cleverness of the artists and/or the tolerance and incompetence of the authorities (1820–30, 1835–48, and 1867–81). However, when the regime was determined enough, as under Napoleon I and Napoleon III (between 1852 and 1867), governments succeeded in almost totally stifling artistic dissent.

The nature of censorship in each period not only strongly shaped the character of the caricatures that could be legally produced, but it also very precisely reflected the general degree of authoritarian tendencies within

each regime: thus not only did the harsher censorship of Napoleon III between 1852 and 1867 compared to that of the Restoration and the July Monarchy reflect a broader tendency towards tighter political controls during the Second Empire, but the loosening of caricature censorship after 1867 corresponded with a general liberalization of Napoleon III's regime. Similarly, the often incoherent nature of censorship between 1871 and 1881 reflected the general instability and uncertainty in French politics of the period, while the censorship surge of 1877 corresponded to an intense political crisis.

In short, the nature of caricatures published in each period reflected the nature of the censorship enforcement of the time, and the nature of the censorship enforcement at any particular time reflected the general attitude—as well as the particular fears and beliefs—of each regime. As legislator Robert Mitchell told the Chamber of Deputies in 1880:

Drawings which displease the government are always forbidden. Those which have gained official favor are displayed in the windows of all the bookstores, are sold in all the kiosks. This provides a valuable indicator for the attentive observer, curious for precise information on tastes, preferences, sentiments, hates and intentions of those who have the control and care of our destinies. In studying refused drawings and authorized drawings, we know exactly what the government fears and what it encourages, we have a clear revelation of its intimate thoughts.[6]

Abbreviations Used in Notes

Unless otherwise specified, all books in French were published in Paris.

AN: Archives Nationales, Paris

AP: Archives Parlementaires de 1787 à 1860 (Paul Dupont; various years and volumes are included in the notes)

CB: Claude Bellanger, et al., *Histoire générale de la presse française,* vol. 2 (1969), vol. 3 (1972) (Presses Universitaires de France)

CF: Charles Fontane, *André Gill: Un maître de la caricature* (Editions de l'Ilbia, 1927)

FD: Fernand Drujon, *Catalogue des ouvrages, écrits et dessins de toute nature poursuivis, supprimés ou condamnés depuis le 21 Octobre 1814 jusqu'au 31 Juillet 1879* (Rouveyre, 1879)

GB: Guy Boulnois, *Alfred Le Petit* (Aumale, France: Groupe Archéologique du Val-de-Bresle, 1987)

GBA: Gazette des Beaux-Arts

GC: John Grand-Carteret, *Les moeurs et la caricature en France* (Librarie Illustrée, 1888)

GT: La Gazette des Tribunaux

GV: Georges Vicaire, *Manuel de l'amateur de livres du XIXe siècle* (A. Rouquette) (various volumes and years given in notes)

HA: Henri Avenal, *Histoire de la presse française depuis 1789 jusqu'à nos jours* (Flammarion, 1900)

HEF: Histoire de l'édition française, vol. III (Promodis, 1985)

JO: Journal Officiel

RJ: Philippe Roberts-Jones, *De Daumier à Lautrec: Essai sur l'histoire de la caricature française entre 1860 et 1890* (Les Beaux-Arts, 1960)

Notes

PREFACE

1. *Le Collectioneur Français,* February 1979, p. 11.
2. L. Gabriel-Robinet, *La Censure* (Hachette, 1965).
3. Raymond Manlevy, *La Presse de la IIIe République* (J. Foret, 1955), p. 137.
4. Hifzi Topuz, *Caricature et société* (Mame, 1974), pp. 112–14; *New York Times,* July 24, 1987; February 25, May 13, June 18, August 11, 1988; *Ann Arbor News,* August 12, 1988.
5. Edward Tannenbaum, *1900: The Generation Before the War* (Garden City, N.Y.: Anchor, 1976), p. 4.

CHAPTER ONE

1. *AP,* vol. 34 (1876), p. 31, vol. 98 (1898), pp. 741, 744; AN, F^{18} 2342, F^{18} 2363.
2. André Blum, *La caricature révolutionnaire (1789 à 1795)* (Jouve, 1919), p. 14; *AP,* vol. 98 (1898), pp. 257–58, 407.
3. AN, F^{18} 2342; *AP,* vol. 34 (1876), p. 330.
4. John and Muriel Lough, *An Introduction to Nineteenth-Century France* (London: Longman, 1978), p. 219; Donald English, *Political Uses of Photography in the Third French Republic, 1871–1914* (Ann Arbor, Mich.: UMI Research Press, 1984), p. 16; James Cuno, *Charles Philipon and La Maison Aubert: The Business, Politics and Public of Caricature in Paris, 1820–40,* Ph.D. diss., Harvard University, 1985, p. 51; AN, F^{18} 2342.
5. AN, F^{18} 2342; *JO,* June 8, 1880, pp. 6212–13.
6. *Le Grelot,* November 5, 1871; *AP,* vol. 34 (1876), p. 666, vol. 98 (1898), p. 552.
7. *AP,* vol. 26 (1874), pp. 285–86, vol. 98 (1898), pp. 257, 407.
8. AN, F^{18} 2342; *GT,* April 16, 1835; *AP,* vol. 26 (1874), p. 286, vol. 98 (1898), pp. 741–42; Blum, "La caricature politique sous la monarchie de juillet," *GBA* 62 (1920), p. 262.

9. Richard Godefrey, *English Caricature, 1620 to the Present* (London: Victoria and Albert Museum, 1984), p. 10; Bevis Hillier, *Cartoons and Caricatures* (Dutton, 1970), p. 7; Robin Lenman, *Censorship and Society in Munich, 1890–1914,* Ph.D. diss., Oxford University, 1975, pp. 98, 137; Ann Allen, *Satire and Society in Wilhelmine Germany: Kladderadatsch and Simplicissimus, 1890–1914* (Lexington: Univ. of Kentucky Press, 1984), pp. 120, 154.

10. Mary Lee Townsend, *Language of the Forbidden: Popular Humor in "Vormarz" Berlin, 1819–1848,* Ph.D. diss., Yale University, 1984, pp. 277, 281; Lionel Lambourne, *An Introduction to Caricature* (London: Victoria and Albert Museum, 1983), p. 10; Moshe Carmilly-Weinberger, *Fear of Art: Censorship and Freedom of Expression in Art* (New York: Bowker, 1986), p. 157.

11. GC, p. 108; Henri Beraldi, *Les graveurs du XIXe siècle* (Conquet, 1888), p. 136; CF, vol. II, p. 276.

12. Cuno, "The Business and Politics of Caricature: Charles Philipon and La Maison Aubert," *GBA* 106 (October 1985), p. 105; CB, vol. 3, p. 161; Roger Bellet, *Presse et journalisme sous le Second Empire* (Colin, 1967), p. 312; Elisabeth Dixler and Michael Dixler, *L'Assiette au Beurre* (François Mapero, 1974), p. 220.

13. Annie Renonciat, *La vie et l'oeuvre de J. J. Grandville* (Vilo, 1985), p. 76; *CF,* vol. 1, p. 37, vol. 2, p. 317; CB, vol. 2, p. 352.

14. *Louis-Philippe: L'homme et le roi* (Archives Nationales, 1974), p. 132; Richard Terdiman, *Discourse/Counter-Discourse: The Theory and Practice of Symbolic Resistance in Nineteenth-Century France* (Ithaca, N.Y.: Cornell University Press, 1985), p. 153.

15. C. A. Ashbee, *Caricature* (London: Chapman and Hall, 1928), p. 47; Alla Sytova, *The Lubok: Russian Folk Pictures* (Leningrad: Aurora, 1984), p. 13; Allen, *Satire and Society,* p. 199; Steve Heller, "Simplicissimus," *Upper and Lower Case* (December 1981), p. 16.

16. *Moniteur Universel,* September 10, 1835, February 18, 1852.

17. These shifts can be traced in the organizational listings published annually by the French government in the *Almanach Royale.*

18. AN, F[18] 2342, F[18] 2363.

19. AN, F[18] VI. 48, F[18]* VI. 133, F[18]* I. 29; Paul Ducatel, *Histoire de la IIIe République vue à travers l'imagerie populaire et la presse satirique,* vol. 2 (Jean Grassin, 1975), p. 49; Michael Driskel, "Singing 'The Marseillaise' in 1840: The Case of Charlet's Censored Prints," *Art Bulletin* 69 (1987), pp. 603–24.

20. *L'Eclipse,* December 1, 1872, September 20, 1874; *Le Titi,* August 2, 1879; *La Jeune Garde,* December 15, 1878; *Le Carillon,* October 25, 1879; Driskel, "Singing 'The Marseillaise' in 1840," p. 623; *Le Grelot,* February 3, 1878; *JO,* June 8, 1880, p. 6213.

21. *Moniteur Universel,* September 10, 1835; Roger Passeron, *Daumier* (New York: Rizzoli, 1981), pp. 95, 264–65; James Parton, *Caricature and Other Comic Art in All Times and Many Lands* (Harper & Brothers, 1878), pp. 236–37; Jules Brisson and Felix Ribeyre, *Les Grands Journaux de France* (Jouaust, 1863), p. 414.

22. *Le Temps,* October 16, 31, 1880; February 5, 1881; AN, F[18] 2342, May 20, 1822, October 7, 1835; March 30, 1852; F[18] 2363, January 8, 1878; *GT,* July 21, 1880.

23. On the personal authorization rule and its implementation, see Robert J. Goldstein, "Approval First, Caricature Second: French Caricaturists, 1852–81," *Print Collector's Newsletter* 19 (1988), pp. 48–50.

24. CF, vol. 1, pp. 37, 224; John Grand-Carteret, *Les moeurs et la caricature en Allemagne, en Austriche et en Suisse* (Hinrichsen, 1885), p. 410.

25. Charles Virmaitre, *Paris-Canard* (Savine, 1888), p. 121; RJ, p. 107.

26. Many of these authorizations are quoted in GC, p. 383; and in Bellet, *Presse et journalisme,* pp. 88–89.

27. Arsène Alexandre, *La maison de Victor Hugo* (Hachette, 1903), p. 125.

28. CB, vol. 3, p. 21.

29. Pierre Casselle, "Le régime legislatif," in *HEF,* p. 53; CB, vol. 3, p. 155; Charles Ledre, *Histoire de la presse* (Arthème Fayard, 1958), p. 209.

30. HA, p. 258; CB, vol. 3, pp. 19—21.

31. Bellet, *Presse et journalisme,* p. 17.

32. On the "melon" incident, see CF, vol. 1, pp 252—61; and André Gill, *Vingt années de Paris* (Marpon and Flammarion, 1883), pp. 1—10.

33. On Sainte-Pelagie, see Bellet, *Presse et journalisme,* pp. 177—81; Philip Spencer, "Censorship by Imprisonment in France, 1830—1870," *Romanic Review* 47 (1956), pp. 32—38.

34. Passeron, *Daumier,* p. 69; GB, p. 42.

35. Passeron, *Daumier,* pp. 67—72.

36. Ibid., p. 68; *La Caricature,* February 7, 1833.

37. GB, p. 41.

CHAPTER TWO

1. GC, p. 523; Jean Adhemar, *Imagerie populaire française* (Milan: Elect, 1968) p. 142; GB, p. 36; *La Charge,* April 7, 1870; Raymonde Branger and Alain Pelizzo, *André Gill: Chargez* (Le Chemin Vert, 1981), p. 10.

2. *La Revue Comique,* October 15, 1871; Robert de la Sizeranne, *Le miroir de la vie* (Hachette, 1902), pp. 137—39.

3. Jules Brivois, *Bibliographe des ouvrages illustrés du XIXe siècle* (Conquet, 1883), p. 71.

4. J. Deschamps, *Notice sur la caricature après la révolution de 1848* (Rouen: Paul Leprêtre, ca. 1880), p. v.

5. *La Caricature,* January 31, 1833; *Le Grelot,* November 12, 1871; *Le Charivari,* April 21, May 29, 1851.

6. *AP* 27 (1874), p. 7; *GT,* June 29, 1830; *La Caricature,* February 2, 1832.

7. André Blum, *La caricature révolutionnaire (1789 à 1795)* (Jouve, 1919), p. 15.

8. Florent Fels, "La caricature française de 1789 a nos jours," *Le Crapouillot* 44 (1959), p. 56.

9. Leon Bienvenu, *Histoire tintamarresque illustrée de Napoléon III,* vol. 2 (1877), pp. 645—50.

10. Pierre et Paul, "Henri Demare," *Les Hommes d'Aujourdhui* 4 (no. 200, ca. 1885).

11. *GT,* June 27, 1832.

12. AP, vol. 34 (1876), p. 31; *Le Triboulet,* August 15, 1880.

13. E. Money, "La caricature sous la Commune," *Revue de France* (April 1872), p. 39; Henry Poulaille, *Aristide Delannoy: Un crayon de combat* (Saint-Denis, France: Le Vent du Ch'min, 1982), p. 67.

14. Charles Pitou, "Charles Gilbert-Martin," *Les Hommes d'Aujourd'hui* 6 (no. 312, ca. 1890).

15. RJ, pp. 102—4; CF, vol. 1, pp. 200—205, vol. 2, pp. 115—18; Charles Virmaitre, *Paris-Canard* (Savine, 1888), pp. 153—57.

16. Ann Taylor Allen, *Satire and Society in Wilhelmine Germany: Kladderadatsch and Simplicissimus* (Lexington: University of Kentucky Press, 1984), p. 142; Louis Morin, *Le dessin humoristique* (Henri Laurens, 1913), p. 4.

CHAPTER THREE

1. Unless otherwise indicated, this section is essentially drawn from GC, pp. 1–40; André Blum, *L'estampe satirique en France pendant les guerres de religion* (Giard & Briere, ca. 1916); Champfleury [Jules Fleury], *Histoire de la caricature sous la réforme et la ligue: Louis XIII à Louis XVI* (Dentu, 1880); and a series of seven articles published by Blum under the title "L'estampe satirique et la caricature en France au XVIIIe siècle," *GBA* 52 (1910), pp. 379–92; 53 (1910), pp. 69–87, 108–20, 243–54, 275–92, 402–20, 449–67.

2. See, in general, on attempts at art censorship before 1789, Moshe Carmilly-Weinberger, *Fear of Art: Censorship and Freedom of Expression in Art* (New York: Bowker, 1986), pp. 1–65; and Jane Clapp, *Art Censorship* (Metuchen, N.J.: Scarecrow, 1972), pp. 1–98. The Luther quotation is from C. A. Ashbee, *Caricature* (London: Chapman and Hall, 1928), p. 37.

3. Ralph Shikes, *The Indignant Eye: The Artist as Social Critic in Prints and Drawings* (Boston: Beacon, 1969), p. 57; W. A. Coupe, "The German Cartoon and the Revolution of 1848," *Comparative Studies in History and Society* 9 (1966–67), p. 139; Blum, *L'estampe satirique, GBA* 52 (1910), p. 384.

4. Alfred Soman, "Press, Pulpit and Censorship in France Before Richelieu," *Proceedings of the American Philosophical Society* 120 (1976), pp. 450–511; Georges Veyrat, *La caricature à travers les siècles* (Charles Mendel, 1895), p. 13; Michel Ragon, *Le dessin d'humour: Histoire de la caricature et du dessin humoristique en France* (Paris: Fayard, 1960), p. 21; M. C. Leber, *De L'état réel de la presse et des pamphlets depuis François I jusqu'à Louis XIV* (Techener, 1834), p. 16.

5. W. Gurney Benham, *Playing Cards: History of the Pack and Explanation of its Many Secrets* (London: Spring Books, 1931), p. 82; J.-H. Mariejo, *Histoire de France illustrée depuis les origines jusqu'à la révolution*, vol. 6, *La réforme et la ligue* (Hachette, 1911), p. 254; L'Abbé Reure, *La press politique à Lyon pendant la ligue* (Picard, 1898), pp. 19, 55.

6. A. H. Mayor, *Prints and People* (New York: Metropolitan Museum of Art, 1971), text accompanying print 556; Pierre Clement, *La police sous Louis XIV* (Dider, 1866), pp. 76–77; René de Livois, *Histoire de la presse Française*, vol. 1 (Lausanne: Spes, 1965), p. 47.

7. Champfleury, *Histoire de la caricature sous la réforme*, p. 256; Champfleury, *Histoire de la caricature au moyen age et sous la renaissance* (Dentu, 1875), pp. 166–68.

8. Blum, *L'estampe satirique, GBA* 52 (1910), pp. 390–91; 53 (1910), p. 72; RJ, p. 23.

9. Champfleury, *Histoire de la caricature sous la réforme*, pp. 279–80.

10. This section is based on the following sources except where otherwise indicated: Blum, *La Caricature Révolutionnaire (1789 à 1795)* (Jouve, 1919); Champfleury *Histoire de la caricature sous la République, L'Empire et la Restauration* (Paris: Societé des gens de lettres, 1874); GC, pp. 41–62; Blum, "La caricature en France sous le Directoire," *La Révolution Française* 70 (1917), pp. 226–41; Blum, "La caricature en France sous le consulat et l'empire," *Revue des Etudes Napoléoniennes* 19 (1918), pp. 296–312; Jules Renouvier, *Histoire de l'art pendant la révolution* (Jules Renouard, 1863), pp. 480–95; Catherine Clerc, *La caricature contre Napoléon* (Promodis, 1985); A. M. Broadley, *Napoléon in Caricature*, vol. 2 (London: John Lane, 1911), pp. 1–99; Jean Adhemar, *Graphic Art of the 18th Century* (New York: McGraw-Hill, 1964), pp. 177–88; Jean-Jacque Levèque, *L'art et la révolution française, 1789–1804* (Neuchatel: Ides et Calendes, 1987), pp. 213–19; Edmond de Goncourt and Jules de Goncourt, *Histoire de la societé française pendant la révolution* (Dentu, 1864), pp. 267–80; Robert Holtman, *Napoleonic Propaganda* (Baton Rouge: Louisiana State University Press, 1950), pp. 161–68; *French Caricature and the French Revolution, 1789–99* (Los Angeles: Grunwald Center for the Graphic Arts, 1988).

11. Maurice Tourneux, *Bibliographie de l'histoire de Paris pendant la révolution française* (Imprimerie Nouvelle, 1894), p. xvii; Adhemar, p. 177.

12. Renouvier, *Histoire de l'art pendant la révolution,* p. 481; Blum, *Caricature Révolutionnaire,* pp. 18–19; Goncourt and Goncourt, *Histoire de la societé française pendant la révolution,* pp. 269–70.

13. Clerc, *La caricature contre Napoléon,* p. 43; Ronald Searle, Claude Roy, and Bernd Bornemann, *La caricature: Art et manifeste* (Geneva: Skira, 1974), pp. 58, 68; Levèque, *L'art et la révolution française,* p. 213; Laura Malvano, "Le sujet politique en peinture: Evénements et histoire pendant les années de la révolution," *Histoire et Critique des Arts* 13/14 (1980), p. 43; Blum, *Caricature Révolutionnaire,* p. 21.

14. Arsène Alexandre, *L'art du rire et de la caricature* (Paris: Quantin, ca. 1900), p. 108.

15. Carmilly-Weinberger, *Fear of Art,* p. 59; James Leith, *The Idea of Art as Propaganda in France, 1750–1799* (Toronto: University of Toronto Press, 1965), p. 147; Levèque, *L'art et al révolution française,* p. 219; Adhemar, pp. 185–87.

16. Malvano, "Le sujet politique en peinture," p. 44; A. Aulard, *Paris pendant la réaction thermidorienne et sous le Directoire,* vol. 3 (Quantin, 1899), p. 716.

17. Blum, *Caricature Révolutionnaire,* p. 53; Aulard, *Paris pendant la réaction thermidorienne,* vol. 3, pp. 716, 775, vol. 4 (1900), p. 674.

18. GC, p. 84; W. M. Thackeray, *The Paris Sketchbook* (Philadelphia: Lippincott, 1901), p. 179.

19. Michel Melot, "The Image in France," in *Censorship: Five Hundred Years of Conflict* (New York: New York Public Library, 1984), p. 83; de Livois, *Histoire de la presse,* p. 155; Holtman, *Napoleonic Propaganda,* pp. 44–45; Henri Welschinger, *La censure sous le Premier Empire* (Charvay Freres, 1882), pp. 14, 203–4.

20. Broadley, *Napoleon in Caricature,* vol. 1, pp. xxxi, xxxviii; Clerc, *La caricature contre Napoléon,* p. 19, 28, 117; A. Aulard, *Paris sous le Consulat,* vol. 1 (Leopold Cerf, 1903), p. 94.

21. Adhemar, *Imagerie populaire française* (Milan: Elect, 1968), p. 131; Welschinger, *La censure,* p. 196; Aulard, vol. 4, (1904), p. 567; Ernest d'Hauterive, *La police secret du Premier Empire* (Perrin, 1908), pp. 95, 200.

22. Holtman, *Napoleonic Propaganda,* p. 166; Aulard, *Paris sous le Consulat,* vol. 4, (1904), p. 205.

23. In general, on the restoration, see GC, pp. 95–152; Champfleury, *Histoire de la caricature sous la République;* and Blum, "La caricature politique en France sous la Restauration," *La Nouvelle Revue* 35 (1918), pp. 119–36.

24. Broadley, *Napoleon in Caricature,* p. 68.

25. Blum, "Caricature en France sous le Consulat," p. 307.

26. On *Le Nain Jaune,* see Champfleury, *Histoire de la caricature sous la République,* pp. 336–41; Eugène Hatin, *Bibliographie historique et critique de la presse périodique française* (Firmin Didot Freres, 1866), pp. 320–24; GV, vol. 6, pp. 19–22; CB, vol. 2, pp. 54–56; and Hatin, *Histoire politique et littéraire de la presse en France* (Poulet-Malassis et de Broise, 1864), pp. 89–110.

27. L. Gabriel-Robinet, *La censure* (Hachette, 1965), p. 72; Hatin, *Histoire,* p. 110; CB, vol. 2, p. 41; Jean Watelet, "La presse illustrée," in *HEF,* p. 329.

28. Jean Mistler, François Blaudez, and André Jacquemin, *Epinal et l'imagerie populaire* (Hachette, 1961), pp. 98–100; Adhemar, *Imagerie populaire,* p. 140; Leonard Marcus, *An Epinal Album: Popular Prints from Nineteenth-Century France* (Boston: Godine, 1984), pp. 2–3; HA, pp. 240–41; FD, pp. 198–99; Hatin, *Histoire,* p. 226; Henri d'Almeras, *La vie*

parisienne sous la Restauration (Albin Michel, n.d.), pp. 370–71; *La légende napoléonienne, 1796–1900* (Bibliothèque Nationale, 1969), pp. 37, 42, 44.

29. *Moniteur Universel,* October 10, 1817; Blum, "La caricature politique," pp. 120–21. The 1819 laws are excerpted and translated in John Stewart, *The Restoration Era in France, 1814–1830* (Princeton: Van Nostrand, 1968), pp. 131–35.

30. de Livois, *Histoire de la presse,* p. 192.

31. The discussion in the Chamber of Peers can be found in *AP,* vol. 36 (1874), pp. 285–87.

32. The discussion in the Chamber of Deputies can be found in *AP,* vol. 37 (1874), pp. 5–9, 763. The 1820 law is excerpted and translated in Stewart, *Restoration Era in France,* pp. 135–36.

33. *AP,* vol. 33 (1876), p. 652.

34. Discussion of the 1822 law can be found in *AP,* vol. 34 (1876), pp. 329–32, 345–46, 666; 35 (1877), p. 209.

35. GC, pp. 183, 186; FD, pp. xxv, xxxv, 30, 159; Louis Meynard de Franc, *Catalogue des ouvrages condamnés depuis 1814 jusqu'à ce jour* (Pillet Aine, 1827), p. 5; Almeras, p. 371; Adhemar, *Imagerie populaire,* p. 142.

36. *La Légende Napoléonienne,* pp. 42, 44–45, 57; Marcus, *Epinal Album,* pp. 2–3; Adhemar, *Imagerie populaire,* pp. 140–42; Mistler, *Epinal et l'imagerie populaire,* pp. 100–101; *GT,* November 18, 30, December 27, 1829; January 17, February 4, 6, 1830; AN, F^{18} 2342, F^{18} 2.

37. *GT,* January 6, 1826; de Franc, *Catalogue,* p. 5; Aristide Marie, *Henry Monnier* (Floury, 1931), p. 40; Champfleury, *Henry Monnier* (Dentu, 1889), p. 379; Annie Renonciat, *La vie et l'oeuvre de J. J. Grandville* (Vilo, 1985), p. 63; AN, F^{18} 2342.

38. On *La Silhouette,* see Renonciat, *Grandville,* pp. 67–72; *GV,* vol. 7, pp. 501–8; and James Cuno, "The Business and Politics of Caricature: Charles Philipon and La Maison Aubert," *Gazette des Beaux-Arts* 106 (1985), pp. 96–99.

39. The trial is reported in *GT,* June 26, 1830.

40. The information in this paragraph is entirely drawn from Charles Saunier, "La gravure du Sacre de Napoléon: Estampe seditieuse," *Revue des Etudes Napoléoniennes* 13 (1918), pp. 46–57.

41. John Grand-Carteret, *Napoléon en images* (Firmin-Didot, 1895), pp. 50–51; GC, p. 184.

42. GC, pp. 184–88; *Le Rire,* December 14, 1901, p. 4.

CHAPTER FOUR

1. Gordon Wright, *France in Modern Times,* 2d ed. (Chicago: Rand McNally, 1974), p. 114.

2. B. Sarrans Jeune, *Louis-Philippe et la contre-révolution de 1830* (Thoisnier-Desplaces, 1834), pp. 65–67, 366.

3. F. Fejto, ed., *The Opening of an Era: 1848* (New York: Grosset & Dunlap, 1973), p. 26; Paul Beik, *Louis-Philippe and the July Monarchy* (Princeton: Van Nostrand, 1965), p. 70.

4. The discussion of the October 8, 1830, law with reference to censorship of images is in *AP,* vol. 63 (1886), pp. 532–34; vol. 64 (1887), pp. 42–43, 99.

5. A good summary of these laws can be found in Jurgen Doring, "Die Presse ist vollkommen frei," in *La Caricature: Bildsatire in Frankreich, 1830–1835 aus der Sammlung von*

Kritterr (Munster: Westfalisches Landesmuseum für Kunst und Kulturgeschichte, 1980), pp. 27–28. I am indebted to Lynne Heller for the translation of this article.

6. The relevant discussion of the December 10, 1830, law is in *AP,* vol. 64 (1887), pp. 609–11, 730–32, 750–55; vol. 65 (1887), pp. 304–6, 349–50.

7. Emile Bayard, *La caricature et les caricaturistes* (Ch. Delagrave, 1900), pp. 24, 32. For sources on Philipon, *La Caricature,* and the 1830–35 struggle over freedom of caricature, see Doring, "Die Presse," pp. 27–41; Edwin Bechtel, *Freedom of the Press and L'Association Mensuelle: Philipon versus Louis-Philippe* (New York: Grolier Club, 1952); Aaron Scharf, *Art and Politics in France* (London: Open University Press, 1972); Judith Wechsler, *A Human Comedy: Physiognomy and Caricature in 19th Century Paris* (Chicago: University of Chicago Press, 1982), pp. 66–109; James Cuno, *Charles Philipon and La Maison Aubert: The Business, Politics and Public of Caricature in Paris, 1820–40,* Ph.D. diss., Harvard University, 1985; Cuno, "The Business and Politics of Caricature: Charles Philipon and La Maison Aubert," *GBA* (October 1985), pp. 95–112; Cuno, "Charles Philipon, La Maison Aubert and the Business of Caricature in Paris, 1829–41," *Art Journal* 43 (1983), pp. 347–54; Annie Renonciat, *La vie et l'oeuvre de J. J. Grandville* (Vilo, 1985), pp. 72–97; André Blum, "La caricature politique sous la monarchie de Juillet," *Gazette des Beaux-Arts* 62 (1920), pp. 257–77; Antoinette Huon, "Charles Philipon et La Maison Aubert," *Etudes de Presse* 9 (1957), pp. 67–76; Klaus Schrenk, "Le mouvement artistique au sein de l'opposition de la monarchie de Juillet," *Histoire et Critique des Arts* 13/14 (1980), pp. 67–96; Segolène Le Men, "Ma Muse, Ta Muse, S'Amuse: Philipon et l'Association Mensuelle," *Cahiers de l'Institut d'Histoire de la Presse et de l'Opinion* 7 (1983), 63–102; Charles Malherbe, *"La Caricature" de 1830: Notes bibliographiques* (Libraire Techener, 1898); GV, vol. 2, pp. 46–87; Jules Brivois, *Bibliographie des ouvrages illustrés du XIXe siècle* (L. Conquet, 1883), pp. 71–88; *Philipon's Printmakers: Politics and Society in the Age of King Louis-Philippe* (Boston: Boston Public Library, 1969); Cuno, "Charles Philipon and 'La Poire': Politics and Pornography in Emblematic Satire, 1830–35," *Proceedings of the Consortium on Revolutionary Europe* (Athens, Ga.: Consortium on Revolutionary Europe, 1984), pp. 147–56. See also the sources cited for Daumier, n. 21, and for Grandville, n. 23.

8. *Le Charivari* has been relatively neglected, but see, in addition to scattered material in most of the sources mentioned in the last footnote, GC, pp. 568–71; André Rossel, *Le Charivari: Un journal révolutionnaire* (Editions de la Courtille, 1971); and in German (which I have not read), Ursula Koch, *Le Charivari: Die Geschichte einer Pariser Tageszeitung im Kampfum die Republik (1832 bis 1882)* (Koln: Informationspresse, 1983).

9. Howard Vincent, *Daumier and His World* (Evanston, Ill.: Northwestern University Press, 1968), p. 15; René de Livois, *Histoire de la presse française* (Lausanne: Spes, 1965), p. 265; Jean Adhemar, *Daumier: Businessman and Finance* (New York: Vilo, 1983), p. 8; Paul Thureau-Dangin, *Histoire de la monarchie de Juillet* (Plon, 1888), p. 576.

10. James Cuno, "Charles Philipon: The Education of a Caricaturist and the Politics of Transformation, 1820–35," *Proceedings of the Consortium of Revolutionary Europe* (Athens, Ga.: Consortium on Revolutionary Europe, 1986), p. 90; Cuno, "Charles Philipon and 'La Poire,' " p. 95.

11. Michel Melot, "Social Comment and Criticism," in *Lithography: 200 Years of Art, History and Technique,* ed. Domenico Porzio (New York: Abrams, 1983), p. 207.

12. Laura Smith, "Prisons, Prisoners and Punishment: French Caricature and Illustration on Penal Reform in the Early Nineteenth Century," *Arts Magazine* 55 (1981), p. 139; David Gies, *Theatre and Politics in Nineteenth-Century Spain* (Cambridge: Cambridge University Press, 1988), p. 144.

13. Brivois, *Bibliographie,* p. 73; Armand Dayot, *Les maîtres de la caricature française au*

XIXe siècle (Maison Quantin, 1888), p. iii; Henri Beraldi, *Les graveurs du XIXe siècle* (L. Conquet, 1888), pp. 115, 119; Thureau-Dangin, *Histoire de la monarchie de Juillet,* p. 575.

14. GC, p. 202; Dayot, *Les maîtres de la caricature française,* p. v.

15. W. M. Thackeray, *The Paris Sketchbook* (Philadelphia: Lippincott, 1901), p. 181; Heinrich Heine, *French Affairs* (London: Heinemann, 1893), pp. 142, 331; Charles Baudelaire, *The Painter of Modern Life* (London: Phaidon, 1964), p. 172; de Livois, *Histoire de la presse,* p. 232.

16. Stendhal, *Lucien Leuwen* (New York: New Directions, 1950), pp. 28, 33; Victor Hugo, *Les Miserables* (Gallimard, 1951), p. 601; Baudelaire, *Painter of Modern Life,* p. 172.

17. Renonciat, *Grandville,* p. 87; M. Gisquet, *Memoires* (Jamar, 1841), vol. 4, pp. 148–49; Cuno, "Business and Politics of Caricature," pp. 105, 109; Philbert Audebrand, *Petits Memoires du XIXe siècle* (Calmann Levy, 1892), p. 223.

18. Accounts of these trials can be found in *La Caricature,* May 26 and November 17, 1831, February 2, March 15, and May 24, 1832; *GT,* May 24, May 25, and November 14, 1831, February 1, March 8, and May 22, 1832; and *Moniteur Universel,* November 16, 1831, and March 9, 1832.

19. Accounts of this trial can be found in *La Caricature,* January 31, 1833; *GT,* January 30, 1833; and *Moniteur Universel,* January 31, 1833.

20. This trial is reported in *La Caricature,* April 10, 1834, and *GT,* April 5, 1834.

21. The Daumier trial is reported in *GT,* February 23, 1832. On Daumier, see Vincent, *Daumier and His World;* Adhemar, *Daumier: Businessman;* Oliver Larkin, *Daumier: Man of His Time* (Boston: Beacon, 1968); Roger Passeron, *Daumier* (Secaucus, N.J.: Popular Books, 1981); Charles Ramus, *Daumier* (New York: Dover, 1978); Peter Morse, "Daumier's Early Lithographs," *Print Review* 11 (1980), pp. 6–53; Sarah Symmons, *Daumier* (London: Oresko, 1979); Robert Rey, *Daumier* (New York: Abrams, 1965); Arsène Alexandre, *Honoré Daumier* (Laurens, 1888); Adhemar, *Honoré Daumier* (Tisne, 1954); *Daumier in Retrospect, 1808–79* (Los Angeles: Los Angeles County Museum of Art, 1979); *Honoré Daumier* (Boston: Museum of Fine Arts, 1958); Karen Finlay, *Daumier and "La Caricature,"* (Toronto: Art Gallery of Ontario, 1984); Roger Terdiman, *Discourse/Counter-Discourse: The Theory and Practice of Symbolic Resistance in Nineteenth-Century France* (Ithaca, N.Y.: Cornell University Press, 1985), pp. 149–97.

22. On the Charivari prosecutions, see *GT,* August 13, October 20, December 12, 1833; July 1, 12, 1834; January 15, March 22, April 16, 23, October 29, 1835.

23. On Traviès, see Claude Ferment, "Le Caricaturiste Traviès: La vie et l'oeuvre d'un 'Prince du Guignon,' " *GBA* 99 (1982), pp. 62–77. On Grandville, see Renonciat, *Grandville* (quotation from p. 84); Charles Blanc, *Les artistes de non temps* (Firmin-Didot, 1876), pp. 275–312; Laure Garcin, *J. J. Grandville* (Eric Losfield, 1970); and *Grandville: Caricatures et Illustrations* (Nancy: Musée des Beaux-Arts, 1975). On the police raid, see Clive Getty, "Grandville: Opposition Caricature and Political Harassment," *Print Collector's Newsletter* (1984), pp. 197–201.

24. *GT,* August 23, 1831; January 18, 22, February 22, May 11, June 23, August 18, 1832; January 1, 1833; February 5, 1834. Quotations are from January 22 and June 23, 1832.

25. *AP,* vol. 85 (1893), p. 718; vol. 86 (1893), pp. 82–83; Albert Boime, *Hollow Icons: The Politics of Sculpture in Nineteenth-Century France* (Kent, Ohio: Kent State University Press, 1987), p. 49.

26. Bechtel, *Freedom of the Press,* pp. 36–37; Vincent, *Daumier and His World,* p. 59.

27. On *La Charge,* see GV, vol. 2 (1895), p. 253–59; Blum, "La caricature politique," p. 266; Vincent, *Daumier and His World,* p. 52.

28. Le Men, "Ma Muse," p. 111.

29. *Le Charivari,* August 7, 11, 12, 17, 20, 30, September 11, 1835; *La Caricature,* August 13, 20, 1835.

30. The debate on the caricature censorship provision of the "September Laws" is recorded in *AP,* vol. 98 (1898), pp. 256–58, 406–7, 541, 552, 618, 737–45; vol. 99 (1899), pp. 48–49.

31. J. L. Talmon, *Romanticism and Revolt, Europe 1815–1848* (New York: Harcourt, Brace, 1967), p. 74; AN, F[18] 2342, September 23, October 7, October 9, 1835.

32. Michael Driskel, "Singing 'The Marseillaise' in 1840: The Case of Charlet's Censored Prints," *Art Bulletin* 59 (1987), pp. 603–25; AN, F[18] VI. 22; *Punch* 4 (1843), pp. 75, 155.

33. Driskel, "Singing 'The Marseillaise' in 1840," pp. 605–6, 616.

34. Eugène Hatin, *Biliographie historique et critique de la presse périodique française* (Firmin Didot Freres, 1866), p. xcii; tabulation of caricature journals based on listings in GC, pp. 559–604.

35. On *La Caricature Française,* see GC, pp. 204, 562; GV, vol. 2 (1895), p. 87.

36. On *La Caricature Provisoire,* see GC, pp. 564–65; GV, vol. 2 (1895), pp. 89–112.

37. GC, p. 583.

38. On *L'Illustration,* see Jean Watelet, "La presse illustré," in *HEF,* pp. 333–34; David Kunzle, "L'illustration: journal universel, 1843–54," *Nouvelles de l'Estampe* 43 (1979), pp. 8–19; Raymond Bachollot, "Le catalogue des journaux satiriques," *Le Collectionneur Français,* no. 244 (April 1987), pp. 5–6, no. 245 (May 1987), pp. 5–7.

39. *GT,* October 29, 1835.

40. *GT,* December 16, 1838, June 9, 1839, August 23, September 3, 1847; *Moniteur Universel,* October 12, 1842.

41. Charles Ledre, *La presse à l'assaut de la monarchie* (Paris: Armand Colin, 1960), p. 170; FD, pp. 260–61; James Cuno, "Philipon et Desloges: Editeurs des 'Physiologies,' " *Cahiers de l'Institut d'Histoire de la Presse et de l'Opinion* 7 (1983), pp. 148–49.

42. Driskel, "Singing 'The Marseillaise' in 1840," p. 621.

43. Paul Gaultier, *Le rire et la caricature* (Hachette, 1906), p. 127. On social satire and criticism by other caricaturists during the 1835–48 period, see Therese Dolan, "Upsetting the Hierarchy: Gavarni's Les Enfants Terribles and Family Life during the 'Monarchie de Juillet,' " *GBA* 109 (1987), pp. 152–58; Aaron Sheon, "Parisian Social Statistics: Gavarni, 'Le Diable a Paris,' and Early Realism," *Art Journal* 44 (1984), pp. 139–48; and Philippe Kaenel, "Le buffon de l'humanité: La zoologie politique de J. J. Grandville," *Revue de l'Art* 74 (1986), pp. 21–28.

44. Baudelaire, pp. 171, 177.

45. Edward Lucie-Smith, *The Art of Caricature* (Ithaca, N.Y.: Cornell University Press, 1981), p. 78; Wechsler, "Human Comedy," p. 95; Passeron, *Daumier,* p. 115.

CHAPTER FIVE

1. HA, p. 392; André Blum, "La caricature politique en France sous la Seconde République," *Révolutions de 1848* 74 (1919), p. 204. In addition to this article, see, in general on caricature during the Second Republic, GC, pp. 291–333.

2. Maurice Agulhon, *The Republican Experiment, 1848–1852* (Cambridge: Cambridge University Press, 1983), p. 39; CB, vol. 2, p. 207–8.

3. The data on caricature journals are based on a tabulation of the information in GC, pp. 559–604.

4. On Daumier, see Oliver Larkin, *Daumier: Man of His Time* (Boston: Beacon, 1966), p. 86; Roger Price, *The French Second Republic: A Social History* (Ithaca, N.Y.: Cornell University Press, 1972), p. 149. On Cham, see David Kunzel, "Cham, le caricaturiste 'populaire,' " *Histoire et Critique des Arts* 13/14 (1980), p. 211. On Blanc, see Henri d'Almeras, *La vie parisienne sous la République de 1848* (Albin Michel, n.d.), pp. 358–59.

5. HA, p. 430; CB, vol. 2, p. 237; John Merriman, *The Agony of the Republic: The Repression of the Left in Revolutionary France, 1848–1851* (New Haven: Yale University Press, 1978), pp. 31, 36; Ted Margadant, *French Peasants in Revolt: The Insurrection of 1851* (Princeton: Princeton University Press, 1979), p. 214.

6. On *La Revue Comique,* see GV, vol. 6 (1895), pp. 1082–1086; GC, p. 598; Anne McCauley, *Nineteenth-Century French Caricatures and Comic Illustrations* (Austin: University of Texas Press, 1985), pp. 13–14, 33–34; *Caricature-presse satirique, 1830–1918* (Paris: Bibliothèque Forney, 1979), p. 25. On Daumier and Ratapoil, see Roger Passeron, *Daumier* (Secaucus, N.J.: Popular Books, 1979), pp. 162–70; Jeanne Wasserman, *Daumier Sculpture* (Cambridge, Mass.: Fogg Art Museum, 1969), pp. 161–69.

7. Wasserman, *Daumier Sculpture,* p. 161; Howard Vincent, *Daumier and His World* (Evanston, Ill.: Northwestern University Press, 1968), p. 146.

8. AN, F18 2, F18 3; Pierre Casselle, "Le régime legislatif," in *HEF,* p. 50, 53; Adrian Rifkin, "Cultural Movement and the Paris Commune," *Art History* 2 (1979), p. 202.

9. Edward Berenson, *Populist Religion and Left-Wing Politics in France, 1830–1852* (Princeton: Princeton University Press, 1984), pp. 80, 213; Thomas Forstenzer, *French Provincial Police and the Fall of the Second Republic* (Princeton: Princeton University Press, 1981), p. 231; Agulhon, *Republican Experiment,* pp. 90, 100; T. J. Clark, *Image of the People: Gustave Courbet and the Second French Republic* (Greenwich, Conn.: New York Graphic Society, 1973), pp. 93–94; Michel Melot, *Prints: History of an Art* (New York: Rizzoli, 1981), p. 103; Maurice Agulhon, *Marianne into Battle: Republican Imagery and Symbolism in France, 1789–1880* (Cambridge: Cambridge University Press, 1981), pp. 104–8.

10. Antoinette Huon, "Charles Philipon et La Maison Aubert," *Etudes de Presse* 9 (1957), p. 74.

11. HA, pp. 432–33; CB, vol. 2, p. 220; Kunzel, "Cham," pp. 215, 217; GV, vol. 2 (1895), p. 170; Jules Brivois, *Bibliographie des ouvrages illustrés du XIXe siècle* (L. Conquet, 1883), p. 93; GC, pp. 566, 600.

12. Victor Pierre, *Histoire de la République de 1848,* vol. 2 (E. Plon, 1878), p. 541; GT, May 28, 1851; *Moniteur Universel,* June 25, 1851. On Vernier, see J. Deschamps, *Notice sur la caricature après la révolution de 1848* (Rouen: Paul Leprêtre, ca. 1880), pp. 15–24; McCauley, *Caricatures and Comic Illustrations,* p. 37.

13. The press decree was published in *Moniteur Universel,* February 18, 1852. Other information in this paragraph is drawn from Kunzel, "Cham," p. 215; Philip Spencer, "Censorship by Imprisonment in France, 1830–1870," *Romanic Review* 47 (1956), p. 27; Roger Bellet, *Presse et journalisme sous le Second Empire* (Armand Colin, 1967), p. 5; Charles Ledre, *Historie de la presse* (Artheme Fayard, 1958), p. 248.

14. AN, F18 2342, F18 2343. For the details of the personal authorization requirement, see chapter 1. The Hugo quote is from Philippe Jones, "La liberté de la caricature en France au XIXe siècle," *Syntheses* 14 (1960), p. 226.

15. AN, F18* VI. 49, F18* VI. 133. In general, on caricature under the Second Empire, see Bellet, *Presse et journalisme,* p. 87–95; André Blum, "La caricature politique en France sous le Second Empire," *Revue des Etudes Napoléoniennes* 15 (1919), pp. 169–83; and GC, pp. 335–416. The quotations are from Francis Carco, *Les Humoristes* (Ollendorf, 1921), p. 16; and Arsène Alexandre, *L'art du rire et la caricature* (May et Motteroz, ca. 1900), p. 16.

16. Charles Ramus, *Daumier: 120 Great Lithographs* (New York: Dover, 1978), p. 17; Loys Delteil, *Honoré Daumier: Le peintre-graveur illustré,* vol. 27 (Loys Delteil, 1926), text accompanying plates 2725–2726; *L'Eclipse,* September 20, 1874.

17. Ramus, *Daumier: 120 Lithographs,* p. xvii; Blum, "La caricature politique en France sous le Second Empire," p. 173; GC, p. 400; Passeron, *Daumier,* pp. 262–65; *GT,* April 21, 1852; Taxile Delord, *Histoire du Second Empire,* vol. 3 (Ballière, 1873), pp. 203–4. In general on *Le Charivari* during this period, see HA, pp. 482–93; CB, vol. 2, pp. 302–3; Jules Brisson and Felix Ribeyre, *Les Grands Journaux de France* (Jouast, 1863), pp. 399–416.

18. Passeron, p. 264; HA, p. 483; Henri Beraldi, *Les graveurs du XIXe siècle* (Conquet, 1888), p. 80; Emile Bayard, *La caricature et les caricaturistes* (Ch. Delagrave, 1900), p. 152; CB, vol. 2, p. 302–3; Champfleury, [Jules Fleury], *Histoire de la caricature moderne* (E. Dentu, 1885), p. 175. On Cham in general, see Kunzel, pp. 196–224, and a partial English translation: Kunzel, "Cham, the 'Popular' Caricaturist," *GBA* (December 1980), pp. 213–24; also Felix Ribeyre, *Cham: Sa vie et son oeuvre* (Plon, 1884).

19. For listings of caricature journals published during the period, see GC, 559–604; and Jones, "La presse satirique illustrée entre 1860 et 1890," *Etudes de Presse* 8 (1956), pp. 13–113. On *Le Boulevard,* see Elisabeth Fallaize, *Etienne Carjat and "Le Boulevard,"* (Geneva: Slatkine, 1987).

20. *GT,* June 23, 1855; GC, p. 591; Charles Virmaitre, *Paris-Canard* (Savine, 1888), p. 126; Eugène Hatin, *Bibliographie historique et critique de la presse périodique française* (Firmin Didot Freres, 1866), pp. 525, 533; FD, pp. 337–38, 395; Casselle, "Le régime legislatif," p. 53.

21. Bonnet de Coton, May 4, 1867. The data on caricature journals are based on the lists provided in Jones, "La presse," pp. 7–113, and GC, 559–604. In general on the 1867–70 period, see GC, pp. 413–16; RJ, pp. 26–30, 43–45; Bellet, pp. 87–92; Blum, "La caricature politique en France sous le Second Empire," pp. 171–72, 180–83; J. Valmy-Baysse, *André Gill* (Marcel Seheur, 1927) pp. 53–160; CF, vol. 1, pp. 33–65, 175–311.

22. CB, vol. 2, p. 316; Cassele, "Le régime legislatif," p. 53.

23. Leon Bienvenu [Touchatout], *Histoire tintamarresque illustrée de Napoléon III,* vol. 1 (Maurice Dreyfus, 1877), p. 648.

24. On *Le Philosophe,* see Jones, "La presse," p. 99; *Le Don Quichotte,* May 7, 14, June 4, 1887; *Le Temps,* February 2, 1868.

25. On *Le Hanneton,* see Jones, "La presse," pp. 68–69; *Le Temps,* September 6, 1868; Virmaitre, *Paris-Canard,* pp. 83–86.

26. On *La Rue,* see Jones, "La presse," p. 103; Bellet, *Presse et journalisme,* pp. 72, 245; Virmaitre, *Paris-Canard,* pp. 105–6; *Le Temps,* December 28, 1867; January 9, 27, 1868; F. W. J. Hemmings, *Culture and Society in France, 1848–1898* (London: Batsfords, 1971), p. 183.

27. *Le Diable à Quatre,* January 15, 1870; *Le Temps,* December 10, 1869; February 25, 1870.

28. GB, pp. 23–24. See, on *La Charge,* Jones, "La presse," pp. 29–30; and GV, vol. 2 (1895), pp. 259–60.

29. The leading sources on Gill are CF; Valmy-Baysse, *André Gill;* and Armand Lods et Vega, *André Gill* (Leon Vanier, 1887). A collection of his caricatures was published in 1981: Raymond Branger and Alain Pelizzo, *André Gill: Chargez!* (Le Chemin Vert). The quotations in this paragraph can be found in CF, vol. 1, p. 34; vol. 2, pp. 258, 278, 286, 313; GC, p. 384; Bayard, *La caricature,* p. 106; Alexandre, *L'art du rire,* p. 244; *La Lune Rousse,* May 18, 1879.

30. Jean Richepin, ed., *André Gill: Vingt Portraits Contemporains* (M. Magnieret, 1886),

p. 2; CF, vol. 2, p. ii; Valmy-Baysse, p. iii; CF, vol. 2, pp. 278, 305; Michel Ragon, *Le dessin d'humour: Histoire de la caricature et du dessin humoristique en France* (Arthème Fayard, 1960), p. 105.

31. On *La Lune,* see, in addition to the sources on Gill cited in n. 29, Jones, "La presse," pp. 82–83; GV, vol. 5 (1904), pp. 430–31; Virmaitre, pp. 120–30.

32. CF, vol. 1, p. 224.

33. On *L'Eclipse,* see, in addition to the sources on Gill cited in n. 29 above, Jones, "La presse," pp. 51–53; GV, vol. 3 (1897), pp. 558–63.

34. *Le Temps,* January 21, February 1, 14, 1870.

35. On the Manet affair, see Theodore Reff, *Manet and Modern Paris* (Chicago: University of Chicago Press, 1982), pp. 208–9; Anne Hansen, *Manet and the Modern Tradition* (New Haven, Conn.: Yale University Press, 1977), p. 115; Jacquelynn Baas, "Edouard Manet and 'Civil War,' " *Art Journal* 45 (1985), pp. 36–37; Metropolitan Museum of Art, *Manet* (New York: Abrams, 1983), p. 531.

36. There is a massive literature on caricature of the 1870–71 period. For a complete catalog of these caricatures, see Jean Berleux, *La caricature politique en France pendant la guerre, le siège et la Commune* (Paris: Labitte, 1890). Many of these caricatures are reprinted in Paul Ducatel, *Histoire de la Commune et du siège de Paris: Vue à travers l'imagerie populaire* (Paris: Grassin, 1973) and in Susan Lambert, *The Franco-Prussian War and the Commune in Caricature, 1870–71* (London: Victoria and Albert Museum, 1971). For narrative accounts, see Aimé Dupuy, *La guerre, la Commune et la presse, 1870–71* (Paris: Armand Colin, 1959); James Leith, "The War of Images surrounding the Commune," in *Images of the Commune,* ed. James Leith (Montreal: McGill-Queen's Univ. Press, 1978), pp. 101–50; Andre Blum, "La caricature politique en France pendant la guerre de 1870–71," *Revue des Etudes Napoléoniennes* (1919), pp. 301–11; E. Money, "La caricature sous la Commune," *Revue de France* (1872), pp. 33–54; and Michel Troche, "Caricaturistes maudits," in *La Commune de Paris* (Saint-Denis: Musée d'Art et d'Histoire, 1971), p. 56–65.

37. HA, p. 599; Leith, "War of Images," p. 149; Money, "La caricature sous la Commune," pp. 34–35; GC, p. 421.

38. Blum, "La caricature politique en France pendant la guerre de 1870–71," p. 305; Lambert, *Franco-Prussian War,* text to plate 27; CF, vol. 1, p. 82.

39. On Pilotell, see Charles Feld, *Pilotell: Dessinateur et communard* (Paris, 1969), esp. pp. 13–15. On *La Caricature Politique* and its suppression, see Jones, "La presse," pp. 26–27.

40. On the April 15 law, see Jacques Lethève, *La caricature et la presse sous la IIIe République* (Armand Colin, 1961), pp. 25–26, 30.

41. Money, "La caricature sous la Commune," pp. 37, 39, 52, 54; Beraldi, *Les Graveurs,* p. 138.

Chapter Six

1. Jacques Lethève, *La caricature et la presse sous la IIIe République* (Armand Colin, 1961), p. 29. Data on the number of caricature journals published are based on the lists in Lethève, pp. 241–50; GC, pp. 559–604; and Philippe Jones, "La presse satirique illustré entre 1860 et 1890," *Etudes de Presse* 8 (1956), pp. 13–113.

2. Charles Virmaitre, *Paris-Canard* (Savine, 1888), pp. 190–91. On the minor journals listed in this paragraph, see the alphabetically listed discussions of journals in the sources in n. 1, above, especially in Jones.

3. On the "Polinchinelle" affair, see Theodore Reff, *Manet and Modern Paris* (Chicago: University of Chicago Press, 1982), p. 124; Marilyn Brown, "Manet, Nodier and 'Polinchinelle,' " *Art Journal* 45 (1985), pp. 43–48; *Edouard Manet and the Execution of Maximilian* (Providence, R.I.: Brown Universty Press, 1981), pp. 36–37, 216.

4. Raymond Manevy, *La presse de la IIIe République* (J. Foret, 1955), p. 27. See, in general, on the difficulties of caricaturing MacMahon, Virmaitre, pp. 192–94.

5. JO, December 31, 1871; Donald English, *Political Uses of Photography in the Third French Republic* (Ann Arbor, Mich.: UMI Research Press, 1984), pp. 66–68; FD, pp. xxix–xxxi; AN, F¹⁸ 2363; Maurice Agulhon, *Marianne into Battle: Republican Imagery and Symbolism in France, 1789–1880* (Cambridge: Cambridge University Press, 1981), pp. 148–55; *L'Eclipse*, December 8, 1872; *Le Temps*, July 9, October 22, 1874.

6. AN, F¹⁸* I.29; CF, vol. 2, pp. 101–2, 106–7.

7. Henri Avenel, *Histoire de la presse française depuis 1789 jusqu'à nos jours* (Paris: Flammarion, 1900), pp. 746–47. See also, on *Le Don Quichotte* and Gilbert-Martin, Jones, "La presse satirique illustré," pp. 48–49; Laurent Goblot, *Apologie de la censure* (Subervie, 1959), pp. 106–17; and Charles Pitou, "Charles Gilbert-Martin," *Les Hommes d'Aujourd'hui*, 6, no. 312 (ca. 1890).

8. On Gill, see the sources listed in chapter 5, n. 29.

9. George Sala, *Paris Herself Again in 1878–9*, 7th ed. (London: Vizetelly, 1884), p. 296; CF, vol. 2, p. 241; Emile Bayard, *La caricature et les caricaturistes* (Delagrave, 1900), pp. 180–84.

10. AN, F¹⁸* I.29.

11. *La Lune Rousse*, April 20, 27, 1879; *Le Titi*, March 19, June 7, August 2, 1879; GB, p. 38; *Le Carillon*, September 28, October 4, 25, 1879. For information on the journals mentioned in this paragraph, see the alphabetical listings in the sources cited in n. 1, especially in Jones.

12. CB, vol. 3, pp. 179, 327. See also Pierre Albert, *Histoire de la Presse Politique Nationale au Debut de la Troisieme Republique*, Ph.D. diss., University of Pairs, 1977, p. 1090. For additional information on the conservative caricature journals mentioned in the next few pages, see the alphabetical listings in the sources cited in n. 1, esp. in Jones.

13. *JO*, June 8, 1880, p. 6213, December 8, 1878, p. 11598; *Le Triboulet*, April 6, 1879.

14. *JO*, June 8, 1880, pp. 6213–15.

15. HA, p. 613; *Le Triboulet*, August 15, 1880.

16. AN, F¹⁸ 2363, F¹⁸* I. 29, F¹⁸* I. 30, F¹⁸* I. 31; *Le Temps*, April 18, 1878.

17. *JO*, June 8, 1880, p. 6214, July 18, 1880, 8293.

18. These data are based on the listings in the sources cited in n. 1.

19. Philippe Roberts-Jones, *La caricature du Second Empire à la Belle Epoque* (Paris: Le Club Français du Libre, 1963), p. 310; HA, p. 763; Jones, "La presse," pp. 57–59.

20. Henri Beraldi, *Les graveurs du XIXe siècle* (Conquet, 1888), pp. 141–42; Arsène Alexandre, "French Caricature of To-day," *Scribners* 15 (1894), p. 479; John Grand-Carteret, *L'affair Dreyfus et l'image* (Ernest Flammarion, 1898), p. 19.

21. CF, vol. 1, pp. 140, 148, vol. 2, p. 274.

22. Paul Gaultier, *Le rire et la caricature* (Hachette, 1906), p. 213–17; Alexandre, "French Caricature," pp. 479, 492.

23. GB, p. 37; Beraldi, *Les Graveurs*, p. 142; Alexandre, "French Caricature," p. 482; RJ, p. 10.

24. *L'Assiette au Beurre*, June 26, 1907.

25. On Boulangism and caricature, see Beraldi, *Les Graveurs*, p. 142; CB, vol. 3, p. 386; HA, pp. 802–4; Alexandre, "French Caricature," p. 480.

26. English, *Political Uses of Photography,* pp. 119, 122, 149; *Le Figaro,* August 8, 1889, p. 3.

27. GB, pp. 38–42; *Le Temps,* November 6, 1888; Jacques Nere, *Le Boulangisme et la presse* (Armand Colin, 1964), pp. 236–37; Pierre et Paul, "Alfred Le Petit," *Les Hommes d'Aujourd'hui,* no. 381 (ca. 1895).

28. On *Le Courrier Française,* see Jones, "La presse," pp. 39–44; GV, vol. 2 (1895), pp. 1046–1053; Ann Ilan-Alter, "Paris as Mecca of Pleasure: Women in Fin-de-Siecle Paris," in *The Graphic Arts and French Society, 1871–1914,* ed. Phillip Dennis Cate (New Brunswick, N.J.: Rutgers University Press, 1988), pp. 117–24; Raymond Bachollet, "Panorama de la presse satirique française: Les audaces du 'Courrier Français,' " *Le Collectionneur Français,* no. 218 (December 1984), pp. 9–11.

29. On the conviction of Legrand, see Gabriel Weisberg, "Theophile Steinlen and Louis Legrand," *Tamarind Papers* 8 (1985), pp. 6–8; Pierre et Paul, "Louis Legrand," *Les Hommes d'Aujourdhui* 8, no. 383 (ca. 1895); Camille Mauclair, *Louis Legrand* (Henry Babou, 1931), pp. 6–7, 11.

30. *Le Courrier Française,* September 30, October 7, 1888.

31. On *Le Père Peinard,* see Roger Langlais, *Le Père Peinard* (Galilee, 1976); André Nataf, *Des anarchistes en France, 1880–1910* (Hachette, 1986), pp. 161–66; Jean Maitron, *Histoire du mouvement anarchiste en France (1880–1914),* vol. 1 (Societé Universitaire d'Editions et de Librairie, 1951), pp. 131, 249, 439; CB, vol. 3, p. 245.

32. Donald Egbert, *Socialism, Radicalism and the Arts* (New York: Knopf, 1970), p. 253; Annemarie Springer, "Terrorism and Anarchy: Late 19th-Century Images of a Political Phenomenon in France," *Art Journal* 38 (1979), pp. 263–65; Phillip Dennis Cate and Susan Gill, *Theophile-Alexandre Steinlen* (Salt Lake City: Gibbs Smith, 1982), quotation from p. 89; Manevy, *La presse de la IIIe République,* pp. 37–39; Ilan-Alter, "Paris as Mecca," p. 125; Herman Schardt, *Paris 1900: Masterworks of French Poster Art* (New York: Putnam, 1970), p. 56.

33. On caricature and the Dreyfus Affair, see Grand-Carteret, *L'affair Dreyfus,* quotations from pp. 18–19; and Phillip Dennis Cate, "The Paris Cry: Graphic Artists and the Dreyfus Affair" in *The Dreyfus Affair: Art, Truth and Justice,* ed. Norman Kleeblatt (Berkeley: University of California Press, 1987), pp. 62–95.

34. On *La Feuille,* see Raymond Bachollet, "La Feuille," *Le Collectionneur Français,* no. 158 (1979), pp. 7–11. On the bans, see Kleeblatt, *The Dreyfus Affair,* pp. 5, 244; and Lise Moller, "Turkeys in French and English Caricature," in *Tribute to Lotte Brand Philip,* William W. Clark, et al., (New York: Abars, 1985), p. 129.

35. There is a large literature on *L'Assiette au Beurre.* The leading study is by Elisabeth Dixler and Michel Dixler, *L'Assiette au Beurre* (Francois Maspero, 1974). Caricatures from this journal are reprinted in Stanley Applebaum, *French Satirical Drawings from "l'Assiette au Beurre,"* (New York: Dover, 1978); and J-M. Royer, *Le livre d'or de l'Assiette au Beurre* (Paris: Simeon, 1977). See also Gisele Lambert, "L'Assiette au Beurre," *Les Nouvelles de l'Estampe* 23 (1975), pp. 7–17; Raymond Bachollet, "L'Assiette au Beurre," *Le Collectionneur Francais* 155 (1979), pp. 7–9; Steven Heller, "L'Assiette au Beurre," *Upper and Lower Case* 8 (1981), pp. 12–15; Ralph Shikes, "Five Artists in the Service of Politics in the Pages of L'Assiette au Beurre," in *Art and Architecture in the Service of Politics,* ed. Henry Millon and Linda Nochlin (Cambridge, Mass.: MIT Press, 1978), pp. 162–81.

36. On the "Albion" incident, see Raymond Bachollet, "Satire, censure et propagande, ou le destin de l'impudique Albion," *Le Collectionneur Français,* no. 174 (December 1980), pp. 14–15, no. 176 (February 1981), pp. 15–16.

37. On Delannoy and Grandjouan and their legal troubles, see Shikes, "Five Artists," pp.

167, 175; Dixler, *L'Assiette au Beurre,* pp. 284–90, 294–99; Vige Longevin, *Exhibition Jules Grandjouan* (Nantes: Musée des Beaux-Arts, 1969); Henry Poulaille, *Aristide Delannoy: Un crayon de combat* (Saint-Denis: Le Vent du Ch'Min, 1982); Victor Meric, *A travers la jungle politique et littéraire* (Valois, 1930), pp. 30–79; "Grandjouan," *La Révolution Prolétarienne,* no. 552 (1969), pp. 173–74.

38. Meric, *A travers la jungle,* p. 33; Poulaille, p. 5; *L'Humanité,* September 27, 1908.
39. Poulaille, *Artistide Delannoy,* p. 154.
40. Meric, *A travers la jungle,* p. 72; Poulaille, p. 15.

CONCLUSION

1. P. Spencer, "Censorship by Imprisonment in France, 1830–1870," *Romanic Review* 47 (1956), p. 27.

2. On theater censorship in nineteenth-century France, the best source is Odile Krakovitch, *Hugo censuré: La liberté au theatre au XIXe siècle* (Calmann Levy, 1985).

3. On restrictions on political freedom in France and in nineteenth-century Europe in general, see two of my previously published works: *Political Repression in Nineteenth-Century Europe* (London: Croom Helm, 1983); and *Political Censorship of the Press and the Arts in Nineteenth-Century Europe* (London: Macmillan, 1989).

4. Jean-Pierre Bechu, *La Belle Epoque et son envers, quand la caricature écrit l'histoire* (André Sauret, 1960), p. 6.

5. Michel Ragon, *Le dessin d'humour: histoire de la caricature et du dessin humoristique en France* (Fayard, 1960), pp. 34–35.

6. *JO,* June 8, 1880, p. 6214.

Bibliographic Essay

PRIMARY SOURCES

The fundamental and essential source for this study was, of course, the nineteenth-century caricature journals themselves. In France between 1815 and 1914, there were well over three hundred-fifty caricature journals published, of which the vast majority were very short-lived and were not political. Although I made no attempt to examine all of the nonpolitical journals, I examined most of them for the 1815–81 period and all of the seventy-five or so significant political caricature journals for the entire 1815–1914 period, including *Le Nain Jaune* (1814–15), *La Silhouette* (1830), *La Caricature* (1830–35), *Le Charivari* (1832–93), *La Charge* (1832–34), *La Caricature Française* (1836), *La Caricature Provisoire* (1838–42), *La Revue Comique* (1848–49), *Le Boulevard* (1861–63), *La Lune* (1865–68), *Le Philosophe* (1867–68), *La Rue* (1867–68), *L'Eclipse* (1868–76), *La Charge* (1870), *La Caricature Politique* (1871), *Le Grelot* (1871–1907), *Le Cri-Cri* (1872–73, 1876), *Le Trombinoscope* (1872–76), *Le Sifflet* (1872–78), *Le Don Quichotte* (1874–93), *Le Carillon* (1876–83), *Le Droit du Peuple* (1876–81), *La Lune Rousse* (1876–79), *La Jeune Garde* (1877–80), *Le Petard* (1877–79), *Le Titi* (1878–80), *Le Sans-Culotte* (1878–79), *Les Hommes d'Aujourd'hui* (1878–99), *Le Monde Parisien* (1878–83), *Le Triboulet* (1878–1921), *Les Contemporains* (1880–81), *La Trique* (1880–81), *La Silhouette* (1880–1914), *Le Courrier Français* (1884–1913), *La Bombe* (1889–90), *Le Balai* (1891), *Le Rire* (1894–1940), and *L'Assiette au Beurre* (1901–12). Since my major interest was censorship of caricature, especially during the period of censorship between 1822 and 1881, I make no claim to have examined each article or even each issue of these and the many other journals cited here, a task which would consume several lifetimes.

Although the complete repository of nineteenth-century French caricature journals can be found only in the Bibliothèque Nationale, in Paris, for an American

scholar both the distance involved and the well-known (among the scholarly community) logistical difficulties of conducting serious research at the Bibliothèque led me to search out, whenever possible, caricature holdings in American libraries. Almost every important nineteenth-century French caricature journal can be found in an American library, although it is sometimes difficult to locate them in a systematic way, since union lists of periodicals are seriously deficient in this area. In order to save future scholars the problems I encountered, I should mention that probably the best holdings for the pre-1850 period are in the Library of Congress (Washington) and the New York Public Library, both of which contain complete runs of *La Caricature* and substantial holdings of *Le Charivari*. For the period after 1850, the best holding is in the Special Collections Department of the University of Connecticut (Storrs). There are also strong holdings in the special collections departments at the University of Wisconsin (Madison) and Northwestern University (Evanston, Illinois); the latter has the additional bonus of a complete run of *La Caricature*. The Rare Book Room of the University of Michigan Library holds a complete run of *L'Assiette au Beurre* as well as complete runs of André Gill's three major journals, *La Lune, L'Eclipse,* and *La Lune Rousse.*

Aside from the caricature journals themselves, important information on prosecutions of caricature can be found for the pre-1850 period in *La Gazette des Tribunaux,* a legal daily which thoroughly covered press prosecutions before mid-century. After 1850, the coverage in *La Gazette* deteriorated markedly, but fairly good coverage can be found in *Le Temps*. Both of these newspapers have published indispensable indexes.

There are two major governmental primary sources, both of which, curiously, have been ignored by French scholars. The first is the transcript of parliamentary debates, published in a series of volumes under the title *Archives Parliamentaires 1787 à 1860,* and, for the post-1860 period, as part of the daily *Journal Officiel*. There were parliamentary debates of various lengths concerning the caricature censorship in 1820, 1822, 1830, 1835, 1878, and 1880 which are extremely valuable for an understanding of the fears and viewpoints of the authorities. The second critical primary source is the material in the French national archives, including internal memoranda from the interior ministry concerning censorship policy and enforcement, and also some sadly incomplete registers from that ministry of censorship decisions (which are simply listed, without explanations for them). While material relevant to caricature censorship is scattered through many files, the most useful by far are the following: F^{18} 2, F^{18} 2342, F^{18} 2363, F^{18} 2364, F^{18*} I. 28, F^{18*} I. 29, F^{18*} I. 30, F^{18*} I. 31, F^{18*} VI.48, F^{18*} VI.49, and F^{18*} VI.133.

SECONDARY SOURCES

This book is the first attempt in either English or French at a comprehensive study of censorship of caricature in nineteenth-century France. The only previously published study which has focused on this area is a ten-page article by Philippe Roberts-

Jones (who has also published under the name Philippe Jones), "La liberté de la caricature en France au XIXe siècle" (*Syntheses* 14 [1960], pp. 220–30). Roberts-Jones has also contributed two valuable studies on French caricature between 1860 and 1890, both of which have much useful information on censorship scattered through them: *De Daumier à Lautrec: Essai sur l'histoire de la caricature française entre 1860 et 1890* ([Paris: Le Beaux-Arts, 1960], especially pp. 21–40), and his invaluable descriptive catalog of caricature journals, "La presse satirique illustrée entre 1860 et 1890" (*Etudes de Presse* 8 [1956], pp. 15–113). Somewhat less useful on censorship, but still extremely valuable for the 1870–1945 period, is Jacques Lethève, *La caricature et la presse sous la IIIe République* (Paris: Armand Colin, 1961), which was reissued in 1986 stripped of all of its invaluable appendixes, which listed caricature journals and leading caricaturists of the period.

Other useful studies of particular time periods include, for the 1830s, several works by James Cuno, *Charles Philipon and La Maison Aubert: The Business, Politics and Public of Caricature in Paris, 1820–40* (Ph.D. diss., Harvard University, 1985), and two published articles derived from this: "The Business and Politics of Caricature: Charles Philipon and La Maison Aubert" (*Gazette des Beaux-Arts* [1985], pp. 95–112) and "Charles Philipon, La Maison Aubert and the Business of Caricature in Paris, 1829–41" (*Art Journal* 43 [1983], pp. 347–53). Also very helpful for the 1830s is Peter Morse, "Daumier's Early Lithographs" (*Print Review* 11 [1980], pp. 6–53); Aaron Scharf, *Art and Politics in France* (London: Open University, 1972); Edwin Bechtel, *Freedom of the Press and L'Association Mensuelle: Philipon versus Louis-Philippe* (New York: Grolier Club, 1952); and Judith Wechsler, *A Human Comedy: Physiognomy and Caricature in 19th Century Paris* ([1982], pp. 66–109). For the 1835–48 period Michael Driskel, "Singing 'The Marseillaise' in 1840: The Case of Charlet's Censored Prints," (*Art Bulletin* 69 [1987], pp. 603–24) is an outstanding study. A series of oddly neglected articles on various time periods by André Blum contain much useful information on censorship: "La caricature politique en France sous la restauration" (*La Nouvelle Revue* 35 [1918], pp. 119–36), "La caricature politique sous la monarchie de juillet" (*Gazette des Beaux-Arts* 62 [1920], pp. 257–77), "La caricature politique en France sous la Seconde Republique" (*Revolutions de 1848* 74 [1919], pp. 203–15), "La caricature politique en France sous le Second Empire" (*Revue des Etudes Napoléoniennes* 15 [1919], pp. 169–83), and "La caricature politique en France pendant la guerre de 1870–71" (*Revue des Etudes Napoléoniennes* [1919], pp. 301–11).

An outstanding study of a leading caricature journal is Elisabeth and Michel Dixler, *L'Assiette au Beurre* (Paris: Maspero, 1974). Several outstanding biographies of leading caricaturists who had troubles with the authorities are Roger Passeron, *Daumier* (New York: Rizzoli, 1981); Charles Fontane, *André Gill: Un maître de la caricature* (Paris: Editions de L'Ibis, 1927); Guy Boulnois, *Alfred Le Petit* (Aumale, France: Groupe Archéologique du Val-de-Bresle, 1986); and Henry Poulaille, *Aristide Delannoy: Un crayon de combat* (Saint-Denis: Le Vent du Ch'Min, 1982).

In terms of general historical surveys of French caricature, the standard study remains John Grand-Carteret, *Les moeurs et la caricature en France* (Paris: Librarie Illustrée, 1888), which is oddly sketchy on matters related to censorship but invalu-

able for its general breadth and for its descriptive lists of most nineteenth-century caricature journals and short biographies of leading caricaturists. Material on censorship is sparse in four shorter surveys: Arsène Alexandre, *L'art du rire et de la caricature* (Paris: Quantin, ca. 1900); Michel Ragon, *Le dessin d'humour: Histoire de la caricature et du dessin humoristique en France* (Paris: Fayard, 1960); Emile Bayard, *La caricature et les caricaturistes* (Paris: Delagrave, 1900); and Florent Fels, "La caricature française de 1789 a nos jours" (*Le Crapouillot* 44 [1959], pp. 53–72). For general histories of the French press in the nineteenth century the leading study remains Claude Bellanger, et al., *Histoire générale de la presse française* Vol. 2, *De 1815 à 1871* (1969), and Vol. 3, *De 1871 à 1940* (1972) [Paris: Presses Universitaries de France]. Henri Avenal, *Histoire de la presse française depuis 1789 jusqu'à nos jours* (Paris: Ernest Flammarion, 1900), remains very useful also. In English, Irene Collins, *The Government and the Newspaper Press in France, 1814–1881* (1959), is helpful for the print press. Useful collections of nineteenth-century French caricatures can be found in Jacques Sternberg and Henry Deuil, *Un siècle de dessins contestaire* (Paris: Denoel, 1974), and in Jean Duche, *Deux siècles d'histoire de France par la caricature* (Paris: Pont Royal, 1961).

For collections of caricatures published between 1860 and 1890 see Philippe Roberts-Jones, *La caricature du Second Empire à la belle epoque* (Paris: Le Club Français du Livre, 1963), for the period 1890 to 1914, Jean-Pierre Bechu, *La belle époque et son envers, quand la caricature écrit l'histoire* (1980), and for the period 1870 to 1940, Paul Ducatel, *Histoire de la IIIe république: Vue à travers l'imagerie populaire et la presse satirique* (5 vols. Paris: Jean Grassin, 1973–79). A collection of caricatures on the theme of censorship can be found in a special issue of *La Rire* published on December 14, 1901.

There are a number of studies of the general subject of the sensitivity of nineteenth-century French authorities to the political significance of imagery, of which I found the most useful to be Maurice Agulhon, *Marianne into Battle: Republican Imagery and Symbolism in France, 1789–1880* (Cambridge: Cambridge University Press, 1981). Other examples of the genre, which were generally not focused specifically enough on material close to my interests to be terribly helpful to me for this study, include Jame Leith, *The Idea of Art as Propaganda in France* (Toronto: University of Toronto Press, 1965); Albert Boime, *Hollow Icons: The Politics of Sculpture in Nineteenth-Century France* (Kent, Ohio: Kent State University Press, 1987); T. J. Clark, *The Absolute Bourgeois: Artists and Politics in France, 1848–1851* (Princeton, N.J.: Princeton University Press, 1982); Patricia Mainardi, *Art and Politics of the Second Empire: The Universal Expositions of 1855 and 1867* (New Haven: Yale University Press, 1987); and Miriam Levin, *Republican Art and Ideology in Late Nineteenth-Century France* (Ann Arbor, Mich.: UMI Research Press, 1986).

Readers interested in the general subject of political controls and political censorship in nineteenth-century Europe will find considerable material in two of my previous books: *Political Repression in Nineteenth-Century Europe* (London: Croom Helm, 1983), and *Political Censorship of the Arts and the Press in Nineteenth-Century Europe* (London: Macmillan, 1989).

Sources for Illustrations

Author's collection: illustrations number 5, 15, 29, 30, 34, 62 (left), 63 (left), 70, 73 (top left and bottom left), 74 (left and right), 75.

Bibliothèque Historique de la Ville de Paris: illustrations number 1 (left), 10 (left), 12 (left), 33, 36 (bottom), 61 (left), 65 (left and right), 73 (bottom right).

Bibliothèque Nationale (Paris): illustrations number 41 (left), 44 (top), 45 (top), 46 (left and right), 53 (top and bottom).

British Newspaper Library (Colindale, London): illustrations number 7 (left and right), 9 (right), 11 (left and center), 14, 19 (bottom), 20 (top and bottom), 40 (left and center), 42 (right), 49, 52, 63 (right).

Detroit Institute of Art: illustration number 47.

Library of Congress (Washington, D.C.): illustrations number 6 (left), 16 (top), 17 (left and right), 21 (bottom), 26, 35 (right), 37 (right), 66 (left and right), 68, 69 (left).

Michigan State University (E. Lansing): illustrations number 16 (bottom), 22 (right), 23 (right), 28 (left).

National Gallery of Art (Washington, D.C.): illustration number 44 (bottom).

New York Public Library: illustrations number 37 (left), 48 (left and right), 54 (left).

Northwestern University (Evanston, Illinois): illustrations number 1 (right), 9 (left), 10 (right), 12 (right), 18 (bottom), 19 (top), 21 (top), 25, 35 (left), 38 (left and right), 39 (left and right), 40 (right), 41 (right), 42 (left), 43 (top and bottom), 45 (bottom), 55 (left), 56 (top and bottom), 57 (left), 58 (right), 59 (left and right), 61 (right), 62 (right), 67, 71 (right and left).

University of Connecticut (Storrs): cover illustration, illustrations number 2, 11 (right), 13, 18 (top).

University of Michigan (Ann Arbor): illustrations number 3 (left and right), 6 (right), 27, 36 (top), 50 (top and bottom), 51 (left and right), 73 (top right).

University of Wisconsin (Madison): illustrations number 22 (left), 28 (right), 32, 54 (right), 55 (right), 57 (right), 58 (left), 69 (right), 72 (left and right).

Wayne State University (Detroit): illustrations number 4, 8, 23 (left), 24, 31, 60 (right and left), 64.

Index

Page numbers for illustrations are in italics. An italicized entry following a journal indicates a caricature published in that journal, and italicized entries following names (or symbolic representations such as the "pear") indicate that that person or symbolic representation is either the artist of the caricature printed on that page or is depicted in the caricature. Page numbers for caption material from the caricatures are in roman type.